War and
Aesthetics

Prisms: Humanities and War
Edited by Anders Engberg-Pedersen

War and Aesthetics: Art, Technology, and the Futures of Warfare, edited by Jens Bjering, Anders Engberg-Pedersen, Solveig Gade, and Christine Strandmose Toft

War and Aesthetics

Art, Technology, and the Futures of Warfare

edited by
Jens Bjering, Anders Engberg-Pedersen, Solveig Gade,
and Christine Strandmose Toft

The MIT Press
Cambridge, Massachusetts
London, England

The MIT Press would like to thank the anonymous peer reviewers who provided comments on drafts of this book. The generous work of academic experts is essential for establishing the authority and quality of our publications. We acknowledge with gratitude the contributions of these otherwise uncredited readers.

This book was set in Deca Serif and Neue Haas Grotesk Text Pro by Westchester Publishing Services. Printed and bound in the United States of America.

Library of Congress Cataloging-in-Publication Data is available.

Names: Bjering, Jens, 1982- editor. | Engberg-Pedersen, Anders, editor. | Gade, Solveig, editor. | Toft, Christine Strandmose, 1986- editor.
Title: War and aesthetics : art, technology, and the futures of warfare / edited by Jens Bjering, Anders Engberg-Pedersen, Solveig Gade, and Christine Strandmose Toft.
Description: Cambridge, Massachusetts : The MIT Press, [2024] | Series: Prisms : humanities and war | Includes bibliographical references and index.
Identifiers: LCCN 2023033664 (print) | LCCN 2023033665 (ebook) | ISBN 9780262048736 (hardcover) | ISBN 9780262377638 (epub) | ISBN 9780262377621 (pdf)
Subjects: LCSH: Aesthetics, Modern—21st century. | Art and war.
Classification: LCC BH301.W37 W37 2024 (print) | LCC BH301.W37 (ebook) | DDC 111/.85—dc23/eng/20231117
LC record available at https://lccn.loc.gov/2023033664
LC ebook record available at https://lccn.loc.gov/2023033665

10 9 8 7 6 5 4 3 2 1

Contents

III THE FUTURES OF WAR

Introduction

Jens Bjering, Anders Engberg-Pedersen, Solveig Gade,
and Christine Strandmose Toft

We rarely think of war as an aesthetic phenomenon. Most often, war is conceived as the brute realization of realpolitik, as the violent manifestation of a political rationality. Perhaps best encapsulated by the motto engraved on Louis XIV's cannons, *ultima ratio regum* (the final argument of kings), the call to arms would appear to lead us into a world and domain of experience at odds with the ideas of the secluded realm of art and refined appreciation conjured by the term "aesthetics." Yet, contemporary discussions about the changing character of warfare, on the one hand, and about the concept of aesthetics, on the other, are beginning to make visible the many overlaps between the two phenomena. Within the traditional arts, scholars of, for example, literature, dance, and film are revising the established aesthetic categories that inform the representation of warfare, while political scientists and scholars of military technology are rethinking the field of war studies from an aesthetic perspective.[1] The present book brings together a number of leading thinkers to reflect on the ways in which an aesthetic approach may inform our understanding of warfare.

Two conceptions of the term "aesthetics" are central to this endeavor. The first of them harkens back to the philosophers and theorists of the eighteenth century. They established the basic parameters of the field that we today associate with "aesthetics" or "philosophical aesthetics." In this narrower sense, the term designates the field of the fine arts as a separate, autonomous realm as well as the theory of the fine arts. What purpose artworks serve, which rules artists should follow, how they engage their audience, or with which categories—from the "beautiful" and the "sublime" to the "interesting" or the "zany"—audiences should approach them are all questions for philosophical aesthetics from Immanuel Kant and Friedrich Schiller to Elaine Scarry and Sianne Ngai.[2]

Vying with this established concept, however, a broader notion of "aesthetics" has gained traction in recent years. Etymologically, the term derives from the word *aesthesis*, meaning "perception" and "sensibility," and in this sense, it can be traced back to ancient Greek thought. It was the German philosopher Alexander Baumgarten, however, who, in 1739, first established aesthetics as a distinct field of philosophical inquiry. In 1750, he published *Aesthetica*, his major treatise on the subject, which he defined as "the science of sensory cognition."[3] Baumgarten's new science set out to examine both immediate perceptions (*sensualia*) and perceptions of absent objects (*phantasmata* and

imaginatio).[4] In the past two decades, this conception of aesthetics has had a major impact on humanities scholarship, particularly through the intermediary of French philosopher Jacques Rancière. Aesthetics, for Rancière, involves the distribution and representation of the sensible. It denotes the forms of sensibility that make up the shared experience of our common world as well as the representations of artworks. Organizing our perception of social and political relations by rendering their various elements either visible or invisible, aesthetics thereby emerges as a much broader category that spans the traditional divide between the fine arts and political representations of society. Just as political discourse makes visible certain elements of the society it purports merely to describe and pushes other elements into the shadows, so the works of authors and artists have political implications through their selective choices of what to make visible and to whom to give a voice.[5] Building on Rancière's work, Matthew Fuller and Eyal Weizman have more recently argued for an even broader, or more foundational, conception of aesthetics that includes the nonhuman sensing capabilities of materials and technological apparatuses in a range of investigative fields: law and human rights, journalism, science, and data analytics, to mention but a few.[6]

In the twenty-first century, both the narrow and the broad conceptions of aesthetics have been closely linked to war. As a response to the wars in Iraq, Afghanistan, and Syria and to the 2022 Russian invasion of Ukraine, there has been a resurgent interest in warfare among literary and cultural scholars, who have grappled with the challenges war poses to aesthetics in the narrower sense of the term. This reconsideration of how art represents warfare involves a revision of some of the established ideas within aesthetic theory. How does art avoid an aestheticization of violence when conventional aesthetic categories of art meet the brute reality of warfare? Which new strategies can art devise to counter the political aestheticization of war? And how does art make visible another realm of warfare far away from the battlefield in the experience of the everyday on the home front?

Already in the scholarship on the arts, however, there is a sense that we need to supplement the traditional examination of art and war with a broader concept of aesthetics to grasp the aesthetic dimension of warfare properly. As a military phenomenon, war is bound up with language, with texts, with designed fabrics, with an aesthetic imaginary that military institutions co-opt and deploy as elements of actual war operations. Outside the realm of art itself, the aesthetic dimension of warfare has become particularly salient with the development of military technology. From the efforts of the Napoleonic Wars to map the potential theaters of war on the European continent to One World Terrain, a digital database of the entire globe including building interiors and subterranean and suboceanic spaces currently developed by the US Army Futures Command, and from the invention of the telescope to satellite imagery and the algorithms that train artificial intelligence (AI) to "see" and sort images and data, the gradual optimization of

instruments for reconnaissance and targeting have sharpened, extended, and expanded war's sensory apparatus. From this perspective, military technology is an applied science of perception. Producing, enhancing, and reconfiguring the sensible inputs that come to establish the perceptual world of war, these technologies are at a fundamental level aesthetic in nature. Contemporary warfare is to a large extent constituted by a martial techno-aesthetic apparatus whose production of visibilities and distribution of the sensible make up the mediated reality within which wars unfold.[7]

This aesthetic perspective on war continues a line of inquiry opened by Paul Virilio. In his 1984 book *War and Cinema: The Logistics of Perception*, Virilio suggests a close link between art and warfare. Interweaving analyses of films by, for example, D. W. Griffith, Abel Vance, and Jean Renoir with a history of imaging techniques in military targeting, he claims, in one of his many apodictic statements, that "war is film, and film is war."[8] For Virilio, the concurrent emergence of cinema and aviation gave rise to the technologically mediated image, which increasingly came to supplant immediate perception on the battlefield.

This convergence of military technology, perception, and aesthetics goes beyond cinema. As mentioned above, it has a deeper history that includes, for example, early mapping and analog war games, and it structures the contemporary techno-aesthetic regime of digital simulations and synthetic training environments.[9] Moreover, the martial techno-aesthetic apparatus that has taken form in the twenty-first century also goes beyond the visible image. Contemporary military technologies engage a spectrum of sensations inaccessible to the human sensorium. They have come to colonize those strange foreign lands that lie beyond human perception, a supra-aesthetic realm from which they encircle, sense, and target the world perceptible to human beings. But techno-aesthetics has broken free not only from the limits of human perception to reach into the supra-aesthetic but also from the present to colonize the future and produce new configurations of time. Today, algorithmic warfare generates an array of imagined futures that act recursively to shape present decision making. The preemptive logic of the military security apparatus encourages the technological fabrication of contingent events that may or may not take place in order to act on these potential events before they can become real. Since these crucial decisions are increasingly withdrawn from human perception and judgment as they become steadily automated, it is all the more important that we understand just how the techno-aesthetic construction of violent futures takes place. How do machines perceive? How do algorithms fabricate imaginary but actionable futures, and what are the larger implications of our martial techno-aesthetic present for artistic interventions, for democracy, and for ethics?

To answer these questions, we brought together artists with scholars in the humanities and social sciences for three war seminars that took place in Copenhagen at the Danish War Museum and the Royal Danish Library between 2018 and 2021. *War and Aesthetics* grew out of these lectures and conversations, and it is naturally both shaped

and limited by them. The discussions of art, for example, focus on literature, dance, and photography, but the arguments have broader applicability beyond the art forms represented in this collection of essays and can be extended to architecture, film, television, and games.[10] Similarly, the organization of the book reflects the main topics of the war seminars: art, technology, and futurity. The first section focuses on the rethinking of aesthetics in the field of art and in the military sphere, the second examines techno-aesthetics and the wider political and theoretical implications of war technology, and the third analyses the future temporalities that these technologies produce. But the formal distinction between the sections is to some extent artificial. Indeed, the book argues that aesthetic configurations of perception, technology, and time are central to artistic engagement with warfare, just as they are key to military AI, high-tech weaponry, and satellite surveillance. It is precisely by gathering artists, scholars of the arts, and scholars of technology and by tracing the entanglements of their discussions that it becomes possible to outline the aesthetic dimension of warfare.

Art, Aesthetics, and the Everyday

So many writers, Kate McLoughlin has noted, "depict a *surrender* in the face of representing war."[11] The scope of military operations and their intensity have time and again presented a challenge to writers who sought to transform their experiences and ideas into art. And yet, the literary canon is abundant with war stories. This central aesthetic paradox is accompanied by a debate about representational authority: Who is allowed to speak or write about war to begin with? In his examination of World War I poetry, for example, James Campbell coined the term "combat Gnosticism" to designate the long aesthetic tradition of representing combat as a qualitatively distinct form of experience that is all but impossible to communicate to anyone who has not experienced it themselves. Especially in the wake of Paul Fussell's *The Great War and Modern Memory* (1975), this claim to exclusivity has been replicated by numerous literary critics who equate war with combat. For these critics, only works that grow out of personal combat experience count as legitimate war writing. As a consequence, Campbell argues, the mainstream canon of war writing has been skewed and limited, leaving out the experiences and writings of women, civilians, and noncombatants.[12]

The contributions by Phil Klay and Kate McLoughlin explore both the paradox of war representation and the debate on literary authority. In "War, Beauty, and the Trouble with Witness," writer and former marine Phil Klay challenges the widespread inclination to read war poems as documentary reports rather than as works of art if they emerge from actual combat experience. He begins with one of the most renowned war poets, Wilfred Owen, who condemns the social values that led to the slaughter of World War I. Owen uses his own personal experience not only to persuade readers of the truth of his account but also to silence those who might not share his view of the war: if you had

seen and heard what I have, Owen writes in his most widely read war poem, "Dulce et Decorum Est," you would not tell young men desperate for glory that it is both sweet and fitting to die for one's country. But who is he speaking for, Klay asks? Is this how his brothers-in-arms would have wanted to be represented and remembered—for their immense sufferings, as victims? What about all the other parts of their war experience: their joy, their camaraderie, the ecstasy of watching the spectacle of the war from afar? In order to create an image of the war capable of soliciting moral condemnation on the part of the readers, several truths are left out of Owen's poetry. Klay reminds us that epistemological and moral claims are closely entwined with the aesthetics of a given work of art. Reflecting on his own experiences in Iraq, Klay proceeds to explore how the challenges that beset war writing in the twentieth century have only intensified in the first decades of the twenty-first.

Kate McLoughlin continues the exploration of these challenges, but she shifts focus to the writing of wartime. In her chapter, "War's Deep Time," she examines how twenty-first-century poets have responded to the wars in the Middle East by creating a curious temporal order that is not only endless but also beginning-less. While the so-called war on terror has alternately been described as the "forever war," wars have long been experienced as endless.[13] The novelty of contemporary poetry lies in the shape they give to a never-beginning, never-ending temporal order. McLoughlin's chapter suggests that the poetic response to the political rhetoric of the "forever war" has been to extend the war into the past. This stretching of time arises through a widespread use of intertextuality, which invokes and mingles both ancient and recent conflicts. Reframing contemporary wars along a deep temporal axis, poetry, McLoughlin shows, thereby enables a different interpretation of twenty-first-century conflict than do the frames provided by political discourse and conventional historiography.

A particularly salient problematic in the artistic representations of war is the tension between the visible and the invisible. From Roman triumphal columns via Napoleonic battle paintings to the televised shock-and-awe tactics deployed by the US military in Iraq in 2003, wars have been represented as breathtaking spectacles as part of strategic attempts to mobilize and shape the perceptions and imaginaries of populations.[14] Soliciting strong emotional responses from viewers, spanning from horror to marvel to pride, such war spectacles have often been framed as extraordinary, even sublime events that constitute a break from the conventionality of everyday civilian life.[15] Political geographers, sociologists, and political philosophers, however, have argued that war need not be spectacular or exceptional.[16] Ingrained in the fabrics of everyday life—be it in the form of policing operations, data surveillance, or everyday militarism—war also appears as a quotidian, even invisible affair that nevertheless has a deep impact on people's lives. Indeed, as the historian Tarak Barkawi has argued, the idea of war as an exceptional event reveals a highly Eurocentric perspective. Colonial violence was by no means limited in time and space. It was everywhere and ever present.[17]

From different vantage points, the contributions by Vivienne Jabri, Caren Kaplan, Joseph Vogl, and Arkadi Zaides all investigate the imbrication of war and aesthetics with the everyday. In the chapter "War, the Aesthetic, and the Political," Vivienne Jabri evokes political philosopher Franz Fanon to remind us that war and violence were indeed integral parts of everyday life in the colonial state. Setting out to explore how aesthetic interpretations may render war visible as part of the routine of daily life, Jabri takes issue with two well-known aesthetic strategies related to war. The first is associated with strategies of "aestheticizing politics," as Walter Benjamin termed the fascist and nazi attempts of his time to instrumentalize aesthetics in the service of politics and ultimately war.[18] The other pertains to artists' attempts to politicize aesthetics to use it to mobilize *against* war. According to Jabri, both strategies are based on a notion of war as spectacular and exceptional. To capture the way in which war as part of everyday life appears to defy the sphere of representation, she turns instead to philosopher Theodor Adorno's concept of "aesthetic negativity" and the visual works of contemporary artist Jananne Al-Ani. To Jabri, Al-Ani's aerial photographs of Middle Eastern landscapes reveal, in a most unspectacular manner, the structural violence inscribed in the gaze from above, as well as the historical colonial practices in which this very gaze is embedded.

While Jabri examines how photography reveals how war is embedded in everyday life, Caren Kaplan turns to textile. In the chapter "The Fabric of War: Lace, Gender, and Everyday Militarism," Kaplan uses textile as a lens through which to study the role of aesthetics as part of the "legitimizing mythologies" and the "intensely normalizing practices" of warfare. Kaplan takes her point of departure in her encounter at the Boston Museum of Fine Arts with an enormous lace panel commemorating the Battle of Britain in 1940. From a materialist and feminist perspective, the chapter then proceeds to trace the use of lace during World War II in quotidian, less spectacular military items. Focusing on the British company Dobsons and M. Browne & Co., which repurposed its production of lace curtains into mosquito and camouflage netting for the troops during World War II, Kaplan intervenes in established histories of military camouflage. These histories have typically emphasized the role of male avant-garde artists, but Kaplan instead sheds light on the role of female labor by emphasizing the shared material infrastructures and modes of production that link the fabrication of aesthetic textile panels and mundane military items in times of industrial warfare. Putting pressure on traditional binaries such as craft/industry, recreational activity/labor, domestic/public sphere, combat zone/civilian sphere, she demonstrates the link between industrial infrastructures, gendered divisions of labor, and everyday militarism, and she disabuses us of any ideas about the purity and nonutility of aesthetic fabrics.

The transgression of the boundaries between the civilian and the military sphere is also central to Joseph Vogl's chapter. While Kaplan is mainly preoccupied with the less visible processes and instances of a general militarization of the everyday, Vogl investigates the highly spectacular phenomenon of "running amok." Vogl traces the

history of the concept of "running amok" within a European context from the early modern to the late modern era. Imported from Southeast Asia, the term first appeared in a European setting in travelogues from the sixteenth century. In these texts, "amok" is described as a moment of exception—a warlike ritual imbued with enmity and hostility that momentarily dissolves the boundaries between war and civil life. For the European colonial masters, "amok" first appeared as something exotic and fascinating, but Vogl shows how the phenomenon began to take on a new significance toward the end of the eighteenth century. Closely linked to emerging state structures, colonial bureaucracy, and the birth of the disciplines of psychiatry and social statistics, "amok" now stepped out of its early warlike associations. Instead, it was individualized and pathologized at the same time as it became a matter of probability rather than exceptionality—a "calculable asset of depreciation" rather than an expression of the intervention of the powers of faith. Consequently, from the 1960s onward, "amok" has increasingly been regarded as a phenomenon that emerges from ordinary, everyday life. Vogl, however, argues that we need to reframe these acts as warlike phenomena. Not only do the perpetrators frequently observe military protocols, but they also transform sites of civil order—schools, shopping malls, and so on—into war zones. Moreover, with reference to various written materials left behind by amok runners (who are far from unaware of their future deeds), Vogl argues that they explicitly identify as enemies of society—enemies who seek to dismantle the very structure of society through their violent acts. In this way, Vogl demonstrates how "amok" has undergone a remarkable conceptual transformation: from a category used to describe the exotic and threatening acts of the Other, it has become a declaration of war embedded in the everyday fabric of Western societies.

These fuzzy lines of demarcation between the military and the civilian spheres equally allow for traffic in the other direction. While art and everyday life are pervaded by war and violence, military institutions have also operationalized aesthetics to optimize the war machine. In the chapter "Blurry Manifestos: The Eshkol–Wachman Movement Notation and Its Militarized Applications," Arkadi Zaides explores the history of an influential movement notation system developed between the late 1950s and 1970s by Israeli dance theorist Noa Eshkol and Israeli architect Avraham Wachman. Envisioned as an objective and highly precise method of mapping and documenting human movement, the system was developed within and intended for the field of dance. Owing to its precise ability to record bodily mobility and the complex ways in which gestures are affected in space, the system was soon appropriated by the fields of aeronautics and cybernetics and used in international militarized contexts such as the NASA Apollo program. With a view to the Israeli context within which the system was developed, Zaides argues that when engaging with the system, one must necessarily take into consideration its embeddedness in the then still relatively new and deeply militarized State of Israel. More specifically, he has in mind the project of the Israeli state to create a new "body image" of both the Israeli people and their land and the state's politics of mapping, colonizing,

and controlling the movement of the Palestinian bodies. Demonstrating how the Eshkol group's notation of the dances of indigenous communities in Palestine came to serve as part of the Israeli politics of containment and how the late Wachman would draw on the principles developed in the notation system in order to promote Israeli settlements, Zaides shows how, in times of war and conflict, aesthetic tools are in the most seamless and unspectacular manner transformed into technologies of power and violence.

Reimagining Technology

The wider co-option and transformation of aesthetics by military institutions suggests that we reappraise and reimagine the nature of contemporary war technologies as well as their wider effects on society. In the twenty-first century in particular, martial techno-aesthetics has reconfigured war's sensory apparatus with the aid of simulations that format and train soldiers' perceptions and via satellites and targeting systems that expand the ambit of vision to enable novel ways of seeing and killing. Yet, these technologies themselves often remain invisible. In its various forms, the contemporary technological apparatus of war widely evades human perception and public awareness and thereby the possibility to comprehend it properly or even to debate its utilization. The three chapters by Ryan Bishop, Elaine Scarry, and James Der Derian all ask us to rethink and reimagine the technologies that pervade and inform contemporary warfare.

As Ryan Bishop shows in "Eyes, Ears, Mouths: A Sensorial Military Triptych (with Satellite, Electronic Music, and Vocoder)," military technology has been a revolutionary force of aesthetics, expanding and transforming the realm of human perception all the while enabling novel artistic means for analyzing and interpreting the military's sensorial revolution. While military surveillance technologies operate in the distant skies beyond the ken of unaided human vision (eyes); while sound technologies to detect and locate nuclear explosions such as the Fast Fourier Transform algorithm perform an aesthetic sequencing of raw data before the sound waves become available to the human sensorium (ears); and while the invention of the vocoder enabled for long-distance military telecommunication by converting speech into code that in turn would be decoded and reconstructed at the receiving end (mouth), artists such as Trevor Paglen, Leif Inge, and Wendy Carlos have exploited these very technologies to make their perceptual operations and transformation visible and audible and bring them into the ambit of human sensation. In this perspective, military technologies must be reimagined as powerful aesthetic tools that are at once symbiotic with and in opposition to the aesthetic imaginaries developed in the realm of art.

The 2022 Russian invasion of Ukraine also demands a reframing of a military technology that has once again come to pose the greatest security threat on the planet: nuclear weapons. If, as Derrida argued during the Cold War, total nuclear war is constituted by a fantasy or a phantasma, in so far as the "remainderless destruction" of

the globe can only be imagined,[19] the fact that the choice to engage in a nuclear war bypasses the usual democratic procedures of public discussion and consent forces us to revisit the philosophical underpinnings of democracy and reimagine the constitutional justifications for nuclear weapons in the first place. As Elaine Scarry argues in "Philosophy and the Weapons of Nuclear War," the current political architecture that subtends nuclear war dismantles any meaningful notion of consent, thereby rendering the social contract void. Returning to the work of Thomas Hobbes, Scarry lays out how—in opposition to many neorealist interpretations—the prevention of injury is fundamental to Hobbes's theory of the social contract. Indeed, the prohibition on war is its "first, and Fundamentall Law." Against this philosophical background, however, the global nuclear regime undermines the social contract that grounds contemporary democracies. The brakes that most democratic constitutions put on war—political deliberation, the complexities of mass mobilization, the public nature of war preparations—are all suspended by the provisions for nuclear warfare. In other words, a philosophical perspective on nuclear weapons reveals the profound political consequences of contemporary war technology.

Developments in technology, however, not only require a fundamental rethinking of democracy but also invite a new theory of the very nature of warfare. The conception of war in the field of international relations has long been based on Newtonian physics and a neorealist interpretation of Hobbesian politics. However, with the rise of cyberwarfare and the prospect of quantum computers transforming war as we know it, this basic world picture may soon be rendered obsolete. In his chapter "Theorizing War: From Classical to Quantum," James Der Derian argues that to manage the unpredictable effects of state-of-the art military technology and to grasp the interconnected, mediated, and observer-dependent character of contemporary and future warfare, a quantum perspective may offer a new and better heuristic. Connecting the thoughts of Carl von Clausewitz, Friedrich Nietzsche, and Niels Bohr, Der Derian outlines a new conceptual frame to prepare us for the military technologies of the future and the radical uncertainties of the wars to come.

The Futures of War

James Der Derian offers a glimpse into the future of warfare. The authors in the final section, however, analyze the changing character of futurity itself, for in the twenty-first century, the military has made the future actionable in a radically new way. In a martial context, the question of time has traditionally been connected to the ability to react promptly and decisively to new developments on the battlefield and in the larger strategic situation—connected, that is, to the speed with which information about enemy movements, the status of friendly forces, weather conditions, and so on could travel from one person or unit to another person or unit. Until the development of

radio—arguably the first example of what Ryan Bishop in his chapter calls "real-time tele-technologies"—this speed had not changed much for centuries or even millennia. It was, roughly speaking, that of a galloping horse, the primary technology for long-distance communication for both Alexander the Great of Macedonia and Frederic the Great of Prussia, twenty-one centuries apart as they were. Alongside so many other martial techno-innovations—most famously gunpowder but also innovations in boat types, in armor, in the social makeup of armies—the (in)ability to convey information in real time over distances exceeding the reach of a human voice or, in clear weather, the human gaze remained a constant that made war a phenomenon the commander literally had to see with his own eyes in order to be updated on the *now* of the situation. If the commander wanted to react to what Mark B. N. Hansen in his chapter refers to as "moments that demand real time response," he therefore had to put himself within direct aesthetic, perceptive reach of the battle. Conversely, the farther removed he was from battle, the more temporal latency and aesthetic inaccuracy he had to suffer, sometimes with fatal consequences. War, perception, technology, time, then, are always linked and form the basic unit in the constant struggle to inch as closely as possible to the very *now* of war, to the real time of decisions and of battle.

While in the past, questions of information and temporality were a question of catching up to the now, the final chapters all examine how the nature of, use of, and attitude toward time itself have changed profoundly in the wars of the twenty-first century. How so? We might say that the struggle to inch closer to the ability to relay information and act in real time has been inverted. With 9/11 as the master signifier for the security regime of the new millennium, catching up to the now—ambitious and impossible as this had been for generations of human belligerence—was no longer enough, since the now could mean an entirely unforeseen deadly attack. Instead, what emerged after 9/11 was in a certain sense a surpassing of the now of real time, a move to pass beyond control of the now and into the future in order to preempt the brutal intrusion of surprise geopolitical events. Turning the future itself into a battleground means turning away from Carl von Clausewitz's dictum that, in war, one should focus not on the possible but only on the probable.[20] Instead, one should assume the potentiality of all future threats, as outlandish or improbable as they might be, and try to prevent them before they materialize as even the slightest threat in the present.

As these chapters argue, this shift to the future was made possible only through an extended use of both software and hardware. In other words, it was made possible through the development of algorithms and drones. More than anything else, these two technologies have changed the very nature of war, not separately but rather as a mutually dependent techno-conceptual apparatus. It is also in the drone and in the algorithm that we find the departure point from earlier claims to a qualitative shift in war's nature, for the algorithm and the drone move us beyond the real-time, cinematic, tele-technological transmissions from the battlefield, which define so much of Paul

Virilio's analyses, and into something completely new. In other words, the algorithm and the drone constitute technological novelties that have changed wartime itself.

Homing in on the nature of the AI software technologies that enable so-called signature strikes, Anthony Downey, in his chapter "The Future of Death: Algorithmic Design, Predictive Analysis, and Drone Warfare," notes that these targeted drone killings represent a form of technological determinism, inasmuch as predictive analyses seek to extrapolate from past behavior (data) to calculate the likelihood of future events (unknown data). Based on algorithmic analyses, in which an individual or a group of individuals' movements both virtually and physically might lead to a future terrorist attack that has to be preempted through state-sanctioned assassination, these signature strikes remain the emblematic expression of the drone–algorithm apparatus's transfiguration of war into a phenomenon with a violent claim on the future itself. Yet, the problem remains that AI and algorithms make mistakes and that these mistakes lead to the death of innocent civilians. Remarkably, these mistakes are not freak accidents, nor are they related to events that can be viewed as external to the technologies that make them. Rather, Downey shows that these mistakes are part and parcel of the architecture of the technological apparatuses that recognize and label individuals for targeting and that this architecture's choice of targets for elimination is based on neocolonial undercurrents. Perhaps the most striking aspect of this technologically determined proneness to error is the inherent paranoia of AI, its ability to "hallucinate" imaginary threats into being and to react to those threats with lethal consequences.

While Anthony Downey focuses on the technological assemblage of AI and drones, Mark B. N. Hansen focuses on the logic of futurity that governs the US military's "predictive machine" and its routine killings of putative enemies. In his chapter "When Timing Is Decisive: Distributed Sovereignty's Halting Problem," Hansen begins his analysis with the Reagan presidency. He notes that the sovereignty of the commander in chief was essentially emptied out by Reagan's claim not to remember exactly who gave which orders during the Iran–Contra affair. Reagan thereby replaced formidable sovereign power with a perhaps paradoxical sovereign ignorance. While Reagan was able to disentangle himself from the Iran–Contra fallout through this modality of sovereignty as ignorance, Hansen claims that a new mode of breaking with traditional thoughts on personalized and localizable sovereignty began with the Bush Jr. administration and reached its pinnacle with the Obama administration. By relying on a whole matrix of actors—human, machinic, and algorithmic—to reach decisions as to who to kill and who to let live, this new mode of sovereignty represents a distribution of the sovereign power to decide who must live and who must die. The second part of Hansen's chapter engages with the precise logic of the predictive aspects of this distributed sovereignty, noting that the US drone-assassination apparatus is not so much an expression of a *preemptive* logic as it is an expression of a *predictive* logic. While the difference between preemption and prediction might seem academic, Hansen's argument is vital to understand and

demystify the nature and logic of drone assassinations and signature strikes: we are not dealing with an effect without a cause—that is, with the production of a future set of events that must be prevented in the present—but rather with a new and strengthened faith in causality—a fetishism of causality, one might call Hansen's predictive machine, a predictive machine representing a distributed sovereignty whose basic logic is no longer localizable or acts as one powerful commander in chief but instead automatically executes a distributed life-or-death decision immediately.

Can war itself survive this predictive machine, this global system of violence from afar? Caroline Holmqvist's chapter "The End of Reciprocity?" claims that "in the modern social imaginary, war had temporal demarcations." Wars had, in short, beginnings and endings. While acknowledging that such Western imaginaries about war always contained more than a measure of colonial ideology (for what looked like peace in Europe was always undergirded by a constant violence in other parts of the world), Holmqvist claims that war has undergone a qualitative shift, which makes it even less demarcated temporally and spatially today. A cornerstone of the reasonably clear temporal and spatial demarcation of old was reciprocity. Forever wars were essentially unsustainable as never-ending phenomena because they were reciprocal affairs in which two enemies at least to some extent inflicted casualties on each other. Yet, building on the track laid down by Anthony Downey and Mark B. N. Hansen, Holmqvist identifies the present global wars of drone strikes and special forces operations as affecting a qualitative transfiguration of war precisely through the *loss* of reciprocity. The drone pilot's physical safety from harm and his or her invisibility from his targets is the most emblematic expression of this qualitative shift—an expression that raises questions about whether what we are witnessing today even qualifies as war and, if so, whether war's nature has undergone an ontological shift. Moreover, because US drone strikes and special ops appear endless, they come to colonize the future and make it impossible to imagine war's traditional dialectic counterpart: peace. The second part of Holmqvist's chapter proceeds to suggest new ways to conceptualize reciprocity, even in the current situation. If, for one, we stop subscribing to liberal fetishizations of a post-antagonistic war—to dreams about being able to wage wars that, at least on our end, are bloodless— an avenue might be opened up for realizing that the targets of drone strikes might be invisible in an optical sense, but that both the drone operator and the target in ethical terms can nonetheless be mutually visible. Doing so reinstates reciprocity on the level of an ethics that recognizes the Other in new ways and might thus affect a decolonization of the future.

Finally, Louise Amoore, in her chapter "The War on Futures," analyses and criticizes attempts to demarcate clearly the difference between technologies used for war and technologies used for other putatively more peaceful endeavors. She asks why it is impossible to delimit ethically and politically peaceful technologies from technologies used in and for war. Drawing first on Norbert Wiener's refusal to do any "war work"

and then, more than half a century later, on thousands of Google employees' written protest over having their work be part of Project Maven, a Pentagon-sponsored program for video analysis, Amoore argues that science and technology do not emerge in "some kind of non-political sphere of laboratories and computer models." They always form part of a war-infused system, most prominently in the realm of policing and border patrolling. With this observation, Amoore picks up the theoretical gambit proposed by Michel Foucault in *Society Must Be Defended*, in which he sought to invert Clausewitz's famous dictum that war is the continuation of politics and suggested instead that war is the continuation of politics by other means. Politics, Amoore argues, is not something that can ever be disentangled from war. It is, if not actual war, then warlike.

What does such ontological spillover between war and politics mean when the (algorithmic) technologies we use for war today have already identified the enemies of the states using them? It means that we are not only waging war on the perceived terrorist enemy but that we are waging a "war on futures"—on our own collective political futures, first and foremost, but also on our individual futures, with all the contingencies and possibilities they might or should hold. This war on the future is the consequence of the ontological nature of the relation between war and politics and the specific assemblage of technologies defining this relation today, an ontology and an assemblage that make the neat separation between war and everything else impossible to sustain. Ending on a hopeful note, however, Amoore describes welcoming scenes from the Berlin Central Station on March 3, 2022, where "Berlin residents are crowding the concourse to welcome the arrival of those people fleeing the war in Ukraine." This scene, Amoore notes, serves as a counterimage to the algorithmic war on the future by representing an openness to the non-algorithmically defined or identified human other, an openness that runs counter to, and perhaps may even counteract, the logic of futurity found in the algorithmic apparatus.

The 2022 Russian invasion of Ukraine would appear to mark the end of the so-called war on terror as the primary global war imaginary. But the return of great power politics and the spectacular imaginary of nuclear warfare should not make us forget that other less visible forms of warfare—algorithmic war, cyberwar, hybrid war, and drone war—continue unabated and extend even further into the everyday civilian sphere where technologies inconspicuously structure the political, economic, and affective lives of citizens across the globe. Contemporary warfare and the wars to come will span a perceptual spectrum that stretches from the cataclysmic spectacularism of potential nuclear war to the invisible supra-aesthetic realm beyond human perception. A key task of art in the coming years will be to make this spectrum of war perceptible in order to reveal military attempts to foreclose the future and to allow us to imagine alternative forms of a more peaceful future coexistence.

Notes

1. See, for example, Anders Engberg-Pedersen and Neil Ramsey, eds., *War and Literary Studies* (Cambridge, MA: Cambridge University Press, 2023); Kate McLoughlin, *Authoring War: The Literary Representation of War from the Iliad to Iraq* (Cambridge, MA: Cambridge University Press, 2011) and *Veteran Poetics: British Literature in the Age of Mass Warfare, 1790–2015* (Cambridge, MA: Cambridge University Press, 2018); Paul K. Saint-Amour, *Tense Future: Modernism, Total War, Encyclopedic Form* (Oxford: Oxford University Press, 2015); Jan Mieszkowski, *Watching War* (Stanford, CA: Stanford University Press, 2012); Santanu Das, *India, Empire, and First World War Culture: Literature, Images, and Songs* (Cambridge, MA: Cambridge University Press, 2018); and Mary A. Favret, *War at a Distance* (Princeton, NJ: Princeton University Press, 2010). Within political science and studies in military technology and culture, see especially Roland Bleiker, *Aesthetics and World Politics* (Basingstoke, UK: Palgrave Macmillan, 2009); Roland Bleiker, ed., *Visual Global Politics* (London: Routledge, 2018); Jenny Edkins and Maja Zehfuss, *Global Politics: A New Introduction*, 3rd ed. (London: Routledge, 2019); John Beck and Ryan Bishop, *Technocrats of the Imagination: Art, Technology, and the Military-Industrial Avant-Garde* (Durham, NC: Duke University Press, 2020); Louise Amoore, *Cloud Ethics: Algorithms and the Attributes of Ourselves and Others* (Durham, NC: Duke University Press, 2020); Caren Kaplan, *Aerial Aftermaths: Wartime from Above* (Durham, NC: Duke University Press, 2018); Elaine Scarry, *Thermonuclear Monarchy: Choosing between Democracy and Doom* (New York: W. W. Norton, 2016); Susan Schuppli, *Material Witness: Media, Forensics, Evidence* (Cambridge, MA: MIT Press, 2020).

2. In addition to the classical texts, see, for example, Elaine Scarry, *On Beauty and Being Just* (Princeton, NJ: Princeton University Press, 1999) and *Dreaming by the Book* (New York: Farrar, Straus and Giroux, 1999), as well as Sianne Ngai, *Our Aesthetic Categories: Zany, Cute, Interesting* (Cambridge, MA: Harvard University Press, 2012) and *Theory of the Gimmick: Aesthetic Judgment and Capitalist Form* (Cambridge, MA: Belknap Press of Harvard University Press, 2020). For a useful overview, see Paul Guyer, *A History of Modern Aesthetics* (Cambridge, MA: Cambridge University Press, 2014).

3. Alexander Gottlieb Baumgarten, *Aesthetica/Ästhetik*, vol. 1 (Hamburg: Felix Meiner Verlag, 2007), 10.

4. Baumgarten, *Aesthetica/Ästhetik*, vol. 1, XXV, 14, 28, 30.

5. See Jacques Rancière, *Malaise dans l'esthetique* (Paris: Éditions Galilée, 2004), *Le Partage du sensible: Esthétique et politique* (Paris: La Fabrique Éditions, 2000), *The Politics of Aesthetics: The Distribution of the Sensible*, trans. Gabriel Rockhill (London: Continuum, 2004), and *Aesthetics and its Discontents*, trans. Steven Corcoran (Cambridge: Polity Press, 2009); Jacques Rancière, Gavin Arnall, Laura Gandolfi, and Enea Zaramella, "Aesthetics and Politics Revisited: An Interview with Jacques Rancière," *Critical Inquiry* 38, no. 2 (Winter 2012): 289–297. See also Mark Foster Gage, ed., *Aesthetics Equals Politics: New Discourses across Art, Architecture, and Philosophy* (Cambridge, MA: MIT Press, 2019).

6. Matthew Fuller and Eyal Weizman, *Investigative Aesthetics: Conflicts and Commons in the Politics of Truth* (London: Verso, 2021), 12 and 28. See also Thomas Keenan and Eyal Weizman, *Mengele's Skull: The Advent of a Forensic Aesthetics* (Berlin: Sternberg, 2012).

7. For a more detailed account of the co-option of aesthetics by military institutions, see Anders Engberg-Pedersen, *Martial Aesthetics: How War Became an Art Form* (Stanford, CA: Stanford University Press, 2023).

8. Paul Virilio, *War and Cinema: The Logistics of Perception* (London: Verso, 1989), 34. The book was originally published in French as *Guerre et cinéma 1: Logistique de la Perception* (Paris: Seuil, 1984).

9. See also Antoine Bousquet, *The Eye of War: Military Perception from the Telescope to the Drone* (Minneapolis: University of Minnesota Press, 2018).

10. For exemplary work in these fields, see Eyal Weizman, *Forensic Architecture: Violence at the Threshold of Detectability* (New York: Zone Book, 2019); Matthew Fuller and Eyal Weizman, *Investigative Aesthetics: Conflicts and Commons in the Politics of Truth* (London: Verso, 2021); Laura Kurgan, *Close Up at a Distance: Mapping, Technology, and Politics* (New York: Zone Books, 2013); Beatriz Columina, *Domesticity at War* (Cambridge, MA: MIT Press, 2007); Reinhold Martin, *The Organizational Complex: Architecture, Media, and Corporate Space* (Cambridge, MA: MIT Press, 2003); and Timothy Lenoir and Luke Caldwell, *The Military-Entertainment Complex* (Cambridge, MA: Harvard University Press, 2018).

11. McLoughlin, *Authoring War*, 5.

12. James Campbell, "Combat Gnosticism: The Ideology of First World War Poetry Criticism," *New Literary History* 30, no. 1 (1999): 203–215.

13. See McLoughlin's comprehensive study, *Authoring War*.

14. See W. J. T. Mitchell, *Cloning Terror: The War of Images, 9/11 to the Present* (Chicago: Chicago University Press, 2010); Jan Mieszkowski, *Watching War* (Stanford, CA: Stanford University Press, 2012); Clare Finburgh: *Watching War on the 21st Century Stage: Spectacles of Conflict* (London: Bloomsbury, 2017).

15. See Anders Engberg-Pedersen and Kathrin Maurer, eds., *Visualizing War: Emotions, Technologies, Communities* (New York: Routledge, 2018).

16. See Derek Gregory, *The Colonial Present* (Oxford: Blackwell, 2004); Louise Amoore, "Algorithmic War: Everyday Geographies of the War on Terror," *Antipode: A Radical Journal of Geography* 41, no. 1 (2009): 49–69, and *The Politics of Possibility: Risk and Security Beyond Probability* (London: Duke University Press, 2013); Kevin McSorly, "Predatory War, Drones and Torture: Remapping *The Body in Pain*," *Body and Society* 25, no. 3 (2017): 73–99, "Archives of Enmity and Martial Epistemology," in *(W)archives: Archival Imaginaries, War, and Contemporary Art*, eds. Daniela Agostinho, Solveig Gade, Nanna Bonde Thylstrup, and Kristin Veel (Berlin: Sternberg Press, 2020), 39–58; Michael Hardt and Antonio Negri, *Empire* (Cambridge, MA: Harvard University Press, 2000); Michael Hardt and Antonio Negri, *Multitude: War and Democracy in Age of Empire* (London: Hamish Hamilton, 2004).

17. Tarak Barkawi, "Decolonizing War," *European Journal of International Security* 1, no. 2 (2016): 199–214. See also Franz Fanon, *The Wretched of the Earth*, trans. Constance Farrington (Harmondsworth, UK: Penguin, 1967).

18. Walter Benjamin, "The Work of Art in the Age of Mechanical Reproduction," *Illuminations*, ed. Hannah Arendt, trans. Harry Zohn (New York: Schocken Books, 1969 [1935]).

19. Jacques Derrida, "No Apocalypse, Not Now (Full Speed Ahead, Seven Missiles, Seven Missives)," *Diacritics* 14, no. 2 (Summer 1984): 30.

20. Carl von Clausewitz, *Vom Kriege* (Bonn: Dümmler, 1980), 308.

I

ART, AESTHETICS, AND THE EVERYDAY

1

War, Beauty, and the Trouble with Witness

Phil Klay

Let's start with a glorious death, shall we? Imagine a young, idealistic Englishman leaving for war in December 1916, telling his mother, "There is a fine heroic feeling about being in France."[1] Let us imagine that fine heroic feeling fading as he sees trench warfare, as he is gassed, as he marches through shelled and flooded terrain, as men lose their boots in the mud and march on with freezing and bloody feet, as machine-gun fire impacts around them. Imagine him with his men caught in the snow, in a field, with no support troops. "I kept alive on brandy," he writes, "the fear of death, and the glorious prospect of the cathedral town just below us, glittering with the morning."[2]

Imagine him blown into the air by a shell and then spending days trapped beside the body of a dead friend, after which he receives medical and psychiatric treatment in England. Imagine him beginning to speak out against what is happening overseas, developing his own poetic language of protest. Imagine him horrified by the war, traumatized by the war, morally repulsed by the war. Now imagine him deciding to return to France anyway.

Imagine him writing, two months before his death: "I shall be better able to cry my outcry, playing my part."[3] Imagine him under heavy fire that kills all but two officers from his unit. And imagine him leading his men back to safety and receiving the Military Cross for valor. Imagine how the constant death numbs him, how he comforts his mother, lies to his mother, tells her, "It is a great life. I am more oblivious than alas! yourself, dear Mother, of the ghastly glimmering of the guns outside, & the hollow crashing of the shells. There is no danger down here, or if any, it will be well over before you read these lines."[4]

Imagine him sitting alone, reading a copy of Swinburne's *Poems and Ballads*, with a little postcard of old Scarborough kept in it to remind him of England. Imagine his face shining with "wonder and delight"[5] when a fellow officer quotes Keats to him. Then imagine him on a doomed mission to build a bridge over a canal under fire. His unit drops piers into the water, fixes poles from one pier to another, and hooks them together with duckboard as the machine guns open up, as gas begins replacing the early morning fog, quickly killing nearly three fourths of the unit's engineers.

Imagine our young, idealistic Englishman patting his men encouragingly, amid the terror telling them, "Well done," and "You are doing well, my boy."[6] A shell drops on the fledgling bridge, destroying it. Imagine our young lieutenant struck and killed.

This man I'm asking you to imagine is, of course, Wilfred Owen. And the reason I'm asking you to imagine his life before I ask you to consider his poetry is because, more than almost any other poet who preceded him, his life is inextricable from his poetry.

In "Dulce et Decorum Est," his most famous poem, he addresses Jessie Pope, a war poetess, writing out of her imaginative capacities rather than from personal exposure to combat, and declares that only if she too were haunted, as he was, by dreams of the horrible deaths by gas he had witnessed, she "would not tell with such high zest / To children ardent for some desperate glory, / The old Lie: Dulce et decorum est / Pro patria mori."[7] This is not simply the somber voice of experience cautioning the neophyte but rather a moral witness, using personal encounter to condemn the social values that led to such slaughter. His experience in the war is the trump card used to silence her.

That moral witness, a voice of prophetic denunciation, continues in poem after poem. With him, we hear the "mad gusts tugging on the wire," see "death's promises . . . and life's half-promise," and ask, "What are we doing here?" and "What passing bells for these who die as cattle?"[8]

And just in case you missed it in the poetry itself, Owen wrote a preface clarifying that his poetry stood in sharp contrast to politically acceptable pretty versions of the war:

> This book is not about heroes. English poetry is not yet fit to speak of them. Nor is it about deeds, or lands, nor anything about glory, honour, might, majesty, dominion, or power, except War. Above all I am not concerned with Poetry. My subject is War, and the pity of War. The Poetry is in the pity. Yet these elegies are to this generation in no sense consolatory. They may be to the next. All a poet can do today is warn. That is why the true Poets must be truthful.[9]

In other words, despite all the care Owen took with his lines, his complex arrangement of symbol, his mastery of assonance, alliteration, and slant rhyme, his work was primary concerned not with aesthetic qualities at all but rather with "truth" and "pity," which meant his own personal political convictions and sensibility transmuted into verse. As Seamus Heaney would later describe him:

> Wilfred Owen, and others like him in the trenches of Flanders, are among the first of a type of poet who increasingly appears in the annals of twentieth-century literature, and who looms as a kind of shadowy judging figure above every poet who has written subsequently. The shorthand name we have evolved for this figure is the "poet as witness," and he represents poetry's solidarity with the doomed, the deprived, the victimized, the under-privileged. The witness is any figure in whom the truth-telling urge and the compulsion to identify with the oppressed becomes necessarily integral with the act of writing itself.[10]

To this from Heaney, we might add one other component in poetic witness: that the author's identification with the oppressed is done not simply in word but also in deed. The poet's head, even if ever so tentatively, should have spent time in the noose. Thus, the poet's life and work become unified; imaginatively considering the experience from which the author speaks becomes part of the aesthetic experience of reading the poem.

In "The Death of the Author," Roland Barthes argued, in reference to a passage from Balzac, that "all writing is itself this special voice, consisting of several indiscernible voices, and that literature is precisely the invention of this voice, to which we cannot assign a specific origin: literature is that neuter, that composite, that oblique into which every subject escapes, the trap where all identity is lost, beginning with the very identity of the body that writes . . . it is language which speaks, not the author."[11] This rather playful image of the poem as a disembodied aesthetic object could never be less helpful than with such poetry as was produced during World War I. As Heaney would put it, Owen "seemed almost to obliterate the line between art and life . . . His poems have the potency of human testimony, of martyr's relics, so that any intrusion of the aesthetic can feel like impropriety . . . he earned the right to his lines by going up the line, and nobody who has read Owen's poems and letters can underestimate their cost in terms of trauma and courage and heartbreak."[12]

All this is true, so true. One cannot help but admire Owen, the eloquent tongue matched with deep moral principle enacted under great suffering to the point of death. And yet, and yet, something in me rebels against Owen, the Christ-like martyr to poetic witness. When I write fiction, when it's working, I feel a sort of wild, anarchic freedom before me, one that opens a gulf between my work and whatever subject I feel moral urgency to bear witness to. This is a chaotic, unruly part of myself, one that I'm not sure speaks well of me, although it is one that I suspect is inseparable from the creation of art and one that pushes me to ask impertinent questions, even of the dead.

I

My first impertinent question is, Who the hell is Wilfred Owen speaking *for*? After all, his is not a poetry of narrow personal complaint. As W. B. Yeats complained of Owen's generation of officer's poetry, "they were not without joy—for all skill is joyful—but felt bound, in the words of the best known, to plead the suffering of their men."[13] And there's something rather slippery there. Did these men want to be spoken for, and even if they did, would it really be their suffering they wanted pleaded on their behalf?

As Janet Watson points out in her 2004 book *Fighting Different Wars*, although "the received history of the war starts with idealistic volunteers and ends with shattered veterans . . . this story . . . does not reflect popular views from during the war itself."[14] And the historian Jonathan Ebel, reflecting upon his study of the personal writings of American soldiers during World War I, notes that "many American soldiers came back

from their war with a religious fervor that saw meaning in their suffering . . . Soldiers' and war workers' writings do not allow the honest historian to write a polemical history or a predictable ideological critique."[15] According to an obituarist, one of the officers who died alongside Owen in that useless bridge-building assault "fell smiling in the death he had wanted, that of a 'soldier and gentlemen.'"[16] This may be an obituarist's puffery, and it may not. The writings of Ernst Jünger are proof that even a man of exquisite artistic sensibilities and perception could endure the horrors of frontline combat and still declare his country, as he does in *Storm of Steel*, "eminently worthy of our blood and our lives."[17] Jünger was a born warrior, of course, but born warriors exist, even if they're underrepresented in the ranks of poets and novelists who do so much to shape our images of war.

One such man was a Special Forces veteran I interviewed for my last book, who told me about an Afghan officer he had come to befriend and admire. "We were supposed to be teaching him," he said, "but he was teaching me what it was to lead." After narrating a bit of their friendship, he said, "I was there when he died, and his last words he spoke to me." The room fell very quiet, and he paused, seemingly captured by memory. And then he told me the Afghan officer's last words. "He said to me, 'Sir, I need more hand grenades.'" There was another pause, and the veteran shook his head. I was waiting for an expression of grief, but instead he told me, "Man, I wish I could die with some badass shit like that."

Of course, that veteran is an unusual sort, but not *so* unusual. And he's a sort that tends to receive more admiration from rank-and-file soldiers than your average sensitive poet type. "Bitches and guns, this is every man's dream, I don't want to go home, where I'm just an ordinary human being," raps R.A. the Rugged Man in a verse describing his father's experience in Vietnam.[18] War holds a powerful allure for far more men than modern literature often acknowledges.

But it isn't just the accounts of born warriors that give me pause but also accounts of everyday soldiers, as in the poetry of David Jones, who served in World War I as an enlisted man. Jones hews tightly to the perception of the everyday soldier, catching the rhythms of speech, using slang and Cockney and the myths populating the minds of the Welsh soldiers he served with, creating a poetic form that is humbler in scope while more startlingly innovative with language. Here, in Jones, is the death of an officer, Mr. Jenkins:

Mr. Jenkins half inclined his head to them—he walked just
barely in advance of his platoon and immediately to the left
of Private Ball.
 He makes the conventional sign
and there is the deeply inward effort of spent men who would
make response for him,

and take it at the double.
He sinks on one knee
and now on the other,
his upper body tilts in rigid inclination
this way and back;
weighted lanyard runs out to full tether,
 swings like a pendulum
 and the clock run down.
Lurched over, jerked iron saucer over tilted brow,
clampt unkindly over lip and chin
nor no ventaille to this darkening
 and masked face lifts to grope the air
and so disconsolate;
enfeebled fingering at a paltry strap—
buckle holds,
holds him blind against the morning.
 Then stretch still where weeds pattern the chalk predel-
la—where it rises to his wire—and Sergeant T. Quilter takes
over.[19]

Unlike Owen, who gives us descriptions such as "devil's sick of sin," "froth-corrupted lungs," and "vile, incurable sores," embedding the poet's after-the-fact understanding (and moralizing) into the image, Jones describes death at the level of pure perception, showing us the imagery seemingly undigested. We are told not that the officer is shot, only how he appears at the moment of his shooting. And because Jones is so close to the mind caught at the moment of perception, with all its strangeness and even weird allusiveness (like that reference to the "ventaille," the protective face mask on a knight's helmet), we get a kind of restraint, a care at the overstepping moralism we see in Owen. There is romanticism here, but the romantic past crops up, as Jones explains in his remarkable preface, not because of an imposition of the poet but rather because the consciousness of history and myth is one with the perception of a group of Welsh soldiers. "I have only tried to make a shape in words," he writes, "using as data the complex of sights, sounds, fears, hopes, apprehensions, smells, things exterior and interior, the landscape and paraphernalia of that singular time and of those particular men. I have attempted to appreciate some things, which, at the time of suffering, the flesh was too weak to appraise."[20]

His accomplishment of this seemingly humble task is why the book was met with gratitude by an ex-soldier such as Herbert Read, who wrote, "For the first time all the realistic sensory experiences of infantrymen have been woven into a pattern which, while retaining all the authentic realism of the event, has the heroic ring which we

associate with the old chansons de geste . . . a book which we can accept as a true record of our suffering and as a work of art in the romantic tradition of Malory and the Mabinogion."[21]

The emphasis here is on "true record," distinct from Owen's true warning. This makes Jones more capacious, capturing a symphony of truths unavailable to the virtuosic soloist. As the poet Tom Sleigh argues, in Jones:

> The humanist assumptions that condition Owen's relation to war, and his vocabulary for it, are not only inoperative, but irrelevant to the men in the ranks. Owen's deeply felt understanding of what he famously called the pity of war, and the poetry that is in the pity, seems at best, at least in Jones's war, to be nothing but heroic posturing in an anti-heroic guise. And at worst, the truly great-hearted, empathic identification that Owen makes with his own soldiers seems like a form of unconscious class condescension.[22]

And here we have one obvious problem with poetry of witness, which is that the poet's voice necessarily imposes itself as the voice of the oppressed, always a dubious proposition. The poet of witness comes to us precisely as Chinua Achebe complained Marlow comes to us, "not only as a witness of truth, but one holding those advanced and humane views appropriate to the English liberal tradition." At his worst, Owen's soldiers suffer the way Conrad's Africans do, in "a metaphysical battlefield devoid of all recognizable humanity."[23]

Tom Sleigh dramatizes this problem in his remarkable 2015 poem "Homage to Basho." In one section, he tells a story from after the Gulf War. He's teaching a class of undergraduates, one of whom he, and he alone, knows is a young Iraqi girl who lived through it. In a discussion of the conflict, the students adopt an easy, uncomplicated acceptance of the justice of the war, with not one voicing disapproval, and so he decides he'll unsettle them:

> I then asked them what they would say to someone who actually lived through the bombardments to achieve these worthy goals—and that this someone was here, sitting among them, as one of their fellow classmates? How would they explain to the classmate the necessity of the bombs? Silence fell on the room. Everyone looked deeply uncomfortable: I realize that I betrayed them, as well as the young Iraqi woman, who sat very still in her seat.[24]

Eventually, after awkwardness, the student Sleigh singled out gives this account of her experience: "We sat in our house with the lights off. The bombs went on for a long time, and when they stopped, all of us were so tired, we went to sleep." Here, the girl whom Sleigh expected to plead her suffering on behalf of his political ideals gives a story that, although it unsettles, doesn't easily transmute her into an object political lesson.

To some, though, such objects, rather than people, are what we need. The great critic Paul Fussell famously slights "In Parenthesis" because it contains "unfortunately, no precedent for an understanding of the war as a shambles, and its participants as victims."[25] For those who prefer their literature to have easily digestible messages that discard the messy complications of life, moralistic fiction is an ever-present option. It just means stepping on the voices of those you're ostensibly speaking for.

II

This leads me to my second question: Why should I grant that Owen is telling me anything close to the truth? Prophetic denunciation is all well and good, but as Saul Bellow once cautioned, "the prophet must be genuine. If, in place of the word of God that he must utter, he should have a literary program in his back pocket, his prophecies can never be accepted."[26]

Where does that leave Owen and his followers? It should be clear by now that there are truths left out of Owen. His truth-telling urge is not about a capacious evocation of experience but rather about an alliance of moral outrage and sensibility. "The true Poets must be truthful," he says, but the truths must conform to his notion of the good.

Should this trouble us? The literary critic Hilary Edwards Lithgow has pointed to an exchange between the American writers Malcolm Cowley and Archibald MacLeish that neatly sums up the divided opinion. To a writer such as Cowley, who served as an ambulance driver in World War I, it matters little whether one of Owen's fellow officers "fell smiling in the death he had wanted, that of a 'soldier and gentlemen.'" Cowley writes:

> If we emphasize the useless deaths of the last war, we can be certain of our attitude toward the next. But if, on the other hand, we emphasize the happy illusions of these men who died . . . , then we can look forward . . . to the battles in which other generous and loyal men . . . will die in the same courageous fashion. We may even come to share the illusions of the dead, and we shall in any case defend the system which makes the next war as inevitable as tomorrow.[27]

This is the literary version of the noble lie. The writer must take care which truths to tell, since the wrong truths can support monstrosities. Trim your own memories, lest you believe them, and especially lest others believe them.

To MacLeish, who served in the artillery and lost a brother in Belgium, this "is the First World War seen through a keyhole, interpreted from a mountaintop, judged in its causes and effects. It is a very impersonal and terrifying war. It has no heroes. It is not human. . . . Its stories are not stories of men in warfare, but of beginnings, devices, forces, the greed of bankers, the treachery of politicians, the rapacity of munitions makers . . . the deaths of millions."

Such a description of the war might satisfy our desires for political categorization, and it *might* be instrumentally useful (although exactly how useful is up for debate), but it leaves aside something critical. The war, MacLeish writes, was "a war of parades, speeches, brass bands, bistros, boredom, terror, anguish, heroism, endurance, humor, death. It matched great cruelty with great courage. It had its fine sights and its unspeakable sights. It was a human war. Its adversaries were men and its stories were stories of men." Then, in a powerful assault against the notion of judging men by the historical events they are tethered to, he continues:

> Obviously, standing here up on the little heap which time forever pushes up to give a better perspective of the past—obviously you and I, alive in the year 1933 band and looking back—obviously we can say in your fine phrase: "they died bravely, they died in vain." History of the post-war world proves they died in vain. Every economic consideration proves they died in vain. But what, I demand of you as poet, not as editor, what is vanity in death? Is it economic frustration? Is it failure to ameliorate the lot of society? Is it historical abortiveness? Or is it perhaps conceivable that death is something between a man and his own soul, a personal and not a social experience? Is it perhaps conceivable that the measure of vanity in a man's death is to be found not afterwards in history which to him has no existence, but presently in the circumstances in which his death is met? Is it perhaps conceivable that to die generously and loyalty to a believed-in cause is not, regardless of the success of that cause, regardless even of its validity, to die in vain? I ask you this as a poet.[28]

The Palestinian-American poet Noor Hindi, in "Breaking [News]," makes a similar complaint about the disjunction between the human subject and the desire for political action. After noting the need, in interviews, to reframe her subjects in order to make them appeal to consumers, she writes:

> I become a machine. A transfer of information. They become a plea for empathy, an oversaturation of feelings we'll fail at transforming into action. What's lost is incalculable.[29]

What is lost when the poet becomes a machine is, of course, the very humanity of her subject that spurs her to write in the first place. Nevertheless, the moral urgency of the subject of the war has converted some of its greatest writers to embrace such reductions.

After Vietnam, the writer Tim O'Brien decided that the variety of actual experiences and perceptions of soldiers was unimportant—"you can tell a true war story by its absolute and uncompromising allegiance to obscenity and evil," he writes, and echoing Owen, he declares that "if at the end of a war story you feel uplifted, or if you feel that some small bit of rectitude has been salvaged from the larger waste, then you have

been made the victim of a very old and terrible lie." His example of this, provocatively, is a classic story of military heroism, which he tells like this:

> You can tell a true war story by the questions you ask. Somebody tells a story, let's say, and afterward you ask, "Is it true?" and if the answer matters, you've got your answer.
>
> For example, we've all heard this one. Four guys go down a trail. A grenade sails out.
>
> One guy jumps on it and takes the blast and saves his three buddies.
>
> Is it true?
>
> The answer matters.
>
> You'd feel cheated if it never happened. Without the grounding reality, it's just a trite bit of puffery, pure Hollywood, untrue in the way all such stories are untrue. Yet even if it did happen—and maybe it did, anything's possible—even then you know it can't be true, because a true war story does not depend upon that kind of truth. Happeningness is irrelevant. A thing may happen and be a total lie; another thing may not happen and be truer than the truth. For example:
>
> Four guys go down a trail. A grenade sails out. One guy jumps on it and takes the blast, but it's a killer grenade and everybody dies anyway. Before they die, though, one of the dead guys says, "The fuck you do that for?" and the jumper says, "Story of my life, man," and the other guy starts to smile but he's dead.
>
> That's a true story that never happened.[30]

Now, I happen to have met a man who jumped on a grenade. He was born in Jackson, Mississippi, in 1989, and twenty-one years later, he was manning a patrol base in Marjah, Afghanistan, as part of the hopeless surge of troops initiated by President Barack Obama. On November 21, the Taliban attacked his base, and one fighter threw a hand grenade that landed in his sandbagged position that he shared with a fellow marine. We may pause here to wonder what we would do in such a circumstance. What Kyle did was jump toward the grenade, which promptly detonated, sending burning-hot slivers of steel into his body at 24,000 feet per second. The blast shattered his jaw, knocked out most of his teeth, shattered one of his arms, and destroyed one of his eyes. He lived, but multiple surgeries followed, as well as nightmares and hallucinations while on pain medication. He tries to stay upbeat. He claims never to have lost his faith in God, although he has questioned why he survived.

It's worth noting that his story is useful to the Marine Corps, which celebrates him—a shining example of the selfless courage that the marines are supposed to represent, disconnected from questions about the failed war in which he was so selflessly courageous. In O'Brien, it is the waste and failure of the war in which truth lies. But the mind recoils at the prospect of looking Kyle in his one good eye and telling him that

the happeningness of his story is irrelevant—that a thing may happen and be a total lie. Suddenly, the idea becomes monstrous.

As the author and Vietnam veteran John Del Vecchio, reflecting on a 1985 conference of Vietnam veteran writers at which O'Brien advocated moving past allegiance to true stories, put it, "I wish I'd been more of a hardass back then and pushed back more against the way some writers presented their fiction as 'more real than reality.' It's gotten offensive the older I've gotten. The truth can hurt. Doesn't mean it's not vital."[31]

III

But this leads to my third impertinent question: If the obligation is to truth (or to a truthy moralism) and not to poetry, then why the hell be a poet?

The inherent messiness in any poetry worth a damn makes its political utility always somewhat chaotic. Even in Owen. When I was joining the Marine Corps, "Greater Love," Owen's subversion of a Swinburne love poem, is one of his works I came back to. I even memorized it after listening to it many times on a recording incorporated into a track on the album *Violent by Design* by undergrad rap group Jedi Mind Tricks:

> Red lips are not so red
> As the stained stones kissed by the English dead.
> Kindness of wooed and wooer
> Seems shame to their love pure.
> O Love, your eyes lose lure
> When I behold eyes blinded in my stead![32]

Note the hierarchy Owen establishes in his verse, with his suffering soldiers immeasurably more valuable than the civilians back home. In another poem he asserts, "These men are worth / Your tears: You are not worth their merriment." Owen's poem assured me that, by joining, I'd be ascending to a higher moral category than civilian. Even his depictions of horror have an erotic charge, as in "Your slender attitude / Trembles not exquisite like limbs knife-skewed." This does not trouble the militarist as much as Owen might think.

In a widely discussed essay for the *New York Times*, Viet Thanh Nguyen, whose own work dramatizes the complex struggles over the memory of war, accused American fiction of being too apolitical and of blithely assuming that we can speak of aesthetic and craft choices without considering their ideological import. In this regard, I think he is on to something: the aesthetic choices made by an artist are related to the sensibility he wants to evoke. Ernst Jünger's bombastic yet cold style is, after all, not disconnected from the enthusiasm with which Fascists embraced his writing. But sensibility is importantly different from political message. Nguyen goes on to praise a different poem by

Noor Hindi than the one discussed earlier, called "Fuck Your Craft Lecture, My People Are Dying." Unlike her poem "Breaking [News]," this is a clearer inheritor of Owen's poetry of witness (an alternate title for "Greater Love" might be "Fuck Your Love Poetry, My People Are Dying"), and it begins by dismissing traditional evocations of beauty. After claiming that it is colonizers who write about flowers, she writes:

> I tell you about children throwing rocks at Israeli tanks
> seconds before becoming daisies.[33]

There's a wonderful sharpness and energy to this poem, although it also engages in precisely the kind of reduction she notes in "Breaking [News]." Are Palestinians restricted to political poetry? Do only colonizers write about flowers? The answer is obviously no.[34] And casting a population solely in this light has dangers. As Simone de Beauvoir pointed out in *The Ethics of Ambiguity*:

> All oppressive regimes become stronger through the degradation of the oppressed. In Algeria I have seen any number of colonists appease their conscience by the contempt in which they held the Arabs who were crushed with misery: the more miserable the latter were, the more contemptible they seemed, so much so that there was never any room for remorse . . . The trick of tyrants is to enclose a man in the immanence of his facticity and to try to forget that man is always, as Heidegger puts it, "infinitely more than what he would be if he were reduced to being what he is"; man is a being of the distances, a movement toward the future, a project. The tyrant asserts himself as a transcendence; he considers others as pure immanences: he thus arrogates to himself the right to treat them like cattle.[35]

Palestinians, in this poem, become immanences, just as the men who die like cattle in Owen become less than men because they are defined by their suffering.

More to the point, though, if the urgency of the title is to be believed, why be in the vicinity of a craft lecture at all? There's something faintly absurd about the image of a poet assuring the dying, "Don't worry, I'll write you a poem, and I won't give a shit about craft while I do it."

When the poet George Oppen became increasingly political during the Great Depression, he famously joined the Communist Party and stopped writing poetry. As Eliot Weinberger notes in his preface to Oppen's poems, "he was perhaps the only Party writer, anywhere, who had never written stirring doggerel or prose propaganda; who both had doubted the efficacy of poetry in hungry times and had resisted the Party's manipulation of the arts; who had believed that the proper role of a Party member was no different for a writer or a factory worker, that the work to be done was agitation and organization, in which poetry could have no place without compromising itself."[36]

Later serving in World War II, he saw active combat and was ultimately severely injured. Lying wounded in a foxhole, surrounded by injured and dying soldiers, he

buried his dog tags, which would have identified him as Jewish to the nearby Nazi enemies. After his return to poetry, he wrote glancingly on the experience in ways that reject totalizing political visions. In "Route," published in 1968, he writes:

> Wars that are just? A simpler question: In the event,
> will you or will you not want to kill a German. Because,
> in the event, if you do not want to, you won't.[37]

For Oppen, words have to be "earned." Words are "frightening." In a 1963 letter, Oppen would explain the origin of his poetic urge like this:

> The mystery for me begins where it begins for Aquinas: The individual encounters the world, and by that encounter with something which he recognizes as being outside himself, he becomes aware of himself as an individual, a part of reality. In that same intuition, he registers the existence of what is not himself, what is totally independent of him, can exist without him, as it must have existed before him, as it will exist after him, and is totally free of nothingness and death (which is, for Aquinas, the intuition of God. It is at any rate the intuition of the indestructible).[38]

The ideological underpinnings of the poet of witness threaten to gobble up that aspect of reality totally independent of the poet. But for Oppen, the poetic response is neither intellectual nor discursive. The poet, he says, "responds by faith … and to his own experience."[39] For Oppen, that "faith" is toward the possibility of the representation of reality. As with Jones, we are back to a humbler but more difficult task than propping up political slogans.

IV

However, there is an even more basic question at hand. In an irascible response to Owen's "the Poetry is in the pity," Geoffrey Hill declared, "The poetry had better not be in the pity, or it won't survive."[40] In a practice such as poetry, long-term significance is utterly dependent on beauty. And beauty is a problem in war. In no other human endeavor does Keats's line run falser: "Beauty is truth, truth beauty,—that is all / Ye know on earth, and all ye need to know." Hence Adorno's infamous declaration: "To write poetry after Auschwitz is barbaric." And although Adorno later walked the claim back by acknowledging that "perennial suffering has as much right to expression as a tortured man has to scream," note what recovers poetry's value here: its documentary aspect, not its aesthetic qualities. Is this enough?

In 1979, Seamus Heaney wrote a beautiful poem about the death of his cousin, Colum McCartney, killed in the Troubles in Ireland. It's called "The Strand at Lough Beg," and in it, the poet walks to the site of his cousin's murder, where he has a vision of the cousin, who he cleanses with moss and morning dew.

It's a beautiful image, a gorgeous poem. But the shame of that beauty, of his audacity in transmuting horror into prettiness, however well meant, haunted Heaney. Five years later, he wrote "Station Island," where he is confronted by ghosts, one of whom is his cousin, come to complain about Heaney's earlier poem. And when I asked Heaney about the discomfiting attraction of some of his lines about violence, he quoted these lines to me, from memory:

> You saw that, and you wrote that—not the fact.
> You confused evasion and artistic tact.
> The Protestant who shot me through the head
> I accuse directly, but indirectly, you
> who now atone perhaps upon this bed
> for the way you whitewashed ugliness and drew
> the lovely blinds of the Purgatorio
> and saccharined my death with morning dew.[41]

Heaney's cousin, fighting against his transformation into an elegiac symbol, asserts his humanity.

In this account, beauty does to the human subject of the poem what moral warning does in Owen and in Noor Hindi: it effaces the individual, eliding their inconvenient qualities in service of the writer's broader vision.

So, that's one problem with beauty. But there is another problem, which is that beauty itself is too chaotic to be tethered to moral impulses. Consider this passage from Sakaguchi Ango's extraordinary essay "Discourse on Decadence," written and published in the months following the Japanese surrender to the Allies in World War II, while Tokyo was still in ruins. Explaining why he remained in Tokyo during the devastating firebombing of the city, which killed around a hundred thousand people, he writes:

> The curiosity I felt towards the coming miraculous rebirth in an unimaginable new world was by far the most striking emotion I've ever experienced. What kept me in Tokyo was, quite simply, a magical spell that demanded that, in exchange for experiencing that mystical intensity, I risk my life by remaining in the city . . . I loved the colossal destruction. There is something eerily beautiful about humans surrendering themselves to fate. While in Kōjimachi the mansions vanished, turned to smoldering ruins in a heartbeat, on the grassy banks of the palace moat an elegant father sat with his daughter, a single red leather suitcase between them. If not for the vast expanse of smoking rubble at one corner of the landscape, it would have looked like a pleasant picnic.[42]

This is honest, and beautiful, but what a terrible beauty it is that he describes. Adorno would know this for the barbarism it is, no matter how much it speaks to parts of the human soul we don't always admit. Owen complained to his mother in a letter of "the

universal pervasion of Ugliness . . . the most execrable sights on earth. In poetry we call them the most glorious." But here is what Jünger, who spent more time on the front line than Owen, saw:

> The battle of the machines is so colossal that man almost completely disappears before it. Often already, caught in the force fields of the modern battlefield, it seemed to me strange and scarcely believable that I was witnessing world-historical events. Combat took on the form of a gigantic, lifeless mechanism and swept an icy, impersonal wave across the ground. It was like the cratered landscape of a dead star, lifeless and radiating heat. And yet: behind all this is man. Only he gives the machines their direction and meaning. It is he that spits from their mouths bullets, explosives and poison. He that elevates himself in them like birds of prey above the enemy. He that sits in their stomach as they stalk the battlefield spewing fire. It is he, the most dangerous, bloodthirsty, and purposeful being that the Earth has to carry.[43]

This might be morally ugly, but it is magnificent. And I suspect Owen felt it too—you catch glimmers of it in his work in a way that you don't in the more blandly didactic work of Siegfried Sassoon. So . . . to speak honestly of beauty is morally dubious.

V

Modern war writers seem to take a more distanced approach to the notion of "poetry of witness." In an essay for *Liberties* entitled "Turning in My Card," Elliot Ackerman promises that although as a marine combat veteran he enjoys "the standing in the great American identity calculus to shut people up,"[44] he will consciously refuse to play that particular card in discussions of war and peace. And he is one of several prominent war writers (Brian van Reet, Brian Turner, and Matt Gallagher in his second novel) whose fiction seems to range deliberately far afield from his own personal experience when discussing war. Writing my first book, I self-consciously wrote from the perspectives of multiple characters, none of whom shared my experience of war (nevertheless, one reviewer noted that my book rang of truth, since "Phil Klay does know because he was there."). Rather than claiming the authority that witness seems to offer, modern war writers seem to want to create spaces where they meet the reader with greater equality.

Unlike the propagandist, for whom the humanity of their audience matters less than the spread of their cause and to whom readers are merely potential carriers of their message, the artist wants engagement. I write about modern war, about our society that kills people via drones, airstrikes, special operations forces, proxy forces, and mercenaries, because I am captured by it, made hostage to it by the way it has shaped my life. Having known those who've fallen, having walked through the ruins of cities destroyed by US airstrikes, having served with complex pride, the subject is not an intellectual

puzzle to me. It's entangled with my sense of myself, my sense of the obligations I owe to others as a US citizen and as a veteran. Especially at a time when much of American letters carries on blithely, as if there were not ongoing wars, or as if the fact that there are ongoing wars is at best an occasion for light political posturing, my goal is to attempt to capture the reader in the same orbit I'm in, even if only for a moment.

This demands writing that is less about transmitting knowledge or decoding meaning than curating an experience. And what the reader takes away from my writing should lie beyond my own conception of the work. A reader is a conversation partner, not a computer decoding a message, and a conversation partner whose responses you can predict is boring.

The morality for writing of this kind, then, entails faith: faith in the reader to be able to handle reality as the writer has seen it, and faith that the creative responses of numerous readers will contain greater wisdom than the narrow strictures of a lone genius bitterly convinced that he, and he alone, has the answers.

We experience a poet's vision and attempt to navigate through their world with the tools supplied by their sensibility. We care for a novel's characters, sometimes love them. If the writer has faith in us, and in our ability to grapple with the full weight of realities we must all confront, we see war's beauty and feel its uncomfortable force and fascination as well as its horror. At times, we even experience ourselves desiring that which we know to be hateful. Faced with such art, our objectivity fails us. We're left adrift before a vision of the world that compels us morally, politically, aesthetically, and spiritually, that doesn't lend itself to abstract truths or cheap pity, that expands our conception of the world in the way that only art can because it is too vivid and concrete to fit into the old categories. And then we, the readers, decide what to do about it.

Notes

1. Dominic Hibberd, *Wilfred Owen* (Kingham: Weidenfeld & Nicolson, 2002), 257.

2. Hibberd, *Wilfred Owen*, 293.

3. Hibberd, *Wilfred Owen*, 407.

4. Hibberd, *Wilfred Owen*, 450.

5. Hibberd, *Wilfred Owen*, 440.

6. Hibberd, *Wilfred Owen*, 452.

7. Wilfred Owen, *The Collected Poems of Wilfred Owen* (A & L eBooks, 2011).

8. Owen, *The Collected Poems*.

9. Owen, *The Collected Poems*.

10. Seamus Heaney, *The Government of the Tongue: Selected Prose, 1978–1987* (New York: Farrar, Straus and Giroux, 1990), 128.

11. Roland Barthes, "The Death of the Author," *Aspen magazine no. 5+6* (New York: Roaring Fork Press, 1967).

12. Heaney, *The Government of the Tongue*, 107.

13. William Butler Yeats, *The Oxford Book of Modern Verse, 1892–1935* (Oxford: Oxford University Press, 1936).

14. Janet Watson, *Fighting Different Wars: Experience, Memory, and the First World War in Britain* (Cambridge: Cambridge University Press, 2004), 5.

15. Jonathan Ebel, *Faith in the Fight: Religion and the American Soldier in the Great War* (Princeton: Princeton University Press, 2010).

16. Hibberd, *Wilfred Owen*, 452.

17. Ernst Jünger, *Storm of Steel* (New York: Penguin Classics, 2004), 33.

18. Jedi Mind Tricks featuring R.A. the Rugged Man, "Uncommon Valor: A Vietnam Story" from the album *Servants in Heaven, Kings in Hell*, released September 19, 2006. Songwriters: Vincenzo Luvineri, Kevin Baldwin, Ryan Andrew Thorburn. Producer: Stoupe the Enemy of Mankind.

19. David Jones, *In Parenthesis* (New York: Compass Books, 1961).

20. Jones, *In Parenthesis*.

21. Thomas Dilworth, *David Jones: Engraver, Soldier, Painter, Poet* (London: Jonathan Cape, 2017).

22. Tom Sleigh, *The Land between Two Rivers: Writing in an Age of Refugees* (Minneapolis: Graywolf Press, 2018).

23. Chinua Achebe, *Hopes and Impediments: Selected Essays, 1965–1987* (New York: Doubleday, 1988).

24. Tom Sleigh, *Station Zed* (Minneapolis: Graywolf Press, 2015), 59.

25. Paul Fussell, *The Great War and Modern Memory* (Oxford: Oxford University Press, 1975), 145.

26. Saul Bellow, *There Is Simply Too Much to Think About: Collected Nonfiction* (New York: Penguin Books, 2016), 162.

27. Malcolm Cowley and Archibald MacLeish, "A Communication: The Dead of the Next War," *The New Republic* (1933, October 4), 214–216.

28. Cowley and MacLeish, *The New Republic*.

29. Noor Hindi, "Breaking [News]" in *Poetry* (2020, December).

30. Tim O'Brien, *The Things They Carried* (Boston: Houghton Mifflin, 1990).

31. Matt Gallagher, "The Forever War over War Literature," *The New Republic* (2020, July 17).

32. Owen, *The Collected Poems*.

33. Noor Hindi, "Fuck Your Craft Lecture, My People Are Dying" in *Poetry* (2020, December).

34. To be fair, Hindi is aware of the complications this causes. In a poem titled, "In Which the White Woman on my Thesis Committee Asks Me about Witness," she poses questions about what

it means to see yourself on television, dying, evoking the strange way in which racial hierarchies and trauma transmitted via media have replaced Owen's moral hierarchy of frontline soldiers and trauma transmitted via exposure to combat.

35. Simone de Beauvoir, *The Ethics of Ambiguity* (Secaucus, N.J.: Citadel Press, 1949).

36. George Oppen, *New Collected Poems* (New York: New Directions, 2008).

37. Oppen, *New Collected Poems.*

38. George Oppen, *The Selected Letters of George Oppen* (Durham, N.C.: Duke University Press, 1990), 91, 92.

39. L. S. Dembo and George Oppen, *Contemporary Literature* 10, no. 2 (Spring 1969), 159–177.

40. Geoffrey Hill, *War and Civilization Series Lecture 2: War and Poetry* G. (2010). Retrieved 2/31, 2023 from https://podcasts.ox.ac.uk/war-and-civilization-series-lecture-2-war-and-poetry

41. Seamus Heaney, *Opened Ground: Selected Poems 1966–1996* (New York: Farrar, Straus and Giroux, 1999).

42. Sakaguchi Ango, "Discourse on Decadence," in *Literary Mischief: Sakaguchi Ango, Culture, and the War*, eds. James Dorsey and Douglas Slaymaker (Lanham, MD: Lexington Books, 2010).

43. Antoine Bousquet, "Ernst Jünger and the Problem of Nihilism in the Age of Total War," *Thesis Eleven* 132 no. 2 (2016): 17–38.

44. Elliot Ackerman, "Turning in My Card," *Liberties* 1 no. 4 (2021).

2

War's Deep Time

Kate McLoughlin

Three months after 9/11, the American novelist Don DeLillo published an essay called "In the Ruins of the Future," in which he reflected on some of the ways in which the terrorist attacks might change war writing. His thoughts centered on temporality. "This catastrophic event changes the way we think and act, moment to moment, week to week, for unknown weeks and months to come, and steely years," he wrote ("we," here, presumably means "the West").[1] A seismic shift in attitudes, in consciousness even, would develop, or was already developing, and would continue to do so into an indefinite future. A "counternarrative"—"a shadow history of false memories and imagined loss"—would also emerge, since people who weren't present at the attack sites would imagine that they were, and those who hadn't lost loved ones would imagine that they had.[2] Those imaginings would turn into beliefs. There would be no clear, hard-edged account of events but rather a blurred and ghostly set of narratives and counternarratives and even counter-counternarratives. DeLillo's radical prediction was that 9/11 would have the power to change history: in the future, the past would be rewritten. Figurative language might not be up to the task: "The event itself has no purchase on the mercies of analogy or simile. We have to take the shock and horror as it is. But living language is not diminished. The writer wants to understand what this day has done to us. Is it too soon?"[3] Epistemology and ethics are bound up in this last question. The time when we might be able to "understand"—when we *should* understand—is unknowable.

DeLillo's essay asked questions that illuminate war and time, and wartime, in twenty-first-century poetry. What thematic and formal responses have poets of the wars in the Gulf and in Afghanistan made to the long-standing challenges of representing conflict temporality? Among other things, they have embraced deep time. In her 2008 book *Through Other Continents: American Literature across Deep Time*, Wai Chee Dimock defines "deep time" as "temporal length added to the spatial width of the planet": time that is as profound as the oceans and as high as the sky.[4] More recently, Paul Saint-Amour has cast "deep time" as "a longer scale of centuries and even millennia."[5] He likens looking into deep time to standing on "the edge of a continental shelf where, with our feet still in the shallows of calendrical time, we peer over that rim into the undersea canyon."[6] In Saint-Amour's words, "deep war time" is "a temporal cut where we might read the reciprocal inscriptions of the fleeting and the durative, the poem and the fossil."[7]

But I think there's more to deep time than length of scale. To get a sense of that meaning, we need to go back to the end of the eighteenth century, when thoughts about the age of the Earth were beginning to change. In a 1788 article entitled "Theory of the Earth," the Scottish geologist James Hutton commented that the rock record he had analyzed showed "no vestige of a beginning" and "no prospect of an end."[8] Hutton took his fellow Scot, the scientist and clergyman John Playfair, to look at the rock strata off the coast of Scotland. When Playfair grasped its significance, he felt his mind "grow giddy by looking so far into the abyss of time."[9] The concept of deep time I want to work with is not just a long time-scale but also one that has the properties of beginninglessness, endlessness, and giddiness.

These properties are endemic to war experience. Mary Dudziak's (2012) study of modern American wartime, *War Time: An Idea, Its History, Its Consequences*, analyses, from a legal-political perspective, the way in which conflicts spill past start and end dates. As Dudziak shows, the starts of wars can be messy, and justifications for initiating them are often ambiguous or manufactured (examples include the sinking of the USS *Maine* that precipitated the Spanish–American War, the Tonkin Gulf Resolution that inaugurated Vietnam, and the supposed existence of weapons of mass destruction that formed the pretext for the 2003 invasion of Iraq). Historians frequently fail to agree on the precise moment of initiation of an armed conflict; indeed, wartime may begin in advance of official declarations. The ends of wars are equally problematic—if they end at all. As World War II veteran and critic Samuel Hynes put it in 1992, "war is not an occasional interruption of a normality called peace; it is a climate in which we live."[10] Or, in the words of the Northern Irish poet Michael Longley, "everybody talked about the war ending / And always it would be the last week of the war."[11] Blurred beginnings and endings increase the sense of temporal giddiness.

A number of twenty-first-century poets of war have found ways to evoke this experience of time in their works. Clare Shaw is a poet from Burnley in North West England. Her poem "It Could Have Been," written in response to an invitation issued by the then British poet laureate Carol Ann Duffy, was first published in *The Guardian* newspaper on July 25, 2009. "With the official inquiry into the Iraq War that began in 2003 imminent and the war in Afghanistan returning dead teenagers to the streets of Wootton Bassett," Duffy wrote, "I invited a range of my fellow poets to bear witness, each in their own way, to these matters of war."[12] "It Could Have Been" lists the names (where they are known) of children killed in Iraq, together with the dates and causes of their deaths:

Ali, son of Abdul, 16 months.
Rocket on house, Sadr City, 16.5.2009.

> Ali, but for some detail of history,
> this day could have been yours.
> It could have been you this morning,

stood at the end of your bed,
eyes still shut, arms held up for your mother,
who makes sun and all things possible,
who could, little Ali, be me.

[…]

Sa'adiya Saddam, aged 8, female.
Shot dead by USA forces. Afak, 7/8 Feb, 2009.

It could have been me on that street
with you in my hands
and my hands red and wet
and my face is a shriek
and my voice is a house all on fire
But for geography,
but for biology,
but for the way
things happen,
it could have been

Unnamed female baby of the Abdul-Monim family.
Shot dead, Balal Ruz 22.1.2009.

you falling
you holding your hand up for kissing.[13]

The mood of the poem is subjunctive, a might-have-been outside the linear temporality of the indicative. This is not so much a narrative as a counternarrative—and, indeed, counternarratives are hypothesized. In the first stanza, a dead child is imagined alive. In the second, the speaker imagines herself the mother of a shot child. In the third, a dead baby is frozen in an instant of time. As the poem progresses, the children's imagined lives are conveyed with fewer and fewer details. While the children early in the poem are standing at the end of their beds, shouting "carry," eating breakfast, the last—the "unnamed female baby"—is pictured only as "falling," "holding [her] hand up for kissing." It's as though a fade-out is taking place; the future is becoming ever-more unseeable. Nonetheless, in these very scanty details, Shaw still manages to project a life: a toddler tumbling and holding out her bruised hand to be kissed better. It's a trace of an existence but still substantial enough to exist as an alternative reality.

The poem makes another point in its ending—or lack of ending. The list of child fatalities could go on and on: there's no sense in which these are the last children to die. The title "It Could Have Been" also calls out for the addition of the word "You," alerting the reader to the historical, geographical, and political contingency of these losses,

which, in other circumstances, could have been ours. In this poem, we don't yet have an archaeological sense of deep time, but we do have that giddying sense of endlessness and a haunting alternative reality.

Brian Turner is an American poet and essayist who fought in Iraq and Bosnia with the Second Infantry Division of the US Army. His debut collection, *Here, Bullet* (2005), won a number of awards; his second, *Phantom Noise* (2010), was shortlisted for the T. S. Eliot poetry prize. "A Soldier's Arabic" is the opening poem of *Here, Bullet*:

This is a strange new kind of war where you learn
just as much as you are able to believe.
Ernest Hemingway

The word for love, *habib*, is written from right
to left, starting where we would end it
and ending where we might begin.

Where we would end a war
another might take as a beginning,
or as an echo of history, recited again.

Speak the word for death, *maut*,
and you will hear the cursives of the wind
driven into the veil of the unknown.

This is a language made of blood.
It is made of sand, and time.
To be spoken, it must be earned.[14]

This is a careful, guarded, respectful poem. Like Clare Shaw's "It Could Have Been," it uses the pronoun "we," and it initially seems as though this will work to establish a privileged viewpoint, a superiority of "us" over "them." But this possibility is cancelled: rather than "they," the speaker simply says that "another" might think differently. There are plural ways of seeing, that is: one person's end is another person's beginning, just as some languages are written from left to right and others from right to left. The linguistic point is also an historiographical point that doubts the fixity of ends and beginnings. The poem's aesthetic is boustrophedonic. Like a team of oxen pulling a plough, moving from left to right, then from right to left, it challenges rectilinear temporal narrative. Note, too, the remark about Arabic in the last line: "To be spoken, it must be earned"—not "learned," as one might expect, but "earned." This language's history is composed of "blood," "sand," and "time." It cannot be learned from a textbook or language card: to have the right to speak it requires advanced linguistic knowledge, as well as an understanding of the flaws in thinking that things start and finish, which is also an understanding of how rights accrue in history.

The Iraqi American writer Dunya Mikhail is a Baghdad-born ethnic Assyrian whose first languages are Aramaic and Arabic. A dissident, she fled Iraq for the United States

in 1996.[15] The poems in Mikhail's collection *The War Works Hard* were written between 1984 and 2004 and translated from the Arabic in 2006. (They refer to the Iran–Iraq War of 1980–1988, as well as the Gulf War and Iraq War bracketing the millennium.) *The War Works Hard* includes a poem simply called "O."[16] The title is a closed circle, the poem's shape a spiral. Its visual presentation dramatizes the sense that, once entered, the mental and physical confinement of bombed Iraq cannot be left. It also creates an impression of time as a vortex, as eleven repeated phrases draw the reader, at acceleration, down an eddy of ambulances, emergency rooms, coffins, and graves. The structure is paratactic: the phrases are only connected by being placed adjacent to each other, creating a sense of random happenings. Repetition makes the point that these things are happening to a great many people. As the impersonality of the tone suggests, death has become routine. The title and shape of the poem—the word/sound "O" (a cry of anguish)—provide a commentary on the situation. In narratological terms, "O" also makes the point that it is impossible to find a beginning or an end: the lowercase, unpunctuated, repeated phrases are the very antithesis of linear time. "O" changes temporal perspective, replacing the rectilinear with the spiral, endings with endlessness, and requiring readers to approach the work by twisting their bodies and the text itself.

In these poems by Clare Shaw, Brian Turner, and Dunya Mikhail—poets from very different backgrounds and experiences—there is a recurring impetus to chop up linear time and substitute it with something much more fluid. Another poetic technique for representing deep time can also be found in Mikhail's work and in the poems of the Anglo-Welsh poet Jenny Lewis and the Iraqi poet in exile Adnan Al-Sayegh. This technique consists of intertextual engagement with very ancient literature, specifically the *Epic of Gilgamesh*, "the oldest story in the world, a thousand years older than the *Iliad* or the Bible."[17]

The historical Gilgamesh was king of Uruk (near modern-day Al-Samawah, Iraq) in 2,800 BCE.[18] The oldest versions of a Gilgamesh poem are in Sumerian and date from between 2,100 and 2,000 BCE. There is an Old Babylonian version dating from between 1,700 and 1,600 BCE, and the "standard" Akkadian version, written by the scholar priest Sîn-liqe-unninni, dates from between 1,200 and 1,100 BCE. In 2021, *Gilgamesh* was in the news when a tablet known as the *Gilgamesh Dream Tablet*, which had been looted from Iraq in 1991, was handed back by the United States to Iraq in a ceremony at the Smithsonian. UNESCO called the return of the tablet a "significant victory in the fight against the illicit trafficking of cultural objects," adding that the theft and illicit trafficking of ancient artifacts is "a key funding source for terrorist groups."[19] Ancient in origin, the poem is still intervening in contemporary military conflicts.

In the work of Mikhail, Lewis, and Al-Sayegh, the deities and heroes of ancient Mesopotamia are congregating. Mikhail's "Inanna," written after the fall of Saddam Hussein, imagines the eponymous Sumerian goddess decrying the sight of "antiquities / scattered / and broken / in the museum."[20] Adnan Al-Sayegh's "Uruk's Anthem" catches another monitory glimpse:

I see lightning flicker
 under Ishtar's eyelids.[21]

Jenny Lewis's "Anthem for Gilgamesh" beseeches the legendary Babylonian king to return:

Oh Gilgamesh, come home!
Your people need you like the rain.
Oh Gilgamesh, come home—
I need your DNA beside me again.[22]

Invoking these figures from the literature of Mesopotamian antiquity manipulates time in a number of ways. The references remind the reader of the ancientness of the region's written culture—a culture that, unlike stone monuments, cannot be erased. They create a wider perspective in which to comprehend human affairs: "As for man, [his days] are numbered," Gilgamesh, gentle for once, tells his beloved Enkidu, the wild man; "whatever he may do, it is but wind."[23] They create something new from the ancient past: Nietzsche, distinguishing between "monumental," "antiquarian," and "critical" historiography, would have approvingly included these poets among the "enrichers and increasers of . . . inherited treasure."[24] They also engage with what has been called "difficult heritage": "a past that is recognised as meaningful in the present but that is also contested and awkward for public reconciliation with a positive, self-affirming contemporary identity."[25] Gilgamesh is, as well as a legendary leader "surpassing all other kings, heroic in stature," a violent and tyrannical imperialist—his mission to the Cedar Forest to kill the monster Humbaba has been described as an "eerie counterpoint to the recent [2003] American invasion of Iraq."[26] A reader could well conclude that war is ineradicable from human existence.

Censorship, remarked Mikhail in a 2010 interview with *New Directions*, was her "main reason" for leaving Iraq.[27] The need to disguise what she said led her to accrete "a lot of . . . layers of meanings" in her poetry.[28] Like the rocks, the layers reach back into antiquity— back to the *One Thousand and One Nights*, back to the Roman pantheon, back to the Bible (Mikhail is from Iraq's Christian minority), and back further still to *Gilgamesh*. In "Inanna," the goddess, summoned from antiquity, announces herself imperiously:

 I am Inanna.
And this is my city.[29]

Although traditionally the deity of Uruk, the fabulous polis of Sumer and Babylonia, Inanna seems here to be referring to nearby Baghdad, now roofless and full of people "running / from bombs."[30] Her presence prompts comparison of the ruined city of 2003 with the splendors of ancient Uruk, which the *Epic of Gilgamesh* invites the reader to explore in his or her imagination:

climb Uruk's wall and walk back and forth!
Survey its foundations, examine the brickwork!

Were its bricks not fired in an oven?
Did the Seven Sages not lay its foundations?[31]

This invitation occurs at both the beginning and the end of the epic, creating the form of what one of its translators, Stephen Mitchell, calls a "spiral" rather than a circle.[32] Uruk is perpetuated—immortalized—not only in the work's repeating structure but also in its suggestion of the true nature of the hero's eternal life. Gilgamesh fails to win Utanapishtim's secret of everlasting existence by falling asleep when challenged to remain awake and then squanders the chance to be restored to youth by naively leaving the magic plant beside the pool to be stolen by the snake. Instead, the means by which he finds undying fame is through his own accounts of his exploits:

He came a far road, was weary, found peace,
 and set all his labours on a tablet of stone.
[…]
[*See*] the tablet-box of cedar,
 [*release*] its clasp of bronze!
[*Lift*] the lid of its secret,
 [*pick*] *up* the tablet of lapis lazuli and read out
the travails of Gilgamesh, all that he went through.[33]

In these accounts, the gorgeous city also lives on. Behind bomb-blasted Iraq, Uruk stands: templed, parapeted, inimitable—existing in the deep time of the imagination.

Mikhail laments again over her ruined native city in *Diary of a Wave outside the Sea*. This long verse memoir was written during and after the Gulf War of 1991, published in Arabic in 1995, and translated into English in 2009. Trying to fathom both what has happened to Baghdad and how it can be conveyed to those elsewhere, Mikhail asks:

I wonder how the critics who linked
the theory of aesthetics with that of explosions
felt when they saw the bombs fall
over the building of the Iraqi Writers Union
[…]
over Gilgamesh,
who was searching for immortality
among the ruins.[34]

There is nothing hyperreal about the bombs dropped by the US-led coalition on the city, and nothing beautiful either; they have fallen on places of collaborative creativity and on Gilgamesh himself.[35] Deep cultural foundations have been assaulted. In his perpetual "searching for immortality," Gilgamesh accentuates the temporal aspect of *Diary of a Wave outside the Sea* in which Mikhail sees her necessary exile as an indefinite state of being.

The suite of poems comprising Mikhail's *The Iraqi Nights* opens with Ishtar (the Babylonian version of the Sumerian Inanna) "walking through the souk looking for a gift" for her lover Tammuz.[36] Tammuz (Sumerian Dumuzi) was "punished with annual death and descent to the Netherworld"—another figure of cyclical renewal.[37] Abducted and taken to the underworld herself, Ishtar finds, in Mikhail's version, "the magic plant / that Gilgamesh never stopped looking for"—the plant promising restoration to youth that the legendary hero plucked from the depths of the sea and then lost.[38] Imprisoned, Ishtar makes her plans:

> I'll show it to Tammuz when he comes
> and we'll journey, as fast as light,
> to all the continents of the world,
> and all who smell it will be cured
> or freed,
> or will know its secret.[39]

The Iraqi Nights is, like its Arabian namesake, a longing for indefinitely prolonged existence: beginningless and endless deep time. This vision of eternal life suffuses the more mundane desire, in the seventh and last poem in the suite, for an ongoing existence in Iraq in which, in "every moment / something ordinary / will happen / under the sun."[40] So dreams Ishtar, but in a later poem in the volume, "Your E-mail," the goddess's return is only fleeting. She "comes back to life / to sing a song / for the wrecked cities" but a moment later is "leaving through the gate."[41] It seems that Baghdad/Uruk's deity, disillusioned by humankind's continuing violence, is deserting her.

Adnan Al-Sayegh is mentioned by Mikhail in *Diary of a Wave outside the Sea*, where she refers to him as "the first one" to designate their 1980s generation of Iraqi poets "the war poets."[42] Al-Sayegh's criticism of the Baathist regime led in 1993 to his exile in Jordan and Lebanon. In 1996, he was sentenced to death for writing "Uruk's Anthem"; since 2004, he has lived in exile in London. Of the "Iraq that's gone," he writes: "half / its history was kohl & song / its other half evil, wrong."[43] The good and right half of Iraq that is kohl (used in ancient times as an eye and face cosmetic) and song appears intermittently in "Uruk's Anthem," some sections of which, translated into English, appeared in *Singing for Inanna* (2014), a publication jointly produced with Jenny Lewis to accompany the British Museum's program of workshops and performance *Writing Mesopotamia*. In 2020, Seren Press published further fuller extracts as *Let Me Tell You What I Saw*. "Uruk's Anthem" flashes sadness and anger by turn: among its chief regrets is that the rich heritage of Mesopotamia has been squandered:

> We would have gone on building these lands
> as God wanted in his Babylonian dream—
> waters and prayers rippling over the steps of its hanging gardens
>
> but they destroyed us.[44]

The layering of the lines constructs an edifice that hangs like the gardens for an instant, only to topple over again. Later comes the same lament:

Is this Euphrates
nothing but our rippling blood from the age of Sumer?
......... flowing into the pockets of governments
that flay us with salt and revolutions?[45]

The ellipses are evocative of those in the clay tablets on which the ancient Mesopotamian epics are inscribed: here is another, infernal, version of deep time in which what never ceases to be repeated is violence and destruction.

The Anglo-Welsh poet Jenny Lewis is Al-Sayegh's UK collaborator. Lewis's 2014 collection *Taking Mesopotamia* includes poems from her earlier work with Al-Sayegh, *Now as Then* (2013) and *Singing for Inanna* (2014); the first also contains translations into Arabic by Al-Sayegh. These three volumes, a fourth chapbook, *The Flood* (2017) (also with translations by Al-Sayegh), and her 2018 *Gilgamesh Retold* merge into a single creation; repeated poems become part of a common collective. Lewis's personal connection with Iraq arises through her father, Thomas Charles Lewis, a Second Lieutenant in the Fourth Battalion, the South Wales Borderers (now the Royal Welsh), deployed and wounded in the Mesopotamian campaign of World War I.[46] "He died of a coronary thrombosis when I was a few months old," notes Lewis, "and I have been searching for him ever since."[47] "Anthem for Gilgamesh" makes the point more obliquely with a play on the poet's first name: "The genie said *I am on my way to paradise / to look for my father.*"[48]

Commenting on her 2010 verse drama, *After Gilgamesh*, Lewis remarked that "the crossing over of ancient and modern timeframes [is] a technique that I naturally gravitate toward as a way of exploring big, humanitarian issues."[49] She is fully aware of the "difficult heritage" of the epic, whose protagonist she describes as "an arrogant, ruthless and violent tyrant who makes life hell for his subjects."[50] *Taking Mesopotamia* is also unafraid to confront problematic legacies. Looking for her father, Jenny/the genie hops between the Iraq War of 2003, World War I, and the deep time of *Gilgamesh*, juxtaposing imagined moments from the Mesopotamian campaign with renditions of twenty-first-century interviews and translations of episodes from the epic. Water—flood—and eternal life are vehicle and tenor of the metaphorical scheme of the collection.[51]

"How Enlil, god of air, sent the Flood to get rid of humans" is the first rendition of an episode from *Gilgamesh* in *Taking Mesopotamia*, describing how the god who "hated war" turned "city and desert" into "ocean."[52] Mesopotamia is submerged:

there were only waves of silence
that went on and on to the edge of the drowned world.[53]

Two pages later comes another flood. "April 1916," voiced by "Tom" (the poet's father), recalls "a strange regatta" that occurred when five hundred British and Indian soldiers were obliged to learn to punt over "Floods three feet deep":

We needed
to find Noah and his ark before we started to go
slowly, one by one and two by two, into the dark.[54]

The Noah story (Gen. 6:14) also forms the epigraph to a poem three pages later. But this poem, "How the one wise man, Uta-napishtim, survived the Flood," carries the reader to an ark story some thousand years older than the Hebrew Bible. The initial temporal range—from Genesis to World War I—is rolled out by another third. And transcending even these three millennia, there comes into view one of the only two people to survive Enlil's flood, the now-immortal Uta-napishtim (the other person is his wife). High on the mountain top, Uta-napishtim sits "carving stories / onto clay tablets."[55] The literary record is what alone endures over time, as Gilgamesh is to learn.

The penultimate poem of *Taking Mesopotamia* is "Now as Then," reprised from Lewis and Al-Sayegh's 2013 collection of the same title. In that volume, the poem is accompanied by a photograph of a stone relief from Nineveh dating from c. 690 BCE, held in the Ashmolean Museum, Oxford.[56] The relief depicts captives being escorted out of Babylon by Assyrian soldiers. Another stone, like Hutton's geological samples, without beginning or end, the fragment suggests that war's victims form an infinite stream. Lewis's poem picks up this sense of infinity, with the repeated word "always" and present participles mirroring the stone's relentless procession:

And always the scent of cedar and cypress, boxwood and juniper.
Always the mayfly hovering over the water.
Always the mother and child leaving their country for ever.[57]

"Epilogue," the last poem in *Taking Mesopotamia*, is just as fluid. It speaks of "the desert's music / of water, irrigating and cleansing" (the benign opposite of flood) and concludes with "sounds of life trying / to go on as long as water continues to flow."[58] There is no punctuation after "flow," and on the next page, Al-Sayegh's Arabic translations of Lewis's poems begin—or, rather (since Arabic is written from left to right), end; or, rather, join up with the originals. English and Arabic languages, Welsh and Iraqi cultures, different times and different places, "now as then," flow together in a confluence. Together, these two poets have recreated the spiral aesthetic of *Gilgamesh*, the formal equivalent of deep time.

Gilgamesh is an epic in which standard linear time is stretched, an epic about the hope of eternal life (or, in Rainer Maria Rilke's formulation, "the fear of death"), an epic that offers the prospect of immortality through writing.[59] Spiraling over millennia, it imbues the poems of Mikhail, Al-Sayegh, and Lewis with a never-beginning, never-ending temporal order: a deep time that is at once an enriching source of inalienable cultural history and a challenging inheritance. In their poetry, reappearances of the epic are suffused with a sense of longing as great as its hero's desire for eternal fame. "Oh Inanna," cries Al-Sayegh, "how do we get back to Uruk?"[60]

These time tricks are not new. The temporal effects described here are recognizable from literary works produced between the two world wars, such as Hope Mirrlees's *Paris* (1919), T. S. Eliot's "The Waste Land" (1922), James Joyce's *Ulysses* (1922), and David Jones's "In Parenthesis" (1937). Saint-Amour has brilliantly characterized such works as encyclopedic "counter-epics."[61] Petitioning ancient as well as more recent literature, of both East and West, these compendious poems and novels refute the logic of traditional epic, which, in Hegel's analysis, activates "the total conspectus of the whole of the national spirit."[62] The modernist, encyclopedic counter-epic is "comprehensive" without being coherent, that is, and the works by Mikhail, Al-Sayegh, and Lewis discussed here have something of this shattered aesthetic.[63] But if the modernists pile up "heap[s] of broken images"—eclectic collections of decontextualized and de-temporalized cultural shards—Mikhail, Al-Sayegh, and Lewis draw on area-specific literary legacies to convey a sense of time outside time.[64] The seemingly infinite durability of the ancient texts they petition is a countervailing temporal order both to the "forever war" of late capitalism and to the serial, synchronic palimpsest of invasions of the region—a palimpsest with which the Iraqi poet Sinan Antoon opens his 2003 essay "Of Bridges and Birds":

THEY CAME TO BAGHDAD

945 Buwayhids; 1055 Seljuks; 1258 Mongols led by Hulagu; 1340 Jalayrs; 1393 & 1401 Mongols led by Tamerlane; 1411 Turkoman Black Sheep; 1469 Turkoman White Sheep; 1508 Safavids; 1534 Ottomans under Sultan Sulayman the Magnificent; 1623 Safavids; 1638 Ottomans under Sultan Murad IV; 1917 British; 1941 British again to depose pro-German government; 2003 Anglo-American invasion.[65]

Like Mikhail, Al-Sayegh, and Lewis, Antoon challenges the rhetoric that aestheticizes violence—a Fox News description of the B-52 bombers as "beautiful birds"; Donald Rumsfeld's reference to "the humanity which went into the making of these weapons"—by turning to timeless elements of Iraqi culture: kahi, a Baghdadi pastry eaten with cream and syrup; cardamom tea sipped in an old café; people singing traditional *maqāmāt* together.[66] But even as they look to deep time, none of these writers forget that this is the "painfully present tense."[67] The bombs are falling now.[68]

Notes

A version of part of this essay originally appeared as "Mesopotamia" in *Modernism/Modernity Print Plus* 5.2 (2020) © 2020 Johns Hopkins University Press and is reprinted with permission of Johns Hopkins University Press. I am grateful to Dunya Mikhail, Adnan Al-Sayegh, and Jenny Lewis for their very helpful feedback on an earlier draft.

1. Don DeLillo, "In the Ruins of the Future: Reflections on Terror and Loss in the Shadow of September," *Harper's Magazine*, December 2001, 33.

2. DeLillo, "In the Ruins of the Future," 35.

3. DeLillo, "In the Ruins of the Future," 39.

4. Wai Chee Dimock, *Through Other Continents: American Literature across Deep Time* (Princeton, NJ: Princeton University Press, 2008), 23.

5. Paul Saint-Amour, "Afterword: Deep War Time," *Modernism/Modernity Print Plus* 5, no. 2 (2020), https://modernismmodernity.org/forums/posts/stamour-deep-war-time, accessed March 24, 2022.

6. Saint-Amour, "Afterword: Deep War Time."

7. Saint-Amour, "Afterword: Deep War Time."

8. James Hutton, "Theory of the Earth; or, An Investigation of the Laws observable in the Composition, Dissolution, and Restoration of Land upon the Globe," *Transactions of the Royal Society of Edinburg* 1, no. 2 (1788): 304.

9. John Playfair, "Biographical Account of the Late Dr James Hutton," *Transactions of the Royal Society of Edinburgh* 5 (1805): 73.

10. Samuel Hynes, *A War Imagined: The First World War and English Culture* (London: Pimlico, 1992), xii.

11. Michael Longley, "The War Poets," in *Poems 1963–1983* (Harmondsworth, UK: Penguin, 1986), 168.

12. Carol Ann Duffy, "Exit Wounds," *The Guardian*, July 25, 2009, https://www.theguardian.com/books/2009/jul/25/war-poetry-carol-ann-duffy, accessed March 24, 2022.

13. Clare Shaw, "It Could Have Been," *The Guardian*, July 25, 2009, https://www.theguardian.com/books/2009/jul/25/war-poetry-carol-ann-duffy, accessed March 24, 2022.

14. Brian Turner, "A Soldier's Arabic," in *Here, Bullet* (Hexham, UK: Bloodaxe Books, 2011), 1.

15. See Saadi Simawe, "Introduction," in Dunya Mikhail, *The War Works Hard*, trans. Elizabeth Winslow (Manchester: Carcanet, 2006), vii.

16. Dunya Mikhail, "O," in *The War Works Hard*, ed. Dunya Mikhail, trans. Elizabeth Winslow (Manchester: Carcanet, 2006), 23.

17. Stephen Mitchell, trans., *Gilgamesh: A New English Version* (London: Profile, 2004), 1.

18. See Andrew George, "Introduction," in *The Epic of Gilgamesh: The Babylonian Epic Poem and Other Texts in Akkadian and Sumerian*, trans. Andrew George (London: Penguin, 1999), lx; and Mitchell, *Gilgamesh*, 5–6.

19. Alison Flood, "Gilgamesh Dream Tablet to be Formally Handed Back to Iraq," *The Guardian*, September 21, 2021, https://www.theguardian.com/books/2021/sep/21/gilgamesh-dream-tablet-to-be-formally-handed-back-to-iraq, accessed March 24, 2022.

20. Dunya Mikhail, "Inanna," in *The War Works Hard*, ed. Dunya Mikhail, trans. Elizabeth Winslow (Manchester: Carcanet, 2006), 12. The Sumerian Inanna, "Queen of Heaven," goddess of sex and war and deity of the city of Uruk, was known as Ishtar to the Babylonians; see George, *The Epic of Gilgamesh*, 222.

21. Adnan Al-Sayegh, "Uruk's Anthem," in *Singing for Inanna: Poems in English and Arabic*, eds. Jenny Lewis and Adnan Al-Sayegh (Cardiff: Mulfran Press, 2014), unpaginated.

22. Jenny Lewis, "Anthem for Gilgamesh," *Singing for Inanna*, unpaginated.

23. George, *The Epic of Gilgamesh*, 19 (brackets in original).

24. Friedrich Nietzsche, *On the Advantage and Disadvantage of History for Life* [*Vom Nutzen und Nachteil der Historie für das Leben*] (1874), trans. Peter Preuss (Indianapolis, IN: Hackett, 1980), 64.

25. Sharon Macdonald, *Difficult Heritage: Negotiating the Nazi Past* (Abingdon, UK: Routledge, 2009), 1.

26. George, *The Epic of Gilgamesh*, 2; Mitchell, *Gilgamesh*, 26.

27. Cathy Linh Che, "New Directions Interview with Dunya Mikhail," *Cantos: A New Directions Blog*, April 7, 2010, https://ndpublishing.wordpress.com/2010/04/07/new-directions-interview-with-dunya-mikhail/, accessed March 24, 2022.

28. Che, "New Directions Interview with Dunya Mikhail."

29. Mikhail, "Inanna," 11.

30. Mikhail, "Inanna," 11.

31. George, *The Epic of Gilgamesh*, 2, repeated 99.

32. Mitchell, *Gilgamesh*, 62.

33. George, *The Epic of Gilgamesh*, 1–2 (brackets and italics in original).

34. Dunya Mikhail, *Diary of a Wave outside the Sea*, trans. Elizabeth Winslow and Dunya Mikhail (New York: New Directions, 2009), 17.

35. The aesthetic theories Mikhail criticizes are presumably those of Jean Baudrillard, whose *The Gulf War Did Not Take Place* was published in 1991.

36. Dunya Mikhail, *The Iraqi Nights*, trans. Kareem James Abu-Zeid (New York: New Directions, 2013), 3.

37. George, *The Epic of Gilgamesh*, 222.

38. Mikhail, *The Iraqi Nights*, 8.

39. Mikhail, *The Iraqi Nights*, 8.

40. Mikhail, *The Iraqi Nights*, 12.

41. Mikhail, *The Iraqi Nights*, 45.

42. Mikhail, *Diary of a Wave outside the Sea*, 78.

43. Adnan Al-Sayegh, "Iraq," in *Now as Then: Mesopotamia–Iraq*, ed. Jenny Lewis and Adnan Al-Sayegh (Cardiff: Mulfran Press, 2013), 12.

44. Jenny Lewis and Adnan Al-Sayegh, eds., *Singing for Inanna: Poems in English and Arabic* (Cardiff: Mulfran Press, 2014), unpaginated.

45. Lewis and Al-Sayegh, *Singing for Inanna*, unpaginated.

46. Jenny Lewis, *Taking Mesopotamia* (Manchester: Carcanet, 2014), 11. The Royal Welsh regiment was deployed to Iraq in 2007.

47. Lewis, *Taking Mesopotamia*, 11.

48. Lewis and Al-Sayegh, *Singing for Inanna*, unpaginated.

49. Jenny Lewis, "After Gilgamesh Research," https://jennylewis.org.uk/projects/after-gilgamesh-research/, accessed March 24, 2022.

50. Lewis, "After Gilgamesh Research."

51. The title is a quotation from the 1919 *Memoirs and Reflections* of Lord Grey of Fallodon, British Foreign Secretary from 1905 to 1914: "Taking Mesopotamia . . . means spending millions on irrigation" (quoted in Lewis, *Taking Mesopotamia*, 15).

52. Lewis, *Taking Mesopotamia*, 24.

53. Lewis, *Taking Mesopotamia*, 24.

54. Lewis, *Taking Mesopotamia*, 26.

55. Lewis, *Taking Mesopotamia*, 29.

56. Ashmolean Museum AN1933.1575. See Ashmolean Museum, Oxford, The Ancient Middle East Gallery, https://www.ashmolean.org/ancient-middle-east-gallery#listing_149736_0, accessed March 24, 2022.

57. Lewis and Al-Sayegh, *Now as Then*, 6; Lewis, *Taking Mesopotamia*, 78.

58. Lewis, *Taking Mesopotamia*, 79.

59. "Das Epos der Todesfurcht" (Rainer Maria Rilke, *Briefwechsel mit Helene von Nostitz* [Frankfurt: Insel Verlag, 1976], 99); quoted in Mitchell, *Gilgamesh*, 202.

60. Al-Sayegh, "Second Song to Inanna/Ishtar"; Lewis and Al-Sayegh, *Singing for Inanna*, unpaginated.

61. Paul K. Saint-Amour, *Tense Future: Modernism, Total War, Encyclopedic Form* (Oxford: Oxford University Press, 2015), 186.

62. Georg Wilhelm Friedrich Hegel, *Aesthetics: Lectures on Fine Art*, vol. 2, trans. T. M. Knox (Oxford: Oxford University Press, 1975), 1045; quoted in Saint-Amour, *Tense Future*, 185.

63. Saint-Amour, *Tense Future*, 186.

64. T. S. Eliot, "The Waste Land" (1922), *Collected Poems 1909–1922* (London: Faber and Faber, 1963/1986), 61–86, l. 22.

65. Sinan Antoon, "Of Bridges and Birds," *Al-Ahram Weekly*, April 17–23, 2003, https://archive.globalpolicy.org/security/issues/iraq/attack/2003/0417ofbridges.htm, accessed March 24, 2022.

66. Antoon, "Of Bridges and Birds."

67. Antoon, "Of Bridges and Birds."

68. Antoon, "Of Bridges and Birds."

3

War, the Aesthetic, and the Political

Vivienne Jabri

Introduction

Images of war and destruction—from Don McCullin's famous photographic renditions of the Vietnam War and other conflicts to new and more recent footage from Iraq, Syria, Afghanistan, and now Ukraine, to name but a few locations of deadly violence—invite the public gaze into seemingly distant terrains, evoking multiple emotions and used in judgment and other modes of response, including the legitimization or condemnation of military interventions. With the emergence of smartphones and social media, we receive instant images from war zones of the experience of violence as this impacts on bodies and populations. The gaze of she or he who points the camera becomes our gaze, rendering the viewer not so much complicit but certainly witness to what the unleashing of violence can do. The photography of war, like the art of war, and Don McCullin, like Goya,[1] suggest this constitutive role for their photographic and artistic productions, respectively; the imprint of violence produced in the work comes to make its imprint on the viewer as subject invited as participant in the gaze. In, for example, David Campbell's interpretation of Don McCullin's war works, the photographer invites the viewer as witness, and in witnessing the outrages contained within the frame, the viewer is not just witness but also somehow complicit and therefore implicated.[2] Such a witnessing element, as Alex Danchev memorably argued, is not just in the gift of the artist: "works of art themselves bear witness," and he pointed to Picasso's *Guernica* and Paul Klee's *Angelus Novus* as exemplary of artworks' "witnessing" of the devastations of war.[3] In viewing such works in the gallery space, we are transported to the zones of war and adversity. The abstractions of these particular works add to their resonance; the destruction of war premised in rightly universal terms relating to human suffering. We are reminded by these modernist artists that war and modernity are intimately related, that in our compelling gaze to the future, as Walter Benjamin saw, we are already constituted by wreckage and debris. In reference to Klee's *Angelus Novus*:

> His face is turned towards the past. Where we perceive a chain of events, he sees one single catastrophe which keeps piling wreckage upon wreckage and hurls it in front of his feet. The angel would like to stay, awaken the dead, and make whole what has been smashed. But a storm is blowing from Paradise; it has got caught in his wings

with such violence that the angel can no longer close them. This storm irresistibly propels him into the future to which his back is turned, while the pile of debris before him grows skyward. This storm is what we call progress.[4]

Our time in the present is replete with violence, and we have lived our short twenty-first century with the reality and threat of violence; specifically, the violence of warfare predominantly experienced by the target populations on the receiving end of militarized interventions, of civil war factions armed through an ever-expanding global arms market and geopolitical alliances engaged in proxy wars, and of local governing regimes that recognize no limits in their struggle to retain or even regain control of their fragmented and fractured societies. There is no shortage either of the sensationalist and emotive imagery of the killed and injured, of the displaced and humiliated. It is as if with death and injury comes another profound loss: the right to privacy and dignity. The gaze, with the help of the lens, inflicts yet another moment of violence against the violated. It is hence not altogether surprising that debates centered on the photography of war persist beyond Susan Sontag's iconic reflections[5]; the bearing witness comes with costs, but who is the bearer of such costs if not the killed and injured now rendered in aestheticized form? Bearing witness and the raising of emotions do not in themselves tell us much about the meaning and location of the political in depictions of the violence of war.

This chapter places the lens on the intersection points between the categories contained in the triptych of the title. Focusing on the visual arts in particular, it first investigates the question of the aestheticization of violence and the production of particular forms of political discourse and practice. The meeting point between aesthetics and war can reproduce the shock and awe aspect of war and render this the driver of a distinct form of politics wherein the model of war is rendered the organizing principle for the constitution of political community. At the same time, the intersection of the aesthetic and war can also generate an oppositional discourse wherein the depiction of violence in all its visceral and embodied definition uses shock and awe, and the aestheticization of violence, for seemingly humanitarian or ethical purposes. This chapter considers, in the first section, the political implications of aesthetic interpretations of war that are based on the "sublime" and the "exceptional" as the lenses through which the category of war is constructed. War may constitute experience that is of the sublime, but how this is mobilized becomes a crucial question in considering the intersection of the aesthetics of war with politics. The chapter then considers interpretations of war that are not based on its exceptionality but rather, inspired by Fanon on colonial violence[6] and Foucault on the government of populations,[7] locate war and its constitutive elements in the everyday and the routine, the former in relation to the violence of the colonial state and the role of the arts in resistance, and the latter in relation to rationalities of government based

on disciplinarity and surveillance. Drawing on contemporary postcolonial art together with the aesthetic thought of Walter Benjamin, Theodor Adorno, and Frantz Fanon, this chapter considers the political implication of a form of aesthetic practice that seeks to de-aestheticize the violence of war. It proposes that the form such artworks take can generate a reflexive dialogical form of politics, one that refuses the aestheticization of war and of politics as such.

War, the Sublime, and the Aesthetics of the Exception

War produces an aesthetic of spectacle and fascination.[8] This applies as much to the structures that perpetuate war's presence in the human condition as it does to its technologies and its battlefield manifestations. Reading Clausewitz's *On War*, the imaginary is populated not only by massed troops, movement, invasion, and resistance but also by decision-makers in strategic deliberation with military leaders and by people or populations standing in judgment or as casualties of war.[9] The strategy of war and its conduct rely on its constitutive visual refractions; that the enemy and audiences alike can see, and therefore know, of the resources mobilized, that the sheer display of power, from troops marching with impossible precision to the technologies that constitute a war machine, can potentially come to full use should a line be crossed. The spectacle may precede the outbreak. Yet, it is the spectacle that can carry much of the constitutive weight or agency,[10] impacting as it potentially can do on the rationalization of war, on loyalties and enmities, on the calculations of potential enemies, and on the disciplining of audiences or constituencies and their reactions.

The aesthetic of war can hence be constitutive of its conduct, and this aesthetic is, in turn, constitutively related to the projection of sovereign power. This performative aspect of sovereign power was clearly in evidence in the shock and awe strategy that informed the 2003 invasion of Iraq.[11] The overwhelming use of nighttime aerial bombardment of a capital city, namely Baghdad, was aimed not just at the defeat of the enemy and its armed forces but also at a wider regional and global audience lest anyone mistook the message: that the invasion could take place with impunity, and that opposition would be futile. Addressed at both domestic and global audiences, the message was clear: that war is a necessity, framed as a response to an imminent existential threat, that its enactment constitutes an articulation of sovereign power beyond its territorial base, and more crucially still, that such enactment can navigate the very limits of the juridical-political ordering of the modern international order and be defined in terms of its transgressive capacity.[12]

The aesthetic of war in its practice and its representation in works of art can be associated with the concept of the "sublime," which, according to Kant, makes reference to that which confronts and overwhelms the senses. Kant's focus on the role of the "spectator" in his *Critique of Judgement* points to the relationship he suggests between

war and the sublime. Hannah Arendt quotes a particular passage that equates heroism with the sublime:

> Even in the most highly civilised state this peculiar veneration for the soldier remains . . . because even [here] it is recognised that his mind is unsubdued by danger. Hence . . . in the comparison of a statesman and a general, the aesthetical judgement decides for the latter. War itself . . . has something sublime in it . . . On the other hand, a long peace generally brings about a predominant commercial spirit and, along with it, low selfishness, cowardice, and effeminacy, and debases the disposition of the people.[13]

For Kant, the concept of the sublime is significant in that, evoking excess or even the transgression of the senses, it presents a challenge to understanding and epistemic comprehensibility. It hence presents us with the opportunity to reflect on the limits of reason. Rendered in Kantian terms, the sublime has both a universal as well as a particular connotation; it is "a means of characterising objects and human types," in his *Observations on the Beautiful and the Sublime*, and "as the feeling aroused by the failure of the imagination to comprehend the 'absolutely great,'" in his *Critique of Judgement*.[14] The notion of the sublime as the uncapturable, and hence the horrific, presents a challenge to understanding. Yet, what is clear in Kant's evocation of the concept in relation to war is that "the account of the onlooker," to use Arendt, is distinct from a "moral-practical reason" that considers both the costs of war and human "progress," judging "cosmopolitan peace" as the latter's ultimate arbiter, as might be found in Kant's *Perpetual Peace*. The aesthetics of war may produce fascination and even limit judgment. Yet, reason emerges as the legislator of war's political implications.

The Kantian confinement of the sublime to aesthetic judgment must remain both intriguing and paradoxical when considered in the context of war. It is intriguing in that war as sublime object retains its powerful hold on the subject and is hence always a spectral background to reflections on war when it enters the tribunal of reason. It is paradoxical in that the experience of the sublime is not in itself a basis for action. In this Kantian rendition, the spectacle of war qualifies for aesthetic judgment. Yet, the matter of cosmopolitan peace is for political deliberation based on calculative and moral reason. Although Kant's rendition of the sublime far exceeds the remit of this chapter, its evocation in this context seeks to draw attention to the tensions generated in the subject when confronted by that which evokes horror—tensions that point to not only the distinction of the faculties in Kant but also the turn to, one might say, critical reflection, when aesthetic judgment comes face to face with practical moral reason and therefore deliberation and reflection on the costs of war.[15]

The Kantian sublime is ultimately tamed in the context of wider political considerations. This perspective can be contrasted with those that see the aesthetics of war at the very core of politics. War is an assault on the senses, particularly to those in proximity, combatant and noncombatant alike. However, its assault is also upon those

who are its audience, the onlookers or spectators whose interpretations may exceed the aesthetic through reflection on the wider societal and political implications of war. Yet, the aesthetic, as indicated by Benjamin's focus on the Futurists and Fascism, is used for political mobilization. Where Fascism draws on war for its aesthetic rendition of politics, Benjamin, as highlighted by Hammer, places primacy on the "politics of aesthetics" and "de-aestheticisation."[16] Focusing on the work of art and its political positionality, Benjamin suggests "all efforts to render politics aesthetic culminate on one thing: war." He quotes from Marinetti's Futurist manifesto on the Ethiopian colonial war:

> For twenty-seven years we Futurists have rebelled against the branding of war as antiaesthetic... Accordingly we state:... War is beautiful because it establishes man's dominion over the subjugated machinery by means of gas masks, terrifying megaphones, flame throwers, and small tanks. War is beautiful because it initiates the dreamt-of metallisation of the human body. War is beautiful because it enriches a flowering meadow with the fiery orchids of machine guns... War is beautiful because it creates new architecture, like that of the big tanks, the geometrical formation of flights, the smoke spirals from burning villages, and many others... Poets and artists of futurism!... remember these principles of an aesthetics of war so that your struggle for a new literature and a new graphic art... may be illuminated by them.[17]

The aestheticization of politics through war had to be confronted, according to Benjamin, not with an aestheticized politics but rather with a politicized art willing not just to confront Fascism directly but also to use forms that challenged those he viewed as fascist tropes—the application of criteria of beauty, as we see in the above Futurist quote, to the deaths of human beings: "*fiat ars—pereat mundus.*"[18] In considering war as the paramount placeholder in the aestheticization of politics, any critical reflection on the art of war, as will be argued below, draws attention not only to the potentiality of a de-aestheticized form in the art of war but also to the politics *of* or *within* the aesthetic.

What a "de-aestheticization" of war confronts, however, is a worldview whereby the sublime of war comes to service an aesthetics and a politics of the "exception": enmity and antagonism toward the other, untrammeled power in the hands of the sovereign, the adoption of emergency measures, and the reification of the military model rendered societal. We see this reification of the war model in Carl Schmitt's "privileging of the *Ausnahmezustand*, or state of exception, vis-à-vis political normalcy," to quote Richard Wolin.[19] This privileging comes to constitute "the 'choice' of a worldview—which simultaneously express an aesthetic sensibility: that of an 'aesthetics of horror'" suggestive of "a temporal semantics of rupture, discontinuity, and shock" that then is the basis for the constitution of the political.[20] The aestheticization of politics, as recognized by Benjamin in commenting on the Futurists in the context of Fascist politics, is at the

heart of a Schmittian worldview whereby aesthetic categories come to define sovereign power and its articulation in the "decision." According to Peter Burger:

> The scandalous aspect of Carl Schmitt's writings lies in the fact that he develops a political theory from this worldview. The aesthetic desire for the exception, which surpasses the ordering categories of the understanding, becomes the foundation of a theory which has the formation (*Gestaltung*) of reality as its goal. On the basis of this transfiguration, it follows logically that Schmitt is able to assimilate the aesthetic categories of the "new and the strange" to the decision, which he conceives, following the model of the free act of the artistic genius, as an absolute act.[21]

Like the Futurists, the aesthetics of war underpins a Schmittian aesthetic of horror as the defining linchpin of a politics of the exception. The Schmittian "worldview" mobilizes a particular aesthetic in its rendition of the political. Considered in relation to our triptych of this chapter's title, the intersections of war, the aesthetic, and the political lose their critical generativity but are reduced to an instrumental rationality that comes to service a particular politics, that of the exception. However, as indicated above, there is no singular rendition of war, nor is there a uniform aesthetic that can be attributed to war. What meaning is associated with war is in itself situated in contingencies of power and knowledge that inform the discursive formations constitutive of realms of meaning that artists draw upon in their engagements with war.

The Aesthetics of War and Opposition

Even the critical attitude toward war, which historically depicts horror, suffering, and even the dehumanization of those who inflict pain with indifference, is premised on a certain aestheticization of war that seeks to mobilize its horrors toward emotive humanitarian responses. War remains as the exceptional moment in these renditions and cannot therefore constitute the norm. However, in considering Goya's iconic *Disasters of War*, his series of eighty-five etchings narrating Spain's 1808–1814 *Guerra de la Independencia*, we are confronted with profound questions relating to the aesthetic and the political, core to which is the question of interpretative mediation between the artist, the artwork, and the sociopolitical and hermeneutic context that impacts on the work's production and reception. At the same time, there is a timelessness to the works in the series, capturing as they do not so much the distance between war and politics but rather their close proximity (see figure 3.1).

Although Goya's work is conventionally interpreted in terms of its universal opposition to war, the conceptual content of the work suggests not only a plurality of interventions into a tense discursive milieu between the religious and the secular but also a focus on war and resistance, even what Goya's contemporary, Clausewitz, came to refer to as "total war" involving a "people."[22] As Caygill highlights:

Figure 3.1

Francisco Goya, *No se puede saber por qué*, 1863.
From *Los Disastres De La Guerra*, Madrid, 1863.
Photo credit: © Royal Academy of Arts, London.

Clausewitz's *On War* finds itself in the same predicament as Goya's *Disasters of War*, namely that of having to make visible a new form of violence and warfare. It was not only a question of describing or analysing the monster or colossus of Napoleonic warfare whose self-consuming escalation of violence was allegorically represented by Goya in terms of Saturn devouring his own children, or a monster prowling the land, but also resistance and the horrors of the guerrilla. Goya's etchings invent a new language to express with appropriate intensity this new, terrible warfare. The erosion of the distinction between civil and military expressed in the armed nation met a resistance which affirmed it by not recognising any distinction between the military and civilian nation.[23]

Far from distancing war from the political, Goya's etchings suggest an aesthetic articulation that places itself in-between, and therefore in relation to, war and the political, as the triptych of the title to this chapter suggests. There is therefore no singular meaning in Goya's visual rendition of the events he seeks to capture, one that might be reduced to moral outrage, and hence a depoliticised opposition to war as such. There is, rather, a conceptual engagement with war, one rendered in visual form, provoking a rethinking of war in a revolutionary, and nationalist, age.

While Goya's etchings defy singular interpretations, they nevertheless raise significant questions relating to the intersections suggested by the triptych of war, aesthetics, and politics. In their evocation of the juxtaposition of domination and resistance, their focus on the violence of war seems at once to suggest a constitutive place for war in the realm of politics; indeed, the future of Spain as no less than a sovereign national entity is laid bare upon the canvas. However, the etchings at the same time point to the sublime horror of war, its shocking evisceration of the body and the body politic alike. We might say that the aesthetic rendition of war, its aestheticization, comes face to face with the political in *Disasters of War*.

The tension between the aesthetic and the political in relation to Goya's war etchings is revealed in what we might consider as the *political within the aesthetic*, the space of interpretative engagement that emerges from the artistic productions of other artists responding to Goya. One of the most significant of such responses emerged in 2003 through the work of Dino and Jake Chapman, who enact what can be referred to as a political moment with their brutal but effective reinterpretation of Goya's *Disasters of War* series. This was not simply a reinterpretation in art criticism but rather an aesthetic intervention on the work itself. In the year of the invasion of Iraq, Jake and Dino Chapman committed an act that seemed to totally denude any moral content in Goya's *Disasters of War*. Having purchased the Goya prints, they proceeded to draw on the images; where there were beheaded corpses there now were heads of clowns or cartoonish animals (figure 3.2).

What were once revered as inaugurating a modern disgust with war and its dehumanizing effects were now subject to a defilement no less violent in its seeming entitlement to mock death and suffering. However, for Jake Chapman:

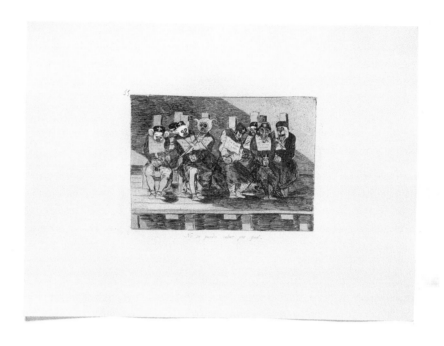

Figure 3.2

Jake and Dino Chapman, *No se puede saber por qué*, 2021. Photo credit: © 2023 Artists Rights Society (ARS), New York/DACS, London.

We decided to draw on Goya. The idea of drawing on the work was a way of amplifying some of the more monstrous or abject element of the work, to tease them out . . . That's our argument about the Goyas, part of the institutional framework that kind of suppresses the work by this kind of absurd ethical dynamic which is to say that these images are almost journalistic depictions of atrocity. If you actually look at the Goya pictures the degree of the artist's interest kind of gravitates towards the areas of laceration and castration and cutting, and so in a way they kind of undermine the moral framework that seems framed by it . . . So I think by drawing on them we were trying to get people to actually look at the work.[24]

The Chapmans' actions, superimposing their mocking imagery onto the somber content of Goya's etchings, constituted no less than a "counterpoint," to use Walter Benjamin, to the orthodoxy surrounding interpretations of *Disasters of War*. Their disruptive reading does not suggest any less an opposition to war, but rather, that the aestheticization of violence comes to be complicit in the reproduction of violence; that the detailed depictions of the human body in pain belie a fascination with the spectacle. The Chapmans' intervention, coming as it did in the context of a highly contested war, constituted an aesthetic-political event, one that ruptured conventional, "humanitarian" readings of artworks that depict the violence of war in aestheticized form.[25]

Fanon, Foucault, and the De-aestheticization of War in Contemporary Art

War has a temporality and a spatiality that distinguishes it from the norm, the routine, and the everyday. Yet, the constitutive features of war—the construction of enemies, the use of violence as instrument of coercion, the infliction of harm and injury to many, the adoption of exceptional practices that transgress societal and juridical rules—may so structure the everyday and the routine in certain contingent conditions that the line between war and peace, war and security, no longer holds. While Schmitt and his fellow radical conservatives were committed to the disruption of the boundary between the norm and the exception, such blurred boundaries were and continue to be a constitutive feature of lives lived across seemingly diverse contexts, from the colonial violence inflicted, as Frantz Fanon highlights, against the colonized, through to more recent locations of military interventions and civil wars wherein the everyday is indistinguishable from war.[26] The continuity between Fanon's renditions on the colonial condition and Michel Foucault's analytics of liberal governmentality is evident when considered in relation to the government of populations; both reveal the mobilization of a rationality of rule based on exclusion, incarceration, and violence, raising the question of how such violence is treated aesthetically.[27] As evidenced in the experiences of such populations in more recent militarized interventions, from Afghanistan to Iraq, war is rendered a "technology," to use a Foucaultian term, in the government of population.[28]

Political contestation within the aesthetic domain relates to the question of how violence comes to be depicted through works of art. This becomes particularly resonant in a postcolonial context replete with practices that have their historic base in colonial government. The London-based artist Jananne Al-Ani seeks to portray the violence of colonial occupation but does so not in the reproduction of images that reproduce "bare life," to use Agamben, but rather in enabling a revelation of what occupation means: dispossession.[29] Al-Ani's aerial photography, in a series of photographs and video installations, *Shadow Sites I* and *II*, shows landscapes devoid of human presence, evoking Western assumptions of "lands without a people," used in the occupation of territory in the Middle East (figure 3.3).

The form itself, aerial photography, used in surveillance and archaeological searches, conveys the idea not only that the territories underneath are of strategic interest but also that underneath the surface of such landscapes are histories, all too peopled and present in the consciousness of those occupied. In Al-Ani's later work *Black Powder Peninsula*, the artist deploys drone footage over the Kent landscape to reveal the remains of a gunpowder factory and those of a building used by the Anglo-Iranian Oil Company, in the midst of an everyday landscape in the "Garden of England."

As outlined by the curators of the exhibition *Traces of War* (2016), we see in this video installation "the machinery and economy of empire and its violent dispossessions is here brought home to its origins, in the traces left behind on an all-telling landscape … The viewer experiences the density of the work, of time and space compressed, histories connected, from the Kentish landscape to the Middle East"[30] and its colonial past and postcolonial present.

Archaeology and genealogy run through Jananne Al-Ani's work, as is evident in the above discussion. Crucially, they also inform her method or practice as she aerially traces empire in the landscapes of the Middle East. Such tracing reveals the emergence of aerial photography as a strategic asset in World War I and the use of the technology in the development of aerial archaeology as a discipline, both forming inspirations for her own use of such technology in her practice:

I visited the Air and Space Museum archives in Washington DC, where I discovered the unpublished reconnaissance photographs of the Western Front, taken by a unit established by Edward Steichen while working for the Aerial Expeditionary Force during World War I. This was the first instance of a really systematic and strategic use of aerial photography, which resulted in striking images of landscapes obliterated by shelling and criss-crossed by trenches, but abstracted to such a degree as to have become like exquisite and minimalist works of art … Interestingly, some of the earliest experiments in aerial bombardment were carried out by the British Air Force in the north of Iraq in the 1920s, after the end of World War I and the collapse of the Ottoman Empire.[31]

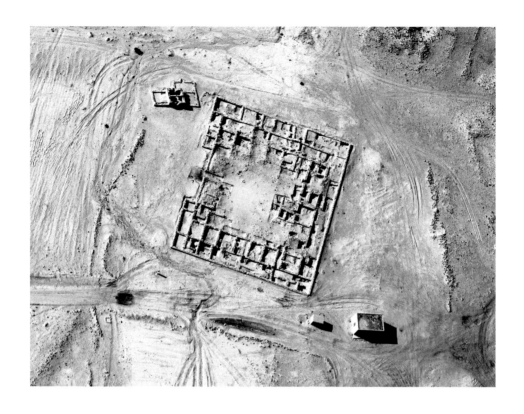

Figure 3.3

Jananne Al-Ani, "Aerial III." Production still from
the film *Shadow Sites II*, 2011.

Vivienne Jabri

Figure 3.4

Jananne Al-Ani, "Still XI." From the film *Black Powder Peninsula*, 2016.

In *Shadow Sites I* and *II*, Al-Ani captures the intimate historical relationship between aerial photography as a wartime asset and the development and evolution of visual archaeology. As she states:

> The term "shadow site" is the technical definition in aerial archaeology for a site that only appears when the sun is low in the sky and casting long shadows. So, in 2010, I travelled to Jordan, hired an aerial film specialist and a light aircraft and took this as my guiding principle when shooting, working only in the first hour or two after sunrise. I chose to work in Jordan because it sits at the centre of a number of highly contested sites—just east of Israel and occupied Palestine, and sharing borders with Iraq, Saudi Arabia and Syria.[32]

The archaeological and the genealogical are clearly present in Al-Ani's work, mobilizing as she does the very same technologies of war to reveal how power operates in the present.

Artists and their artworks negotiate the terrain between the categories of our triptych, as is evident from the above discussion. At the same time, they negotiate an interpretative milieu that can inform the work and toward which the work may challenge, fracture, or generate reflexivity or deliberation. There is no clear-cut formula for artist or viewer. How, then, do we begin to make sense of the political when the artwork refuses the aestheticization of violence, or when the aesthetic response to war is productive of the political *within* the aesthetic? There is, at the same time, no singular interpretation of the intersection between the aesthetic and the political, as is clear in considering for our purposes, in this chapter, Fanon's thought on art in the colonial context and how it can relate to the debate between Benjamin and Adorno.

Adorno, Benjamin, and Fanon on the Political *within* the Aesthetic

The colonial condition was not a matter considered by the early and later Frankfurt School theorists. My aim in this section is not so much to address this deficit but rather to consider the triptych of the title to this chapter from the viewpoint of two of the Frankfurt School's most significant voices, Benjamin and Adorno, while enacting an "interruption," to use a Brechtian term, by returning to Fanon and his considerations of the role of the arts in the colonial context and the anti-colonial struggles of his time.

In his iconic "essay" *The Work of Art in the Age of Mechanical Reproduction*, Benjamin seeks a conceptualization of the "politics of art" that resists and counters Fascist uses of art: "The concepts which are introduced into the theory of art in what follows differ from the more familiar terms in that they are completely useless for the purposes of Fascism. They are, on the other hand, useful for the formulation of revolutionary demands in the politics of art."[33] For Benjamin, the historic emergence of the reproducibility of the work of art dislocates it from its original time and place,

thereby challenging notions of "authenticity" and affirming "that which withers in the age of mechanical reproduction is the aura of the work of art." The age of mechanical reproduction inaugurated a dislocation of art from ritual and tradition and, more controversially, from the "doctrine of l'art pour l'art"; that art must be conceived in terms of "autonomy": "the instant the criterion of authenticity ceases to be applicable to artistic production, the total function of art is reversed. Instead of being based on ritual, it begins to be based on another practice—politics."[34]

Considered in terms of our triptych—war, the aesthetic, and the political—Benjamin compels us to see how violence is used in works of art and to what ends. Although his concerns related primarily to the rise of Fascism and the imminent threat of violence and war and their uses in an aestheticized politics, the salience of his words comes to the fore in present-day aestheticization of violence and its uses for political purposes. The aesthetics of shock and awe could be seen to merge into the *politics* of shock and awe in strategies of war and how these are communicated to a wider global audience. However, as indicated earlier, we can also discern the aesthetics of violence used for other purposes, namely those that might be related to moral outrage at the violence perpetrated against other human beings. The latter too become complicit in the aesthetic reproduction of violence. In relation to the artwork, the "exhibition value" of a work, according to Benjamin, derives not from its assumed "authenticity" but rather in how it potentially communicates an alternative politics through evocations of complexity and interruption, hence his advocacy of the photomontage, first used by the Dadaists in 1915 in their protests against World War I.[35]

Theodor Adorno refused to countenance the idea that a concept or even a work of art could "represent" in any form or even capture the extremes of violence perpetrated against human beings in war or in the concentration camp. Drawn from the debates on the aesthetic that engaged Adorno and his contemporaries, the debate centered on the role of the arts in transformative or even revolutionary politics. In opposing aspects of Benjamin's aesthetic thought in particular, Adorno sought to retain an element of "autonomy" for the artist and their work; that modern art could be seen not as simply a "product" of the sociopolitical and economic contingencies of the day nor as simply representing particular class interests. For Adorno, "A successful work, according to immanent criticism, is not one which resolves objective contradictions in a spurious harmony, but one which expresses the idea of harmony negatively by embodying the contradictions, pure and uncompromised, in its innermost structure."[36] Art at one and the same time contains social contradictions in its structure while having problematic relations with social reality. As Martin Jay suggests in reference to Adorno's understanding of polyphonic music, "As was the case with all cultural phenomena, it was neither fully reflective nor fully autonomous."[37] Rather than seeing art as a form of communicative practice, Adorno suggests that art criticism differentiates between the meaning an artist wants to convey and the artwork's "Gehalt," the Hegelian synthesis of form and

content, "hidden in the structure of the work."[38] What emerges is a conceptualization of the work of art in terms of its "dialectical mediation," through the artist, the canvas, the sociopolitical. For Martin Jay:

> The Frankfurt School's aesthetic criticism maintained a determined stress on the importance of mediation and nonidentity. Because Adorno, like others in the Institute, denied the existence of philosophical first principles, he always interpreted even the most reified artifacts of affirmative culture as something more than derivative reflections of a more fundamental reality.[39]

To ask the question of the political value of an artwork is not to impose external criteria through which we might judge its worth but rather to engage with the work dialectically, to discern especially the internal contradictions of a work, its import in relation to wider contradictions in aesthetic production and in the contingencies of the sociopolitical.

Fanon's reflections on the role of the arts in anti-colonial resistance are crucial in considerations of the intersection of war, the aesthetic, and the political, particularly, as argued in this chapter and elsewhere, in considering the political *within* the aesthetic.[40] Although the detail of Fanon's dialectical thought are well beyond the remits of this chapter, of significance is Fanon's dialectical reading of colonized art and its modes of articulation. Core to Fanon's analytics is the permeation of colonial violence into the lived experience of the colonized, so that war is not an extraordinary event, its violence being constitutive of the colonial condition and hence the of colonial subject. The "dialectical significance" of colonial practices becomes clear when tracing "cultural" responses to colonial domination.[41] The colonial negation or denigration of the history of the colonized is met with enhanced efforts at the reclamation of history; the colonial "racialisation" of thought compels the "native intellectual" to fight on "the field of the whole continent."[42] This search for an "authentic work of art," according to Fanon's critical position, misses the point of the dialectical positionality of the colonized as they find themselves in a struggle against domination and therefore looking toward a future to come. Fanon's "negativity"[43] is hence evident in his critique of "representative art," seeking in art "a true invitation to thought."[44]

The point of this discussion is not to draw parallels between Fanon, on the one hand, and Benjamin and Adorno, on the other, nor is it to create an artificial "conversation." Rather, it is to assert a critical positionality where, in place of the aestheticization of violence and in place of representational art, we find reflection on what constitutes the intersection of the political and the aesthetic, particularly in the context of war. Crucially for our present purposes, locating the political in works of art engaged with the subject of violence, the temptation is to focus on the anti-war content of the work, as has conventionally been done in relation to Goya as the quintessential anti-war statements. Yet, the political in Goya is revealed not simply through historical analysis of his immediate context but also through an act of aesthetic intervention that destabilizes

conventional understandings. Fanon's aesthetic thought is often reduced to judgments of value as these relate to the anti-colonial struggle. However, what we see in the above discussion is Fanon's critical engagement with the political in art, an engagement that is dialectical and negative. For Fanon as for Adorno, "Art is autonomous and it is not; without what is heterogeneous to it, its autonomy eludes it."[45]

Conclusion

The three categories that constitute our starting triptych—war, the aesthetic, and the political—stand uneasily in relation to each other. There is a constitutive tension within the triptych, and this tension is evident at the intersections and limits between the categories. The violence of war is both the master signifier and the all-too-material presence, challenging, as Walter Benjamin recognized, the aesthetic and the political—indeed, collapsing the line between them. This collapse of the difference between violence and politics was, for Benjamin, the inauguration of the fascist subject and the fascist polity. Spectacle and spectatorship were its core operational form and violence, the deaths of human beings, ruin, and debris its primary inspiration. However, Benjamin seeks to redeem the political in the arts; the capacity of the latter to resist but also potentially to destroy Fascism, and his advocacy of a particular form of art, the de-aestheticized, the un-auratic, the reproducible, the collective, as is rendered possible in photomontage and film, enables him to think the political in art in terms of its capacities to mobilize against Fascism.

While Adorno expressed his opposition to Benjamin's Brechtian understanding of "committed" art, preferring instead to pursue an understanding of the aesthetic and the political in terms of aesthetic negativity, he too was distinctly opposed to the aestheticization of violence and the suffering of human beings. The negativity that informs Adorno's philosophy resists the idea that the concept contained in a work of art can fully capture the materiality of suffering, and in this light, any evocation of such violence could only emerge in the trace of memory and fragment—traces that then might be drawn upon in the act of memorialization after Auschwitz, that art in its most abstracted form could carry the (political) burden of a refusal to reconcile with a politics of spectacle. Just as Adorno's aesthetic negativity suggests the limits of representation, and for him, the "advanced" modern work renders even such limits its subject matter, so too there is creative distance between the work and the sociopolitical milieu within which and from which it emerges. Yet, the work of art for Adorno, following Hegel's aesthetic theory, is itself a "social fact," challenged and challenging the constitutive milieu that renders it possible and meaningful in deliberative contestation. Adorno's art is less easily associated with protest and resistance. Yet, like Benjamin, there is a most profound and distinctly political and ethical responsibility accrued to the work of art. However, this is not a politics that seeks to render beautiful destruction and human suffering

but rather one that disabuses the premise of both a fascist art that celebrates violence and a humanitarian art that wishes to mobilize through its aestheticized depictions of killing and destruction.

Fanon's understanding of colonial violence and his analytics of resistance inform his engagement with the role that the arts and artists can and have played in anti-colonial struggle. The violence of war, for Fanon, permeates the everyday, articulated as it is in practices built on a wholesale negation of peoples colonized. His dialectical reading of both the colonial condition and the form that artworks take is mobilized toward a negativity that seeks in art evocations of a time and a place not legislated by colonial domination. Understood thus, the works that produce the most profound understanding of how violence permeates the political are those that depict its most hidden aspects; Jananne Al-Ani's aerial photographs of the landscapes of the Middle East revealing again the epistemological and structural violence of untrammeled power. This is art that bears its aesthetic negativity in its form, and the form remains in productive tension with its content, for the content cries out to be revealed. Yet, its full revelation would destroy the work. In such works and in many others in contemporary art, we see a politics that problematizes the domain of the aesthetic, a politics within aesthetics but not collapsed into it.

Notes

1. Don McCullin is an award-winning photojournalist whose war photography, from Cyprus to Vietnam to more recent conflicts in Lebanon, Iraq, Syria, and other war zones, was the subject of a major retrospective in 2019 at Tate Britain. One of his most iconic photographs from the Vietnam conflict is "Shell-shocked Marine, the Battle of Hue" (1968). The exhibition guide, *Don McCullin 5 February 2019–6 May 2019*, can be found at tate.org.uk. Francisco Goya is considered one of the foremost Spanish artists of the late eighteenth and early nineteenth centuries and is most renowned for his painting, *The Third of May 1808*, depicting a firing squad of Napoleon's soldiers directing their guns at Spanish resistance fighters, and the work that comes under scrutiny later in this article, *Disasters of War*, which focuses on the atrocities committed during Napoleon's invasion of Spain in 1807–1808. Much of Goya's works, including this one, can be found at the Museo del Prado in Madrid. See http://www.museodelprado.es.

2. David Campbell, "Cultural Governance and Pictorial Resistance: Reflections on the Imaging of War," *Review of International Studies* 29, no. 1 (2003): 57–73.

3. Alex Danchev, "Witnessing," in *Visual Global Politics*, ed. Roland Bleiker (London: Routledge, 2018), 332.

4. Walter Benjamin, "Theses on the Philosophy of History," in *Illuminations: Walter Benjamin*, ed. Hannah Arendt (London: Pimlico, 1999).

5. Susan Sontag, *On Photography* (London: Penguin Books, 1979).

6. Frantz Fanon, *The Wretched of the Earth* (Harmondsworth, UK: Penguin, 1967).

7. Michel Foucault, *Discipline and Punish* (London: Penguin, 1977); "Governmentality," in *Michel Foucault. Power: The Essential Works*, ed. James D. Faubion (London: Allen Lane, 2001).

8. See, for example, Daniel Pick, *War Machine: The Rationalisation of Slaughter in the Modern Age* (New Haven, CT: Yale University Press, 1993) on the fascination with high-technology warfare and bureaucratized killing; James Chapman, *War and Film* (Trowbridge, UK: Reaktion Books, 2008) on war and its representation in film using the three tropes of "spectacle," "tragedy," and "adventure"; and Alex Danchev, "Bug Splat: The Art of the Drone," *International Affairs* 92, no. 3 (2016): 703–713, on "drone aesthetics" and drone warfare.

9. Carl von Clausewitz, *On War* (Oxford: Oxford University Press, 2008).

10. That war as such has constitutive capacity, for individuals, the political community, and the international, see Vivienne Jabri, *War and the Transformation of Global Politics* (London: Palgrave Macmillan, 2007). That the spectacle of war can have constitutive capacity is assumed in the war strategy of shock and awe, as will be discussed below, suffice it to point out that the history of warfare and its representations from ancient times to the present assume such wider constitutive capacity. See, in particular, Anastasia Bakogianni and Valerie M. Hope, eds., *War as Spectacle: Ancient and Modern Perspectives on the Display of Armed Conflict* (London: Bloomsbury, 2015).

11. Foucault, *Discipline and Punish*; Vivienne Jabri, "Shock and Awe: Power and the Resistance of Art," *Millennium: Journal of International Studies* 34, no. 3 (2006): 819–839.

12. Vivienne Jabri, *The Postcolonial Subject: Claiming Politics/Governing Others in Late Modernity* (London: Routledge, 2013), 108–130.

13. Hannah Arendt, *Lectures on Kant's Political Philosophy*, ed. Ronald Beiner (Chicago: University of Chicago Press, 1992), 53.

14. Howard Caygill, *A Kant Dictionary* (Oxford: Blackwell, 1995), 379.

15. I am indebted to Hannah Arendt's reading of Kant's *Critique of Judgement* in this context. Also of significance is Bernouw's reading of Kant's notion of the sublime in the context of his Critiques; see Jeffrey Bernouw, "The Morality of the Sublime: Kant and Schiller," *Studies in Romanticism* 19, no. 4 (1980): 497–514.). For a wider discussion of the sublime in the context of war and the "resistance of art," see Jabri "Shock and Awe." For a focus on the sublime and the political, although with a different iteration, see, in particular, Michael J. Shapiro, *The Political Sublime* (Durham, NC: Duke University Press, 2018), whose core thesis is that the sublime is mediated by a plurality of interventions and the role of the arts therein. Shapiro's aim is to question "Kant's commitment to a universalizing sensus communis," drawing on "the way artistic and cultural texts intervene and mediate the experience of the sublime" (10). For an alternative understanding of the "sublime" in relation to the aesthetic experience and the political, and one inspired by Jacques Rancière, see Lola Frost, "Aesthetics and Politics," *Global Society* 24, no. 3 (2010): 433–443.

16. Espen Hammer, *Adorno and the Political* (London: Routledge, 2005), 122.

17. Benjamin, *Illuminations*, 234.

18. Benjamin, *Illuminations*, 235.

19. Richard Wolin, "Carl Schmitt: The Conservative Revolutionary Habitus and the Aesthetics of Horror," *Political Theory* 20, no. 3 (1992): 424–447, 432.

20. Wolin, "Carl Schmitt," 433.

21. Quoted in Wolin, "Carl Schmitt," 434.

22. Javier Lopez-Alos, "Alternative Forms of Historical Writing: Concepts and Facts in Goya's *Disasters of War*, in *Theories of History: History Read across the Humanities*, ed. Michael J. Kelly and Arthur Rose (London: Bloomsbury, 2018). Goya's *Disasters of War* has been subject to a number of interpretations, from a focus on Spain's political context of the time to Goya's aesthetics. See, in particular, Mark McDonald, "Goya's Graphic Imagination," in *Goya's Graphic Imagination* by Mark McDonald, Mercedes Ceron-Pena, and Francisco J.R. Chaparro (New York: Metropolitan Museum of Art, 2021) and Jesus Vega, "The Dating and Interpretation of Goya's 'Disasters of War,'" *Print Quarterly* 11, no. 1 (1994): 3–17.

23. Howard Caygill, *On Resistance: A Philosophy of Defiance* (London: Bloomsbury, 2013), 21-22

24. "Lost Art: The Chapman Brother vs Goya," July 25, 2015, Tate video, https://www.youtube.com/watch?v=wt-jVRpotIo, accessed March 19, 2019.

25. However, see Philip Shaw, "Abjection Sustained: Goya, the Chapman Brothers and *Disasters of War*," *Art History* 26, no. 4 (2003): 479–504, for an interpretation of the Chapman Brothers' intervention that challenges their claimed critique of Goya's (and his interpreters') "ethics of humanism." What Shaw sees in his Lacanian reading is a "reinvention" rather than a "retreat" from humanism.

26. Fanon, *The Wretched of the Earth*.

27. As Foucault states in *Discipline and Punish* in reference to technologies of government implicated in the production of the "disciplinary individual": "In this central and centralised humanity, the effect and instrument of complex power relations, bodies and forces subjected by multiple mechanisms of 'incarceration', objects for discourses that are in themselves elements for this strategy, we must hear the distant roar of battle" (308). While Foucault does not consider colonial government, nor does he reference Fanon's writings on the colonial condition, his work is nevertheless significant in our understanding the microcosm of liberal governmentality as it was, and continues to be, articulated in colonial and postcolonial contexts.

28. See Jabri*, War and the Transformation of Global Politics* and *The Postcolonial Subject* for an elaboration of the governing practices that identify war's presence in the everyday of populations under occupation. The genealogy of such practices lies in colonial contexts. They include the division of populations along sectarian and tribal lines, spatial dividing lines, the control of movement through the utilization of armed checkpoints, the control of economic activity, the racialization of populations, and the construction of hierarchies of worth along racist lines.

29. Giorgio Agamben, *Homo Sacer: Sovereign Power and Bare Life*. (Stanford, CA: Stanford University Press, 1995).

30. The exhibition, *Traces of War*, curated by Cecile Bourne Farrell and Vivienne Jabri, took place at the Inigo Rooms, King's College London, in 2016.

31. Jananne Al-Ani interviewed by Cecile Bourne-Farrell, co-curator (with Vivienne Jabri) of the exhibition, *Traces of War* (2016), and reproduced in the catalogue of the exhibition, *Traces of War: An Exhibition on the Everyday of War* (King's College London, 2016).

32. Interview with Jananne Al-Ani, conducted by Cecile Bourne-Farrell, in *Traces of War*. Al-Ani pays homage to the historian Kitty Hauser and her history of visual archaeology in Kitty Hauser, *Shadow Sites: Photography, Archaeology, and the British Landscape 1927–1955* (Oxford and New York: Oxford University Press, 2007).

33. Benjamin, *Illuminations*, 212.

34. Benjamin, *Illuminations*, 218.

35. As the Tate's description of photomontage states, it "is often used as a means of expressing political dissent." The examples of artists using the form include John Heartfield, a German artist whose work "used reconstructed images from the media to protest against Germany's Fascist regime," and Peter Kennard, famously of the work "The Kissinger Mind," whose works depict police brutality and the nuclear arms race. See https://www.tate.org.uk/art/art-terms/p/photomontage.

36. Adorno, quoted in Martin Jay, *The Dialectical Imagination: A History of the Frankfurt School and the Institute of Social Research 1923–1950* (London: Heinemann, 1973), 179.

37. Jay, *The Dialectical Imagination*, 182.

38. Peter Uwe Hohendahl, *Reappraisals: Shifting Alignments in Post War Critical Theory* (Cornell, NY: Cornel University Press, 1991), 89.

39. Jay, *The Dialectical Imagination*, 181.

40. See Jabri, *The Postcolonial Subject,* for an elaboration on Fanon and "negativity." For Fanon's dialectics, see Reiland Rabaka, *Forms of Fanonism: Frantz Fanon's Critical Theory and Dialectics of Decolonization* (New York: Lexington Books, 2010); Geo Ciccariello-Maher, *Decolonizing Dialectics* (New York: Duke University Press, 2017); and Matthias Pauwels, "Portrait of the Artist as Colonized Subject," *Theoria* 65, no. 155 (2018): 72–97.

41. Fanon, *The Wretched of the Earth*, 169.

42. Fanon, *The Wretched of the Earth*, 170–171.

43. Homi Bhaba, *The Location of Culture* (London: Routledge, 1994), 238.

44. Fanon, *The Wretched of the Earth*, 183.

45. Theodor W. Adorno, *Aesthetic Theory* (London: Bloomsbury, 2018), 8.

4

The Fabric of War: Lace, Gender, and Everyday Militarism

Caren Kaplan

Every war is fought, every army is maintained in a military way and in a militaristic way. The distinction is fundamental and fateful. The military way is marked by a primary concentration of men and materials on winning specific objectives of power with the utmost efficiency, that is, with the least expenditure of blood and treasure. It is limited in scope, confined to one function, and scientific in its essential qualities. Militarism, on the other hand, presents a vast array of customs, interests, prestige, actions and thought associated with armies and wars and yet transcending true military purposes . . . Its influence is unlimited in scope.

—Alfred Vagts, *A History of Militarism*[1]

When we consider war, we don't usually think of lace. However, on a work-related trip to Boston, Massachusetts, back in 2012, I found myself with a few hours to myself on a chilly day. I headed to the Museum of Fine Arts to walk around indoors and get a cup of tea at their café. To my surprise, I discovered an exhibition titled *Beauty as Duty: Textiles on the Homefront in WWII Britain*. There, in pride of place at the center of the room, was an extraordinary object: an enormous lace panel, more than five feet wide and fifteen feet tall, commemorating the Battle of Britain, the air war that took place in the skies above London and other sites between July and October 1940. I had never seen anything like it. Amid the climbing roses and curling leaves that I would expect to see in fine lace were numerous aircraft vigorously defending the homeland, along with figures of aviators, searchlights, ground artillery installations, and falling or burning buildings. Along the lower edge of the panel was inscribed one of Prime Minister Winston Churchill's most well-known wartime quotes: "Never was so much owed by so many to so few." I spent quite a lot of time moving closer and farther back, viewing the piece from different angles. I was truly stunned by its scale and what seemed to me to be the novelty of it—a gigantic lace curtain depicting air war. Since lace is usually associated with purely decorative domestic items or the fashions of previous centuries, I was curious about the choice of this medium for the commemoration of acts of war.

The lace panel was made by Dobsons and M. Browne & Co. in Nottingham, once the "capital" of the now-defunct British lace trade, to celebrate the successful repelling of the German aerial invasion.[2] Dobsons and M. Browne & Co. had turned their production during wartime from lace curtains to mosquito and camouflage netting. However, between 1942 and 1946, the company devoted scarce resources of labor and materials

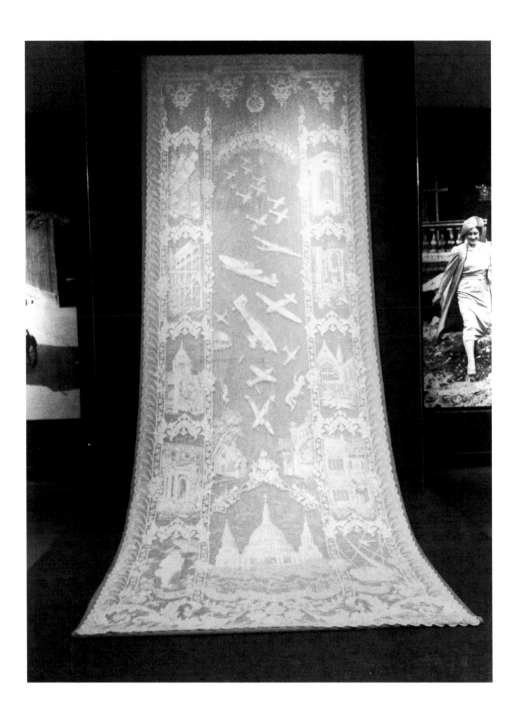

Figure 4.1

Commemorative lace panel: The Battle of Britain.
Dobsons and M. Browne & Co., Nottingham,
1942–1946. Exhibited at the Boston Museum of
Fine Arts, 2011–2012 (photo by the author).

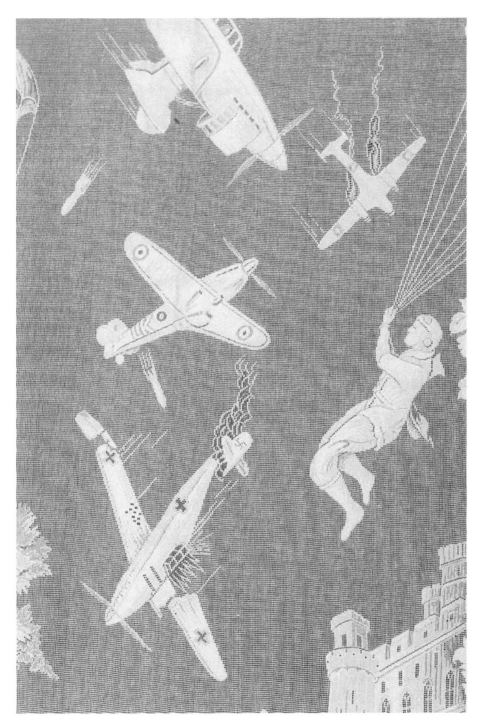

Figure 4.2

Commemorative lace panel
detail (photo by Gavin Kemp
Photography Ltd.).

to produce more than thirty commemorative Battle of Britain lace panels, which were exhibited around the country and in several Commonwealth nations to boost patriotic morale and to demonstrate the artistry of the Nottingham lace industry.[3] The surviving lace panels are now scattered among regional and military-themed museums—relics not only of a major air war of the mid-twentieth century but also of an industry struggling to remain relevant in an era of rapidly changing tastes and technologies.

The Battle of Britain lace panel reminded me that fabrics are part of the material infrastructure of warfare—crucial to the war effort but often "unseen" due to the every-day nature of their fabrication and modes of use. For every remarkable or celebratory example, such as a commemorative lace panel or decorative banners, there are myriad banal items, such as bandages, tents, blankets, uniforms, flags, and camouflage. Their design and production may move in and out of military use or reference to warfare. However, focusing on less obvious objects and modes of fabrication can generate questions about the material infrastructure of the military industrial complex as well as the parameters and definition of warfare, transitions in military procurement and logistics, technological innovation, and cultural practices in relation to gender, class, and nationality.[4] These sociological and historical elements are crucial, but they also need to be linked to the matter of fabrication itself, always integral to the making of meaning as well as objects, whether we are talking about texts or textiles.

The blurry boundaries between military and civilian arenas in the era of the world wars are often obscured by the insistent narrative of separate spheres in modern democracies. In wartime, reports about the "conversion" of peacetime industries to sup-ply the needs of the military reinforce the discourse of a strict division. However, the infrastructure of industrialization has almost always depended on militarized colonial occupations for resource extraction as well as military contracts. Divisions of labor and labor pools can also be viewed as linked to national projects of empire that have been backed by force. To begin to understand war's fabrications, then, we have to deconstruct the binaries of private/public, craft/industry, domestic/foreign, and civilian/military. We need to think through a large and expansive field of objects, methods, personnel, locations, and time periods. A focus on the quotidian, less spectacular elements of society during times of seemingly endless war allows us to understand the legitimating mythologies of warfare better, its intensely normalizing practices.[5] As Steven Flusty has argued, the best way to understand how neoimperialism (and its wars) are "created, valorized or concealed, received, reinterpreted, and even refused" is to pay attention to everyday actions and implements.[6] Expanding inquiry into everyday militarism directs our attention to the "grey sites" that are so "flat and horizontal," as Pierre Bélanger and Alexander Arroyo put it, as to render them "difficult to recognize and represent."[7] In the case of the US military, they argue, there is a "critical deficit of public, geographic knowledge" on the "worldwide footprint" of the "single largest landowner, equipment contractor and energy consumer in the world."[8] This military infrastructure is "so vast

and omnipresent" that "we are no longer able to detect its extents," given that it is "rendered invisible by its scale."[9] Everyday militarism can be characterized by its capacity to be "hidden in plain sight," even as it "saturates our surroundings" through "different temporalities, scales and legacies."[10]

On many levels, we "know" that fabric is part of the story of warfare—it is ubiquitous. But what do we actually know about this infrastructural material—its mode of coming into being, its uses, and its meanings? From the construction of war balloons and parachutes to tents and blankets, flags and streamers, bandages and shrouds, not to mention the myriad programs to supply knitted items to deployed troops, fiber arts, crafts, and manufacturing have played a key role in warfare in the modern era. Yet, if the ways that textiles have contributed directly to war efforts are deemed hardly worthy of study, the more quotidian aspects and complex relations remain difficult to trace. Fabric is so much a part of everyday life that we can miss the power and import of its "communicative and haptic power."[11] As Minoo Moallem has argued, the "binding force" of the neoliberal era relies on "sentiments, affects, sensibilities, habits, and the ways in which power is aestheticized," mediating wartime images and products through trade and consumption.[12] Wartime fabrics such as lace netting bring us into the middle of things in dynamically political moments. Yet, through their very banality, they can blunt our apperception of materiality, of conditions of fabrication and distribution, of relationality.

In the grand scheme of textiles, lace suggests frivolity and opulence. It might stand as the very opposite of a wartime fabric. Nevertheless, the infrastructures involved in producing lace not only have lent themselves to supplying modern wartime material but also complicate the discourse of industrialization during an era of intensified political violence. Tracing the history of an object such as the Battle of Britain lace panel can reveal some of the shared relations and infrastructures inherent to fabrication, linking lace to its more obvious wartime counterpart: camouflage netting. The physical properties shared by lace and netting include the interplay of presence and absence, the promise of partial visibility, and the delivery of intermittent obscuration along with the promotion of deception (as well as resistance, or even reworkings, of solidarities on the ground).[13] In netting, the appearance of delicacy belies significant strength, and the same is true of some versions of lace. A lace curtain allows light to penetrate, offering partial vision, yet scrambles the perception of viewers. Camouflage netting also relies on the subversion of perspective and the disruption of sense. As Olga Boichak has argued, camouflage netting does not just mask the presence of military objects from aerial observation; the view from below the netting also matters, generating "forms of sociality and resistance hiding in plain sight."[14] These characteristics of openwork fabrics such as lace and netting became vibrantly incorporated into twentieth-century military endeavors, drawing on an industrial infrastructure that was always receptive to if not already thoroughly implicated in war work.

Fabricating Lace: Craft, Industrialization, and "Hidden Hands"

Even when it's on the table
In front of us, lace is what's missing,

The art of making something of absences,
Of what is felt more than known,

The history of women.
—Dana Sonnenschein, "A History of Lace"[15]

Things made from thread and yarn would seem to have nothing to do with the serious matters of satellites and surveillance, drones and distance warfare, or subjects such as optics or materials such as aluminum, glass, or concrete. Just as we hardly think about the maker of "pillow lace" in the late eighteenth century when we consider the emergence of neoclassical painting or Napoleonic cavalry, except perhaps as a piquant side note on decoration, we do not assume that a Jacquard loom in Nottingham in the 1940s matters in the age of airpower, except as a tool for ornamentation of interior spaces.

The word "decoration" is key, linked not only to a mode of representation but also to gender. Certainly, anything to do with fabric is usually associated with female labor or recreational activity and therefore either sentimentalized or denigrated. Whether we think of Penelope as the figure of perfect marital fidelity sitting at her loom while she awaits the return of her husband Odysseus or Betsy Ross sewing the flag during the American Revolution, the production and use of fabric, particularly before the industrialization of textile production, is heavily linked to the domestic sphere and the maternal work of care for the family. However, the historical relation between female cultural and material producers of fabric requires careful demythologization. Across historical periods and locations, we can find men spinning, knitting, weaving, making nets, and so on. Indeed, everyone—men, women, and children—worked "at home" until relatively recently in human history. Yet, in the West, in modernity, discursively if not materially, women have been tied to fiber arts and the so-called private sphere, and this affects how we view fabric and textile fabrication in wartime.

Therefore, it should not be surprising that feminist researchers and writers have been at the forefront of the study of textiles and fiber arts. Some of the most interesting scholarship links women's textile fabrication to political activity, to dissent, and even to violence. In her work on fiber imagery in stories and legends about the Trojan Wars, Lois Martin found "deadly slings, treacherous snares and nets, and crimson carpets marking a path to murder"—imagery at odds with the trope of Penelope passively sitting at her loom, weaving and unraveling her never-ending shroud.[16] Martin is fascinated instead by Clytemnestra's net, which becomes key in the effort to murder Agamemnon and then is used as forensic evidence in Orestes's trial for matricide. As Martin writes, "rather than being marginalized as soft, superfluous 'women's work,' textiles could have terrifying power: as weapons, as agents of torment, and as prizes so alluring as to drive greed out-of-bounds."[17]

Rozsika Parker, in her now-classic work *The Subversive Stitch*, has argued that embroiderers do not just make pretty pictures with thread as part of a frivolous pastime or due to a lack of more profound artistic talent. Rather, for centuries, women have transformed materials "to produce sense—whole ranges of meanings," and the women who do the bulk of such work are and have been powerful fabricators of objects and cultures.[18] Similarly, Julia Bryan-Wilson asks, "What does it mean to imagine the sewing needle as a dangerous tool and to envision female collective textile making as a process that might upend conventions, threaten state structures, or wreak political havoc?"[19] Bryan-Wilson argues that textiles are "in the fray"—that is, they are often not only in the center of "heated disputes, controversies, and disagreements" about the "materiality of gendered labor" but also integral to debates about "the limits or boundaries between high and low" cultural production, since "their constant use in and affiliation with the everyday, trigger suspicions that such boundaries might not exist."[20] It is this "instability of textiles' relationality" that Bryan-Wilson links in some instances to a queer sensibility and politics, specifically through tactility and "different sorts of bodily orientations" that contribute to "volatile interfaces between public and private selves."[21] Above all, Bryan-Wilson reminds us that textiles "help define our relationship to interiors and exteriors; they shape how we move through space, and they alert others to our sense of self and signal our attempts to collectively belong."[22]

Feminist scholarship on fiber arts reminds us that, as Bryan-Wilson claims, "it matters whose hands hold the needles, and under what circumstances."[23] This approach begins to deconstruct the entrenched mythologies of modernity in relation to textiles and their making; for example, the history of the transition from preindustrial to industrial eras and the role of textiles and fiber arts in this pervasive storyline. According to the standard discourse, for centuries, textiles were produced in the home or in linked cottage industries primarily by women who were able to pick up or put down their tasks as they were interrupted by the needs of children and family members. In other words, preindustrial textile production was particularly well suited to the primordial aspects of women's daily lives, and their participation in this sphere of activity was deemed to be inherent to feminine nature.[24] This supposedly bucolic situation was altered profoundly as more people moved, voluntarily and involuntarily, to cities and production and consumption shifted, often forcibly, from the home to the factory. While both men and women, especially very young women and girls, worked in the first factories, by the time full industrialization became the norm, men were viewed as the "breadwinners" and women as more part-time or flexible workers, and therefore they were paid less. In particular, women's craftwork became understood as a thing apart from industrialization, given that it was conducted in the home away from the modern workplace and linked to their domestic, reproductive, and maternal activities.

Glenn Adamson argues that the emergence of craft as a "coherent idea, a defined terrain" as industry's opposite takes place *simultaneously* with the rise in mass

manufacturing.[25] Modern industry became figured as technically complex, efficient, and scaled for mass production and consumption, and the idea of craft was relegated to the hearth and home, discredited and viewed as inferior. The "undifferentiated world of making" became divided into a set of binaries, including "craft/industry," "freedom/alienation," "hand/machine," and "traditional/progressive," but Adamson reminds us that craft and industrial manufacturing "were created alongside one another, each defined against the other through constant juxtaposition."[26] The discursively blunt division of industry and craft into two opposite social spheres not only bolsters the antinomies of public/private, male/female, empire/colony but also ignores the material evidence of widespread handcrafting in industrial manufacturing.[27] Adamson is not arguing that artisanal work did not take place before the late eighteenth century or that industrialization did not cause suffering or exploitation. Rather, his research historicizes the making of things and therefore meaning across periods and locations and reminds us that fabrication is never homogeneous. A nuanced history of the production of textiles in the age of machines demonstrates, however, that the dominant narrative of industrialization is sometimes overly homogeneous, eliding distinctions of nationality, location, time period, and many other specifics. Industry and craft may not be so much oppositional as relational.

The fabrication of lace troubles any such strict divisions between individualized craftwork at home and alienated mass production in the factory. Even seventeenth-century bobbin lace production, often romanticized as a prototypical craft worked by women in picturesque small villages, was, in fact, a huge industry that employed large numbers of impoverished small children as well as young women, all poorly paid. Pamela Sharpe argues that the making of bobbin lace was a "type of early mass production," always "a cheap and mechanical type of manufacture."[28] Conversely, lace produced on a machine often requires extensive hand treatment and finishing. Sheila Mason's research on the Nottingham lace industry presents a view of a manufacturing process that was a "complex web of individual, though interrelated, businesses" that were distinguished by types of machines, operators, trades, and production sites, including the home.[29] As Gail Baxter has described it, the nature of the Nottingham lace trade was "fractured," with many companies contributing a "finished product" that required the coordination of "the machine holders who physically made the lace, the finishing trades who undertook the processes necessary to make the lace ready for sale, and the wholesalers who sold and distributed the lace."[30] However, Baxter points out, even these three divisions are inadequate to account fully for the "true scale of the number of different processes, companies, and people involved either directly or indirectly with the lace trade."[31] Many of the hands, literally and figuratively, involved in the production of lace remain hidden, obscured by the emphasis on machines and industrialization in the Nottingham brand.

Industrial lace making around Nottingham developed out of the older stocking knitting trade in the late eighteenth and early nineteenth centuries and soon became the

region's largest employer. Initially, the lace, like the stocking and gloves made on knitting frames, was produced in the home or small workshops, and the process could involve the entire family. Handmade lace had been either crocheted (commonly associated with lace makers in Ireland in no small part as a strategy to employ women during the Great Famine) or created with a needle (point lace) or with bobbins (pillow lace). Since these practices were time-consuming and painstaking, lace products were extremely expensive. Numerous industrial innovations (including the introduction of steam, Jacquard looms, and quality spun fiber) and changes in trade and fashion shifted lace making to a more efficient and therefore more affordable commodity.

The industrialization of the knitting and lace trades may have increased efficiency, but that process was accompanied by radical changes in divisions of labor and modes of work that also instigated strife and rebellion. The first organized attacks on factory machinery linked to the Luddite movement took place in the vicinity of Nottingham between 1811 and 1812 during a period of economic stress caused in part by the costs of the Napoleonic Wars as well as a severe depression in the textile industry. In his history of Nottingham hosiery and lace manufacturing, William Felkin notes that by 1812, nearly half the population in the region was unemployed.[32] Conditions were so severe and concerns over the intensification of redundancy through new machinery that reduced workforces even further grew so great that many forms of rebellion broke out, including the smashing of machines. The government sent in large numbers of troops until, as Felkin (who was an eyewitness to the events) describes it, Nottingham "seemed as if in a siege."[33] This level of repression and an Act of Parliament that made machine smashing punishable by death dampened the rebellion in Nottingham (although it spread to other textile-producing areas in the country). Many scholars have argued that the Luddites, especially the early adherents in Nottingham, were not so much against all machinery—many of them were enthusiastic users of knitting frames and other mechanized devices—but rather against the most exploitative aspects of mass industrialization.[34] Following the severe government response to the Luddite movement, hosiery and lace makers were pushed increasingly from their homes and small workshops into larger factories.

In the United Kingdom (as elsewhere in Europe and the United States), the textile industry in general and lace making in particular were highly stratified by gender. If early lace manufacture was, as some scholars argue, a unique example of "female dominated" work, the introduction of heavy machinery and bricks-and-mortar factories shifted the social relations of the industry.[35] The Nottingham industrial lace machine operators were primarily male, dubbed "twist hands," and they were paid by the piece. By World War I, twist hands were among the highest paid factory workers in Britain and were considered to be an elite workforce, while industrial female lace workers were primarily consigned to "finishing," a process that bleached, dyed, and embroidered a product that emerged from machines smeared with graphite and largely unrecognizable as anything luxurious or fine (figures 4.3 and 4.4). Working conditions for finishers were among the worst

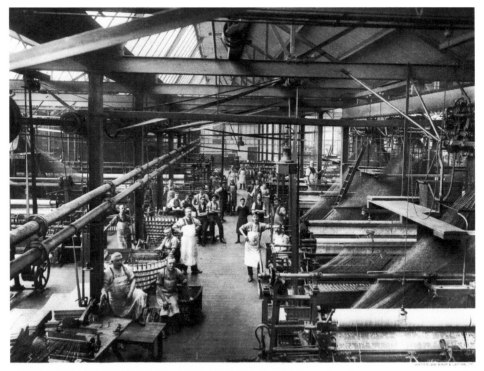

Interior Talbot Lace Curtain Factory.

Figure 4.3

Twist hands, Talbot Lace Curtain Factory of
Thomas Adams Ltd. on Nottingham Road, 1914.
Photograph by Waterlow Bros. and Layton
Ltd. for Nottingham City Council. Photo credit:
© PictureNottingham.

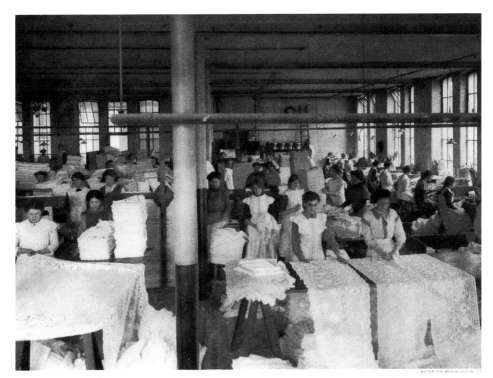

Finishing Department.

Figure 4.4

Lace finishers, Talbot Lace Curtain Factory of
Thomas Adams Ltd. on Nottingham Road, 1914.
Photograph by Waterlow Bros. and Layton
Ltd. for Nottingham City Council. Photo credit:
© PictureNottingham.

in Britain, rife with tuberculosis and other communicable diseases. Many lace workers ruined their eyesight at an early age. At the height of the industry, just before World War I, entire families, ranging from grandparents to very small children, were involved in "finishing" what was otherwise considered to be an industrially mass-produced commodity. Despite all of this extensive handwork conducted by various kinds of workers in diverse kinds of settings and situations, Nottingham lace "became the by-word for machine-made lace," and the industry was promoted as a masculine one dominated by "male merchants, machine owners, twist hands, and designers."[36]

Twentieth-century world wars altered this seemingly rigid division of labor, as women were mobilized to fill in for men who were fighting or never returned. Yet, thanks to entrenched attitudes among the manufacturers or even the union officials who sought to "protect" "men's" jobs while they were in the military, war did not fundamentally change women's opportunities for advancement in the industry. Changes in fashion following World War I reduced demand for lace, and the Nottingham lace industry entered a period of steady decline.[37] Many firms concentrated on household furnishings such as curtains and tablecloths. In an advertisement in *The Nottingham Journal* on January 3, 1939, Dobsons and M. Browne & Co. could still describe themselves as "the largest manufacturers of lace window furnishings in the world" (figure 4.5). By the time the company produced the Battle of Britain lace panels several years later, the heavy restrictions placed on the industry overall during the war due to shortages of material and labor had reduced the output of domestic and all fashion products in favor of mosquito, sand fly, and camouflage nets. The hands that held the needle were often female, but their labor in producing the commemorative panels was largely hidden.

Lace Goes to War: Camouflage Netting

Whereas discrete or decoy objects became simply *other* objects of a visual field, the netting worked by actually occluding the field itself . . . Netting was a veil that made it impossible to detect precise shape and texture – both in real time (by either aerial observer or cameraman) and in interpreted time (by the photographic analyst of periodized surveillance images).

–Hanna Rose Shell, *Hide and Seek*[38]

In August 1943, C. B. J. Molitor, an executive at the North American Lace Company in Philadelphia, wrote an indignant letter to the editors of the *New York Times*. In an editorial on essential war work published in the paper several days earlier, the editors had dismissed a manufacturer with the words "He had better not make lace in time of war."[39] Molitor objected to this demeaning comment, declaring that "lace has truly gone to war" and has become "a most important article in the war effort."[40] Pointing out that lace manufacturers in the United States were working "sixteen hours a day" to respond to the government demand for camouflage netting, Molitor observed that the women of the country would have to forgo more "ephemeral" products so that every "tank, jeep,

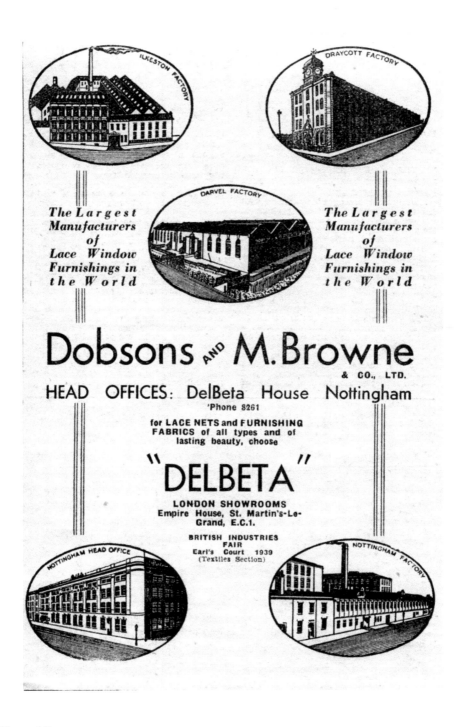

Figure 4.5

Dobsons and M. Browne & Co., "The Largest
Manufacturers of Lace Window Furnishings in
the World." Advertisement, *Nottingham Journal*,
January 3, 1939 (photo by the author).

truck, and mobile gun" could "sport new garb"–camouflage netting produced by lace manufacturers.[41] The editors replied that the US War Manpower Commission listed the "manufacture of brocades, damasks, chiffons, velvets, laces and similar fancy fabrics" as "non-essential," ending with the lukewarm concession: "We presume, however, that lace ceases to be 'fancy' when it is made for use in camouflage nets."[42]

In fact, earlier that very year, the *New York Times* had reported that lace factories in the United States would be shut down for the duration of the war unless they converted their equipment to produce "sandfly, mosquito, and camouflage nets."[43] Eager to make it clear that they were avidly doing their part in the war effort, textile companies sought coverage in magazine and newspaper articles and even published brochures and promotional materials. The Pepperell Manufacturing Company, which employed more than 8,500 people in factories in New England and the deep South, produced a lavishly illustrated book titled *People of Peace at War* that asserted that although textiles "do not have the immediate romance which attends the making of a new plane," industrially produced fabrics "are as important as guns, range finders, or aluminum."[44] Among the many textile products that Pepperell made for the US Armed Forces was mosquito netting (referred to as "Insect Cloth") for the Pacific war theater. In the United Kingdom, by 1941, the major textile factories were under "constant commission" to "produce vast quantities" of netting.[45] In 1943, the *Manchester Guardian* reported that the "Nottingham lace curtain industry ... has already converted something like two-thirds of its entire equipment" to the production of camouflage nets.[46]

The netting produced by lace manufacturers was integral to a particular kind of camouflage that was especially effective in the era of mid-twentieth-century airpower.[47] Camouflage is based on the phenomenon of "visual subterfuge" found in nature, as when animals change color to resemble their surroundings or when they construct hiding places out of available materials.[48] The emergence of aerial warfare during World War I rendered many standard practices obsolete. Regiments could no longer assume that they could remain undetected in a rearguard area, and sensitive installations could be spotted easily from the air. All of the militaries involved in World War I soon learned to camouflage their weapons and personnel whenever possible. The French army established the first *section de camouflage* in 1915 under the direction of artist Lucien-Victor Guirand de Scevola, while the British created their camouflage section in 1916 under the command of Lieutenant Colonel Francis Wyatt (who was not an artist but who was assisted by the painter Solomon J. Solomon). The American Camouflage Corps, established in 1917 and directed by artist Homer Saint-Gaudens, did not reach Europe until early 1918, only several months before the end of the war. In just a few short years, military camouflage became an established practice.

The first attempts at camouflage were executed by painting solid objects either in "dazzle" patterns to confuse perception or in colors resembling the landscape. But the artists and engineers involved in camouflage units soon found that the reflection of light

Figure 4.6

Gunners of the Royal Garrison Artillery under
camouflage netting, near Arras, April 2, 1918.
Photograph by Second Lieutenant David McLellan.
Photo credit: © IWM Q 8657.

and the disturbance of movement called for more texture and complexity in order to avoid telltale shadows and other giveaways. Netting garnished with painted cloth strips or pieces of local flora proved to be highly effective in hiding even large areas from aerial detection. As Solomon wrote in his postwar publication *Strategic Camouflage*, "By stretching the netting taut over any object, like a gun, or a whole battery, and threading it more and more thinly toward the edges with material such as grass, or rags of canvas, only a negligible shadow would be cast on the ground."[49] Thanks to such techniques and materials, camouflage began to obsess many military minds, and by World War II, it had achieved what one historian has referred to as a "monumental scale."[50]

Zoologist Hugh Cott in his *Adaptive Coloration in Animals*, published in 1940, explained the basic principle of camouflage through the prosaic example of a net curtain that screens the interior of a room from inquisitive passersby: "details in the room beyond are openly exposed to view—although they cannot be seen clearly."[51] This interplay in netting between seen and unseen, presence and absence, is part of what made it so effective for camouflage in the era of early airpower. Not only could it be easily altered, but it also offered an inherently dynamic texture: unreflective, adaptable, and mobile. In his 1942 manual *Modern Camouflage*, Robert Breckenridge advised that camouflage netting should never be looked at as a "solid opaque screen"; rather, the "openings in the net are as important as the opaque areas."[52] Thus, netting lent itself admirably to the military's aim to "conceal the fact that they were concealing," and it was utilized by the Germans as well as their allied adversaries.[53] Armies became experts in "textual subterfuge," as Hanna Rose Shell has put it, producing the "visual illusion of absence" through a "constant state of transformation."[54] This was accomplished by garnishing the nets, usually with raffia, scrim, and canvas scraps inserted by female workers on the home front and augmented on site by soldiers with local materials to lend credibility.

Most histories of camouflage emphasize the role of artists, primarily male, who played a significant role in the theorization and production of military camouflage. The striking visual forms of painted camouflage in the era of World War I have drawn comparisons to the art movement of cubism, giving rise to the frequent quotation attributed to Pablo Picasso: "*C'est nous qui avons fait ça!*" (We did it first!).[55] This has led to the conclusion that camouflage was almost inevitable, attracting legions of young male modernist painters and set designers to the task of creating deceptive masterpieces. In fact, most of the early camoufleurs were not cubists, but they did draw on cubist methods, breaking contours, placing shapes in a variety of relationships to each other, displacing or changing tones, shifting perception.[56] In his study of the influence of art movements on camouflage, Roy Behrens argues that along with cubism, nineteenth-century impressionism, especially pointillism, must also be seen as an influence on the first camoufleurs.[57]

Caren Kaplan

Figure 4.7

Camouflage net garnishing by Women in the
Voluntary Services (WVS) (Mrs. Walters and
Mrs. James), c. World War II. Ministry of Information
official photographer. Photo credit: © IWM D 17196.

By World War II, camouflage had developed into a sophisticated enterprise that drew on the expertise of stage designers, lighting experts, and sound technicians as well as artists. Camouflage had become a subject taught in art schools such as Pratt Institute in New York City, which started an interdisciplinary lab on the topic in their School of Architecture, or through military camouflage sections such as the ones organized by the Royal Engineers in Kensington or the US Army unit at Fort Belvoir in Virginia.[58] In Britain in 1942, more than eighty camouflage officers and technical assistants (with many artists among them) were at work in the Design Division at the Ministry of Home Security's Camouflage Establishment, and there were other such units at the Ministry of Aircraft and the armed services.[59]

Given that camouflage aimed to deceive reconnaissance and attack aircraft through manipulating perception and generating illusion, it should be of no surprise that surrealists were also drawn into the enterprise. As Ann Elias notes, the "central aesthetic and psychological predilections of Surrealism–doubling, displacement, and metamorphosis" were reflected in "camouflage tactics" from their earliest iterations.[60] By the advent of World War II, surrealist artist Roland Penrose wrote a well-regarded manual on camouflage for the British Home Guard and gave lectures all over Britain on camouflage and civil defense. The section on "nets" in the chapter on "Materials and Equipment" in Penrose's manual gives careful instruction on how to garnish netting and includes illustrations for garnishing helmets. For basic garnishing, Penrose advised British civilians to purchase "two yards of ordinary curtain netting" and to dye it in "yellowish greens and browns."[61] We can well imagine that entire families in Britain–men, women, and children–studied Penrose's manual and other sources of instruction and became ad hoc civil camoufleurs in order to protect their homes, businesses, and persons from aerial attack.

We might consider the apotheosis of camouflage netting to be the so-called flat-top variety–perhaps epitomized by the camouflaging of the Lockheed Vega aircraft plant in Burbank, California, during World War II. The enormous factory was covered by "a giant canopy of chicken wire, scrim netting, and painted canvas," all "supported by a scaffolding of posts and cables," with roads painted coming and going along with canvas houses with wash lines, trees, and shrubbery.[62] Fake cars were moved in and out of the scene and wash was hung and removed at regular intervals to simulate a real town. All of this work was conceived and executed by artists, designers, painters, and builders attached to the military (and who drew upon the expertise they gained to help build Disneyland a few years after the end of the war).[63] As Seymour Reit has pointed out, exact replication was not needed: "The aim of such concealment wasn't to hide a target perfectly, but simply to baffle and disorient an enemy flier for a few critical moments."[64] Similar efforts, ranging from the camouflaging of single buildings to airfields to waterways and roads and entire districts, were attempted in every major industrialized country touched by the war.[65] Enormous amounts of netting, fiber for

INDUSTRIAL CAMOUFLAGE

THE ART SCHOOL
PRATT INSTITUTE

CAMOUFLAGE LABORATORY
DEPT. OF ARCHITECTURE

GARNISHING THE NET

Garnished nets are used for military as well as industrial installations. Experiments with flat-tops provide indispensable experience in color and pattern imitation. Screening of large roofs is a multiple application of the single net, but built for longer duration and greater steadiness. Fishnet, easily folded and portable, is principally used for mobile situations. These nets need much adjustment in changing weather, because they shrink when they get wet and expand as they dry out. Therefore, more stable nets are used for large installations: chickenwire, galvanized wire net, welded reinforcing nets, expanded metal, stucco binder mesh, and even steel grating. The photograph shows fish nets garnished with garlands - strips of cloth or osnaburg woven in and knotted in varying densities, with the ends hanging to increase the effect of depth.

72

Figure 4.8

"Garnishing the Net," *Industrial Camouflage Manual*, Pratt Institute, 1942 (photo by the author).

small leaves and twigs can be stuffed inside them so as to break up the characteristic shape of the helmet. If a larger mesh is used it should be easy to insert small leaves, grass or tufts of scrim or painted sacking. Certainly it would be in-

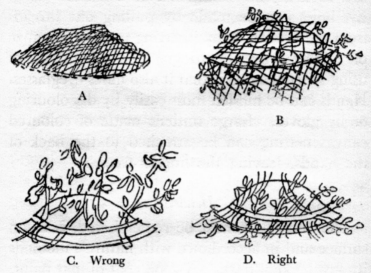

FIG. 33.—Methods of camouflaging Helmets.

A. Small mesh net stuffed with garnish underneath.
B. Net garnished with leaves or scrim.
C. and D. Branches and grass held on by band fixed to helmet.

advisable to add more garnish than is strictly necessary. It should never be allowed to form plumes, towering above the head which may give their wearer away by movement. Whatever garnish is used must be suitable to the immediate surroundings. The purpose in view is merely

Figure 4.9

"Methods of Camouflaging Helmets," Roland Penrose, *Home Guard Manual of Camouflage*, 1941 (photo by the author).

garnishing, and workers to accomplish the garnishing and other effects were required for these extraordinary efforts.

It is clear that camouflage was designed and theorized primarily by men, many of them in the arts—either painters or photographers or designers who were deliberately mobilized for this work. Although the US Women's Reserve Camouflage Corps, sponsored by the National League for Women's Service, trained women to design and test camouflage during World War I, they remained stateside and were treated by the press as oddities or dismissed as mere seamstresses.[66] Women appear in the history of camouflage primarily as garnishers, work that followed pattern designs that were preconceived by predominantly male "experts." It is also possible that women in the lace factories were producing much of the netting used as a base for this form of camouflage, but a search for information on the female net makers or garnishers yields very little. There are images of women garnishing nets in the collection of the British Imperial War Museum. The noted British war artist Evelyn Dunbar produced a painting titled *Convalescent Nurses Making Camouflage Nets* in 1941.[67] In 1942, Dorothea Lange was hired by the US War Relocation Authority to document the removal of US citizens of Japanese descent from their homes to distant camps.[68] One series of photographs that she made at Manzanar in the California desert includes images of Japanese American women garnishing camouflage nets. According to a US National Parks Service website, more than five hundred Japanese Americans "wove camouflage nets for the US Army," producing "an average 6,000 nets a month" until the net factory was closed after the Manzanar Riot in December 1942.[69] These images provide tantalizing hints of women's participation in camouflage fabrication and suggest links to work in lace factories.[70] We must conclude that the gaps in the fabric of this history are as important as the scant information that is available to the contemporary researcher.

War Work: Fabricating Everyday Militarism

A major stumbling block on the road to ongoing militarization—between and within states—could take the form of feminist curiosity.

—Cynthia Enloe, *Maneuvers*[71]

When I walked into the Museum of Fine Arts on a blustery day some years ago, I was working on a book on aerial images and modern warfare. I was immersed in scholarship on the history of photography, the emergence of military camouflage, and shifts in the perception of the visible. Although I enjoyed working with fiber and textiles as hobbies, I never connected these materials to the subject of my research. The Battle of Britain lace panel was stretched in front of me, lit dramatically, calling out for me to pay attention to this example of the fabric of war. I saw the lace panel, but I did not "see"—I missed the opportunity to understand the connections between the history of

Figure 4.10

Evelyn Dunbar, *Convalescent Nurses Making
Camouflage Nets*, oil on canvas, 1941. Photo credit:
© IWM ART LD 11664.

Caren Kaplan

Figure 4.11

Dorothea Lange, *Making Camouflage Nets for the War Department*, Manzanar Relocation Center, July 1, 1942. Photo credit: US National Archives 538116.

industrialization, gendered divisions of labor, and the dynamics of militarism in everyday life. This chapter marks my first effort to see what might be hidden in plain sight in the history of fabrication, textiles, and women's labor.

In the English language, the word "fabric" derives from the Latin *fabrica* ("something skillfully produced") or *fabricare* ("to make, construct, fashion, build"). Etymological sources note that the word first signified a building and later a machine, moving on to indicate "something made," that is, fabricated.[72] By the late eighteenth century, the meaning in English also became pointed specifically to "textile, woven, or felted cloth." The word "fabrication" also connotes falseness—fabricating a tissue of lies. Thus, thinking about war through fabric requires a sense of warfare as historically constructed, relational or connecting, and conditional, as shaping or manipulating meaning or our sense of reality. We may also expand our sense of war to include many forms of political and social violence, not just the conventional, declared warfare between nation-states.

Fabrication is at the heart of the troubled relations between industrial infrastructures and militarism, particularly in terms of everyday ways of making things and living lives. In this light, we can note that lace making has been the subject of discussion in critiques of capitalism from the eruption of the Luddite rebellions in the early nineteenth century to Engels's discussion of lace makers and Marx's highlighting of lace making in the exploitation of women and children to Maria Mies's classic Marxist feminist analysis of the female lace makers of Narsapur, India.[73] Less attention has been paid to the way that the debates about the role of machinery in relation to human labor in the industrialization of lace making are also integral to the relations between the military and militarism. Minoo Moallem's work on war carpets from the Afghanistan/Pakistan border zone and cycles of occupation and warfare in the context of empire and feminized labor reminds us that the "violence of war" and the "pleasures of consumption" are intrinsic to global trade.[74] Returning to Bryan-Wilson's argument that textiles are "in the fray"—that is, they instigate and mediate relationships across scales, spaces, and temporalities—we might open our minds to consider how folding war into fabric and vice versa disturbs our historical and analytical frameworks.

The Battle of Britain lace panels created by a venerable Nottingham lace manufacturing house offer a visual narrative account that is crammed with symbols, images, and text all looped together through interstitial netting. There is so much to "see" and to understand, and the impact of the scale of the project is such that it is easy to forget that there is just as much, if not more, that is not visible or perceptible. Like all lacework, illusion is a key dynamic in operation in these commemorative panels. Of the scant information available about the production of the panels, we know that the designer, draughtsman, and primary producers were male. We do not know how many other people worked on the pieces, helping to operate the machinery or clean and finish the work. We also do not know how most of these people felt about the choice of images and icons that were included or their own experiences during the war. When the panels

were displayed in department stores or presented in ceremonies to officials in Britain or locations around the Commonwealth, how were they received? Closely related to the curtains and tablecloths that still adorned many households—although falling out of style—did the lace panels signal pride in a national industry, instill wonder over craftsmanship, or serve as curios . . . a method of fabrication somewhat out of place?

In focusing on a peculiar example that oscillates between the everyday and the extraordinary, I am trying to make a number of claims, tying knots between loose loops, if you will. I am interested in exploring the matter of fabrication in modernity—its modes of production and divisions of labor, certainly, but also the cultural products it creates, its dispositional force. Given the fundamentally structuring aspect of warfare and uneven power relations in modernity, there is no way to understand fabrication without war and vice versa. But that said, it is also crucial to avoid reifying and reproducing exhausted tropes and antinomies that mystify both warfare and industry. Focusing on the everyday, the unspectacular, the banal, and the unlikely elements that nevertheless braid themselves into a culture dedicated to the pursuit of empire through violence opens feminist analysis to a critical practice of curiosity and surprise as well as dissent.

Notes

1. Alfred Vagts, *A History of Militarism: Romance and Realities of a Profession* (New York: Norton, 1937), 11.

2. Carol Quarini, "Unravelling the Battle of Britain Lace Panel," *Textile: The Journal of Cloth and Culture* 18, no. 1 (2020): 24–38. See also https://carolquarini.com/battle-of-britain/.

3. Quarini, "Unravelling the Battle of Britain Lace Panel," 32.

4. There is a significant body of work on war textiles as records or commemorations of violent events or experiences. Often produced by survivors in war zones or refugees, these works are usually crafted by women. See Minoo Moallem, "The Intangible Stories of War Carpets: War, Media, and Mediation," in *Feminist Approaches to Media Theory and Research*, eds. Dustin Harp, Jaime Loke, and Ingrid Bachman (London: Palgrave, 2018); Marjorie Agosín, *Tapestries of Hope, Threads of Love: The Arpillera Movement in Chile* (Lanham, MD: Rowman and Littlefield, 2008); Ariel Zeitlin Cooke and Marsha MacDowell, *Weavings of War: Fabrics of Memory: An Exhibition Catalogue* (East Lansing, MI: Michigan State University Museum, 2005); Deborah A. Deacon and Paula E. Calvin, *War Imagery in Women's Textiles: An International Study of Weaving, Knitting, Sewing, Quilting, Rug Making and Other Fabric Arts* (Jefferson, NC: McFarland, 2014); Linda Gerdner, *Hmong Story Cloths: Preserving Historical and Cultural Treasures* (Atglen, PA: Schiffer, 2015); and Enrico Mascelloni, *War Rugs: The Nightmare of Modernism* (Milan: Skira, 2009). Wendy Wiertz at the University of Huddersfield is engaged in research on the Belgian "war lace" produced just after World War I. See her book, *War Lace* (Antwerp: Phoebus Foundation, 2022), and post at the "By the Poor, For the Rich: Lace in Context" blog, https://laceincontext.com/war-lace/.

5. I discuss this in relation to current events in "Everyday Militarisms: Drones and the Blurring of the Civilian-Military Divide during COVID-19," in *Drone Aesthetics: War, Culture, Ecology*, eds. Michael Richardson and Beryl Pong (London: Open Humanities Press, forthcoming).

6. Steven Flusty, Jason Dittmer, Emily Gilbert, and Merje Kuus, "Interventions in Banal Neoimperialism," *Political Geography* 27, no. 6 (August 2008): 617–618.

7. Pierre Bélanger and Alexander S. Arroyo, *Ecologies of Power: Countermapping the Logistical Landscapes and Military Geographies of the US Department of Defense* (Cambridge, MA: MIT Press, 2016), 17.

8. Bélanger and Arroyo, *Ecologies of Power*, 16.

9. Bélanger and Arroyo, *Ecologies of Power*, 17.

10. Caren Kaplan, Gabi Kirk, and Tess Lea, "Everyday Militarisms: Hidden in Plain Sight/Site," *Society and Space Forum*, March 8, 2020, https://www.societyandspace.org/articles/editors-letter-everyday-militarisms-hidden-in-plain-sight-site.

11. Jennifer Harris, "Blurring Boundaries: Textiles and Everyday Life," *Embroidery*, August 2020, 53.

12. Moallem, *"Intangible Stories,"* 259.

13. Olga Boichak, "Camouflage Aesthetics: Militarisation, Craftivism, and the In/Visibility of Resistance at Scale," *Contemporary Voices: St. Andrews Journal of International Relations* 3, no. 1 (2022): 6.

14. Boichak, "Camouflage Aesthetics," 2.

15. Dana Sonnenschein, "A History of Lace; The Great Chain of Being," *Feminist Studies* 46, no. 2 (2020): 498.

16. Lois Martin, "Webs of Wrath: Terrible Textiles from the War on Troy," *Textile: The Journal of Cloth and Culture* 1, no. 3 (November 2003): 245.

17. Martin, "Webs of Wrath," 245.

18. Rozsika Parker, *The Subversive Stitch: Embroidery and the Making of the Feminine* (London: Women's Press, 1984), 6.

19. Julia Bryan-Wilson, *Fray: Art and Textile Politics* (Chicago: University of Chicago Press, 2017), 1.

20. Bryan-Wilson, *Fray*, 4.

21. Bryan-Wilson, *Fray*, 29.

22. Bryan-Wilson, *Fray*, 34.

23. Bryan-Wilson, *Fray*, 35.

24. Rozsika Parker relates that although the panoramic embroidered linen panel known as the "Bayeux Tapestry" (which depicts events leading up to and including the Battle of Hastings) was certainly a commissioned "workshop production," from the nineteenth century onward, it was stubbornly attributed to Queen Matilda as an example of individual handiwork and wifely devotion. Fine handwork was a preferred occupation for females across classes but especially viewed as an approved leisure activity for middle-class and wealthy girls and women in industrializing nations. Parker, *The Subversive Stitch*, 26–27.

25. Glenn Adamson, *The Invention of Craft* (London: Bloomsbury, 2013), xiii.

26. Adamson, *The Invention of Craft*, xiii.

27. See the discussion of the emergence of skilled craftsmanship in lace manufacturing in Tom Fisher and Julie Botticello, "Machine-Made Lace, the Spaces of Skilled Practices and the Paradoxes of Contemporary Craft Production," *Cultural Geographies* 25, no. 1 (2018): 49–69.

28. Pamela Sharpe, "Lace and Place: Women's Business in Occupational Communities in England 1550–1950," *Women's History Review* 19, no. 2 (2010): 287, 291.

29. Sheila Mason, "The Machine-Made Lace Industry of Nottingham," in *Lace Here Now*, eds. Amanda Briggs-Goode and Deborah Dean (London: Black Dog, 2013), 14–16.

30. Gail Baxter, "Hidden Hands and Missing Persons," *Textile: The Journal of Cloth and Culture* 18, no. 1 (2020): 41.

31. Baxter, "Hidden Hands," 41.

32. William Felkin, *A History of the Machine-Wrought Hosiery and Lace Manufactures* (Cambridge: W. Metcalfe, 1867), 231.

33. Felkin, *A History*, 235.

34. E. J. Hobsbawm, *Labouring Men: Studies in the History of Labour* (Garden City, NY: Anchor Books, 1967), 9; E. P. Thompson, *The Making of the English Working Class* (New York: Vantage Books, 1966), 891–892; Kirkpatrick Sale, "The Achievements of 'General Ludd': A Brief History of the Luddites," *The Ecologist* 29, no. 5 (September 1999): 310–313.

35. Pamela Sharpe cites Maxime Berg's research to note that "lace was second only to wool in the number of women it employed in the early industrial period." Sharpe, "Lace and Place," 301; Maxime Berg, *The Age of Manufactures, 1700–1820* (London: Fontana, 1985), 137.

36. Baxter, "Hidden Hands," 50.

37. Geoffrey Oldfield, "The Nottingham Lace Market," *Textile History* 15, no. 2 (January 1, 1984): 207.

38. Hanna Rose Shell, *Hide and Seek: Camouflage, Photography, and the Media of Reconnaissance* (New York: Zone Books, 2012), 120.

39. "How To Be Essential," *New York Times*, August 23, 1943, 14.

40. C. B. J. Molitor, "Lace Has Gone to War," *New York Times*, August 27, 1943, 16.

41. Molitor, "Lace Has Gone to War," 16.

42. Editorial comment in Molitor, "Lace Has Gone to War," 16.

43. "Lace Men Warned to Convert Mills," *New York Times*, January 9, 1943, 19.

44. Pepperell Manufacturing Company, *People of Peace at War* (Boston: Pepperell Manufacturing Company, 1943), 35.

45. Henrietta Goodden, *Camouflage and Art: Design for Deception in World War 2* (London: Unicorn Press, 2007), 99.

46. "US Camouflage Nets," *Manchester Guardian*, August 18, 1943, 2.

47. See my book *Aerial Aftermaths: Wartime from Above* (Durham, NC: Duke University Press, 2018) for an extensive discussion of relevant modes of perception and technologies of observation. See also Beaumont Newhall, *Airborne Camera: The World from the Air and Outer Space*

(New York: Hastings House, 1969), and Marc Dorrian and Frederic Pousin, eds., *Seeing from Above: The Aerial View in Visual Culture* (London: I. B. Taurus, 2013).

48. Jonathan Miller, "Visual Subterfuge in the Natural World," in *Camouflage*, ed. Tim Newark (London: Thames and Hudson, 2007), 12.

49. Solomon J. Solomon, *Strategic Camouflage* (London: John Murray, 1920), 58.

50. Newark, *Camouflage*, 108.

51. Hugh B. Cott, *Adaptive Coloration in Animals* (Oxford: Oxford University Press, 1940), 51, cited in Isla Forsyth, *Second World War British Military Camouflage: Designing Deception* (London: Bloomsbury, 2017), 60.

52. Robert P. Breckenridge, *Modern Camouflage: The New Science of Protective Concealment* (New York: Farrar and Rhinehart, 1942), 153.

53. Guy Hartcup, *Camouflage: A History of Concealment and Deception in War* (New York: Scribner's, 1980), 7.

54. Shell, *Hide and Seek*, 123, 109, 121.

55. Newark, *Camouflage*, 72.

56. Roy R. Behrens, *False Colors: Art, Design and Modern Camouflage* (Dysart, IA: Bobolink Books, 2002), 69.

57. Behrens, *False Colors*, 74.

58. Konrad F. Wittmann and Pratt Institute, *Industrial Camouflage Manual* (New York: Reinhold, 1942); John R. Blakinger, "Camouflage, 1942: Artists, Architects, and Designers at Fort Belvoir, Virginia," in *Conflict, Identity, and Protest in American Art*, eds. Miguel de Baca and Makeda Best (Newcastle upon Tyne, UK: Cambridge Scholars, 2015), 35–56.

59. Brian Foss, *War Paint: Art, War, State and Identity in Britain, 1939–1945* (New Haven, CT: Yale University Press, 2007), 16.

60. Ann Elias, "Camouflage and Surrealism," *War, Literature and the Arts* 24 (2012): 2.

61. Roland Penrose, *Home Guard Manual of Camouflage* (London: George Routledge, 1941), 84.

62. Seymour Reit, *Masquerade: The Amazing Camouflage Deceptions of World War II* (New York: Hawthorn Books, 1978), 88.

63. Reit, *Masquerade*, 88.

64. Reit, *Masquerade*, 82.

65. There were many such examples, including the Potez Aircraft factory in occupied France and the Rocklea munitions plant near Brisbane, Australia. See Roy M. Stanley II, *To Fool a Glass Eye: Camouflage versus Photoreconnaissance* (Washington, DC: Smithsonian Institution Press, 1998), 149.

66. Behrens, *False Colors*, 65.

67. Gill Clarke, *Evelyn Dunbar: War and Country* (Bristol, UK: Sansome, 2006), 105–106, 108.

68. For discussion of Lange's government photography at Manzanar, see Thy Phu, "The Spaces of Human Confinement: Manzanar Photography and Landscape Ideology," *Journal of Asian*

American Studies 11, no. 3 (2008): 337–371; Linda Gordon, "Internment without Charges: Dorothea Lange and the Censored Images of Japanese American Internment," *Asia Pacific Journal* 4, no. 1 (2006): 1–10; and Carol B. Conrad, "Unshuttered Lens: Dorothea Lange, Documentary Photography, and Government Work, 1935–1945," *Teaching History* 33, no. 1 (2008): 33–43.

69. "Camouflage Net Factory at Manzanar," https://www.nps.gov/places/camouflage-net-factory -at-manzanar.htm, accessed November 14, 2021.

70. I learned recently about collaborative community camouflage netting production taking place in Ukraine. Since industrially produced camouflage netting is extremely expensive and apparently less effective because it is too "regular" in its patterning, "homemade" camouflage nets are in high demand especially after the Russian invasion that began in March 2022 (although such projects began as far back as 2014). The netters and garnishers are primarily female. See Boichak, "Camouflage Aesthetics," and Lesia Kulchynska, "Violence Is an Image: Weaponization of the Visuality during the War in Ukraine," *Tactical Media Room—Institute of Network Cultures*, October 26, 2022, https://networkcultures.org/tactical-media-room/2022/10/26/violence-is-an-image-wea ponization-of-the-visuality-during-the-war-in-ukraine-2/.

71. Cynthia Enloe, *Maneuvers: The International Politics of Militarizing Women's Lives* (Berkeley: University of California Press, 2000), 300.

72. "Fabric," https://www.etymonline.com/word/fabric, accessed November 14, 2021.

73. Frederic Engels, *The Condition of the Working Class in England* (London, Sonnenschein, 1892), 190–193; Karl Marx, *Capital: Vol. I* (Moscow: Progress Publishers, 1954), 466; and Maria Mies, "Dynamics of Sexual Division of Labour and Capital Accumulation: Women Lace Workers of Narsapur," *Economic and Political Weekly* 16, no. 10/12 (1981): 487–500.

74. Moallem, "Intangible Stories," 266.

5
Area Panic: Histories of "Running Amok"

Joseph Vogl

The following remarks will discuss the history of an affliction. It not only stretches from the early modern to the modern era and thus cuts across several centuries, but also traverses several continents and bears witness to an extensive geographic journey. It concerns a temporal and spatial migration, and one of those significant movements in which the gateways of the European colonial powers are duplicated into remarkable countermovements, surprising re-imports from the edges of the world. Since the sixteenth century, these imports consist of all kinds of not only wealth but also contact goods, in which something is transported that one might call a cultural revenanthood.

An episode of this affliction has an Eastern flavor. It pertains to a notorious opium eater, originates from the first half of the nineteenth century, and goes roughly as follows. After Thomas de Quincey had dropped out of Oxford and wandered through various regions of the United Kingdom, he settled down in the remote mountainous area of the Lake District, forty miles away from the west coast of England. In his *Confessions of an English Opium-Eater* from 1821, de Quincey recounts an unexpected and puzzling encounter that falls between productive readings of Kant and blissful opium highs and which dates back to the year 1816. He recounts: "One day a Malay knocked at my door. What business a Malay could have to transact amongst English mountains I cannot conjecture."[1] This is how the erratic Malay stands there, in the text and in the mountains of Westmorland: turban and loose trousers, golden-brown and fierce face, thin lips and restless, wild eyes. Of course, there is no genuine understanding. De Quincey attempts by reciting several lines from the *Iliad* in the Greek original, the Malay answers, apparently in Malay, and after the stranger had lain around on the floor for a whole hour, de Quincey brings an end to the confusion and gifts him a piece of opium that would have been enough "to kill three dragoons and their horses."[2] The Malay swallows the dose in one gulp, disappears, and is never seen again.

Whoever the enigmatic Malay may have been, he occupies a precarious position in Thomas de Quincey's autobiographical narrative. One the one hand, he leads us from the "pleasures" to the "pains" of opium in the text and becomes the cipher for uncomfortable hallucinations and bad associations. "The Malay has been a fearful enemy for months," writes de Quincey. "I have been every night, through his means, transported into Asiatic scenes." The "horror" of a South Asian region presents itself here, a

combination of "Oriental names or images" and an "*officina gentium*," an experimental laboratory of humanity itself. And still more: de Quincey is haunted by a sort of nautical overpowering, the glistening surfaces of the mountain lakes transform into oceans, the sensory organs themselves are flooded and result in a "dropsical state or tendency of the brain" populated with the horror of reptiles, amphibians, and crocodiles.[3]

On the other hand, the Malay horror, along with its associated nightmares, is very quickly brought to a concise but unfamiliar term. The Malay, so it goes, becomes the obsessive topic of fantasies and dreams, in which he "brought other Malays with him, worse than himself, that ran 'a-muck' at me, and led me into a world of troubles." And de Quincey does not neglect to provide the foreign word "a-muck" readily with a learned footnote that reads as follows: "a-muck": "See the common accounts in any Eastern traveller or voyager of the frantic excesses committed by Malays who have taken opium, or are reduced to desperation by ill-luck at gambling."[4]

De Quincey's confessions are among the first texts that not only import the use of "amok" into European literature but also relocate the setting of bizarre South Asian dramas to a European motherland. Much more so, they negotiate a transfer, in which the Malay along with a figure of fear, which is identified under the title "amok," encounters an occidental state of mind between waking and dreaming.[5] De Quincey's famous text leaves no doubt: what is now associated with the expression "amok" has the character of an efficient cultural fantasy. It is imported from an East Indian distance, fueled by reports and travelogues, and can then begin, in the nineteenth century, its unique development as a term and phenomenon in the West. Which specific affliction is addressed here? Which observations and encounters are solidified in the word "amok," which is tantamount to "rage" or "fury" in Malay? Which cultural contact products are thereby introduced to Europe? Or posed more simply: What have the European travelers, voyagers, and colonial civil servants been talking about since the sixteenth century when they speak of the "frantic excesses committed by Malays"?

In three different settings, one can demonstrate how a figure of fear takes shape with the Europeans' contact with the Indo-Malay Archipelago that, undergoing various transformations, finds a place in the center of Western societies. Since the early modern era, European travelers have told accounts of "amucos," that is to say, "madmen," in southern India, on the Malay peninsula, on Java, or on other islands of the Archipelago—madmen who suddenly grabbed for their weapons, broke into a murderous frenzy, killed indiscriminately, themselves perished in the process, or, starting in the nineteenth century, ended up in psychiatric institutions. These accounts have been documented since the beginning of the sixteenth century, peaking around 1900 and receding since the 1920s, before finally—like "amok" itself—almost completely disappearing from these geographic regions. Only after World War II does "amok" become a cipher for disturbing acts of violence in Western societies: to the title of pseudo-military attacks that are committed in schools and universities, in supermarkets, in corporate offices or public

Figure 5.1
Engraved map of parts of the East Indies and
Southeast Asia, in John Crawford, *A Descriptive
Dictionary of the Indian Islands and Adjacent
Countries*, London, 1856.

buildings and can always count on heightened attention. What one now calls "running amok" (also as a medical term) cannot be separated from a geographic and historical journey. Still today, the enigmatic figure of the mass shooter who "runs amok" combines the message of exotic acts of violence with the stature of the dangerous individual. Here, one can recognize a specific social figure whose decryption demands a look at the historical and cultural transformations, and hence a look into the history of the modern knowledge of danger.

The early travelogues from the sixteenth century—and this is the first setting—initially describe "amok" in Southeast Asia as ritualized military conduct. They observe a very specific war and emphasize three aspects of it. First, one recognizes in "amok" an unfettered war commonly motivated by the death of a king or headman, in which the untamed violence of followers evidently breaks out just where the ruler is absent, where there is a vacuum of royal power. "Amok" indicates a temporal as well as physical dissolution of the boundaries of warlike action. Second, "amok" thereby includes not only the ritual practices of a warrior caste that commits itself to the coming battle with something like an oath; it not only designates a militant tactic, a suicidal attack in a dead-end situation. Rather, "amok" is also determined by an unrestrained enmity that knows no conditions for ceasing, that turns against all life, including warriors, men, women, and children in equal measure. Third, the warriors running amok ultimately consider themselves to be doomed, to lead an "abject" life that is outlawed and may be taken by anyone. According to one of the earliest reports from the middle of the sixteenth century, "these were more than 200, who all according to their custom shaved off all their hair, even to their eyebrows, and embraced each other and their friends and relations, as men about to suffer death. In this case they are as mad-men—known as *amoucos*—and count themselves as already among the dead."[6]

In multiple ways, the early narratives on the militant amok from southern India and the Malay Archipelago allege a transgressive figure and a moment of exception: a militant action that temporally and spatially dissolves the boundaries of war; an enmity that makes for an indiscriminate hostility and forgets the distinction between warriors and non-warriors; a group of privileged and chosen ones who stand in distinguished relation to the prestige of the king's role; finally, the signature of a precarious life, which acquires its political significance, its consecration, through the act of fundamental repudiation. If one considers all of these elements together, one comes to the following concise formula: The observation of "amok" was dictated by the symbolism of political power in the early modern era. "Amok" and its actors have become an ambiguous image, in which the figures of archaic warfare, the bestial and the holy, are superimposed, and with the declaration of an irregular war, an uninterrupted enmity persists. An outlying district opens up at the boundaries of the emerging territorial states in Europe, in which "amok" is established as a pointed version of lawlessness, of the absence of governance and suspended sovereignty—in short, of a collapsing statehood and an elementary

hostility to the state. If, in the political imagination of the modern era, the state form is characterized by the fact that it relocates and exports war and hostility to its periphery, one must indeed recognize the effect of a political abjection in the representation of the Indo-Malay amok—an excluded peacelessness in the form of a persisting and unbound war. A critical district arises here, a zone of anomie that eventually obtained the title "area panic."[7] This gives "amok" its first and unmistakable form.

However, three hundred years later, toward the end of the nineteenth century, a distinct change in "amok" became apparent—a second significant setting. With this, "amok" steps out of its warlike passe-partout and is privatized, individualized, and pathologized. One now deals with individual actors without the military or political context, with singular, episodic actions. One may presume the reasons lie in the emerging colonial bureaucracy, in the installation of state structures, in the introduction of a European justice system, and, not least, in the efficacy of a new medical knowledge, psychiatry, which is eager to justify itself by a concentration on particularly somber forms of social danger. But most importantly, the occurrence of "amok" hereby acquires a new character and transmits a modified image of violent actions. Forensic medicine since the nineteenth century thus produces a series of medical histories in which the image of what is now called "true amok" forms and assumes a concise form with the example of the hospitalized perpetrator. According to the reports from Malaysia and Java, the running amok of diverse perpetrators first begins with a depressive resentment—in Malay, *sakit hati*—an indeterminate brooding. This is followed, second, by a sudden episode—*mata gelap*—characterized by seeing red and blurred vision. Third, a frenzy ensues, an unfounded and indiscriminate killing, which commonly occurs with the usual Malay weapons, with sword and dagger, and whose victims are taken at random. And fourth, this episode concludes with amnesia, leaving behind a perpetrator who shows no further indication of insanity or illness. As described in an 1893 case in a Singapore institution:

> There is little to be said about him. He was a tall, spare man, about 40 years old... He rarely spoke unless addressed, but was perfectly rational and coherent in his answers... When spoken to about his Amok, he always became somewhat confused, and persisted in saying that he remembered absolutely nothing about it... Although he knows that any confession can now make no difference to his future, he still denies any recollection of the Amok, and says "As you state I committed these murders and murderous assaults, I suppose I did, but I remember nothing of it."[8]

"Running amok" thus transformed from a warlike ritual to a psychiatric episode, and what now presents itself in the eyes of the European observers is neither a crime nor simply a case of clinical insanity. Clearly, one is dealing with a social event, in which a past history of war, enmity, and threat both solidifies and transforms. This prompts the question: What place does "amok" now occupy in the modern knowledge of danger,

and which form of danger do Western societies recognize when they begin to import both the term and issue of "amok" at the end of the nineteenth century?

To begin with, much like the numerous cases of murder in the West, which nineteenth-century psychiatry deals with under the category "monomania" or "epilepsy," this later form of "amok" is characterized by the fact that it points out gaps in understanding and provokes a very specific type of non-knowledge. This includes that amok attacks usually occur without any previous indication, are committed without a motive from nondescript perpetrators with a choice of victims that is completely arbitrary, and culminate in a non-relation. Accordingly, one confirms that the rationale has remained weak and the investigation of the causes helpless. For this reason, running amok has been addressed again and again as a triggered event, as an act in which—somewhat similarly to explosions—minute inducements have disproportionately large effects and linear causal relations are circumvented. Second, psychiatrists and physiologists have likewise described the episodes of those running amok as nonpersonal occurrences, in which an individual perpetrator in Malaysia reacts in an approximate way that only a crowd of people would in the West. According to an ethno-psychiatric study from 1931, amok symptoms "also occur among us, the white cultural races, but not as they do with the Malay individual, . . . but rather in a group, in a crowd, . . . everywhere, where the individual gives way to the group. In the panic, one thus sees the crowd react in exactly the same way to an undefined, but intensive fear of death, as the person running amok in unrestrained flight, driven by wild fear, running down and stabbing whatever and whoever gets in his way."[9] If "amok" thereby provides a mirror for an emerging mass civilization, it also ultimately leaves behind moral, or rather legal, categories of indebtedness. Malay law did not prosecute those running amok as criminals; at best, they or their families were obliged to pay reparations to the victims—a kind of claim settlement. This repeats itself in the drama of running amok itself. In many Malay villages, one finds wooden pitchforks on the street corners, placed there by public authorities in order to fend off any potential people running amok (figures 5.2 and 5.3). To this, the ethno-psychiatrist Georges Devereux remarked, "These forked staffs had almost the same meaning as public emergency telephones in our modern cities, which serve the purpose of alerting the next police station or fire department in urgent cases."[10] It can be inferred that "running amok" is perceived here less as a crime than as an accident, as an anonymous, impersonal occurrence that, similarly to an accident, comes from the midst of society.

A transition can be traced with the example of running amok, which leads from a warlike action to a specific perilous event, designated by a lack of motive and history, by its triggered character and as a nonpersonal occurrence. In other words, a social irreality appears in "amok," a threat, in which the world of occurrences has detached itself from the world of reasons. The interest in "amok" and its particular appearances since the nineteenth century is evidently related to this increasing groundlessness and

Figure 5.2

Amok (effet de l'opium sur les Malais). Wood cut,
1864, drawing by de Molins and Doerr. Illustration
to M. de Molins, *Voyage à Java*, 1858–1861. From
Le Tour du Monde 10 (1864): 263.

Figure 5.3

Jefferson County Sheriff's Office, Columbine
Documents, JC-001–026022.

eventually marks a social catastrophe, which suddenly and without previous indication breaks out of the standard form—this is the figure in which "amok" entered Western societies. In the 1870s, "amok" actually touches European soil, with newspaper reports on a priest on a ship in the Black Sea, for instance, or a Spanish sailor in a seaman's home in Liverpool.[11] Which self-relation of these societies is expressed here? Which evil, which danger is now denoted with the conjuncture under the title "amok"?

The answer may lead to a provisional thesis. On the one hand, these acts without motives appear against the backdrop of an anthropological novelty, which intensively occupies the humanities in the nineteenth century. In psychiatric jargon, there is repeatedly talk of something "irresistible," an "instinctive impulse," a "sinister urge," an "irresistible force," a "violation of will power," of a dark dynamic that makes every person into a different person or, rather, into a non-person.[12] An agent, an energy, a psychic force is addressed here, which detached itself from the old emotions, passions, and affects, and finally obtained the title "drive." Where one cannot establish insanity, one must appeal to automatic drive mechanisms, which (as Foucault observed) led to a reordering of the psychiatric, anthropological, and political-social fields.[13] However the conjuncture and fate of these drives may have proceeded into the twentieth century, they appear in the nineteenth century as the substrate or shadow of actions and events, in which rational subjects, as if in a dream or trance, unconscious and automatic, obsessive and involuntarily, become someone other than themselves, with an inexplicable absence of any reason. The discovery or invention of the "drives" evidently provides a passe-partout, in which the old warlike form of "amok" transforms and becomes an elementary threatening event, for the very reason that all willpower is suspended in it.

On the other hand, and more generally, it appears as if the import of "amok" is tied to a fundamental transformation of evil in modern welfare societies. The social statisticians of the nineteenth century had already presented the prospect of a new sociodicy that guaranteed the efficient administration of modern societies not only through institutions and justice systems but also through methods of contingency regulation, risk management, and insurance. This social-technical solidarism uses statistics and probability calculations to produce a social character of events, in which all individuals are connected and encounter each other in the regularities of diverse damage events—from sickness to crime. Misfortunes become accidents, criminals become pests, and acts of violence become friction in the system, and rather than simply searching for the guilty, it is worth it to calculate chances, to regulate damages, and to anticipate dangers. The threats one must now deal with are no great exceptions but probabilities—not the intervention of the distant powers of faith but rather calculable assets of depreciation. When considering dangers, one encounters quotas, trends, and normal distributions—certain tendencies toward crime, suicide, and accidents of this or that kind.

The statistician Adolphe Quételet addressed the heart of this new sociodicy in 1832 with his now famous formulation: "Sad state of the human race! We can tell beforehand

how many will stain their hands with the blood of their fellow human beings, how many forgers, how many poisoners there will be, almost as one can foretell the births and deaths that must follow one another. Society contains the germs of all crimes that will be committed in the future. It is society that, to a certain extent, distributes them, and the offender is only the instrument of implementation."[14] Hence, there is neither good nor evil in a moral sense. Materially speaking, there are merely risks. Since the nineteenth century and in conjunction with risk and welfare societies, one is evidently dealing with a world of evil, with a world, for that matter, beyond good and evil, a world of unfounded evils in which the questions of accountability have receded. Evil and violence are subjected to an algorithm of distribution: Everything is related in the assessment of risks—a repulsive neighborhood, in which the neighbor is the evil itself.

Emerging from this sociodicy, this coordination of social events, the modern person running amok emerges. He comes from the ordinary. He follows the law of series. His choice is arbitrary and his randomness exact. Just as with the Malay "amok" of the nineteenth century, there is little to understand in the Western varieties. He can be addressed as a statistical person, *Homo aleator*, with an ontology of risky events. The interconnectedness of all individuals as the sign of potential evils creates the foil against which the figure of "amok" stands out: as an everyday monstrosity, with which an undetectable danger suddenly takes shape and makes it clear that panic and emergency remain embedded in solidary peace. Groundlessness, a triggered event, an impersonal occurrence: with these features, "amok"—derived from warrior rituals—begins its Western career as a form of danger that no longer is excluded from European statehood but rather breaks forth from the center of society. It marks a threat that is the social of society itself.

The career of the more recent, Western "amok" probably began with Charles Whitman, who became widely known as the "madman in the tower." In 1966, Whitman first shot and killed two of his family members and then fifteen people before injuring thirty more from the campus tower of the University of Texas at Austin. This event was immediately connected to the Malay "amok" and became the prototype for further cases in the psychiatric literature under the name "Whitman syndrome." Since then, there has been talk of a new type of student, a "globally hostile student."[15] And since the nineties, a latest variation has been identified: the school shooting or schoolyard massacre, so-called running amok, whose dramatic cases stretch from Littleton, Colorado, to Virginia Tech and Northern Illinois University to Newtown, Connecticut, and Umpqua Community College in Roseburg, Oregon. Which further transformations has the threat undergone here? Is there a new twist to what one calls "running amok"?

One should closely consider an example from this last chapter. On April 20, 1999, the barely eighteen-year-old students Eric Harris and Dylan Klebold shot and killed twelve students and a teacher, as well as themselves, at Columbine High School in Littleton, Colorado. After the police made the investigation files publicly accessible (the

Columbine Documents[16]), the ideally documented facts presented the opportunity for several conclusive observations on the current appearance of this kind of massacre. One can recognize a first distinctive feature in the fact that the setting for this most recent form of "amok" is, almost without exception, designated places of civil order—universities, shopping centers, town halls, corporate offices, schools—places that the attacks transform into a type of war landscape. In this respect, "running amok" appears like a raid that is usually enacted following military protocol. These actions evidently bring a particular form of war into the center of civil life and into its specifically marked milieu. This includes the fact that, particularly in the United States, one must repeatedly acknowledge these acts of violence as a phenomenon of the middle class. Any such Charles Whitman would be immediately identified as an "all-American guy," his family as a model family.[17] And likewise, one could find nothing but normalcy in Littleton: good or average students from so-called intact families.

Second and more concretely, one most notably finds a puzzling image of actions and texts in the Littleton case. This pertains not only to the roughly ten thousand pages of investigative files and reports that accumulated after the crime, but also to the 946 pages of records that came from the teenage perpetrators themselves: journals, school essays, manifestos, short stories, site maps and plans of action, and drawings and sketches. The crime consists of a unity of actions and texts, and the puzzling image results from the unclarity on how the two sides relate to one another. On the one side, the act appears to be a necessary consequence of what is written; since 1998, the diverse scenarios of violence, the plans, and the logistical notes escalated toward the school as the setting and the date of the deed. On the other side, one retrospectively consulted the texts in order to explain the acts and, in that respect, recognized the corresponding anomalies. A story from a creative writing course, for instance, depicts an extended massacre that ends with a triumphant perpetrator: "I not only saw in his face, but also felt emanating from him power, complacence, closure, and godliness."[18] For this reason, "megalomania" and "power complex" were topics in psychiatric evaluations: The deed explicates and consummates itself conversely in the text. A writing that rationally realizes itself in the act, and an act whose insanity is, in hindsight, articulated in the writing: these are the two directions that constitute the puzzling image of the crime. The one is either the proof of a malicious rationality or the sign of delusion for the other. The facts of the writing and the facts of the killing are intertwined in an erratic way. What is presented here is both rational and insane, and it was in this uncomfortable position that the psychiatrists plainly stated "psychopathy": a diagnosis that says nothing more than that perpetrators, when in their right mind, are completely insane.

Third, with these observations, one has already started to play the game that the perpetrators themselves began. Murders and writings are not only entangled but also equal parts of something for which a hyperbolic authorship has been claimed. In this way, the diverse texts are not only an announcement or admission of a future act but

Figure 5.4

Jefferson County Sheriff's Office, Columbine
Documents, JC-001–026307.

explosions, I would have to guess about 6 miles away. Then another one occurred closer. After recalling the night many times, I finally understood that these were diversions, to attract the cops. The last prep was bawling & trying to crawl away. The man walked up behind him. I remember the sound of the impact well. The man came down with his left hand, right on the prep's head. The metal piece did its work, as I saw his hand get buried about 2 inches into the guy's skull. The man pulled his arm out, and stood, unmoving, for about a minute. The town was utterly still, except for the faint wail of police sirens. The man picked up the bag and his clips, and proceeded to walk back the way he came. I was still, as he came my way again. He stopped, and gave me a look I will never forget. if I could face an emotion of god, it would have looked like the man. I not only saw in his face, but also felt eminating from him power, complacence, closure, and godliness. The man smiled, and in that instant, thru no endeavor of my own, I understood his actions.

[handwritten signature]

[handwritten note]

Dylan—

I'm offended by your use of profanity. In class we had discussed the approach of using #!# !

Also I'd like to talk to you about your story before. I give you a grade. You are an excellent writer/storyteller, but I have some problems with this one.

JC-001-026523

Figure 5.5

Jefferson County Sheriff's Office, Columbine Documents, JC-001–026523.

also primarily variations on the topics glory, fame, and infamy. And all of this is conveyed by the attack itself. "I wonder," Eric Harris wrote in his journal, "if anyone will write a book on me. sure is a ton of symbolism, double meanings, themes, appearance vs reality shit going on here. oh well, it better be fuckin good if it is written."[19] Writing about unparalleled acts, then the excess of these acts themselves, then writing about that—this all results in a dense system of reference, with an unmistakable authorship as its vanishing point. And all this produces a uniquely authorized unity of action. As if it all could be said once and for all, as if one could anticipate all discourses, as if all doubt about the imputation should be eliminated in advance, Eric Harris noted shortly before the act, "It's my guilt! Not my parents' guilt, nor my brothers', nor my friends', nor my favorite bands', nor computer games', nor the media's. The guilt is mine."[20]

Fourth, the field, as it were, in which the critical relation between originality and confusability, anonymity and reputation, finds its frame of reference is the field of history. As in most cases of this type, after the fact and to the present day, one has wanted to recognize rampant similitudes, analogies, patterns, and networks of relationships that were to a degree prompted by the perpetrators themselves: scenarios out of first-person shooter games such as *Doom* and *Wolfenstein 3D*; movies such as *The Matrix*, *Natural Born Killers*, and *The Basketball Diaries*; rock groups such as Rammstein, Kein Mitleid für die Mehrheit, and, not least, Marilyn Manson. At the same time, all of these stereotypes are enforced by names from history. April 20, one recalls, is Hitler's birthday, and the texts from Harris and Klebold themselves accumulate references, which are not hard to place as historical indices of various types and range: references to Hobbes and Nietzsche, to Charles Manson and the "Erlking" from Goethe, to Vietnam and Napalm, to World War II and the Nazis, to the attack in Oklahoma City and the riots in Los Angeles. German acquires a special status. At one point, Harris writes, "I love the German language and the 'BRUTE' stuff."[21] And all of this does not just mean the black cult around the swastika, SS runes, and the Iron Cross. Rather, it is much more recognizable that German operates here as the original language of history. As it were, all of the atrocities that constitute the raw material of history are coded in this language. Mass murder and its grim fame amount to the crucial point at which the forbidden and the transgressive are coupled with the exercise of power: the unlawful and the law of history, the terrible event of history as such. From the perspective of these students, the history itself is a forbidden, as it were, obscene and systematically silenced discourse. And all talk, all symbolism, and, even more, all forgery, secrecy, and deception about the truth of history find their utmost refutation here. The extreme crime secures immediate contact with history and, with that, its survival in history. A collective memory is invoked in the monotony of writing, which should be upheld in the act itself. The excess of the crime realizes the double meaning of writing history.

Fifth, we may ask, What is this infamous subject of history? How does it act, and how does it write? What constitutes its depraved renown? The answer to this is redundantly

WWII, vietnam, duke and doom all mixed together. maybe we will even start a little rebelion or revolution to fuck things up as much as we can. i want to leave a lasting impression on the world. and god damnit do not blame anyone else besides me and V for this. dont blame my family, they had no clue and there is nothing they could have done, they brought me up just fucking fine, dont blame toy stores or any other stores for selling us ammo, bomb materials or anything like that because its not their fault. i dont want no fucking laws on buying fucking PVC pipes. we are kind of a select case here so dont think this will happen again. dont blame the school, dont fucking put cops all over the place just because we went on a killing spree doesnt mean everyone else will and hardly ever do people bring bombs or guns to school anyway. the admin. is doing a fine job as it is, i dont know who wll be left after we kill but damnit dont change any policies just because of us. it would be stupid and if there is any way in this fucked up universe we can come back as ghosts or what the fuck ever we will haunt the life out of anyone who blames anyone besides me and V. if by some wierd as shit luck my and V survive and escape we will move to some island somewhere or maybe mexico, new zelend or some exotic place where americans cant get us. if there isnt such place, then we will hijack a hell of a lot of bombs and crash a plane into NYC with us inside iring away as we go down. just something to cause more devistation.

Figure 5.6

Jefferson County Sheriff's Office, Columbine Documents, JC-001–026113.

and clearly formulated. The subject of this history is the enemy of all, the absolute enemy, its milieu the boundless and unfettered war. The propane bombs that Harris and Klebold had installed in the school cafeteria (that they could not ignite) should have caused six hundred deaths. The fleeing as well as the approaching aides should have—according to the plan—perished in a hail of bullets, with all of this filmed by the cameras of the positioned news networks. Most notably, the texts here too left no doubt that an utmost declaration of hostility dictated the extent of the event. The corresponding declarations read as follows: "I want to burn the world, I want to kill everyone"—"you know what I hate? . . . humanity . . . kill everything, kill everything." As his own "final solution," Harris declares "'KILL MANKIND' no one should survive"—"I hate society, I hate people; whatever is human about people has to be killed."[22] This writer, who once saw applying to be a marine as a way out, positions himself as the utmost enemy of society. In the plans of attack, names and individuals appear merely as representatives of a system, of society, and of the collective singular. The perpetrator thereby initiates himself into a circle for which this character type of the generally hostile student has been adapted since the 1960s. The hostility that is articulated here is equally as concrete as it is arbitrary and absolute, and it appears as if a vacant and preformed position is occupied here: the position of an enemy of society, the position of an ultimate enemy of humanity. Thus, if there is a legibility to the crime apart from personal hermeneutics, it merely offers a military, pseudo-military action, an unfettered war, and a last, irrevocable hostility against the civil as such. If one wishes to speak of insanity here, it lies in the concealed yet immediate proximity of war.

Apart from the fact that these crimes, with their explicitness and lack of secrecy, anticipate every explanation; apart from the fact that these perpetrators are not imitators but rather want to be imitators and therefore invoke a gallery of stereotypes and models; apart from the fact that the most cautious commentaries verify the desolation of the American middle class, the "toxic culture" of high schools, the pressure to be normal and bullying; and finally, apart from the fact that the accumulation of these massacres can be detected since the so-called Reaganomics, since the deregulation of the last security reserves[23]—apart from this, one could call this latest form of "amok" a diagnostic crime, diagnostic in two senses. On the one hand, a crisis discourse ensues immediately after this type of attack that operates equally extensively and erratically: one instantly establishes a crisis of the family and the playroom, a crisis of the school and the media, a crisis of the social and the socialization, a failure of the system altogether. By all means, these cases could have been very quickly apprehended simply as symptoms, as indications of a current cultural situation. Yet, on the other hand, this diagnostic work repeats that which the acts and the perpetrators themselves diagnose, in a tautological way: that it is precisely this situation in its generality, that its structures and system character are the cause and location of a battlefield and of all declarations of war.

Figure 5.7

Jefferson County Sheriff's Office, Columbine
Documents, JC-001–026010.

As little as the imprecise term "amok" is nosologically resolvable here and fails as a psychiatric term, so much it invokes a social figure that explicates itself as the occurrence of the highest threat and the declaration of a radical hostility. From afar, this devastation still invokes a collapsing statehood, which the early modern "amok" reports dramatized; from a distance, this indeterminate enemy of society who deploys himself in modern solidarity is still recognizable. The violent act, just like its discursive reproduction, leaves no doubt that we are dealing with the most general manifestos of revolt, revolution, and upheaval, which themselves, in turn, summon the most general manifestos of revolts. In an entry in his video journal recorded shortly before the murders, Eric Harris says, "We're going to kick-start a revolution, a revolution for the dispossessed."[24] Rather than a mysterious act of confused psychopaths, this is the marking of a battle line that runs through civil society—the latest, gruesome, and maybe the only remaining grimace of rebellion.

Notes

1. Thomas De Quincey, *Confessions of an English Opium-Eater* (London: Taylor and Hessey, 1886), 127, https://www.gutenberg.org/ebooks/2040.

2. De Quincey, *Confessions of an English Opium-Eater*, 130.

3. De Quincey, *Confessions of an English Opium-Eater*, 165–170.

4. De Quincey, *Confessions of an English Opium-Eater*, 131, 210.

5. Cf. Philipp Holden, "Love, Death and Nation: Representing Amok in British Malaya," *Literature and History* 6, no. 1 (1997): 43–62.

6. Gaspar Correa (between 1512 and 1561), cited from Henry Yule and Arthur Coke Burnell, *Hobson-Jobson, Being a Glossary of Anglo-Indian Colloquial Words and Phrases and of Kindred Terms* (London: John Murray, 1886), 756. Cf. John C. Spores, *Running Amok: An Historical Inquiry* (Athens, Ohio: Ohio University Center for International Studies, 1988), 11–29.

7. Frank Swettenham, *British Malaya: An Account of the Origin and Progress of British Influence in Malaya*, 7th ed. (London: Allen and Unwin, 1955), 125, 173.

8. W. Gilmore Ellis, "The Amok of the Malays," *The Journal of Mental Science* 39, no. 166 (July 1893): 332.

9. F. H. G. van Loon, "Die Bedeutung ur-instinktiver Phänomene bei 'Primitiven' und in der Kulturgesellschaft," *Zeitschrift für Völkerpsychologie und Soziologie* 7 (1931): 25–26.

10. Georges Devereux, *Normal und Anormal: Aufsätze zur allgemeinen Ethnopsychiatrie* (Frankfurt am Main: Suhrkamp, 1974), 63.

11. Yule and Burnell, *Hobson-Jobson*, 15.

12. Jean Étienne Dominique Esquirol, *Des Maladies Mentales*, vol. 2 (Paris: J.-B. Baillière, 1838), 95 *et seq.*

13. Michel Foucault, *Die Anormalen: Vorlesungen am Collège de France (1974–1975)* (Frankfurt am Main: Suhrkamp, 2003), 170 *et seq.*

14. Adolphe Quételet, *Soziale Physik oder Abhandlung über die Entwicklung der Fähigkeiten des Menschen*, vol. 1 (Jena: G. Fischer, 1914), 106–107.

15. "The Madman in the Tower," *Time*, August 12, 1966, 20–25; John L. Kuehn and John Burton, "Management of the College Student with Homicidal Impulses—The 'Whitman Syndrome,'" *American Journal of Psychiatry* 125, no. 11 (May 1969): 1594–1599.

16. Jefferson County Sheriff's Office, Columbine Documents, www.thedenverchannel.com /download/2006/0706/9477579.pdf.

17. See Gary M. Lavergne, *A Sniper in the Tower. The Charles Whitman Murders* (Denton, University of North Texas Press, 1997), 50–63.

18. http://www.acolumbinesite.com/dylan/writing/dkcw2.png.

19. http://www.acolumbinesite.com/eric/writing/journal/journal.html.

20. http://www.acolumbinesite.com/eric/writing.html.

21. Columbine Documents, JC-001–026856.

22. Columbine Documents, JC-001–026003, 026010, 026012, 026013, 026015.

23. Cf. Mark Ames, *Going Postal. Rage, Murder, and Rebellion: From Reagan's Workplaces to Clinton's Columbine and Beyond* (New York: Soft Skull, 2005).

24. Eric Harris in a video diary, quoted in Ames, *Going Postal*, 149.

6

Blurry Manifestos: The Eshkol–Wachman Movement Notation and Its Militarized Applications

Arkadi Zaides

There are many historical examples of the interconnection between dance, choreography, and war. Dances are practiced before battles, unifying and preparing the fighters to overcome the hardship of the battlefield. From early ages, the so-called weapon dances, for example, were used to simulate, recall, or reenact combats. Dances are also practiced in the midst of fighting to boost morale or in the aftermath of wars—whether to mark victory or to acknowledge defeat or loss. The establishment of the nation-state and the institutionalization of armies have led to the development of military training methods. In addition to the obstacle courses that strengthen their bodies and familiarize them with the type of tactical movement they will use on the battlefield, combat training also entails movements in unison, such as marching or saluting, and this type of choreography is often performed in front of their comrades or an audience. The battlefield itself might be perceived as a mass choreography, where the two combating sides negotiate their space through the use of force. Tactical thinking determines how not only humans but also war machines move in coordination and synchronization on land, on water, and in the air. There is a limited scope of literature that discusses the complex relationship between choreography and modern warfare. The book *Choreographies of 21st Century Wars*, edited by Gay Morris and Jens Richard Giersdorf, arguably constitutes the first study that focuses specifically on this interrelation. By looking at diverse aesthetic and various geopolitical contexts, Morris and Giersdorf point out the more amorphous and shifting quality of modern conflicts and warfare and the more ambiguous boundaries between war and peace. Furthermore, they question whether "choreography also changed its character and objective"[1] within the gray zones of modern warfare and address the need to reconsider its ontological state within the complexity of modern conflicts and war.

I was born in Belarus in 1979 and spent my early childhood in the midst of the collapsing Soviet regime. In the wake of the fall of the Iron Curtain, I immigrated, grew up, and spent most of my adulthood in Israel, a country known for its weapon industry and one that has enforced decades of occupation of the Palestinian people. I now live in Europe, with its long legacy of colonization and increasing border fortification. My personal trajectory in these specific sociopolitical circumstances compelled me to respond to these contexts through my choreographic work. My interest in documentary

practices has led me to documents, archives, and databases that attest to the differing levels of structural violence in the territories in which I live and work. Examination of these documents has become a key component of my artistic practice, which I call "Documentary Choreography." Through the use of documents, this practice is promoting choreography as a potential investigative tool that can, through embodied practices, intervene and question the sociopolitical contexts and the ideologies that shape them. Moreover, as I have demonstrated in my own work,[2] it can propose setups and procedures that are constructive in countering the official narrative produced by those in positions of power and which operate outside of the artistic field.

I was initially interested in the joint work of Israeli dancer, choreographer, and theoretician Noa Eshkol and her student and later professor of architecture Avraham Wachman because their approach questions the notion of "document." The two, often referred to as avant-gardists (Zyman, Finkelman), are renowned for inventing one of the most simple and applicable systems that enable the precise notation of movement patterns (Yanai). However, when I embarked on my historical investigation, I was captivated by the way their system has transcended the artistic field to perform outside of its primary frameworks. Moreover, I was intrigued by the ambiguity around several of the extra-choreographic projects in which Eshkol and Wachman's findings have been implemented, which are, in my view, manifestations of the ontological shift evoked by Morris and Giersdorf in their aforementioned book. The early twentieth century avant-garde movements have often been politically ambiguous and were thus seen as a threat by the ideological systems in which they operated. As dramaturge, curator, and writer Eda Cufer rightly argues, the consideration of the work of avant-garde artists from a contemporary perspective has to address "their structural-aesthetical as well as historico-political features."[3] Moreover, it should be observed within a larger international context fueled by the tensions of the Cold War era.[4] Following Cufer's observation, I wish to look at the Israeli as well as the broader international social and political contexts within which the Eshkol–Wachman notation system was conceived and practiced. I would also like to examine how it came to be associated with structures of power, to the point of being used in militarized contexts. Ultimately, I wish to question the ideological implications of their taxonomy of gesture, their attempt at classifying and schematizing the movement of the human body.

This chapter covers an era spanning from the early 1950s to the late 1970s and situates Eshkol and Wachman's work with contextual references to the early twentieth century, which corresponds to the most fruitful years of the cooperation between the two. Between the Declaration of Independence in 1948 and the late 1970s, the young State of Israel was involved in a series of wars with neighboring Lebanon, Syria, Jordan, and Egypt, as well as with the local Palestinian population. These include, in chronological order, the War of Independence (as it is called by Israelis) or the *Nakba*–the "catastrophe"–as it is referred to by the Palestinians (1948–1949), the Sinai War (1956),

the Six-Day War (1967), the War of Attrition (1968–1970), and the Yom Kippur War (1973). Over these decades, Israel's outer borders underwent dramatic change[5] as the state defined its own (body) image. The tension between the body of the state and the human body as well as the ideology binding them together are an undercurrent in this chapter. With this interconnectedness as a guiding line, I wish to demonstrate: (a) how Eshkol and Wachman's aesthetic attempt to create a system of mapping bodily movement was ideologically linked to the mission of building the new State of Israel, (b) how it is linked to its militarized nature, and (c) how it was subsequently used to map out its political territory.

Notation System for the Creation of Dances

Eshkol–Wachman movement notation (EWMN) was first outlined by Noa Eshkol and Avraham Wachman in a book published in 1958 and titled simply *Movement Notation*. Eshkol was looking for a "theoretical basis which would allow the representation of all movements by means of numerical values."[6] For Wachman, the movement notation system was intended to serve as a language designed for interaction and communication "based on a set of rules" that are "capable of producing the unpredictable or unplanned, in an infinite and unlimited number of combinations and configurations."[7] EWMN is based on an abstract and schematic figure of the human body—a "man without qualities"[8]—with joints acting as the connecting points. Eshkol devised the system after noticing that each axis—or body part—connects to the fixed point of the joint and can therefore move within a sphere. Wachman, who had a specific interest in morphology, proposed an added layout system combining the different spheres created by the different body parts. He also outlined an initial index of signs to indicate direction, range, trajectory, duration, and speed.[9] On a grid, the different body parts and the body's weight and direction are registered on a vertical axis, while the horizontal axis allows the division of time into units. A series of simple symbols and numbers can document the exact position, the weight distribution, and the motions of the body parts in space at any given moment.

Eshkol herself wrote, "It is a significant fact that despite the great number of names associated with attempts to formulate methods of notation for movement and dance, to this day there exists no serious literature of the dance. That is to say, no body of work composed in notation and generally available."[10] While other movement notations (Labanotation, Benesh Movement Notation, and others) were created mostly to document and archive existing choreographies staged by their inventors, the EWMN system was invented in order to create dances. Its primary attempt was to outline the possibilities of the human body, focusing on the connections between the various body parts, and their simultaneous coordinative movement potential. It generated new radical physical discoveries and allowed for abstract and rationalized thinking about movement, detached from any aesthetic preconception.

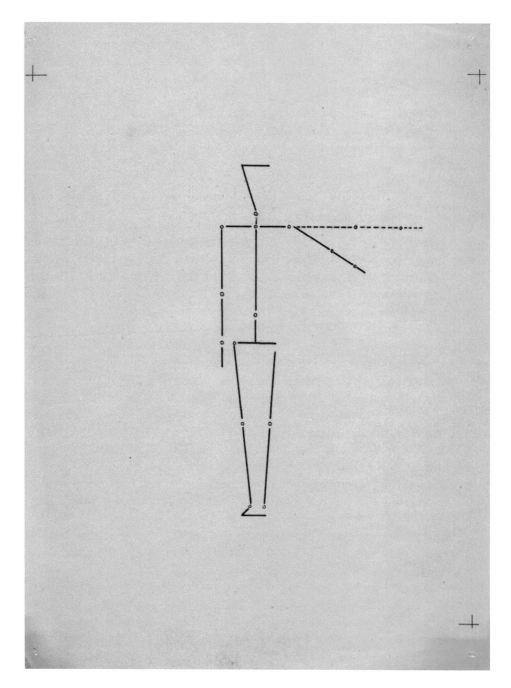

Figure 6.1

Stick figures with changes of position
(movements). The body as a system of axes.
Drawings (illustrations) for the first book, 1958.
Avraham Wachman, 1956–1958. Illustration, ink
on parchment, 21 cm×28 cm. Courtesy of the Noa
Eshkol Archive for Movement Notation.

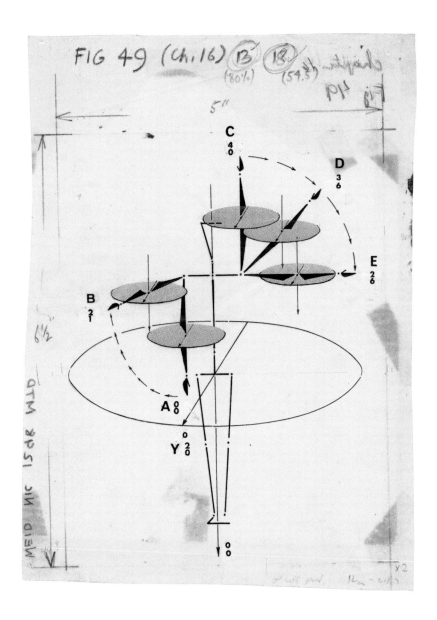

Figure 6.2

A change of relation of a "light" limb to the system
of reference, caused only by the movement of
a "heavy" limb. Avraham Wachman, 1956–1958.
Illustration. Courtesy of the Noa Eshkol Archive
for Movement Notation.

Consequently, Eshkol's own dances were first written using movement notation, and only then would her dancers execute them. With no warm-up and no preparation, rehearsals would consist of executing the notes as precisely as possible. Once a month, the group would open their process to others, with intimate performances. Eshkol rejected all forms of stage design, and movement was the sole focus of her investigation. The stage or the studio space remained empty and devoid of any set, while the group of performers wore similar and neutral clothes and moved to the monotonous sound of a metronome. The choreography was often in strict synchronicity, which would momentarily break into individual movement sequences and then come back to unified movement. At the end of Eshkol's performances, the performers would simply leave the stage without bowing—an action that, in Eshkol's view, was at odds with her movement explorations.

Due to its rather simple, functional, pared-down, and effective approach, EWMN can be used to document all types of movement. In parallel to composing and practicing her dances, Eshkol tested the system in order to examine this applicability. She and her group issued a series of books in which they resorted to the notation system to record various dance types, from folklore to ballet, martial arts, movement therapy, sports education and training, sign language, and more. Her followers further worked with the system to notate the movement of animals, to diagnose autistic movement patterns in babies, and to help overcome learning disabilities. EWMN is still taught today at various academic institutions around Israel.

Zionism: The Architecture of the Body

Eshkol was born at Kibbutz Degania Bet in Mandatory Palestine[11] in 1924. Her parents were among the founding members of the Kibbutz, and her father, Levi Eshkol, would later become Israel's third prime minister. After her parents' divorce, Noa and her mother moved to the city of Holon, and Eshkol embarked on her studies of dance and body culture in neighboring Tel Aviv. Having studied music from an early age, when studying dance, she soon felt the need for a system of dance notation, similar to the one used for music. Her teacher, Tille Rössler, introduced her to the work of dance artist and theorist Rudolf von Laban, who had developed a dance notation system known as the Labanotation. Following Rössler's advice, Eshkol moved to England in 1946 to attend classes at the Art of Movement Studio founded by Laban in Manchester, and she later went to a school established by Laban's student, the German dancer, choreographer, and teacher Sigurd Leeder, in London. In 1951, she returned to Holon and began to teach dance at various institutions.

Wachman was born in 1931 in Lublin, Poland, and immigrated to Mandatory Palestine with his parents in his early childhood. He grew up in Tel Aviv, and as a teenager, he studied performing arts and played the violin. Along with some of Israeli theater's

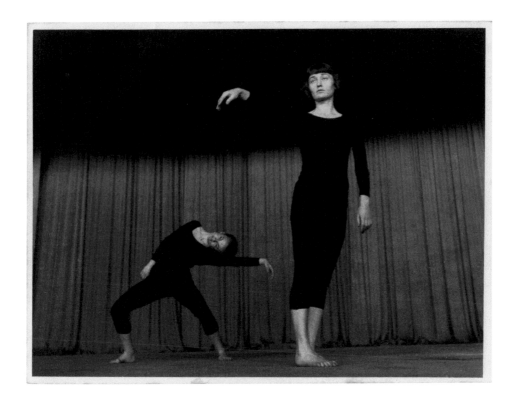

Figure 6.3

"Autumn," duet from the suite *The Four Seasons*,
Chamber Dance Group, performed by Noa Eshkol
and Naomi Polani. Dance composition by Noa
Eshkol, 1954–1956. Photograph, black-and-white
print. Courtesy of the Noa Eshkol Archive for
Movement Notation. Photo Credit: T. Brauner.

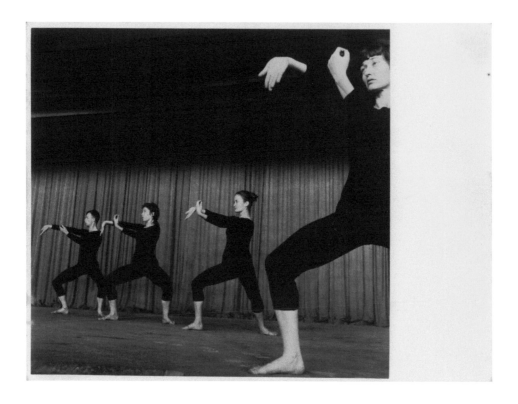

Figure 6.4

The Chamber Dance Quartet (Ensemble 1) dances
"Aviv" by Noa Eshkol. Front: Noa Eshkol. Back
(left to right): John G. Harris, Mirhal'a Sharon, and
Naomi Polani. Noa Eshkol, 1954–1956. Photograph
22.7 cm×18.3 cm, black-and-white print. Courtesy
of the Noa Eshkol Archive for Movement Notation.
Photo credit: T. Brauner.

Arkadi Zaides

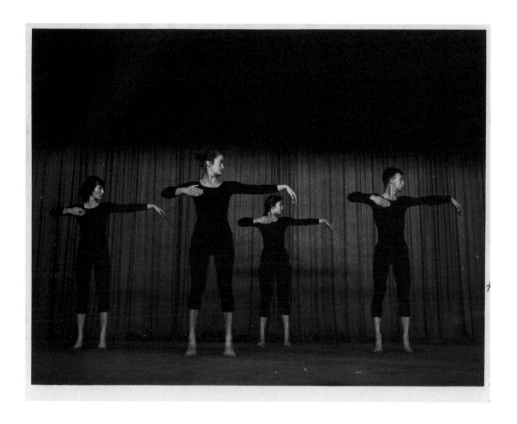

Figure 6.5

The Chamber Dance Quartet (Ensemble 1) dances
"Etude" by Naomi Polani. From left to right:
Noa Eshkol, Naomi Polani, Mirhal'a Sharon, and
John G. Harries. Naomi Polani, 1954–1956. Photo-
graph 22.7 cm×18.3 cm, black-and-white print.
Courtesy of the Noa Eshkol Archive for Movement
Notation. Photo credit: T. Brauner.

founding figures, he was a member of the first class of the Cameri Theater School, where Eshkol taught, and their collaboration began.

Both Eshkol and Wachman were brought up in an environment in which the utopian socialist ideologies of the Kibbutz movement prevailed. This environment was based on the promotion of equality, communal living, and the working of land, on the one hand, and the modernist visionary mission of building a modern Jewish state, on the other. "Wherever the moderns appear with our inventions, we transform the desert into a garden,"[12] wrote the father of modern Zionism Theodore Herzl in his book *The Jewish State*. One of the main aspirations of the Zionist movement was to heal the Jewish nation through the creation of a new Jewish body, transforming the weak, deformed, and exiled body that leaned over books into a strong body that owns and plows its land. "At last, we are allowed space for our bodies to live again,"[13] wrote Max Nordau, a physician, writer, and Zionist leader, who also coined the term *Muskeljudentum* ("Muscular Judaism"). "Let us take up our oldest traditions; let us once more become deep-chested, sturdy, sharp-eyed men."[14] Constructing a "new body" also involved the abandoning of old terminologies and aesthetics. The making of this new body image was reflected in the dances the Zionists practiced, which corresponded to their different origins and backgrounds while always giving them a local interpretation. The first newcomers arriving from Russia at the end of the nineteenth century performed the social dances that they were used to in their homeland. Later on, choreographers immigrating from Eastern and Western Europe brought a professional approach with classic and expressionist aesthetics. Eshkol, on the contrary, was more interested in the functionalities of the human body and its movement rather than in any particular style or any form of expressionism in dance. "The term 'dance,'" wrote Eshkol and Wachman in the preface to their first book, "voices, in every period, a certain range of movements expressing the choice of a composer and dancer and fulfilling the demands of a particular society in a certain epoch." "Movement," on the other hand, "includes in its meaning all the possibilities of movement of the human body in their various manifestations."[15]

As constructing the new emancipated body was closely linked to the process of constructing a modern and sovereign state, it also involved the abandoning of old terminologies and aesthetics. Jewish migrants who escaped an increasing hostility toward their communities in Europe brought new approaches and aesthetics to Palestine. The 1920s and 1930s saw the planning and construction of Tel Aviv, also called the "White City." It consisted of more than four thousand buildings that were erected by architects following the international style that developed in Europe between the two world wars. The Bauhaus movement was thriving, and its ideas of simplicity, functionality, and adaptability captivated the Zionists. The establishment of the State of Israel in 1948 accelerated this process, and architectural innovation was at its core. Simultaneous with his cooperation with Eshkol, Wachman graduated from the Faculty of Architecture and Urban Planning at the Technion, the Israeli Institute of Technology in Haifa, and his

dissertation focused on round and orthogonal buildings. He began to teach morphology, one of his main fields of interest, at the same institution. Morphological architecture, a paradigm developed within the walls of the Technion, increasingly gained national and international interest. It strived to include three-dimensional patterns extracted from the molecular world within architectural practice. Architect and scholar Ifat Finkelman, who conducted an extensive interview with Wachman, reports that while some of the professors at the Technion were interested in morphology to determine the final and defined shape of a building, Wachman and some other colleagues were interested in a general blurring of the boundaries of the field of architecture with other fields of knowledge. They prioritized the dynamic interconnectedness between humans and the spaces they inhabit, detached from any defined aesthetics. As Finkelman points out, the invention of EWMN was instrumental for Wachman's vision and innovative approach within his own field of research. It derived the focus from the "fixed, the stable and the known aspects of architecture toward its shifting qualities."[16]

Movement Notations as Templates of Body Politics

The encounter between the two thinkers revealed that Eshkol's quest to schematize the movement of the body and Wachman's functional approach to shape and space could be complementary. For Iris Lana, a dance researcher, lecturer, and director of archival projects in the field of dance in Israel, practicing EWMN allowed for "a form of total submission which liberates the body on one hand and polices it on the other."[17] It offers a decoded language that needs to be executed, mostly collectively, following a very precise script. Its very strict protocol-like quality and the standardized aesthetics it offers resonate, I would suggest, with the local Israeli body politic and with processes of narrative and identity building that took place in the newly established state. Its development cannot be dissociated from the specific social and political order out of which it emerged. "Dance, like science, participates in a large web of ethical, social and political entanglements, while also constructing models of the moving body,"[18] writes dance historian Susanne Franco. Historically, dance practitioners have often found themselves resisting but also complying with structures of social, economic, and political power through their artistic practice. Several Western dance practitioners resorted to the creation of movement notations, which often became embedded in larger societal transitions and complicit within structures of political and class power.

The earliest movement notation was commissioned for the court of Louis XIV to help the king memorize his famous dance performances. It was published in 1700 by the king's *maître de danse* Raoul-Auger Feuillet in a book titled *Chorégraphie* (Writing Dance).[19] The Beauchamp–Feuillet[20] notation documented a set of basic physical positions laid out on top of a diagram documenting the dancers' movements in space. It formed the fundamentals of the construction of ballet as we know it today. As argued by

Gay Morris and Jens Richard Giersdorf, this notation attempted to mirror the manners of the upper-class elite through the process of registration of movement. It established "terminology and practice of choreography [that] functioned as a textual organisation that works primarily to reinforce a particular kind of order in society."[21] Over the course of two centuries, according to Morris and Giersdorf, it gradually widened the gap between social dance and theatrical dance. Moreover, the growing codification and theatricalization of the dancing body on the aristocratic social stage set an example for the emerging bourgeois social class to emulate.

In the twentieth century, when ballet had become a status symbol and the most highbrow form of Western dance, the mathematician Rudolf Benesh introduced Benesh Movement Notation (BMN), or choreology, co-developed with his wife Joan Benesh, a soloist with the Sadler's Wells Ballet in London. In 1965, BMN inspired the establishment of the Institute of Choreology by the British Minister of the Arts. The institutionalization of the term has led to the establishment of another more debatable field of ethno-choreology. While choreology is mostly used to annotate classical or neoclassical choreographies, ethno-choreology focused on folklore and non-Western body practices. As such, it has deepened the gap between so-called high and low art in dance and between professionalism and amateurism. Furthermore, it has contributed to a long colonial tradition of analyses and to the classification and categorization of foreign and indigenous practices according to Western terms and standards.

Labanotation, or Kinetography, was a notation system outlined by Rudolf von Laban, one of the founding fathers of expressionist dance, a modern type of dance that emerged in Europe at the beginning of the twentieth century. This Hungarian-born dance theorist's notation first appeared in print in Berlin in 1928 in a book named *Schrifttanz* (Written Dance). It is based on a series of abstract geometrical symbols that define the direction and range of the movements as well as their duration and dynamic quality. Within the Weimar Republic, Laban established a network of schools that taught his notation system, and he successfully brought together professional and nonprofessional performers around the art of dance. Labanotation "enjoyed wide popularity in the Weimar Republic because its handy and easily reproducible tools simplified the staging of choreography for large groups,"[22] as dance scholar Evelyn Dörr observes. Von Laban remains an ambiguous figure in the eyes of many historians, and suspicions were raised with regard to his adherence to nazi ideology. When Hitler was sworn in as chancellor in 1933, von Laban was appointed as the director of the Deutsche Tanzbühne (German Dance Theater). He held this position until 1936 and, while in office, was responsible for shaping the face of German dance. One of his biggest artistic achievements, the choreography of *Of the Warm Wind and the New Joy*, was supposed to be performed at the Berlin Olympics (1936), deployed by thousands of performers from all over Germany who were taught the movement via the Labanotation. The work was eventually banned by Hitler, who labeled it too intellectual. This "failure" forced von Laban to leave

Germany and settle in England. During World War II, he applied his notation system to another initiative, this time on the side of the Allied forces, concentrating on maximizing industrial efficiency in wartime factories. In his book *Effort* (1947), von Laban developed his project to improve the efficiency of work by optimizing motion sequences while still maintaining an acceptable level of worker satisfaction.

EWMN as a Modernist Project

As for EWMN, it was devised in opposition to Labanotation, which was described as "arbitrary" by Israeli civil servant and author Zvi Yanai, who served as head of Israel's Ministry of Science in the 1990s. According to Yanai, Labanotation "treats movement as a 'transition' more or less taken for granted, as though there was one way between two points—the most 'natural' one."[23] Furthermore, it is "literary," as it attaches verbal terms (strong, light, free, bound, etc.) to symbols that lead to a subjective interpretation of the notation.[24] Noa Eshkol, who made her formation partly at the Laban school, criticized this arbitrariness, claiming that the proper notation of movement should rely on the highest level of scientific-like precision and leave no room for subjective reading or interpretation, to be "free of verbal terminology and the emotional charges which accompany it."[25] Scientific approach and innovation were also at the heart of the newly established State of Israel; the country itself did not develop organically but rather was engineered in its entirety within a short period of time. The Zionist project as a whole was about decoding the existing paradigms and offering new notes/codes for the emerging state and its people. The Hebrew language itself was reinvented, from the sacred language to a spoken and written language fit for daily use. According to dance historian Ramsay Burt, "with its abstract, formal concerns and its aim of creating a new dance aesthetic, Eshkol's [and Wachman's] project was a modernist one,"[26] and "modernism, as an aesthetic form, was for much of the twentieth century associated with ideologies of progress that have become increasingly problematic."[27] Modernism not only dismissed the past but also literally destroyed old and existing structures in order to impose new ones in their stead. In the Israeli context, the famous phrase cited among the Zionists, "A land without a people for a people without a land," dismissed local communities residing in Palestine, an approach that led to the destruction of their habitat and to the killing or eviction of hundreds of thousands of people from their homeland in order to make room for the Jewish people, assuring the demographical superiority of the Jews over the Palestinians who remained. The Israeli project of modernization through the occupation of Palestine also made sure Israelis gained access to a certain global elite. It is no surprise, then, that the utopian desire of creating a notation system of universal value has led international researchers to take interest in Eshkol and Wachman's findings so that they were applied in various unexpected contexts. One should also not dismiss the fact that Noa Eshkol was Levi Eshkol's daughter.

Her father served as prime minister of the young State of Israel from 1963 to 1969 at the time when her work was drawing increased international attention. Wachman, on his part, became a leading professor in his faculty and, later on, also served as its dean. Ten years after the publication of their first book, Eshkol and Wachman's research and movement notation was implemented in some of the most innovative scientific projects of their time. While their professional achievements and the validity of their movement notation remain exceptional, I would like to question the intersections between their practice, which emerged from an aesthetic field, and its application in fields related to processes of militarization after World War II.

EWMN and Its Militarized Applications

The neutral and scientific approach of EWMN and the very precise simulation of human motion it offers have increasingly gained national and international interest. This was the case when NASA scientists were looking to create the perfect suit that would allow astronauts to move optimally in the outer sphere as part of Project Apollo (1968–1972). The researchers had to look into the perfect engineering equation between different engineering properties of the suit, such as weight, mechanical complexity, and leak rate, while simultaneously ensuring maximized mobility. While other parameters could be measured with precise existing equations, NASA researchers were missing "measurement techniques and specifications for suit mobility,"[28] as reported by John A. Roebuck Jr., leading engineer and project manager for the Apollo program, in his article titled "A System of Notation and Measurement for Space Suit Mobility Evaluation." NASA scientists delved into research in the humanities and the arts, looking for approaches and measurement techniques related to the movement of the human body. Upon discovering the Eshkol and Wachman movement notation, they found it the most useful for this purpose, specifically as it "presented the notion of a unique directional description of limb position earth-bound conceptions and a spatial coordinate system common to all."[29] In the sketches produced by NASA scientists, one could recognize Eshkol and Wachman's way of mapping and notating the human body, as well as the same logic of measuring its mobility.

Yet, Project Apollo did not emerge in a vacuum. It set out to accomplish the goal of landing a man on the moon in the midst of a global ideological conflict between the United States and the Soviet Union. The United States had already lost a battle to the Soviet Union—that of the first country to send a spaceship to space and to enable a human being to orbit Earth. The Space Race, however, has often been interpreted as a display of technological and strategic power—a way for both superpowers to showcase their military potential. The technologies involved in conquering space were therefore also meant to be translated into warfare. Engineering the launch of spaceships allowed the United States to make instrumental progress and to catch up with the USSR in

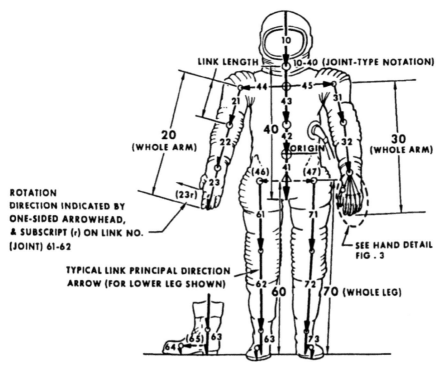

Figure 2. *Link diagram and numerical notation system.*

Figure 6.6

Sketch of the Extravehicular Mobility Unit (EMU) with a link diagram and numerical notation system inspired by the EWMN system. John A. Roebuck Jr., from "A System of Notation and Measurement for Space Suit Mobility Evaluation," *Human Factors* 10, no. 1 (1968): 83.

the development of long-range missile programs. Furthermore, after World War II, the colonial empires began a process of dismantling the colonies that had been established throughout the world prior to World War I. Consequently, outer space became a new territory to be conquered—a new frontier in the competition of global powers.[30] Like a scenario that had already been played out in science fiction, Project Apollo was crucial in making space colonization part of an increasingly likely future. Moreover, the possibility of translating human motion outside of the atmosphere of the Earth, to which EWMN contributed, has led, I would argue, to a paradigmatic shift in relation to the body and the very politics of movement. It literally opened up the possibility of man stepping on and eventually settling on and colonizing new lands beyond planet Earth. It is perhaps quite a big leap to think about the direct link between the development of a dance notation system such as EWMN and the nuclear arms race or the potential colonization of space, but as Gay Morris and Jens Richard Giersdorf remind us, systematic neutrality does not exist, and choreography "can enable, or at least be complicit with colonial, postcolonial, and economically globalizing projects, as much as it can resist such projects."[31]

In the late 1960s, Eshkol and Wachman were directly involved in another ground-breaking project. Upon invitation by the Austrian American scientist Heinz von Foerster, Eshkol (as visiting research professor) and Wachman (as consultant), together with a group of Eshkol's dancers, worked on the notation movement project within the Biological Computer Laboratory (BCL) at the University of Illinois. Founded by von Foerster with support from the Pentagon, and funded by the US Air Force, the US Navy, and NASA, among others, this laboratory examined the possibility of implementing biological processes within computing systems. Von Foerster, who worked in the field of cybernetics, was interested in the reconception of this science within the limits of complexity and unpredictability. The success of EWMN in mapping the movement of both humans and animals was of obvious value for him. Applying his ideas to complex systems "enabled von Foerster to use and extend the [EWM] notation as a control unit for the movement of autonomous robots."[32] During this research, which was funded by the US Army's research department, a computer program was written based on EWMN. In addition, the researchers developed numerous implementations that exemplified how an algorithm could be used to generate actual movement based on symbolic commands. The final report of the project, in which Eshkol and Wachman outlined all the basics of their movement notation, concludes that EWMN "would be of considerable value ... by its immediate applicability to the construction of anthropomorphic automata which are to perform in environments inaccessible or hostile to a human operator, and with which communication is maintained via channels of capacities orders of magnitude below those needed for continuous surveillance and without the benefits inherent in the redundancies of symbolic discourse."[33] Such early experimentations paved the way, I would argue, for the use of automated remote-controlled devices in military and surveillance contexts. Recent implementation of such technologies in the battlefield have further complexified the interconnection between choreography and the military.

Operators now sit at screens, remotely directing the movement and the performance of machines on hostile terrain.

Although von Foerster was unwilling to link his research to military work and now represents the "soft" side of cybernetics, his work entailed an ethical dimension that could not simply be overlooked. Information system researchers Magnus Ramage and Chris Bissell contend that cyberneticists have a moral responsibility toward the military implications of their work. For Ramage and Bissell, "An attempt to ignore the [these] ethical concerns all too often leads to the privileging of those in positions of power."[34] There are no clear records as to whether Eshkol and Wachman were busy with the ambiguous, often militarized, nature of the field of cybernetics in general and the BCL in particular. One can wonder why they never publicly mentioned or discussed their contribution to Project Apollo. To them, the application of their finding as part of Project Apollo was rather marginal.[35] This in itself is rather surprising, given the importance of Project Apollo from a scientific point of view and since it is the third most expensive space program in history. To Eshkol and Wachman, the movement notation system was a work in progress, meant to be implemented and tested in various contexts. But can these implementations of EWMN be observed separately from the larger social and political context of the projects within which they were implemented? And even if unbeknownst to them (which might be the case in Project Apollo), how should an artist or a researcher react when discovering their findings were instrumentalized for purposes they had never envisioned?

"The war and the military always played an ambiguous role in Eshkol's work,"[36] writer and curator Eva Wilson points out. One of Eshkol's greatest supporters throughout her life was Shalhevet Freier. After the establishment of the State of Israel, he led the Mossad's operations in France and was responsible for the implementation of a nuclear pact between the two countries. Later, he was appointed by David Ben Gurion, then Israeli prime minister and minister of defense, to take over the Ministry of Defense's Department of Planning and Research. This institution, later known as Rafael, remains to this day one of the main weapons manufacturers in Israel. Freier also served as the chairman of the Israeli Atomic Energy Committee in the 1980s. As a big supporter of experimentation at the intersection between the sciences and the arts, he was instrumental in the international dissemination of Eshkol and Watchman's book and also supported Eshkol's group activities abroad. Consequently, it is impossible to separate Eshkol and Wachman's work from the ever-militarized Israeli society.

Representatives of the Israeli Defense Forces were also interested in their findings. Michal Shoshani, the director of Noa Eshkol's archive in Holon, recalls a series of meetings between Eshkol and a brigadier general from the Israeli Air Force, in which the two discussed the possibilities of EWMN being used for the analysis of documented aerial battles. Naomi Polani, a dancer in Eshkol's group in the mid-1950s, later became the artistic director of the first Israeli army troops. She choreographed and set the tone for all the army's cultural activities performed for the Israeli soldiers during their service.

Movement Notation as a Template for Documenting the Dances of the Othered

Israel's history as such is deeply embroiled in militarized conflicts through which the country was also able to practice its colonial abilities. As religion historian Daniel Boyarin points out, the ultimate "emancipation" of the Jewish people is "functionally akin to colonisation."[37] As an outcome of the Six-Day War in 1967, Israel's territory expanded tremendously, leading to the occupation of the Gaza Strip, the Golan Heights, the West Bank, and the Sinai Peninsula, the latter being the only territory to be eventually later returned to Egypt.[38] In 1974, Eshkol's group released one of their notation books, this time notating twenty-four Palestinian *dabke* dances as well as Israeli folk dances that appropriated this folklore. The dances were collected by Eshkol's dancer Shmuel Seidel, who traveled between Palestinian villages and notated the different versions of *dabke*. His notations were then brought to the group's studio in Holon and practiced by the other dancers to assess the precision of their notation. "Our hope," wrote Eshkol in the preface of *Debka: Arab and Israeli Folk Dance*, the book that compiled their findings, "is that the present collection will go some way towards preserving a record of the traditional dance style of a culture which is in grave danger of disappearing, as social circumstances change and technological advances reach the Arab villages."[39] While avoiding the very circumstances imposed by the State of Israel and its active part in that same disappearance, she dismissed the imprecise work of anthropologists and ethnologists who "use such excessively generalised terms as 'clapping,' 'stamping,' 'waving arms,' or 'swaying hips,' and try to convey movement qualities by vague expressions like 'soft' or 'wild.'"[40] Instead, she assured "that the formal character of the [*dabke*] dances and the qualities inseparable from the form are in fact preserved."[41] The detailed documentation of all dimensions of life and nature is a process deeply embedded in the colonial project. "The anthropologist who conducts fieldwork in a colonial setting provides that documentation of differences which functions to support continued subjugation of the group he[/she] studies,"[42] wrote architect and professor Diane Lewis around the same time. By applying the movement notation—in Eshkol's view, a more precise methodology than the ones used by anthropologists and ethnologists—to annotate the dances of the indigenous community in Palestine, EWMN played a role not only in the way the movement of the Palestinian bodies was documented and analyzed but also in how it was subsequently controlled and colonized.

Ironically, as Eshkol herself remarked, the Yom Kippur War in 1973, during which a coalition of Arab countries attempted to invade Israel,[43] interrupted the process of working on this book. Shmuel Seidel was called to service on the Syrian front to fight against the same people whose dances he was notating. As Eshkol feared losing Seidel to a war to which she objected and as she felt incapable of composing dances, another practice emerged. This was a sudden turning point in Eshkol's professional trajectory and career. From that day on and for more than thirty years, Eshkol produced more than

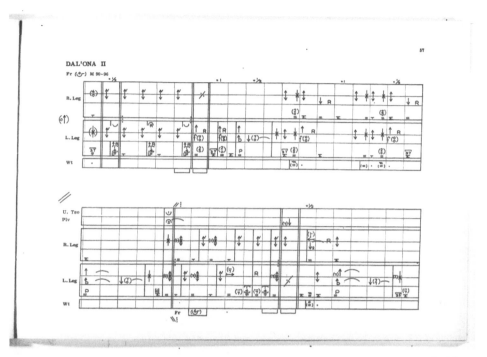

Figure 6.7

Dal'one II (from *Debka: Arab and Israeli Folk
Dance*, 57). Noa Eshkol with Shmuel Seidel, 1974,
movement score. Courtesy of the Noa Eshkol
Archive for Movement Notation.

1,800 wall carpets made from pieces of fabric following a strict set of rules: the pieces were never purchased, only found, they were used without alterations and never cut, none of the fabric patterns included animal or human figures, and no prioritization of forms or colors was allowed. These pure creations of compositions sewed onto fabric became the choreographer's main occupation. She gradually stopped most of her international activity and continued working at her home studio in Holon with a small core group of followers who stayed by her side. Until her death, she remained isolated from institutions. She concentrated on the revision and preservation of EWMN and became increasingly protective about its alteration or distribution.

Defining the "Body Image" of the State

As opposed to the feeling of victory and general euphoria prevailing in Israeli society following the Six-Day War, the Yom Kippur War that endangered the entire Zionist project was followed by major mistrust and criticism toward the Israeli government. Israeli citizens reproached their leaders for not being able to predict the attack from the Arab allied forces. Perhaps it is this disenchantment that also led to a new endeavor in Wachman's work. Ten years after the occupation of the West Bank, when the Israeli settlements project was still in its early stages, Wachman cooperated with Prime Minister Yitzhak Rabin's security advisor, Ariel Sharon, in the creation of the Double-Column Plan. The plan—which Wachman believed would pave the way for the "restoration of the Zionist consciousness"[44]—was aimed at countering the strategically weak geography and dispersion of the Israeli population in the middle of the country, which at the time was no wider than a thin ten-kilometer "column" along the Mediterranean Sea. Wachman saw the occupation of the West Bank as an opportunity to better secure the Israeli territory by creating another "column" of Israeli cities and settlements along the Jordanian border. According to Wachman, nicknamed "the architect of dance notation"[45] by Eyal Weizman in his work *Hollow Land*, blocks of settlements were to be created, connecting smaller rural units with larger urban industrial ones. It also stressed the development of road networks and sought to isolate the mountain areas populated by Palestinians by inserting Israeli traffic corridors that cut across the Palestinian transportation routes.[46] The plan promoted a one-sided solution and urged the Israeli authorities to "take a stand, prepare a comprehensive plan and dictate a geopolitical solution."[47] Wachman believed that only unconditional steps that do "not depend in advance on the consent of the other side"[48] (i.e., the Palestinians) could release Israel from its doomed choreography of violence. The Double-Column Plan was not accepted by Rabin, but Ariel Sharon, who was appointed that same year as minister of agriculture, actively promoted the formation of Israeli settlements in the West Bank. The Double-Column Plan was and still is continuously referred to as the best plan ever designed for the proper securitization of the State of Israel.[49] In the late 1980s, just before the Oslo Accords, its proponents,

including Wachman, founded an association to implement its agenda. The Oslo Accords (1993–1995) de facto fractured the Palestinian territory by endorsing the spread of the already-existing Israeli settlements and the presence of thousands of Israeli settlers on Palestinian land. This same fractionalization was at the heart of the Double-Column Plan, as it proposed "a network superimposed upon another, the pre-existing living Palestinian spaces . . . to split and paralyze the Palestinian one. The result would be several isolated Palestinian cantons, each around a major city, with the connections controlled by Israel."[50]

In an article titled "Israel Must Draw Lines for a Future," published in the *Los Angeles Times* in 1988, Wachman hinted at the interconnectedness of his practice of mapping the movement of the human body and his architectural practice when mapping the territory of the State of Israel as part of his Double-Column Plan. "Moral strength," he wrote, "will no longer work without definite territorial clarity. Israelis, especially the young generation, must have a 'body image' of their land,"[51] provoking an almost pathological relation of (young) Israelis toward their own (incomplete) body of territory. In a morphological analysis of the "solution," Wachman proposed schemes of uni-column, double-column, and multicolumn examples, claiming that the double-column or multicolumn structures "have higher degree of resilience and are superior in terms of interactions within the tissue during peacetime, and are more resistant to the danger of detachment in wartime."[52] The morphologist whose detailed examinations had led to the creation of one of the most celebrated movement notation systems was now analyzing the stability of the Israeli state and presenting a new solution for its, in his eyes, incomplete body, leading to the fractured movement of the Palestinian population through a territorial divide. Wachman moved from a very concrete notation system for dance, exploited in militarized contexts, to a different kind of grammar or notation system, which was supposed to restructure the State of Israel and to create its perfect body politic. Through the construction of a more solid territorial grip, Wachman hoped to counter the moral and economic deterioration that had, in his opinion, taken over Israeli society. He also hoped to bring new sense to the Zionist movement that, in his view, had lost its direction.

Blurry Manifestos

"We live within political systems that have an increasing interest in physical movement, or perhaps just an increasingly effective control over it,"[53] wrote Israeli political theorist Hagar Kotef. In her book *Movement and the Ordering of Freedom*, she focuses on movement as a concept not only for the liberation and emancipation of a modern subject but also through which control of one's rights can be limited or taken away completely. Not only has the taxonomy of gesture in human mobility, as demonstrated within EWMN, contributed to the modernist and contemporary aspiration of optimization of human (Project Apollo) and nonhuman (BCL) mobility, Wachman, its co-creator, also attempted

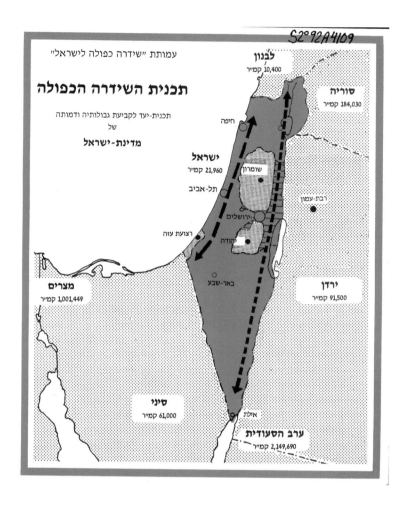

Figure 6.8

Cover image of the Double-Column Plan
association booklet, 1990. From the collection of
the National Library of Israel.

to contribute with his expertise to the reshaping of his state's occupation apparatus, which would consequently lead to the limitation of people's freedom of movement. Moreover, these extra-choreographic articulations of EWMN attempted, in one way or another, to intervene in a certain vision of the future. But exactly what type of future do they lead us to envision?

The genuine attempt by Eshkol and Watchman to map out bodily movement within an aesthetic field of dance has created a template or a tool that can be used and further developed for militarized purposes. Jacques Rancière's concept of "the distribution of the sensible" is grounded on such a porosity between the "aesthetic" avant-garde and the "political" avant-garde. For him, "the notion of the avant-garde defines the type of subject suitable to the modernist vision and appropriate, according to this vision, for connecting the aesthetic to the political."[54] It is at work when groundbreaking ideas transcend the artistic field and actively operate and make a shift in the political sphere through innovation. As author and poet Hans Magnus Enzensberger reminds us, avant-garde—the very concept that connects to groundbreaking experimental, radical, or unorthodox thinking within the arts—is derived from a French term referring particularly to that part of an army that goes ahead of the rest: the main body and the arrière-garde. It has emerged historically in relation to revolutionary movements and ideologies and often expresses an aspiration to freedom gained through resistance. But, as Enzensberger points out, "it remains vague and blurry just what freedom the manifestos of the artistic avant-garde have in mind and what the world *revolution*, frequently though it may appear in them, is supposed to mean there."[55] Modern warfare is a laboratory where aesthetically innovative tools are continuously appropriated for the creation of innovative technologies used for new forms of military experimentations.[56] The aforementioned examples also suggest that body-related knowledge is much more significant to the development of modern warfare than the classical historical readings would have us think. Wars and conflicts have always been the forefront hubs for some of the most groundbreaking inventions, both constructive as well as destructive, and it seems that it is through the arts—literature, music, fine arts, and why not choreography—that some of these tools are imagined and, at times, actualized.

Notes

Thanks to Iris Lana, Amos Hetz, Michal Shoshani, and Mor Bashan for our conversations and to Iris Lana, Yali Nativ, Anders Engberg-Pedersen, Martín Zícari, and Sandra Noeth for their feedback and guidance during the writing process of this essay.

1. Gay Morris and Jens Richard Giersdorf, eds., *Choreographies of 21st Century Wars* (New York: Oxford University Press, 2016), 12.

2. *Archive* (2014) uses footage filmed by B'Tselem—the Israeli Information Center for Human Rights—to challenge the embodied violence of the Israeli society. *Talos* (2017) criticizes an eponymous EU-funded securitization project promoting the development of land drone technology to

survey the borders of Europe. *Necropolis* (2021) is based on the thorough investigation of a list—established by the UNITED civil network—which registers people who lost their lives in an attempt to enter Europe. The project commemorates and collects data on these often-unacknowledged deaths.

3. Eda Cufer, "Art System and Post-WWII Avant-Garde Art," *Springerin* 1 (2011).

4. Cufer, "Art System and Post-WWII Avant-Garde Art."

5. The return of the Sinai Peninsula to Egypt in 1978 marked the end of this process. Nonetheless, another slower, more gradual movement of the borders is still taking place inside the occupied territories of the West Bank.

6. Zvi Yanai, "Notation for Liberation of Movement," *Contact Quarterly* 7, no. 2 (Winter 1982): 11.

7. Avraham Wachman in Ifat Finkelman, "An Anatomy of Space and Body, the 'Eshkol–Wachman Movement Notation' (EWMN) in the Context of Post-War Architectural Culture," MSc thesis, Heb., 2010, 82.

8. Noa Eshkol in Finkelman, "An Anatomy of Space and Body, the 'Eshkol–Wachman Movement Notation' (EWMN) in the Context of Post-War Architectural Culture," MSc thesis, Heb., 2010, 17.

9. Finkelman, "An Anatomy of Space and Body, the 'Eshkol–Wachman Movement Notation' (EWMN) in the Context of Post-War Architectural Culture," MSc thesis, Heb., 2010, 11.

10. Noa Eshkol, "Preface," in *Noa Eshkol, Right Angled Curves (Dance Suite)* (Holon and Tel Aviv: The Movement Notation Society and Tel Aviv University, 1975), 5–6.

11. Following the fall of the Ottoman Empire, between 1920 and 1948, the mandate to rule over the Palestinian territory was given to Great Britain by the League of Nations, the first intergovernmental organization responsible for maintaining world peace. During the course of this mandate, and following the Balfour Declaration (2017), the British government promoted the establishment of a national home for Jews, back then a small minority in the region, in Palestine.

12. Theodore Herzl, *Der Judenstaat* (*The Jewish State*), MidEastWeb, http://mideastweb.org/jewishstate.pdf, 45.

13. Max Simon Nordau, *Zionistische Schriften "II. Kongressrede"* (Cologne: Juedischer Verlag, 1909), 379–380, translation Umland Joshua with the help of Shneer David. Cited in Joshua Umland, *Max Nordau and the Making of Racial Zionism* (Boulder: University of Colorado Boulder, 2013), 5.

14. Nordau, *Zionistische Schriften "II. Kongressrede."*

15. Noa Eshkol and Avraham Wachman, "Introduction," in second draft of *Movement Notation*, type-written and handwritten booklet, 1956, 2.

16. Finkelman, "An Anatomy of Space and Body," 2.

17. Online interview conducted with Iris Lana on July 10, 2021.

18. Susanne Franco, "Energy, Eukinetics, and Effort: Rudolf Laban's Vision of Work and Dance," in *Energy and Forces as Aesthetic Interventions*, eds. Sabine Huschka and Barbara Gronau (Bielefeld Germany: transcript Verlag, 2019), 155–174.

19. The attempt to document dance outlined in the book paved the path toward the modern use of the term "choreography."

20. Another *maître de danse*, Pierre Beauchamp, later claimed to be the original inventor of this notation system.

21. Morris and Giersdorf, *Choreographies of 21st Century Wars*, 8.

22. Evelyn Dörr, "Rudolf von Laban: The 'Founding Father' of Expressionist Dance," *Dance Chronicle* 26, no. 1 (2006): 19.

23. Yanai, "Notation for Liberation of Movement," 4.

24. Yanai, "Notation for Liberation of Movement," 4.

25. Yanai, "Notation for Liberation of Movement," 11.

26. Ramsay Burt, "Living Archives Sharon Lockhart's Collaboration with Noa Eshkol," in *Sharon Lockhart | Noa Eshkol*, eds. Daniela Zyman, Eva Wilson, and Thyssen-Bornemisza (London: Art Contemporary Sternberg Press, 2012), 56.

27. Burt, "Living Archives," 57.

28. John A. Roebuck Jr., "A System of Notation and Measurement for Space Suit Mobility Evaluation," *Human Factors: The Journal of the Human Factors and Ergonomics Society* 10, no. 1 (1968): 80.

29. Roebuck, "A System of Notation."

30. Before discovering the Americas, their potential existence was already thought of as an outer space, and their potential inhabitants were thought of as aliens. It is also not a surprise that the European Space Agency's space lab is called Columbus, hinting to the new extraterrestrial frontiers to be explored and conquered.

31. Morris and Giersdorf, *Choreographies of 21st Century Wars*, 7–8.

32. Joana Chicau, https://joanachicau.x-temporary.org/, accessed October 4, 2022.

33. "Notation of Movement," final report, covering the period March 1, 1968–August 31, 1969, grant DA-ARO-D-31–124-G998, sponsored by US Army Office-Durham, Department of Electrical Engineering, University of Illinois, Urbana, Illinois, 61801, February 15, 1970, Preface, v.

34. Magnus Ramage and Christopher Bissell, "Cyberneticist at War and Peace: Wrestling with Ethical Dilemmas of Information," in *The Difference That Makes a Difference* (DTMD 2015), Vienna University of Technology, Austria, June 5, 2015, 4.

35. No archival records are found in Noa Eshkol's archive that could indicate any contract or economic engagement between NASA and Eshkol and Wachman as indicated to me by Michal Shoshani, the director of Noa Eshkol's archive in Holon.

36. Eva Wilson, "Une Espèce de Sympathie: Eshkol's Spheres and Lockhart's Loxodromes," in *Sharon Lockhart | Noa Eshkol*, eds. Daniela Zyman, Eva Wilson, and Thyssen-Bornemisza (London: Art Contemporary Sternberg Press, 2012), 63.

37. Daniel Boyarin, "The Colonial Drag: Zionism, Gender, Mimicry," in *The Pre-occupation of Postcolonial Studies*, eds. Fawzia Afzal-Khan and Kalpana Seshadri-Crooks (Durham, NC: Duke University Press, 2000), 238.

38. The Israeli disengagement from the Gaza Strip took place in 2005, but Israel is still de facto controlling all aspects of life of the Palestinian population residing there.

39. Noa Eshkol, *Debka: Arab and Israeli Folk Dance* (Holon and Tel Aviv: The Movement Notation Society and Tel Aviv University, 1974), 5.

40. Eshkol, *Debka*, 5.

41. Eshkol, *Debka*, 5.

42. Diane Lewis, "Anthropology and Colonialism," *Current Anthropology* 14, no. 5 (December 1973): 584.

43. In the early stages of the Yom Kippur War, when Israel feared losing due to the surprise attack from the neighboring Arab countries, the then Israeli minister of defense Moshe Dayan proposed to the then prime minister Golda Meir to check the possibility of launching an atom bomb against the Arab armies. Shalhevet Freier was called to the office to discuss the consequences of this option. The discussion eventually didn't take place, as Golda Meir refused this option. In 1977, during the discussions leading to the peace agreements between Israel and Egypt, when questioned about the reasons for the Egyptian army to abort the attack on Israel during the Yom Kippur War, one of the members of the Egyptian delegation mentioned, "Don't think that we don't know . . . You have an atom bomb."

44. The Double-Column Plan association booklet, March 1990, 15. This document is stored in the National Library of Israel. It is a second edition of the booklet originally printed in the 1970s.

45. Eyal Weizman, *Hollow Land, Israel's Architecture of Occupation* (London: Verso, 2007), 80.

46. Weizman, *Hollow Land*, 81.

47. The Double-Column Plan association booklet, 7.

48. The Double-Column Plan association booklet, 7–8.

49. See, for example, an article by Amir Yosi, "Perception of Settlement—The Double Column Plan," *Jokopost*, January 21, 2022, https://jokopost.com/thoughts/36355/, accessed March 8, 2022, or the article by Prof. Haas Elisha, "Strategic Political and Military Thinking Necessitates Strengthening the New Settlement of Eviatar," *Mida*, June 22, 2021, https://bit.ly/3MvGOXs, accessed March 8, 2022.

50. Weizman, *Hollow Land*, 81.

51. Avraham Wachman, "Israel Must Draw Lines for a Future," *Los Angeles Times*, April 17, 1988.

52. Avraham Wachman, "The Double-Column Plan, An Outline for a Territorial Solution and an Overall Physical Plan," *Horizons in Geography* 3 (1977): 48–49.

53. Hagar Kotef, *Movement and the Ordering of Freedom, On Liberal Governance of Mobility* (Durham, NC: Duke University Press, 2015), 1.

54. Jacques Rancière, *The Politics of Aesthetics, The Distribution of the Sensible* (London: Bloomsbury), 29–30.

55. Hans Magnus Enzensberger, "The Aporias of the Avant-Garde," in *Modern Occasions*, ed. Philip Rahv (New York: Farrar 1966), 88.

56. Anders Engberg-Pedersen, "Technologies of Experience: Harun Farocki's Serious Games and Military Aesthetics," *Boundary 2* 44, no. 4 (2017): 162.

II

REIMAGINING TECHNOLOGY

7

Eyes, Ears, Mouths: A Sensorial Military Triptych (with Satellite, Electronic Music, and Vocoder)

Ryan Bishop

Under glass: glass dishes which changed in color
a household iron; bundles of wire become solid
lumps of iron; a pair of pliers; a ring of skull-
bone fused to the inside of a helmet; a pair of eyeglasses
taken off the eyes of an eyewitness, without glass
which vanished, when a white flash sparked
—Galway Kinnell, "The Fundamental Project of Technology"[1]

Armaments and Aisthesis

In a sense, almost all military technological development from the middle of the nineteenth century to the present is essentially aesthetic, in that it is an attempt to extend and modify human perception prosthetically in order to accelerate judgment and inform action. In other more common and connotative meanings of aesthetics, military technology during this same time period has informed traditional aesthetic modes of cultural production in the arts: popular and high, conservative and avant-garde, traditional and experimental. Rather than looking at the military and its operations as the *content* of artistic and aesthetic exploration, this chapter explores military technology as the conditions of possibility and means of production for artistic works and explorations, an exploration intended to bring this technology's capacity for sensorial extension and alteration into explicit public engagement. These means are simultaneously material, technological, and imaginary (noetic), with specific theoretical strands linking seemingly disparate sites, desires, functions, applications, and results. As such, the goal is to understand the works and their media formation as both a product of an aesthetic condition and constitutive of that condition.[2]

The main assertion being put forward in this chapter is that military technology has altered the sense of human perception (aisthesis) and judgment or value (aesthetics) as it pertains to our understanding and experience of time and space (metaphysics). The connections between aisthesis and armaments, or aesthetics and war, find form for us through the alterations of metaphysics that constitute our perception of the world and our positions within it: a metaphysics, then, of military aesthetics as an entire sensorial and perceptual domain. Tele-technologies, broadcast media, and recording/storage/

reproduction technologies all interpret time and space anew, altering our commonsense understanding of them as well as our imaginaries in relation to them.

Metaphysics, as initially formulated in ancient Greek philosophy, addressed first causes and first principles: things that do not change, the building blocks of the observable world. These are immutable phenomena, including being (ontology), time and space (physics), and God/Deus (transcendentalism that is literally meta—or beyond—physics). The list expands or shrinks, especially as philosophy shifts focus from the ancient world to the medieval and into the Enlightenment. Time and space, however, remained immutable in many ways, but mostly with regard to their status as sites of inquiry: Were they natural phenomena and objects? Or sets of relations? Or systems of sets of relations? Or human-generated illusions? Regardless of posited answers to these questions, their stubborn literalness as impediments to human understanding and action cast them as foundations of both physics and metaphysics. Rendering these supposed "immutables" subject to human manipulation and thus turning nature to human advantage, even in the most instrumental fashion, marked a shift from science (as description) to technology (as enacted scientific knowledge).

The heady combination of *techne* and *logos* took direct aim at the barriers imposed by time and space, particularly in technology's manifestations known as media, from writing to long-distance signals to telegraphs to wired/wireless technologies and those reproductive and broadcast technologies that can allow the dead to speak in the present and the present to be everywhere at once in real-time tele-technologies. The attraction of such control over physics in the form of metaphysical manipulation (through alterations of time and/or space relations) for the military reaches back to weaponry used at increasingly further distance and remains at the avant-garde of military research. One important result of this is the mutually influential material and immaterial interaction of technological imaginaries in which imaginaries influence technological development and technological change fires imaginations—a cycle we can call "techno-noetics."[3]

Aisthesis, at the risk of oversimplification, is the ancient Greek formulation of the awareness of and response to stimulation external to the body that emerges as part of the eighteenth century's philosophical apparatus, entering the lexicon from Baumgarten through to Kant, where it takes on a critical hue.[4] Famously, or perhaps infamously, aisthesis (coupled with nous) receives contradictory engagement by Aristotle, who linked it to noesis, ethics, and phronesis in different works. Because ethical judgment in Aristotle depends on perception—which for him is a specific kind of perception, one especially attuned to what others might not have the capacity to detect or discern—the stage is set for its activation through aesthetics, marking it as an order beyond sheer sensation and more aligned with consciousness as commensurate with awareness.

Partly as a reaction to rationalism, materialism, and empiricism, aesthetics constitutes fields of judgment and assessment (the inner experience and interpretation of external reality). Aisthesis, particularly in the influential Platonic lineage, has a lower-level agenda concentrating on the bodily response to any and all stimuli, but also quickly includes (via Aristotle and others) concomitant capacities for interpreting such sensations in terms of safety, pleasure, cultural or symbolic import, and individual as well as collective relevance. Baumgarten's belated (in historical and philosophical terms) conversion of aisthesis into aesthetics seems a somewhat easy step when considered from this perspective.

An example from Gregory Bateson might help us grasp more concretely some consequences of a shift from aisthesis to aesthetics. In his primer *Mind and Nature* from 1972, Bateson includes a chapter cheekily entitled "Every Schoolboy Knows . . ."[5] One of the entries provided for this set of primary foundations of knowledge addresses taxonomies by claiming that the division of the perceived universe into parts and wholes is a useful, and perhaps necessary, tool for human cognition. However, he notes—and this is the key point—*no necessity determines the division*. In other words, how we choose to group together perceived phenomena and their aggregate parts has nothing to do with the phenomena. Rather, it depends on our deciding what is a difference that makes a difference (and in that is all the difference in the world). In our framework, the perception of the universe is aesthesis, and how we divide it at any given time-space configuration is aesthetics, bestowing the division with meaning, value, and judgment. Understanding how the meaningful distinction is made, in turn, alters our understanding of how we understand generally, just as visual technology reconstitutes seeing and the meaning of the eye, sight, visibility, and the seen object. Specific innovations in visual technology reconstitute our understanding of what vision is; for example, Kepler's discovery that the eye and the telescope were optical devices of essentially the same geometrical construction.[6] The entire ontological and epistemological nexus becomes reformulated. This recursive process is ongoing and possibly without end.

The experience of time and/as space offers a fecund exemplification of this recursive process. Disrupting time as lived, experienced, and imagined marks clearly the move from aesthetic acts of ethics and judgment to those of metaphysics. For example, Wolfgang Ernst examines how electrotechnical tools result in "media-induced disruptions of the human perception of time."[7] Within the larger analog experience of modernity and its various medial formations, Ernst argues that either the delays or acceleration of speed remained configured and experienced as phenomenological "time" complete with its linear directionality in Western formulations. But "active digital calculation" has ruptured this line and decoupled time in our imaginaries and experience from its existence as a "despotic signifier."[8]

Slow-motion visual or aural technology reveals this decoupling of time's dominion as a uniform unfolding of events while simultaneously exemplifying the modernist military (and industrial) desire to exert increasingly greater control over temporal phenomena by rendering them spatial. Modern and contemporary modes of acceleration and temporalities as spatially stored units for easy reproduction and organization find perhaps their quintessential form in antiquity with the advent of alphabetical and notational writing (which is why music and poetry became the first domains of mainframe computational aesthetic experiments[9]). The conversion of the inherent evanescence of oral language into "frozen speech" (cf. Ong) is just the kind of technical media "practices that use strategies of spatialization to enable one to manipulate the order of things that progress in time"[10] that form the basis for what Sybille Krämer, Wolfgang Ernst, and others call "time axis manipulation." This capacity allows for not only the storage of temporal phenomena but also the potential to reorder it and restructure it (as with the metaphysics of cinema best evidenced in reverse motion: the shattered glass of water emerging from the floor to assume its unbroken form in the hand with liquid duly contained). For Ernst, "time-critical media" offer just such an alteration of human time, operations that escalated with digital technologies.

Many of the works examined in this chapter can be delineated as "techno-chronoaesthetics," most easily found as microtemporalities produced through military medial instruments. The neat cleaving of time from space in terms of media, aesthetics, technics, and perceived experience is a task performed only through oversimplification or elision of problematic entanglement. As a kind of updated militarized version of Lessing's *Laocoön*, the arguments here suggest the essential attribute of this update occurs with *alterations of space resultant from time-based technics and the modification of time with space-based ones*. And these technics have military provenance or significant military research and development input. All tele-technologies, as Virilio reminds us, convert geographical space into "real time."[11] Over there becomes right now, and it does so through more than a century's sustained technological research combined with the wealth of nations. Examining photography, sound installation, music, and cryptography, we can map some causal relations between armaments, aesthetics, and metaphysics.

The division of history into a kind of progression that moves from mechanical to electric to electronic technologies that in turn shift from time based to time critical, according to Ernst, cannot sustain its linear narrative structure. Digital thought processes found in the application of analog technologies such as writing, print, chrono-photography, phonography, or cinema (as exemplified by Muybridge and Marey and Edgerton) reveal digital precursors to and through analog mechanical media, reconstituting the simple divisions of analog, digital, and post-digital chronological lineage and epochs, none of which is to ignore the import of the steps taken with alphabetic writing

and discrete symbol-based print and the challenges to it made by audiovisual signal recording and transmission, only to return to a kind of truncated alphabet with binary code in digital technologies (*pace* Ernst 2016).

This paper's triptych structure operates around the logic of eyes, ears, and mouths as metonyms for the senses and media involved. Photographic works by Trevor Paglen and Harold Edgerton in the section on eyes are followed in the section on ears by a work from sound artist Leif Inge, and the section on mouths listens to vocoder music from Wendy Carlos, all of which leads to "noetic-technics" resultant from and in metaphysics (in the most denotative sense): a beyond space and time emergent from space and time as experienced. These artistic works exploit military technologies that operate in spectrums of sensation that reside beyond human apprehension and help render them apparent again.

Eyes: Ballistic Aesthetics

Sky is to the 20th Century what landscape was to the 19th Century.
—Jack Goldstein, *Aphorisms*[12]

When a missile threatening in "real time" is picked up on a radio or a video, the present as mediatized by the display console already contains the future of the missile's impending arrival at the target.
—Paul Virilio, *The Vision Machine*[13]

The final chapter of Paul Virilio's (1989) *War and Cinema* is titled "A Traveling Shot over Eighty Years." Penned in the 1980s, this traveling shot is now more than a century old. It also becomes the final (and/or initial) missile impact in Pynchon's *Gravity's Rainbow*, a parabolic arc that again takes decades to find its target in the form of a Los Angeles movie theater in the 1970s. These temporally attenuated and time-defying—or perhaps time-defining—technologically traced arcs of visual imagination exemplify the ballistic aesthetics found in the photographic works and experiments by Trevor Paglen and Harold Edgerton to be discussed here.[14] Ballistic aesthetics becomes ballistic aisthesis on impact. Virilio's "deadly harmony" between eye and weapon function chimes throughout this first panel of the triptych.[15]

US artist Trevor Paglen's work "Keyhold Improved Crystal from Glacier Point (Optical Reconnaissance Satellite USA 186)" is part of his 2014 series *The Other Night Sky*, and it documents that which is largely invisible to the unaided eye and covertly hidden from public discourse and knowledge. This photograph is an analog piece fully informed by digital technologies and made possible only through computer-based calculations. It thus reveals complexities of intertwined histories and the co-presence of different temporalities operative in technologies, aesthetics, and inheritances and the effects of

Figure 7.1
Trevor Paglen, "Keyhold Improved Crystal from
Glacier Point (Optical Reconnaissance Satellite
USA 186)," 2014. Image used with permission from
the artist.

Ryan Bishop

them in our collective daily visual experience. In an artist conversation I conducted with Paglen in Berlin, he spoke at length about his innovative project "The Last Pictures," which entailed putting a chip of images into geosynchronous orbit on a satellite and thus leaving them in space for tens of thousands of years, likely far beyond the span of humans on Earth. It is a grand project—and one relevant for this discussion—but we also discussed his seemingly innocuous landscape image that is apparently an homage to and continuation of landscape photography in the American West, but only apparently so, operating with a subtle shift of figure and ground so that we look to the night sky and not the dimly illuminated terrain.

He explained what one empirically sees when gazing at the photograph: an image of Yosemite in California taken in the middle of the night, so that, in the upper half of the image, we see lines of light made by stars. But about halfway up the image, on the left side, there is a streak made by a reconnaissance satellite called "USA 186," and it is an imaging satellite. So, Paglen is taking a photograph of Yosemite while photographing a spy satellite above Yosemite that was photographing him while he is photographing it. This image works on many different levels: the history of photography, especially in the West, in America; the construction of the iconicity of the landscape in the United States; the role of military experimentation in the West of the United States; the Western frontier as a site of technological and existential experimentation; a contemporary take on the landscape genre as the articulation and enframing of power; and a meditation on the US frontier.

The conceptual and material elements that cohere in Paglen's single image bespeak the acceleration of the visual field and the actual occupation of territory through technological developments that migrate from a camera to atomic weapons to imaging satellites. The rudimentary concerns that guided Norbert Wiener to calculate through computational means the ballistics required to shoot down ever-faster planes and ordnance became the basis of cybernetics when he had to include self-correction within the systematic loop of firing at an accelerating target. These same calculative concerns occupied Paglen for him to shoot the satellite because he needed to pull his photographic subject from the night sky at a specific moment, chart its trajectory using advanced computational methods, and rely on maps provided by amateur sky sleuths who track secret spy satellites via random scraps of data, leaked information, and high-powered telescopes. Determining satellite positioning, exposure times, and aperture time ratios put Paglen in the midst of firing calculations to produce ballistic aesthetics.

Paglen points out that the history of photography in the American West is also the history of military seeing in the West, both ideologically and technologically in terms of the visualizing machines that constitute the two histories. The classic Yosemite images from the nineteenth century were taken by people such as Carleton Watkins, Timothy O'Sullivan, and Eadweard Muybridge, who spent long periods of time photographing

large parts of the West, including Yosemite, while working for the Department of War on "survey missions" that were collected in large tomes titled the *Reconnaissance Survey of the American West*. At play, therefore, is the ideological and colonial tradition of seeing "the unexplored land"–purloined landscapes deemed not only *terra nullis* but also *res nullis*. Mining the aesthetic logistics of these photographs and reconnaissance surveys while also supplementing them, Paglen's photograph offers a contemporary perspective of the deeper temporalities of seeing and control of both the land and its indigenous population.

Muybridge shifts directly from photographing Yosemite to starting his chrono-photographic studies of horses that materialize not only movement in nature invisible to the unaided eye but also the technological innovation of synching a camera shutter to temporal events occurring in the world. His work is extended some decades later by Harold Edgerton, who further speeds up the process with his stroboscopic photographs made at the MIT, following Ernst Mach and the literal ballistic aesthetics of shooting apples and playing cards with bullets. Edgerton's work catches the attention of the US military, and he is hired by the Department of Energy to photograph nuclear bomb tests. The department wanted to photograph the first few nuclear explosions in a time-lapse manner such that they can examine how a nuclear explosion evolves over thousandths of a second. As with the horses galloping and the bullets passing through objects, in order to make very high-speed movement visible, one must slow it down.[16] And to slow it down, the photographic process must be made atomistic and digital in conceptualization if not in technology–that is, generated for potentially infinite exact repetitions of discontinuous data. And Edgerton does just this and at startling speeds.

The next step in the process constitutes an intensified technological feedback loop because the military realizes that Edgerton's camera shutters are actually more accurate than the triggers being used in the nuclear weapons. These mechanisms are effective not only for documenting a bomb's explosion but also for igniting one. Quite literally, then, the shutters migrate from the cameras and become triggers for nuclear detonations. The resultant images can capture the physical effects that they trigger: cause and effect in one visual technological mechanism called a "rapatronic shutter," which used filters and magnets to slice time into microunits.

There exists one more pivotal step operative in Paglen's image. The company set up by Edgerton, called EG&G, operates as a defense contractor and starts building spy satellites equipped with powerful cameras, as one might imagine. The military technological tradition that traces its sources to sites such as Yosemite can also be found in a figure such as Paglen photographing Yosemite in the present, but that tradition is also in the exoplanetary surveillance ring in the sky. Paglen notes that the televisual surveillance apparatus in geosynchronous orbit is just as much a decedent of Timothy O'Sullivan or Muybridge as he is when taking this image.

Ryan Bishop

Edgerton's images taken at one half of one millionth of a second also sketch indelibly a landscape of the second half of the twentieth century: a geography of test sites in the US West as well as atolls in the South Pacific. These artistic landscapes spatialize time operating at vastly different scales: the extreme rapidity of the magneto-optic shutter intersecting with the deep, geological time of radiation poisoning (for Edgerton) and geosynchronous satellites orbiting the Earth until the planet is no more (for Paglen). The cross-functional aesthetics at play in the images aid us in understanding the political nature of temporalities and temporal functions as "an attempt to make sense of the multiple speeds that define various techniques, actions, infrastructures, and not least, lived experiences of contemporary culture."[17] The microtemporalities frozen in Edgerton and macrotemporalities gestured to in Paglen reveal a spectral range that scales astronomically and biochemically: scales, which of necessity *as* scales, imply each in the other. These scales are insensible for humans until rendered in legible forms, means of abstracting, visualizing, and hearing what eludes our sensorium. This spectral range repeats multiple means of inscription to still and frame temporalities for aesthetic and geopolitical functions and controls and, in the process, remakes aesthetics through and as geopolitics: an experience of slowness made medially possible to the senses, to ontology, and to collective imaginaries.

The process Paglen delineated regarding the transfer of the technologies that allowed Edgerton's rapatronic camera and its bespoke magneto-optic shutter to migrate from the camera into the nuclear weapon itself has an earlier link to his experimentation with lightning photographic techniques from the 1930s, as well as flash systems for reconnaissance aerial photography conducted at night during World War II.[18] Similar combinations of capacitors used in these nocturnal flight missions made their way into the detonation mechanisms for nuclear bombs.[19] The synced strobe effect and light shutter developed further in the studio after World War II allowed photography to slice and freeze time for later alteration, application, and study at previously unimagined speeds. In the instance of capturing the development of the nuclear explosion, the magneto-optic shutter refined from earlier experiments allowed time to be sliced less than one half of one millionth of a second (0.5 msecd). Edgerton's archive includes a photograph from Eniwetok Atoll in 1951 in which the nuclear fireball just emerges, some time between 0.0 seconds and 0.0006 seconds, and in that fraction of a second before it becomes the iconic mushroom cloud. The microtemporal slices of the initial second after ignition shaved into milliseconds mark the rapatronic's technics in full and different from the Trinity test images from six years earlier. The resultant multitemporal reality in these photos marks the millisecond "where slowness entangles with the ... time-critical media that are of time, but more importantly [that] manipulate the time axis, which (in)forms our horizon of perception, ethics and more."[20] That is, the images show a micromoment of aesthetics and judgment that rearranged our collective relationship with time.

Within the immediate context of much of the research examined here (the historical Cold War and its continued legacies), the capacity to harness the controlling power of slowness in the name of acceleration (*pace* Virilio) offers both a strategic and aesthetic insight into complex correlations of temporality, materiality, and noetic interactions. Usefully for our purposes here, O'Gorman and Hamilton, mining a rather Virilian vein, link the images EG&G produced of the nuclear cloud to a "deep" medial connection between the technologies of photography and ballistics,[21] underscoring the frame posited here with both Paglen and Edgerton in terms of ballistic aesthetics. The processes deployed, they argue, for these deep media are "*timing, firing* and *exposing*,"[22] all of which prove integral to the capacities and performance of photography and explosive devices.

The atomic bomb test images by Edgerton include military-generated technology as both content and aesthetic medium. The images teach us about the performance of the technological apparatus depicted in them as well as of the apparatus that renders them visible. They embody, capture, and delineate "the context where the psychotechnics/film of technical media becomes the logistical operation of military aesthetic."[23] The aesthetics on display alter time, quite clearly, and have an artistic visual appeal, but they function more as "operational images" in Farocki's terms. Jussi Parikka underscores the institutional role of operational images as an "automation of perception where images are part of a broader system of analysis, identification, tracking, and, indeed, often destruction."[24]

During the historical Cold War, unlocking the means to measure atomic yield of friendly and adversarial weapons, as Edgerton's milliseconds were intended to perform,[25] proved a key cryptographic quandary, whether in visual, aural, or synesthetic forms. Waves, signals, and frequencies filled the military's sensorium. And microtemporal patterns that lay beyond the senses, accessible only by increasingly intensive research into targeted technics, gained exponential momentum. The measurement, recording, storage, and manipulation of temporal phenomena in aural forms are taken up next.

Ears: The Frequency of the Cold War

The cultural and scientific history of the bell provides an example of how one can write cultural history as signal analysis.
—Bernhard Siegert, "Mineral Sound or Missing Fundamental: Cultural History as Signal Analysis"[26]

The capacity to discern the difference between an underground nuclear explosion and natural geological occurrences, such as earthquakes, resides in an aesthetic judgment of a particular stripe, or, rather, it entails transferring that discernment to a frequency or sine wave. How to accomplish this feat resulted in the resuscitation

of a centuries-old mathematical formula sped up for fast calculations through the dromoscopy of military technological demands to slow time. It has become perhaps the most ubiquitous algorithm going today, used in audio signal processing, medical imaging, data visualization, radar, telecommunications, spectral identification, and pattern recognition, as well as electronic music, among other areas.[27] Known as the Fast Fourier Transform (FFT), this hyperactively applied algorithm has its contemporary provenance in telecoms, military geology, and sound synthesis research instigated at the Pentagon and Bell Labs.

The FFT, as famously codified by Cooley and Tukey in 1965, has been described as "an algorithm the entire family can use."[28] Our branch of this family tree is primarily those applications of spectral analysis shaping audio engagements with space (remote sensing, Cold War geology, telecommunications) and time (temporal manipulation) in both military and artistic applications. With mathematical roots back to early nineteenth-century speculative formulations and drawing on theories of periodic oscillation from the third century BCE, "Fourier's solution of all continuous functions (including musical notes) into sums of pure sine harmonics was achieved before Heimholz and Edison."[29] It remained an interesting but not terribly useful mathematical formulation until the 1960s in the form of the FFT. The formula gained rapid and widespread application when Tukey tweaked the model during a meeting held by John F. Kennedy's Science Advisory Committee. In order to ratify a nuclear test ban treaty with the Soviets, means of detecting atomic tests remotely (i.e., without traveling to Soviet nuclear sites), seismological time series accessed by various offshore detectors could be used successfully. However, the computing power and time required for such analysis precluded this solution until Tukey's reduction of the Discrete Fourier Transform into its faster version: the FFT.

In 1959, Vela Uniform was established at the end of the Eisenhower administration to provide adequate capacity for the US military to detect and locate nuclear explosions, whether underground, underwater, or in the upper atmosphere. This project constitutes a primary accelerant for massive research into remote-sensing technologies and media. Three years into the Vela Uniform project, its lead, Dr. Charles C. Bates, offered an update of progress to that point at the 1962 Symposium on the Detection of Underground Objects. Bates claimed the portion of the Vela Uniform mission relevant to those gathered at this symposium that the Advanced Research Projects Agency held on behalf of the US Department of Defense (DoD) was to "undertake research, experimentation and systems development to obtain at the earliest practicable date a system for the detection of nuclear explosions underground."[30] In essence, they were tasked with trying to build acoustic signatures for earthquakes and explosions to distinguish between the two and to verify events in Siberia: a site of both underground testing and much tectonic shifting. Thus, the Soviets could aurally camouflage nuclear tests or

claim misinterpretations of these as actually being natural phenomena and not military technological.

As noted, the spatial dimensions of FFT exploration are actually accessed via time, and the temporal via space. Seismic measurements occur through analysis of temporal data, and the gleaning of these data is made possible by making them into discrete spatial units, as with Edgerton's photos. The inextricable intertwining of time and space continually tells the story that the alteration of one can be found through the other. Such were the assumptions driving much technological research and development during the Cold War.

The aesthetic ramifications of such research, however, were relegated to secondary or tertiary status when the ultimate judgment that determined the success of the mission actually proved it primary. Remote sensing functions as a kind of machinic aisthesis to generate a spectral identity, although the setting of sensors to filter specific kinds of data actually renders it machinic aesthetics even before generating a spectral identity. The need to sort and sift, to sense selectively with remote-sensing tools, establishes a necessary discernment even at the "raw data" collection stage. More aesthetic judgment emerges in the spectral identity: a trace in need of deciphering and interpretation. The spectral stamp might be better understood as spectral agency, such was the chain of actions, operations, decisions, and affordances the windowed or framed signature of sound or vibration waves set in motion. An agency without purpose of their own, spectral signatures drove many remote-sensing operations throughout the Cold War and into the present. The desire on the part of military reconnaissance is to achieve readings of sound waves without variables—a perfectly clear signature—while the occurrence of variables become artistic opportunity, which is what we discuss next.

The technics of Edgerton's magneto-optic lens and its resultant microtemporalities function in artist Leif Inge's 2008 digital artwork *9 Beet Stretch*, a work situated at the intersection of avant-garde found object, sound installation for a gallery setting, and parody of the classical music canon.[31] Inge's instructions for realizing the piece read like a Fluxus conceptual operation transported into a digital future. He asks for the exhibition space to take a CD recording of Beethoven's Ninth Symphony and use granular synthesis software to stretch the work to twenty-four hours in length while maintaining pitch throughout. This results from the affordances of granular synthesis software, which allow one to slice and then splice milliseconds of sound that preserve not only pitch but timbre. In fact, potentially infinite replication of each slice is possible. Because no specific recording is listed in the artwork's instructions, this potentially infinite replication of any specific slice is required for the base material—that is, the recording as "found object"—to be decelerated and elongated to a twenty-four-hour duration.

The "synchronous cloud" of Inge's piece scatters the sonic grains in strict metrical sequencing, and the "density of the grains" determines the time structure of the work.[32] The result is that frequency information can be maintained while temporal duration extends.[33] Because speed determines pitch, the granular technique maintains the speed in the individual unit of isolation but not in the sutured whole. This technique also allows for clear articulation of the instrumentation to maintain pitch throughout the symphony, even when extended to the prescribed length, which can be any length.

The basic technique of Inge's conceptual sonic project resides in the same digital thought processes operative in Muybridge and Edgerton: the temporal manipulation of phenomena in the world through technological means, to record it, store it, alter its temporal duration, and keep the action intact, even if protracted beyond recognition—whether this phenomenon is bird flight, racehorses' gait, nuclear explosions, or recordings of Beethoven's Ninth Symphony. Each is a temporally contained gesture subject to recording technologies that transform time into space for the purposes of reconfiguration in some manner. In the case of Inge's piece, the reconfiguration manifests as deceleration and repetition.[34]

Various terms for granular elements of sound are "quantum acoustics," "sonal atom," and "micro arc," all of which evoke the nano-slice and suture required for theoretical, compositional manipulation of sound predicated on digital techniques that flow from ancient Greek atomistic thinking to the present. Building on insights gleaned from quantum physics in the mid-twentieth century, Dennis Gabor developed "granular" or "quantum" theories about sound that eventually led to experiments with analog technologies into time compression or expansion via phase shifting.[35] Gabor (the Nobel Prize–winning physicist who developed holography) sits neatly in the consistent disentanglement and re-entanglement of space and time that runs throughout this chapter when he writes in the mid-1940s that the two methods for accessing sound signal analysis are idealizations of the signal: one as time and the other as frequency (or space, as in Fourier analysis). Yet, our experience of sound, he states, is inevitably *both* simultaneously and inseparable from one another.[36] Curtis Roads, who developed the first computer-based implementations of granular synthesis at the University of California–San Diego in 1974, argues that that "a granular representation is implicit in the *windowing* technique"[37] applied in the FTT, thus tethering Inge's *9 Beet Stretch* to the Vela Uniform initiative with Bell Labs and military geological research. Like so many technological developments, granular synthesis became standardized and routinized and is now part of many standard off-the-shelf software packages for computer music generation. Once the province of the world's most top-secret labs for remote reconnaissance and spying, this computational technique now nestles softly into domestic consumer products.

Mouth: The Vocoder and Cryptographic Articulation

Homer Dudley explained the vocoder to his children in terms of breakfast: scrambling eggs and then basically re-chickening them.

–Dave Tompkins, *How to Wreck a Nice Beach*[38]

Bell Labs tasked its telephonic engineer Homer Dudley in 1928 with solving a key problem for long-distance communication: how to convey voice across telegraph lines. This necessitated the compression of broadband speech signals, which can exceed 3,000 Hz, to operate on extant telegraph cables with narrow bandwidth capacities. To address this problem, Dudley offered the vocoder: a piece of equipment, but even more so a process housed in different apparatuses. The process consisted of finding an adequate representation of the voice (its sound source and its modulation) that would be encoded as a set of numbers run through filters on the transmission end and sent as a coded message (rather than the actual vocal input itself) that was decoded at the receiving end using an aural synthesizer deploying an oscillator to reconstruct the frequency basics and a set of filters to shape the sound. Patented as the vocoder (a contraction of "voice coder") in 1935, it was introduced to the public at large at the 1939 New York World's Fair. Synthesizer innovator Robert Moog claimed that the vocoder's "only performance criterion" was "intelligibility."[39] However, Moog made this claim in a note about its application by the composer Alvin Lucier, who thus established a new performance criterion: aesthetics.

The conversion of speech to code provides its cryptographic appeal for military communications during World War II. The storage of the temporal processes and data involved in the unavoidable evanescence of speech is an aural equivalent to a visual chirographic writing system, allowing temporal sounds to be made into spatial symbols, which can be altered and reordered. Once again, the connections to the fundamental processes of Edgerton and "granular synthesis" are marked and profound, offering a real key to the techno-imaginative bases for numerous developments and aesthetic works.

Alan Turing spotted the coding and cryptographic possibilities straight away when he visited Bell Labs in 1943, and their collaborative engagements led to an influential updated version of the vocoder that became known as SIGSALY. Initially used for communications between Roosevelt and Churchill starting in the summer of 1943, by the end of the war, terminals had sprung up at allied bases throughout the globe, including a nautical one for General MacArthur in the South Pacific theater. Vocoder use for the military's "secret telephony" also included turntables playing recordings of reversed thermal sounds to create a sluicing background noise to confound German code breakers, records produced for the Pentagon by the Muzak corporation.[40] A mere five years after connecting Roosevelt and Churchill in encrypted strategic discussions as well as coordinating the D-Day invasion and the bombing of Hiroshima, the vocoder traveled

with Dudley to postwar Germany and played a pivotal role in the inspiration to build the first studio dedicated to electronic music composition, musical instrument development, and recording.

Bell Labs pressed on with vocoder research in relation to some of the first experiments in computer music, building on Dudley's and Turing's innovative step of converting analog voice signals into digital data, eventually resulting in Max Matthews's computer program, MUSIC 1, the first program for sound synthesis, which eventually connects with granular synthesis. Building on the advances made by the cryptographic application of the vocoder, this program performs another key step in changing its primary performance criterion by pushing beyond pragmatics to abstractions and aesthetics. The capacity of the vocoder to analyze the voice digitally is modified and occasionally turned against itself, making intelligibility irrelevant or even undesired, through various forms of aesthetic production in popular (art) music (Kraftwerk, ELO, Bootsy Collins, Daft Punk), avant-garde experimental music (Alvin Lucier, Laurie Anderson), and soundtrack (Wendy Carlos).

As with any "tele"-communications device, the vocoder operates in and through the compression of space via a temporally determined event: voice as speech. In addition to contributing to metaphysical manipulation, the vocoder addresses a long-standing relationship between the human voice and technological manipulation in music and instrument technologies. As such, the vocoder as communications tool, musical instrument, and technological experiment (or problem solver) poses aesthetic and epistemological questions about human ontology generally positioned in relation to time and space, as well as the technologies that help humans understand and imagine them. To this, the vocoder adds speech and language as technology. Language and technology often become attributes identified as uniquely pertaining to the human and as being quintessentially human—problematic attributions to be sure.

To exemplify some of what is at stake here, we can turn to yet another computer music revision of Beethoven's Ninth. This one comes via Wendy Carlos and her 1964 aural punctum when first encountering the vocoder at the New York World's Fair. The electronic music innovator of *Switched-On Bach* fame, Carlos developed, with Robert Moog, a bespoke vocoder for a soundtrack she was hired to compose and record. When Stanley Kubrick decided to film Anthony Burgess's polemic against the anti-humanistic dimensions of behaviorism for potential population governance, penalization, and eventual rehabilitation, he approached Carlos to do the soundtrack, and she saw an excellent opportunity to put to work the new vocoder that she had been experimenting with for more than a year. The result is the stunning singing machine used for the "Ode to Joy" in the film and its soundtrack recordings. At the most obvious level, the sheer materiality of its deployment echoes Burgess's argument: that humans forced to do good through psychotropic chemical treatment, image sensitivity training, and behavior modification

become something like "a clockwork orange": an object that has the appearances of being organic but filled with a mechanical apparatus that determines its movements and choices. Here, the relationship between the organic and machinic is rendered ironic to the point of parody, as in the early Greek sense of a para-ode: a song sung alongside the main song and commenting on it.

The main song in this instance is the autonomy of the human as sovereign agent in the celebration of its vaunted ontological position. Beethoven's setting of Schiller, as many have argued, perhaps already ironizes this situation as the bombast of human-istic back-patting finds the Enlightenment running up against Romantic critiques of it. Carlos's vocoder version of this massively overplayed piece underscores the parody by drawing attention to language and technology operating together. Schiller's poetry sung through the vocoder remains intelligible, but barely so, while foregrounding the technology producing "the voice." There is no attempt to hide the technology of produc-tion or its operation—just the opposite, in fact.

Instead, Carlos highlights the mechanized voice *as* mechanized, providing an ironic commentary on our relation to our technology that we believe serves our ends and desires, that we supposedly turn to our advantage, and through which we articulate our mastery and subjectivity. But with Carlos's recording, this is not the message. Here, we have another message, one that states, "We do not even control what we control."[41] The technology of production and reproduction, of machinic generation, does not speak for us but rather *sings us* through a song that proclaims the glory of our agency and autonomy and does so with minimal intelligibility.

To conclude, the techno-noetics operative in the artworks and technics/technolo-gies that made them possible arrive courtesy of the military, the symbiotic momentum between the mutual influence of technologies and imaginaries fully on display. The technologies' foibles and fluctuations for military use, as noted, can become artistic opportunity. Similarly, their emergence from military research-and-development sites undertaking different kinds of research with elective affinities consistently suggested alternative applications. These aesthetic opportunities, instrumentally or artistically applied, show the military to be the institution of human-centric metaphysical inquiry and wizardry without compare in the West. Its centuries-long avant-garde renderings of time and space's plasticity and protean qualities have fueled imaginaries individual and collective, from studios and labs to command centers and classrooms doling out facts about the world and our position in it.

"The Fundamental Project of Technology" is the title of a poem (part of which serves as chapter epigraph) by Galway Kinnell about a visit to the Peace Museum in Hiro-shima. Haunting and haunted, as one might expect, it reminds us—as do the artworks considered in this chapter—that the fundamental project of technology is hominization: how we make and interpret the world, how we understand perception as constantly caught in processes of change and reification, what we imagine we can do through our

capacities to alter time and space, and what we wish to do with these imaginaries in terms of aesthetics and geopolitics and aesthetics *as* geopolitics.

Notes

1. Galway Kinnell, "The Fundamental Project of Technology," 1983, in *Selected Poems* (Tarset UK: Bloodaxe Books, 2000), 126–127.

2. I want to thank Anders Engberg-Pedersen and all those who attended, presented at, and supported the War and Aesthetics seminar in Copenhagen (September 2021), where a version of this paper was presented. Further thanks go to Jussi Parikka and Robert Pietrusko for comments on drafts of this paper. All errors, of course, reside with the author.

3. The term "noetic-technics" is my own, but it shares some affinities with Kittler's update of Münsterberg's "psychotechnics" and a good deal with Stiegler's "protentions."

4. For some varied and interesting takes on aisthesis, see Eve Rabinoff, *Perception in Aristotle's Ethics* (Evanston, IL: Northwestern Press, 2018), and Flora R. Levin, *Reflections on the Nature of Greek Music* (Cambridge: Cambridge University Press, 2007).

5. Gregory Bateson, *Mind and Nature: A Necessary Unity* (New York: Bantam Books, 1972), 25–72.

6. Joseph Vogl, "Becoming-media: Galileo's Telescope," trans. Brian Hanrahan, *Grey Room* 29 (Winter 2008): 18.

7. Wolfgang Ernst, *Chronopoetics: The Temporal Being and Operativity of Technological Media*, trans. Anthony Enns (London: Rowman and Littlefield, 2016), 4–14.

8. Wolfgang Ernst, "Tracing Tempor(e)alities in the Age of Media Mobilities," *Media Theory* 2, no. 1 (2018): 164–180.

9. Hannah B. Higgins and Douglas Kahn, "Introduction," in *Mainframe Experimentalism: Early Computing and the Foundations of the Digital Arts*, eds. Hannah B. Higgins and Douglas Kahn (Berkeley: University of California Press, 2012), 1–14.

10. Sybille Krämer, "The Cultural Techniques of Time Axis Manipulation: On Friedrich Kittler's Conception of Media," *Theory Culture and Society* 23 (2006): 106.

11. Paul Virilio, *War and Cinema: The Logistics of Perception*, trans. Patrick Camiller (London: Verso, 1989), 73.

12. Jack Goldstein, *Aphorisms*, "Jack Goldstein, Films, Records, Performances and Aphorisms 1971–1984" Catalogue, Galerie Bucholz, Koln, and Verlag der Buchhandlung Walther Konig, Koln, 22.

13. Paul Virilio, *The Vision Machine* (Bloomington: Indiana University Press, 1994), 67.

14. Thomas Pynchon, *Gravity's Rainbow* (London: Vintage, 2013), 760, section entitled "Descent": "And it is just here, just at this dark and silent frame, that the pointed tip of the Rocket, falling nearly a mile per second, absolutely and forever without sound, reaches its last unmeasurable gap above the roof of this old theatre, the last delta-t."

15. Virilio, *War and Cinema*, 69.

16. For an extended discussion of technological manipulation of the speed continuum, see Ryan Bishop and John Phillips, *Modernist Avant-Garde Aesthetics and Contemporary Military Technology: Technicities of Perception* (Edinburgh: Edinburgh University Press, 2010), 3–23.

17. Jussi Parikka, *A Slow, Contemporary Violence: Damaged Environments of Technological Culture* (Berlin: Sternberg Press, 2016), 17.

18. See Antoine Prévost-Balga, "'Atomic Explosion Stopped at Millionths of A Second': Media Microtemporalities and Time Synchronisation," *Cinergie – Il Cinema E Le Altre Arti* 9, no. 17 (2020): 173–182; James Elkins, "Harold Edgerton's Rapatronic Photographs of Atomic Tests," *History of Photography* 28, no. 1 (2004): 74–81; and Ned O'Gorman and Kevin Hamilton, "EG&G and the Deep Media of Timing, Firing and Exposing," *The Journal of War and Culture Studies* 9, no. 2 (2016): 182–201.

19. Elkins, "Harold Edgerton's Rapatronic Photographs," 76.

20. Parikka, *A Slow, Contemporary Violence*, 9.

21. O'Gorman and Hamilton, "EG&G and the Deep Media of Timing, Firing and Exposing," 182–201.

22. O'Gorman and Hamilton, "EG&G and the Deep Media of Timing, Firing and Exposing," 189.

23. Parikka, private correspondence, September 2021.

24. Jussi Parikka, unpublished manuscript. 2024.

25. Elkins, "Harold Edgerton's Rapatronic Photographs," 79–80.

26. Bernhard Siegert, "Mineral Sound or Missing Fundamental: Cultural History as Signal Analysis," *Music, Sound, and the Laboratory from 1750–1980* 28, no. 1 (January 2013): 107.

27. Daniel N. Rockmore, "FTT: An Algorithm the Whole Family Can Use," *Computer Science Engineering* 2, no. 1 (2000): 60–64.

28. Rockmore, "FTT: An Algorithm the Whole Family Can Use," 60.

29. Friedrich Kittler, *Gramophone, Film, Typewriter*, trans. Geoff Winthrop-Young and Michael Wutz (Stanford, CA: Stanford University Press, 1999), 48.

30. Charles C. Bates, "Detection and Identification of Explosions Underground (Project Vela Uniform)," *Proceedings of the IRE* 50, no. 11 (1962): 2201.

31. Perhaps, as Alexander Rehding suggests, the work is best understood as residing in the realm of art-inflected ambient music in the mold of Brian Eno.

32. Curtis Roads, "Sound Transformation by Convolution," in *Music Signal Processing*, eds. Curtis Roads, Stephen Travis Pope, Aldo Piccialli, and Giovanni De Poli (New York: Routledge, 2013), 427.

33. Alexander Rehding, *Beethoven's Symphony No. 9* (Oxford: Oxford University Press, 2017), 74.

34. The composer Steve Reich calls granular synthesis the aural equivalent of the freeze frame in cinema.

35. Curtis Roads, *The Computer Music Tutorial* (Cambridge, MA: MIT Press, 1996), 169.

36. Dennis Gabor, "Theory of Communication," *Journal of Institution of Electrical Engineers* 93, no. 3 (1946): 429.

37. Roads, *The Computer Music Tutorial*, 169.

38. Dave Tompkins, *How to Wreck a Nice Beach: The Vocoder from World War II to Hip-Hop, The Machine Speaks* (Chicago: Stop Smiling Books, 2011), 42.

39. Robert Moog, "An Introduction to *North American Time Capsule 1967*," in *Mainframe Experimentalism: Early Computing and the Foundations of the Digital Arts*, eds. Hannah B. Higgins and Douglas Kahn (Berkeley: University of California Press, 2012), 187.

40. Tompkins, *How to Wreck a Nice Beach*, 18.

41. Benjamin Bratton, "On Geoscapes and the Google Caliphate: Reflections on the Mumbai Attacks," *Theory Culture and Society* 26, nos. 7–8 (2009): 335.

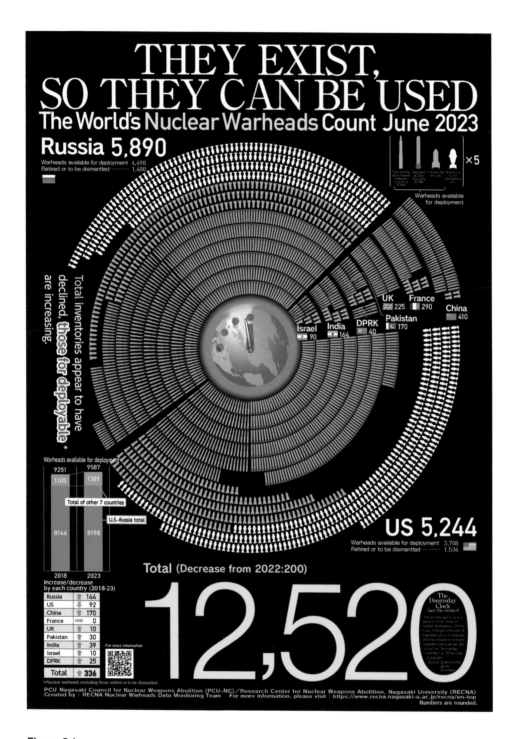

Figure 8.1

The current nuclear architecture. For an explanation, see the boxed text.

8

Philosophy and the Weapons of Nuclear War

Elaine Scarry

Introduction

In the 1995 legal case against the use or threatened use of nuclear weapons at the International Court of Justice, seventy-eight countries asked the court to decide whether nuclear weapons are illegal. While many litigants argued that such weapons violate specific humanitarian and environmental instruments, such as the Convention on the Prevention and Punishment of Genocide, the Geneva Protocols, and the Rio Declaration on Environment and Poverty, Japan argued that nuclear weapons do not simply violate individual covenants; they assault and damage the philosophical underpinnings of international law.[1]

The United States—in a joint statement by the Department of State and the Department of Defense—argued that none of the international protocols named by the litigants made the possession of nuclear arms, the threat of their use, or their use illegal. For example, the country rejected the relevance of the 1948 UN Convention on the Prevention and Punishment of the Crime of Genocide. In its written statement to the court, the United States—acknowledging that nuclear weapons are designed to kill millions of people—argued that "the deliberate killing of large numbers of people is not sufficient to establish this offense" of genocide; genocide only takes place if the aggressor sets out to destroy "in whole or in part, a national, ethnical, racial or religious group, as such."[2] In some cases, the United States rejected the specific instrument on the basis that it predated the invention of atomic weapons and therefore could not possibly apply. In other cases, the instrument postdated atomic weapons but did not explicitly mention those weapons and therefore did not apply. In still other cases, the protocol *did* postdate those weapons and *did* explicitly mention nuclear weapons, but the opposition was only, they claimed, an *aspiration*, not a *prohibition*, and therefore without legal force. So, the litigants' invocation of conventions on genocide, on the environment, on suffering that crosses borders into neutral countries were each, one by one, summarily dismantled and dismissed.

The single charge the United States left unanswered was the one made by Japan: the argument that the possession, threatened use, or use of such weapons violates the philosophical foundation of international law. Had they attempted a philosophical defense of their weapons possession, they might have introduced the possibility that nuclear

The 2023 chart—made by the Nagasaki Research Council and based on figures provided by the Federation of American Scientists—shows the nuclear arsenals of the nine nuclear states, with the United States and Russia together possessing more than 90 percent of the world total. Each icon represents five warheads. The blue icons are submarine launched warheads; the orange, warheads launched from land; the green, warheads delivered from the air; the white, warheads that are nominally "retired" but not yet dismantled and therefore still available for use. In October 2017, the *New York Times* estimated that if the United States "decimated" seven countries—Russia, China, Iraq, Iran, Syria, Libya, and North Korea—70 percent if its stockpile would remain.

At the center of the chart is the Doomsday Clock, a graphic invented by the Bulletin of Atomic Scientists in 1947 to compress a great deal of technical information into an easy-to-grasp summary image. It is currently set at 90 seconds to midnight, the smallest window of time and highest danger interval in any period since the first appearance of the clock.

That the nuclear peril is higher in the twenty-first century than it was in the twentieth century—apprehended by scientists and peace activists alike—is also acknowledged by people who served inside the US government. Robert McNamara, who served as secretary of defense during the Cuban Missile Crisis, wrote a 2005 *Foreign Policy* article warning that "US nuclear policy" has grown "more dangerous": it is "immoral, illegal, militarily unnecessary, and dreadfully dangerous." Former secretary of defense William Perry is so alarmed by the current danger (and widespread ignorance of the danger) that he is devoting the last years of his life to the William Perry Project, a project to educate the citizenry to work for the elimination of the weapons. Former secretary of state Henry Kissinger joined Perry and other colleagues in 2007 to call for "global zero" and, in July 2021, was quoted in *The Guardian* as stating that advances in artificial intelligence, along with other factors, made the possibility of nuclear catastrophe higher than it was in the Cold War. Contributing to the accelerating peril is the growing number of nuclear states, each increasing the chance of inadvertent or intentional nuclear war.

At least four of the states—the United States, Russia, India, and France—have constitutions that explicitly restrict how that country can enter war, provisions that are radically incompatible with nuclear weapons and which, if followed, would have made that country's acquisition of weapons technology impossible. In the case of each country, the application of the constitution to the country's arsenal would go a long way toward dismantling that arsenal. The US Congress currently has pending legislation designed to do exactly that: it draws on the constitution to render illegal the US arrangement for "presidential sole authority and first use," the arrangement that has been in place since the weapons were first invented. But such legislation can only be passed if the citizenry demands that it be passed—a call from the population that is currently inaudible.

International pressure toward abolition is also growing. The Treaty on the Prohibition of Nuclear Weapons, adopted on July 7, 2017, entered into force on January 22, 2022. So far, the nine nuclear states have ignored the treaty. The US government has not even acknowledged its existence (and the country's media is almost as silent). How the government might defend its nuclear arsenal against the pressures of this treaty is suggested by its response to the 1995 case at the International Court of Justice detailed in the article.

While, then, both national and international legislation are currently being brought to bear on the nuclear peril, the goal of abolition will probably be reached only when awakened citizenries within the nuclear states come forward to demand the honoring of constitutional and international law.

weapons and philosophy can coexist. By not addressing it, they might be said to have confirmed Japan's conclusion. In a world of nuclear weapons, philosophy has already been made so marginal (at least by those in possession and control of the weapons) that a nuclear state need not even attempt to dismantle it; it is already gone.

While at first glance it seemed the United States did not offer a response, on a second level, one sees that perhaps they did, without ever using the word "philosophy." While the United States put forward an array of arguments to explain why international protocols and covenants are inapplicable to a determination of the legal status of nuclear weapons, it provided a single, recurring refrain throughout the document: the use or threatened use of nuclear weapons belongs to the future and therefore a formal ruling would constitute "judicial speculation about hypothetical future circumstances"[3]; "the Court should not, on a matter of such fundamental importance, engage in speculation about unknown future situations"[4]; a judgment cannot "be made in advance or in the abstract"[5]; to rule that nuclear weapons would bring "severe damage" to neutral countries (and therefore violate neutrality rules) would be "in any event highly speculative."[6] The Court is repeatedly chided for agreeing to give an advisory opinion on a subject that is "vague,"[7] "hypothetical," and "abstract."[8]

The speculative, the hypothetical, and the abstract have—according to their argument—no legal standing or force; they have no ground in this dispute. But, of course, the speculative, the hypothetical, and the abstract are the terrain of philosophy. Philosophy is time independent; its subjects belong to the past, present, and future. Even if, then, the outcome of using or threatening to use nuclear weapons truly belongs to the future, it should be a subject accessible to and assessable by human intelligence and argument. But does knowledge about these weapons reside in the future? The use of the word "future" by the United States is incoherent. The effect of delivering a nuclear weapon is not theoretical or abstract, since the United States dropped a weapon on Hiroshima, another on Nagasaki, and sixty-seven on the Marshall Islands. The medical and environmental effects—despite US attempts to withhold and obscure them—are well known, and scientists have extrapolated from these outcomes to specify the ghastly scale of harm that will be inflicted on many species and on Earth itself with the much larger warheads of today. Furthermore, what portion of the current US nuclear architecture do the members of the US defense team believe is future? If it takes ten thousand steps to put a nuclear architecture into place, 9,999 are already complete and continually renewed (including the arrangement for hair-trigger alert). All that is missing, all that is "future," is the single last step of the ten thousand steps: the issuing of the launch order by the president (a launch order that has been knowledgably described as "half the length of a tweet"[9]) followed by the uninterrupted verification and execution of the order, estimated to take five minutes for the launch of a ground-based missile and fifteen minutes for a submarine-launched missile.[10]

Long before this 1995 case, however, the nuclear architecture had disabled the capacity for philosophical thought among nuclear weapons makers and nuclear policymakers (even if not necessarily among the millions of residents who are targeted by the weapons), and it did so in at least three realms: social contract practice, social contract theory, and democratic peace theory.

Social Contract Practice Sabotaged in the Nuclear Age

When, in the Nuclear Age, international law is perceived to have a potential philosophical basis, that basis is usually identified as "consent." States have the ability to enter voluntarily into—to consent to—contracts, treaties, and agreements with other states. So, it is relevant to note that the phenomenon of consent was among the first casualties of the Nuclear Age, since in no nuclear state was the legislature or population consulted about their own country's acquisition of them. That erasure meant that before a question could even arise about agreements *among* states, the practice of consent had already been sabotaged *within* each of the weapons-holding states. The existence of this weaponry within those states also from that founding moment forward sabotaged the country's ability to follow its own constitution about the most risk-filled act any country ever undertakes: the act of going to war.

As Hanna Pitkin has noted, consent is the area of philosophy where theory and practice ride closest to one another, since it is often to address some real-world emergency or problem that social contract theory comes into being or undergoes a new surge of clarification.[11] In the realm of "practice," the social contract theory of Hobbes, Locke, Rousseau, and Kant eventually crystalized into national constitutions, first in the United States, then in France, and soon throughout the world. These constitutions compress philosophy into a shorthand—a shorthand enfolding within it several centuries of argument that brought the constitutions into being. As Thomas Paine wrote in *The Rights of Man*, "the American constitutions were to liberty [or the capacity for consent] what a grammar is to language: they define its parts of speech, and practically construct them into a syntax."[12]

It is therefore illuminating, before turning back in time to the consent philosophers themselves, to see that at least four of the nuclear states—the United States, France, Russia, and India—have explicit constitutional provisions that require the country to carry out a large-scale act of argument and deliberation, concluding in a declaration of war, before ever beginning to inflict injury on a foreign people. It may not be an exaggeration to say these particular social contracts require a formal act of philosophic deliberation and argument before consenting to inflict injury. In other words, not only is the provision itself a compressed piece of philosophy, but also what it requires is a new, next act of philosophical argument: What does it mean when we call a country an enemy? Has the country designated an "enemy" carried out acts that make it eligible

to be so designated? Have we or any allied nations carried out similar acts? If so, does that invalidate the application of the word "enemy" in the present case? Are the acts it carried out, even if enemy actions and unparalleled by actions we or allies have carried out, so egregious that injuring their population and our own is necessitated? These are the key questions consistently debated at length by the national assembly in the United States before the Atomic Age when the country still followed its constitution: the War of 1812, the Mexican American War of 1846, the Spanish American War of 1898, World War I, and World War II. Each of these wars was preceded by a formal congressional declaration of war which was itself preceded by an extended debate about the key philosophical questions enumerated above.

The requirement for a large public debate about the meaning of the word "enemy" is starkly incompatible with and can never be made to align with nuclear weapons, whose very design requires (a) contracting human authorization of war to the smallest number of people possible—preferably to one person; (b) replacing the public arena with the deepest secrecy possible; and (c) contracting the time of thinking from what had been the timetable of legislative debate—days, weeks, or even months—now down to seconds and minutes. This requirement for deliberation by the legislative assembly is article I, section 8, clause 11 in the US constitution; article 35 in the French constitution; article 246 in the Indian constitution; and article 102 in the Russian constitution. If the provisions had been adhered to, each of the four countries would have had to rule out the possession of nuclear weapons at the moment possession was first contemplated.

The Russian constitution (like the constitution of non-nuclear Norway) provides an explicit distinction, implicit in them all, between an executive's ability to act militarily up to—but not a foot beyond—the country's border and the legislature's responsibility for the use of any military force one foot beyond the national borders; that is, a distinction between "defense" (before this word was stripped of all coherent meaning) and "offense." If Russia is attacked or its borders are violated by armed aggression, the president may begin to act to defend the country up to those borders (article 87), thereby taking unilateral action to defend the interior of the country. But article 102 stipulates that the use of force *outside the borders* can only be taken by the Federal Council (the analogue of the US Senate), and article 106 assigns to the Federal Council the responsibility for protecting the borders and overseeing war and peace.

Having instituted a form of weaponry that annihilates the constitutional requirement for a large labor of deliberation by a public assembly, the United States in the Nuclear Age embarked on a seemingly nonstop series of conventional wars—in Korea, Vietnam, former Yugoslavia, Iraq,[13] Afghanistan, and Syria—without once having a congressional declaration of war, thus illustrating the way nuclear weapons sabotage Thomas Paine's syntax of consent, not only in the use and threated use of this form of weaponry but also henceforth in any act of war making for the next seventy years.

The constitution of North Korea, unlike that of the United States, Russia, India, or France, explicitly gives its leader the power single-handedly to authorize war. Insofar as the United States, Russia, India, and France each have a nuclear architecture that gives the country's president "sole authority" for a nuclear launch, each of those four countries is following the North Korean, rather than its own, constitution.

The Framing Philosophy of Thomas Hobbes

The sudden revelation of a new invention in the world—an invention whose moral character should have been immediately legible in the catastrophes of Hiroshima and Nagasaki—could have, if history could be rewound, incited a new turn in social contract thinking, bringing it from the interior boundaries of the nation-state into the international realm, assisting and furthering the faltering aspirations that had been imbedded in the pre–Nuclear Age founding of the League of Nations and the United Nations. A first philosophical step—following the easy-to-discern fact that nuclear weapons completely dismantle consent and social contract—would have been on a global scale the howl of alarm and demand for total abolition voiced by Bertrand Russell, W. E. B. DuBois, and other philosophers. But rather than feeling chastened by the glaring discrepancy between constitutions and nuclear weapons, participants in this new world either ignored the philosophical consequences of the new invention or reached back behind the constitution to the antecedent philosophers and tried to incorporate them into the new architecture of power that had the ending of life on Earth as its predictable and often predicted outcome. In the Nuclear Age, social contract theorists are either omitted from international relations and its major school of neorealism or, much worse, made to become apologists for genocidal forms of power. Thus, Thomas Hobbes was adapted to their needs. So unrecognizable is the account of Hobbes most of us have heard about for the last seventy years that it will be helpful to pause for a moment to contemplate Thomas Hobbes 101—not the difficult and complex corners of his philosophy but rather the first principles from which all else flows.

The covenant among people exists in order to eliminate the action of injuring. Injury and the covenant are fundamentally at odds. Hobbes states in *Leviathan* that injury is to the social contract as logical absurdity is to discourse: "Injury, or Injustice, in the controversies of the world, is somewhat like to that, which in the disputations of Scholers is called Absurdity."[14] His earlier work, *On the Citizen*, anticipates the idea that injury and absurdity are analogous: "And there is an analogy between what in ordinary life is called [injuria] and what in the schools is usually called absurdity."[15] In a third work, *De Corpore*, Hobbes again puts the analogy in front of his readers.[16] Hobbes is not simply denouncing injury by calling it "absurd." Rather, he is making a much more extreme statement: as absurdity is starkly incompatible with and represents the dissolution of intelligent argument, so injury is incompatible and enacts the dissolution

of social contract. (This is the truth we should have seen in the terrifying wounds of Hiroshima and Nagasaki.) The dissolution of the contract, in turn, is a reversion to the condition of injury.

His statement about injury might accurately be rewritten as a statement about war: "War is to the social contract as logical absurdity is to discourse." The stark antagonism between war and social contract is one he repeats frequently throughout *Leviathan*: "The finall Cause, End, or Designe of men . . . is . . . getting themselves out from that miserable condition of Warre."[17] They accomplish that end, as the full passage shows, by creating the social contract: "The finall Cause, End, or Designe of men, . . . in the introduction of that restraint upon themselves, (in which wee see them live in Common-wealths,) is the foresight of their own preservation, and of a more contented life thereby; that is to say, of getting themselves out from that miserable condition of Warre." So stark is the opposition between the social contract and the state of war that Hobbes often refers to the social contract as "Articles of Peace": "The Passions that encline men to Peace, are Fear of Death; Desire of such things as are necessary to commodious living; and a Hope by their Industry to obtain them. And Reason suggesteth convenient Articles of Peace, upon which men may be drawn to agreement."[18] He also specifies that these Articles of Peace can be called the "Law of Nature"–a potentially confusing term, but one that in *De Cive* he carefully distinguishes from "state of nature," a synonym for "state of war."[19] So different are the two–the one meaning "peace" and the other "war"–that Hobbes writes, "The laws of Nature are silent in the state of nature."[20] Using the phrase "Law of Nature," he repeatedly designates "peace" as the raison d'être of the social contract, and war as the contract's very opposite:

The first, and Fundamentall Law of Nature . . . is, to seek Peace, and follow it.[21]

To remain still in the condition of War . . . is contrary to the first and Fundamentall Law of Nature, which commandeth men to Seek Peace.[22]

He that . . . is guilty of the warre . . . doth that, which is contrary to the fundamentall Law of Nature, which commandeth to seek Peace.[23]

The prohibition on war, the aspiration to peace, is not, then, simply a feature of the social contract but what he repeatedly designates "the first, and Fundamentall Law."

Because the aspiration to peace is "the first, and Fundamentall Law," many other principles and rules follow from it. Most important among these other principles is the equality of all people in the formation of the social contract. A contract for peace can only be achieved if, as Hobbes writes in *Leviathan*, all participants are equal or are treated as equal to one another: "If Nature therefore have made men equall, that equalitie is to be acknowledged: or if Nature have made men unequall; yet because men that think themselves equall, will not enter into conditions of Peace, but upon Equall terms, such equalitie must be admitted."[24] If this key corollary were transferred

from the social contract of the nation-state to a social contract binding the countries of Earth, the equality of all people would be a necessary feature, one that is lost upon the great powers today.[25]

The idea that the social contract simply is a contract for peace is so fundamental to the writings of Hobbes that it should be unnecessary to belabor it. But it is necessary to do so for three reasons. The first is the world in which we now live. As Bernard Gert writes in his preface to *De Cive*, "In this day of nuclear weapons, where whole nations can be destroyed about as easily as a single man in Hobbes's day, we would do well to pay increased attention to the one philosopher to whom the attaining of peace was a primary goal of moral and political philosophy."[26] The second is that peace has been underemphasized—often almost erased—in writings about Hobbes. In an article entitled "Thomas Hobbes's 'Highway to Peace'" (a phrase from Hobbes's "Preface to the Readers" in *De Cive*), Donald Hanson laments the discrepancy between the major position Hobbes accords peace and the marginal position it is accorded in Hobbes scholarship.[27] The third is the erroneous—it would not be inaccurate to say preposterous—idea that because Hobbes sanctioned a strong sovereign, he would sanction a sovereign armed with genocidal weapons. Nothing could be further from the truth. The absolute power Hobbes conferred on the sovereign was the power to do one thing: stop injury. How so erroneous a view could come about (and how linked the general distortions of Hobbes's philosophy are to the onset of the Atomic Age) will be addressed below. For now, it will be important to recognize that although in the Nuclear Age people have forgotten Hobbes's first principle—that the social contract exists to get us out of the condition of war—the writers of constitutions very much had that principle in mind.

The national constitutions that come into being in the eighteenth through twentieth centuries announce the framing opposition between contract and injury. The social contract is essentially a covenant for peace, as we can see in the fact that so many national constitutions explicitly designate international peace a central aspiration, either in the preamble (e.g., the constitutions of Andorra, Azerbaijan, Bahrain, Benin, Brazil, Bulgaria, Burkina Faso, Cameroon, Central African Republic, Chad, China, Croatia, Egypt, Germany, Indonesia, Japan, Oman, Pakistan, Senegal, and Turkey) or in an early article (e.g., the constitutions of Albania, Angola, Cape Verde, Ecuador, Finland, Italy, and Laos). It is also the case that many countries identify domestic peace as a central aspiration in either their preamble (e.g., the constitutions of Cambodia, Ecuador, Guatemala, Honduras, Laos, Macedonia, Turkey, and Uganda) or an early article (e.g., the constitutions of Cambodia, Cameroon, Croatia, Djibouti, Equatorial Guinea, and Ireland).[28]

At issue here is not the extent to which each of these countries lives up to this aspiration but simply the stark fact that peace is the goal aspired to. The inclusion of the word "peace" is not an accident or an ornament but rather an essential statement of what the constitution is: a covenant for peace.

The social contract tradition inaugurated by Hobbes and continued by Locke, Rousseau, and Kant helped to bring about the array of democracies whose aversion to war has been celebrated by Bruce Russett and other theorists such as Michael Doyle and Spencer Weart. Both the phenomenon of democratic pacifism and its sabotaging by nuclear weapons will be scrutinized below. Hobbes's contributions to nonviolence have also been recognized by thinkers in disciplines distinct from political philosophy. In *The Better Angels of Our Nature*, for example, cognitive scientist Steven Pinker attempts to document the diminution of many forms of violence over fifty centuries. When at the end of the book he comes to the difficult task of designating the cause of this decrease in injury, he puts in front of us one leading candidate: *Leviathan*—both Hobbes's book and what followed the book, the creation of actual Leviathans, states that prohibited their citizens from injuring.[29]

When one hears the name "Hobbes," the first word that should come to mind after the words "social contract" is the word "peace." The deep philosophical momentum of Hobbes toward international peace was recognized by Immanuel Kant. As Richard Tuck has compellingly shown, Kant in *Perpetual Peace* as well as in many other writings seized upon and made luminously available the implications of Hobbes's stress on peace that had eluded even Rousseau.[30] Kant argued against the legitimacy of preemptive strikes and the unending preparation for harm: "We have to admit that the greatest evils which oppress civilized nations are the result of war—not so much of actual wars in the past or present as of the unremitting, indeed ever-increasing preparation for war in the future."[31]

Given that Hobbes has, over four centuries, been successful in both the theory and practice of reducing injury, why should it matter to us that his obsessive aspiration to peace has come in recent decades to be decoupled from his name. The answer is this: at the onset of the Nuclear Age, at the very moment that democracy was being dismantled by weapons that made democracy impossible (a moment when Hobbes could have brought us to our senses), a view of Hobbes became dominant that not only severed him from the aspiration for peace but also made him an apologist for authoritarian nuclear regimes and for international anarchy.

The originator of the social contract was now invoked to authenticate what amounted to the tearing up of the social contract. Scanning the "standard image" of Hobbes in the classroom at the end of the 1980s, D. C. J. Carmichael found that in the preceding decades, the "standard picture of Hobbes" had three features: his "political theory [was] rigidly authoritarian, anchored in a repellent view of human nature and argued with more precision than anyone can bear."[32] While, as Carmichael shows, that "standard" picture is currently undergoing a glacial revision, a distorted image of Hobbes is still available to those who champion nuclear world order and our permanent state of nuclear readiness.

How, given the fact that Hobbes issues statements about peace on every third or fourth page, is it possible that his center of gravity could be ignored—omitted as is usually the case or, alternatively, mentioned but mentioned as though it were itself an

inert idea with no implications for lived arrangements? For example, in the Nuclear Age, Hobbes's name has often been coupled with that of Carl Schmitt, the German philosopher who argued that in a state of emergency, the führer may suspend the constitution. (Although this view of emergency was written during the German Third Reich, it would also license the arrangements nuclear states have for presidential first use.) As Tom Sorell shows, Schmitt, in endorsing the führer's personal action in dissolving the constitution, thought Hobbes also endorsed the personal. But this, as Sorell argues, is utterly wrong: in Hobbes's commonwealth, everyone transfers their decision-making power to the sovereign precisely because the sovereign transcends the personal and acts on the citizenry's behalf.[33] Yet, Schmitt is not someone who failed to notice the word "peace." In one of his writings on Hobbes, *The Leviathan in the State Theory of Thomas Hobbes*, many passages acknowledge peace as Hobbes's central passion.[34] For Schmitt, the idea of peace apparently implied no obligatory real-world pressure toward preventing injury.

It is also crucial to recognize the time signature—to recognize that it is in the period immediately following the invention of nuclear weapons that the view of Thomas Hobbes, severed from his first principle of peace, becomes increasingly distorted. Just as nuclear weapons could only come into being by silently bypassing constitutional requirements for war making, so their existence changed the way people regarded the constitution: suddenly, long-revered protocols seemed like archaic and embarrassingly feminine constraints on our gigantic masculine war machine. Swaggering and unstoppable, surpassing in blast and burn power every weapon the world had ever seen, nuclear weapons could not be stopped by armies of opposition, let alone by a few words of script on a piece of paper. Their existence also changed the way those thinking about international relations would think—or rather stop thinking—about the ethical norms embedded in centuries of moral and political philosophy. This ethics-free arena required a deformation in the way Hobbes was viewed.

Political theorist Brian C. Schmidt has tracked the "divorce between political theory and international relations" that occurred in the 1950s, 1960s, and 1970s. While political theory continued to address "normative issues, such as the nature of justice, freedom, [and] equality," international relations underwent a "bizarre detour" in which it prided itself on a "value-free" school of "realism," marginalizing all "old-fashioned" values in the name of "a theory of survival."[35] Insofar as it wanted to dignify this ethical vacuum with a philosophical name, a name was chosen: Thomas Hobbes. Historian David Armitage has shown in detail that it was not the philosophy of Hobbes that led to the twentieth-century theory of international anarchy—just the reverse. Only after a position of international anarchy was invented was Hobbes dragged (kicking and screaming) into this arena: "Hobbes was only identified as a theorist of international anarchy once a consensus had emerged that the international realm was indeed anarchic . . . Hobbes did not directly inspire the conception of the relations between states

as fundamentally anarchic. It was instead the proponents of a 'discourse of anarchy' in international relations who co-opted Hobbes."[36] Noel Malcolm has also provided a tour de force account of the puzzling "asymmetry" between Hobbes scholars who barely mention international relations (because Hobbes so seldom addresses it) and international relations scholars who present Hobbes as the champion of ethics-free realism, power politics, and imperialism.[37]

None of the three (Schmidt, Armitage, or Malcolm) explicitly attribute these detours into philosophical lawlessness to the invention of nuclear weapons, but the timing of the many writings they review coincides with the period of intense nuclear standoff, a period that both Schmidt and Armitage see ending with the twenty-first-century return of moral and political philosophy to the international arena.[38] The Cold War period pushed to the background Hobbes's identification of the laws of nations with the laws of nature, which require us to seek peace, and foregrounded instead Hobbes's account of "the state of nature" as a war of all against each, as though this were the state Hobbes advocated rather than the state he dedicated his life to eliminating.

Every schoolchild during the Nuclear Age would come to know Hobbes's statement that life is "nasty, brutish, and short" without learning that Hobbes says this is only what life is like when we choose war over social contract. The passage from which the three famous words come warns that without the social contract, there can be no "Industry . . . no Culture of the Earth; no Navigation . . . no commodious Building; . . . no Instruments of moving . . . no Knowledge of the face of the Earth; no account of Time; no Arts; no Letters; no Society."[39] This is not the condition Hobbes recommends. Nor is it the condition Hobbes says we are fated to endure. It is the condition he warns we will suffer if we tear up the social contract and disregard its requirement to seek peace. The loss of civilization that in Hobbes's description follows from the tearing up of the social contract matches the predicted erasure of civilization widely acknowledged to be the outcome of nuclear war: our phrasing "no libraries, no roadways, no books, no governments . . . etc." might easily be rephrased "no commodious buildings, no instruments of travel and navigation, no account of time, no arts, no letters." When the blizzard of flashes of light and mushroom clouds come, it will mean that the act that began in 1945—the ripping up of the contract that came down to us across millennia and provided the foundation for almost every gift we have enjoyed—is now complete.

Democratic Peace Theory

Given that the nuclear architecture can only come into being by jettisoning constitutions and the social contract theory that led to them, it can be no surprise that these weapon arrangements also disable democracy's thrust in the direction of peace, since democracy is a near synonym for constitutions and social contract. But because democratic peace theory is deservedly celebrated for serving as a lone voice countering the

neorealist position in international relations, it may be helpful to see how its features are each in turn unmade.

Does the social contract only aspire to peace, or does its braking system ensure peace? Many observers agree with Bruce Russett's conclusion that democracies are peace loving: democracies do not go to war with democracies.[40] Russett not only amasses empirical evidence but also enumerates features that he and others put forward to help to explain why this outcome should be the case. But each of these features—a guarantor of democracy when the nation-state's military is conventional—ceases to work when the state becomes nuclear. Each feature that is true in the first case becomes false in the second.

Here is Russett's list of peace-creating features, followed, in each case, by the deformation that occurs with nuclear weapons. First, democracies, unlike autocracies, are inherently transnational: "Democracies foster, and are fostered by, the pluralism arising from many independent centers of power and influence" and therefore encourage "transnational linkages."[41] A nuclear state has no interest in sharing nuclear weapons with other countries (nor in seeing other centers of nuclear power and influence arise), although it may ask other countries to station its own weapons and communications systems on their grounds. Second, democracies are "dovish" because "democratic processes produce restraint by the general populace which will have to pay the price of war in blood and money."[42] The population in nuclear states has almost no knowledge about, and certainly no say over, the country's nuclear weapons; it has no power to exercise any restraint over their making or their use. Third, "the complexity of the mobilization process"—the gigantic labor of amassing and moving tens of thousands of fighters and pieces of equipment—"means that leaders will not readily embark" on war.[43] Nuclear weapons eliminate mobilization: the total injuring power is already amassed inside the weapons, the weapons themselves are in the location from which they will be fired, the longitude and latitude of both probable and possible targets have already been assigned to specific warheads.[44] Fourth, in a democracy, "dissent within broad limits by a loyal opposition is expected and even needed for enlightened policy-making, and the opposition's basic loyalty to the system is to be assumed in the absence of evidence to the contrary."[45] With rare exceptions, no "loyal opposition" to nuclear weapons exists on the floor of Congress, inside the White House, the Supreme Court, the military, or at any other level of governance such as the state legislatures. Only once people retire from their government positions and are therefore out of power do they sometimes express opposition. Fifth, in a democracy, "the process [of war preparation] is immensely more public than in an authoritarian state."[46] Little to no information is publicly available about nuclear weapons, their location, or their targets on any given day (even the commander of a submarine is not told what "destination" is indicated by alphanumeric codes he is instructed to program into the missiles on his ship); executive discussions about their contemplated use are released decades after the president is out of office. It

is not possible for an authoritarian country to be less public or less subject to restraint by the public than is currently true in the nominally democratic nuclear states.

If the war-impeding features on Bruce Russett's list disappear in the presence of nuclear weapons, that is because democracy itself disappears in the presence of nuclear weapons. Is it only the war-impeding features of democracy that disappear? As social contract theory reminds us, a constitutional state exists to impede injury and war. If it has lost its braking powers on war, it stands to lose everything on Hobbes's list: industry, agriculture, commodious buildings, navigation, transportation, knowledge of the face of the Earth, arts, letters, and society. What features of democracy do we imagine can continue if there is Earth-wide slaughter?

It has been observed that Hobbes's great invention was peace and Locke's great invention was liberty. The social contract is a brake on injuring: that is its fundamental—almost its only—purpose. But it does not act as a brake on living or on lovemaking or on debating or on skiing: that is why it is the guarantor of liberty. Stop (stop injuries) and go (stay alive, write books, get married, laugh): these are the two motions the great invention was designed to bring about. But it cannot for very long do the second if it has forgotten how to do the first.

Notes

1. Advisory opinion on the *Legality of the Threat or Use of Nuclear Weapons*, International Court of Justice, "Letter dated 14 June 1995 from Minister at the Embassy of Japan, together with Written Statement of the Government of Japan," 1.

2. *Legality of the Threat or Use of Nuclear Weapons*, "Written Statement of the Government of the United States of America," 33 (the final phrase quoted is a citation from Article II of the UN Convention). The United States has not yet chosen to acknowledge the existence of the International Treaty on the Prohibition of Nuclear Weapons, which was adopted on July 7, 2017, and entered into force on January 22, 2022. Some preview of its response, however, may be glimpsed in its 1995 "Written Statement" to the International Court of Justice.

3. "Written Statement of the Government of the United States of America," 2.

4. "Written Statement of the Government of the United States of America," 4.

5. "Written Statement of the Government of the United States of America," 30.

6. "Written Statement of the Government of the United States of America," 32.

7. "Written Statement of the Government of the United States of America," 5.

8. "Written Statement of the Government of the United States of America," 30.

9. Bruce Blair (former missile launch officer), "Chain of Command," lecture at "Presidential First Use of Nuclear Weapons: Is It Legal? Is It Constitutional? Is It Just?," co-organized by Elaine Scarry and Jonathan King, Harvard University, Science Center C, November 4, 2017.

10. Bruce G. Blair, interviewed by Dave Merrill, Nafeesa Syeed, and Brittany Harris, "To Launch a Nuclear Strike, President Trump Would Take These Steps," *Bloomberg*, January 20, 2017.

11. Hanna Pitkin, "Obligation and Consent," *The American Political Science Review* 59, no. 4 (December 1965): 990.

12. Thomas Paine, *The Rights of Man, Common Sense, and Other Writings*, ed. Mark Philp (Oxford: Oxford University Press, 1995), 147.

13. Congress carried out a conditional declaration of war prior to the Gulf War against Iraq (1990). But all previous Congressional deliberations on war rejected as illegal a "conditional" formulation, on the grounds that the "conditional" erases the whole force and purpose of a declaration by enabling Congress to disown its responsibility for authorizing the bloodshed to come.

14. Thomas Hobbes, *Leviathan*, ed. C. B. Macpherson (New York: Penguin, 1968, 1985), 191.

15. Thomas Hobbes, *On the Citizen*, trans. and ed. Richard Tuck (Cambridge: Cambridge University Press, 1998), 44. Injury and injustice are almost synonyms, as Hobbes's first quotation indicates. Tuck translates the Latin *iniuria* in this second passage as "wrong" (or injustice), whereas I retain "injury," as did the 1651 English translation (long thought to be Hobbes's own).

16. "The breach or violation of covenant, is that which men call *injury*, consisting in some action or omission, which is therefore called *unjust* . . . There is a great similitude between that we call *injury*, or *injustice* in the actions and conversations of men in the world, and that which is called *absurd* in the arguments and disputations of the Schools . . . And so *injury* is an *absurdity* of conversation, as absurdity is a kind of injustice in disputation." Hobbes, *De Corpore Politico or The Elements of Law*, in *The English Work of Thomas Hobbes of Malmesbury*, vol. 4, ed. William Molesworth (London: John Bohn, 1811), 95, 96.

17. Hobbes, *Leviathan*, 223.

18. Hobbes, *Leviathan*, 188.

19. Hobbes, *On the Citizen*, 108.

20. Hobbes, *On the Citizen*, 69. As astonishing as it may seem, some of the twentieth-century misidentification of Hobbes as an exponent of brutal international realism comes from quoting the term "laws of Nature" as though it meant "state of Nature."

21. Hobbes, *Leviathan*, 210. The word "peace" or the phrase "covenant of peace" occurs more than eighty times in *Leviathan* and seventy-three times in *De Cive*, often preceded by some designations such as "the first law," "the fundamental law."

22. Hobbes, *Leviathan*, 209.

23. Hobbes, *Leviathan*, 210.

24. Hobbes, *Leviathan*, 212.

25. Among the corollaries is Hobbes's conception of a double braking system on going to war: the brake provided by a requirement for legislative authorization, and the brake provided by the citizens serving as soldiers. See Elaine Scarry, *Thermonuclear Monarchy: Choosing between Democracy and Doom* (New York: Norton, 2014), 195–248. This essay is drawn from *Thermonuclear Monarchy*, chapters 1 and 4, as well as from the author's preface to the forthcoming Japanese translation by Kazashi Nobuo.

26. Thomas Hobbes, *Man and Citizen (De Homine and De Cive)*, ed. Bernard Gert (Indianapolis, IN: Hackett, 1991), 28.

27. Donald W. Hanson, "Thomas Hobbes's 'Highway to Peace,'" *International Organization* 38, no. 2 (Spring 1984): 329–354. The striking description of a social contract as "a highway to peace" is drawn from the English translation of *De Cive* that was long regarded (mistakenly, according to Richard Tuck) as Hobbes's own; Tuck's translation of this phrase is "the royal road to peace," which accords with the original Latin, *pacis via regia*; *Elementa Philosophica de Cive* (Amsterdam: Henr. & Viduam Th. Boom, 1642), pages unnumbered. Via Regia is also the name of a literal highway running between Eastern and Western Europe. Estimates about the century in which it was first built vary greatly (from 1 BCE or earlier to the eighth or ninth century CE). The first written mention of it is in the thirteenth century CE. In England, the idea of the Via Regia has antecedents in Bede but comes to the fore in the early twelfth-century writings of Henry of Huntingdon, after which it enters many legal treatises (beginning with *Leges Edwardi*) and literary accounts by Geoffrey of Monmouth and Havelok the Dane. The idea of the King's Four Highways, two of which run north–south and two east–west, is elaborately bound up with the guarantee of peace on those roads. See Alan Cooper, "The King's Four Highways: Legal Fiction Meets Fictional Law," *Journal of Medieval History* 26 (2000): 351–370, and Robert Allen Rouse, *The Idea of Anglo-Saxon England in Middle English Romance* (Cambridge: D. S. Brewer, 2005), 100–126.

28. My thanks to former research assistant Matthew Spellberg for patiently compiling this list of national constitutions.

29. Steven Pinker, *The Better Angels of Our Nature: Why Violence Has Declined* (New York: Penguin, 2011), 680–682.

30. Richard Tuck, *The Rights of War and Peace: Political Thought and the International Order from Grotius to Kant* (Oxford: Oxford University Press, 1999), 209–219, 224–225. See also Richard Tuck, "Hobbes and Democracy," in *Rethinking the Foundations of Modern Political Thought*, eds. Annabel Brett, James Tully, and Holly Hamilton-Bleakly (Cambridge: Cambridge University Press, 2006), 171-191.

31. Kant, *Conjectures on the Beginning of Human History*, and *Perpetual Peace: A Philosophic Sketch*, cited in Tuck, *The Rights of War and Peace*, 217, 219.

32. D. C. J. Carmichael, "Teaching Thomas Hobbes," *Canadian Journal of Political Science* 23, no. 3 (September 1990): 546. Fortunately, Carmichael's article was occasioned by the appearance of eleven new books on Hobbes in the late 1980s and early 1990s that together worked to bring about "a fundamental reorientation" toward Hobbes. As he notes, a distilled version of this profound about-face can be found in Richard Tuck, *Hobbes: A Very Short Introduction* (Oxford: Oxford University Press, 1989).

33. Tom Sorell, "Schmitt's unHobbesian Politics of Emergency," in *Leviathan Between the Wars: Hobbes's Impact on Early Twentieth Century Political Philosophy*, eds. Luc Foisneau, Tom Sorell, and Jean-Christophe Merle (Frankfurt: Peter Lang, 2005), 130, 138.

34. Carl Schmitt, *The Leviathan in the State Theory of Thomas Hobbes: Meaning and Failure of a Political Symbol* (1938), trans. George Schwab and Erna Hilstein, foreword Tracy B. Strong (Chicago: University of Chicago Press, 2008), 31, 33, 34, 35, 46. Schmitt reveres Hobbes and makes many accurate statements about the matchless scale of his influence (86 and *passim*).

35. Brian C. Schmidt, "Together Again: Reuniting Political Theory and International Relations Theory," *British Journal of Politics and International Relations* 4, no. 1 (April 2002): 115–140, esp. 121, 122. Schmidt cites the phrase "bizarre detour" from Steve Smith, "'The Forty Years' Detour: The Resurgence of Normative Theory in International Relations," *Millennium: Journal of International Studies* 21 (1992): 489–506.

36. David Armitage, "Hobbes and the Foundation of Modern International Thought," in *Rethinking the Foundations of Modern Political Thought*, eds. Annabel Brett, James Tully, and Holly Hamilton-Bleakly (Cambridge: Cambridge University Press, 2006), 219–235, esp. 231–232.

37. Noel Malcolm, "Hobbes's Theory of International Relations," in *Aspects of Hobbes* (Oxford: Oxford University Press, 2002), 432–456.

38. Schmidt describes the many writings that herald the return of ethics and values to the international realm, such as those by philosophers John Rawls and Jürgen Habermas, international scholars Richard Falk and Charles Beitz, and feminist theorists Rebecca Grant and J. A. Tichner. See Schmidt, "Together Again," 122, 124–125, 138, 132, 133.

39. Hobbes, *Leviathan*, 186. It is impossible to imagine Hobbes countenancing an international arrangement in which a handful of men hold the power to annihilate the citizens of other countries or their own. What did Hobbes regard as "the greatest disadvantage that can occur in a commonwealth"? His answer: "massive slaughter of the citizens" (173). This is the fate nuclear weapons hold out as a daily possibility. When Hobbes names this "massive slaughter of the citizens" as the greatest disadvantage he can imagine, he says that it cannot arise in any of the three forms of government he describes (monarchy, aristocracy, and democracy) but only from anarchy, which is the dissolution of all three forms.

40. Bruce Russett, *Grasping the Democratic Peace: Principles for a Post-Cold War World* (Princeton, NJ: Princeton University Press, 1993). Various scholars challenge or qualify Russett's claims. One recent book, for example, qualifies this optimistic view of democracy by showing that "states in the early phases of transitions to democracy are more likely than other states to become involved in war." Edward D. Mansfield and Jack Snyder, *Electing to Fight: Why Emerging Democracies Go to War* (Cambridge, MA: MIT Press, 2005).

41. Russett, *Grasping the Democratic Peace*, 26.

42. Russett, *Grasping the Democratic Peace*, 30, 31 (citing reasons given by other scholars, and showing it is true only when democracies contemplate fighting other democracies).

43. Russett, *Grasping the Democratic Peace*, 38. Russett writes, "The greater the scale, cost, and risk of using violence, the more effort must be devoted to preparations in public, and of the public" (39).

44. Until the Clinton administration, the longitude and latitude of particular cities were preprogramed into US missiles before they were loaded onto *Ohio*-class submarines. The fear that a hacker might initiate the launch of one of these preprogrammed missiles led to a shift to open-ocean targeting. Although no longer preprogramed, specific warheads continue to be assigned to specific cities and geographical regions all over Earth. In his memoire, former vice president Dick Cheney reports that when he took office, he realized no one in any branch of the military could tell him how many nuclear warheads had been assigned to a given city. Taking the example of Kiev, he asked each branch of the military to find out how many had been assigned "under the current plan" to that one city. The answer, when it eventually came back, was "dozens." Dick Cheney, *In My Time: A Personal and Political Memoir* (New York: Simon and Schuster/Threshold, 2011), 233.

45. Russett, *Grasping the Democratic Peace*, 31.

46. Russett, *Grasping the Democratic Peace*, 38.

9

Theorizing War: From Classical to Quantum

James Der Derian

War and Paradox

Speaking about quantum mechanics and the futures of war in Copenhagen's historic War Museum, formerly the Royal Danish Arsenal, I could not resist opening with the familiar quote from folk philosopher and baseball manager, the great Yogi Berra: "The future ain't what it is used to be."[1] Berra's paradox expresses a general unease about a future that bears little resemblance, for better or worse, to the past. On that day of presentations in Copenhagen, against a backdrop of swords, muskets, and cannons from the past, and with the Long War in Afghanistan, Iraq, and Syria winding down in the present, a glimmer of hope cut through the anxiety of an uncertain future. Might we possibly be heading back to a foretold future of a long peace (Gaddis), an end of history (Fukuyama), the obsolescence of war (Mueller), the transition from imperial to civil wars (Hardt and Negri), and a decline in global violence (Pinker)?[2] Perhaps now, with the spread of democracy, wealth, and enlightened values in Europe and around the world, the weaponry and barbarity of the last century would be consigned to naval yards, army bases, or even nuclear missile siloes refurbished into peace museums.

Perhaps not. As I revised my talk for this book, the COVID global pandemic hit, and national borders were slammed shut; democracy suffered its highest decline since 2010, with more than half of the world's population living under authoritarian regimes; the Doomsday Clock ticked down to 90 seconds to midnight, the closest it has ever been to nuclear apocalypse; and Russian tanks rolled across Ukraine's border, with no end in sight for Europe's worst conflict since World War II.[3]

In the end, I decided to treat the proliferation of paradox and rise in uncertainty in our strange times as good reason to double down on my original intent to quantize the futures of war. I take my lead from two Nobel laureates in quantum physics, who fittingly come from Denmark and Australia: Niels Bohr, who when confronted in a colloquium by yet another counterintuitive quantum phenomenon exclaimed, "How wonderful that we have met a paradox—now we have some hope of making progress"; and William Lawrence Bragg, who when seeking to make sense of the observer-dependent properties of light declared, "Everything in the future is a wave; everything in the past is a particle."[4]

Rather than indulge in Berra's nostalgia for a rosy past that never was or succumb to the nihilism of a dark future too difficult to measure, I propose to use the ideas of

Bohr, Bragg, and other quantum theorists as an intellectual springboard to speculate with a mindful pessimism *and* a willful optimism about the futures of war *and* peace.[5] This will require something of a quantum leap or, more accurately, because a quantum leap is actually infinitesimally small, a trip down the quantum rabbit hole. "Quantizing war" means accepting paradox—that more than one truth can be true at the same time—as an inherent feature not only of war but also of any inquiry into the futures of war. We need to recognize how information is created by a conflict between incompatible wavelike futures and particle-like pasts (complementarity); how an act of observation alters the reality observed, especially in the prediction of the future from past realities (uncertainty); and that actions in one place can produce near-synchronous, non-local, acausal effects in another place (entanglement). Most importantly, it means accepting that futures of both war *and* peace exist in a single state of probabilities right up until a measurement, observation, or decision is made—and accepting that dead *and* alive people, not cats, are in the box (superposition).

We also need to acknowledge (but seem to keep forgetting) that the complementary and paradoxical character of war predates quantum—or at least as we know it today. For example, if war, as Heraclitus first claimed, is the father of all things, then peace can only be understood as a relation(ship) of war. The Roman general Vegetius made a dictum of the paradox—*igitur qui desiderat pacem, praepert bellum* (if you want peace, prepare for war)—assuring in the process long if indefinite futures for war. H. G. Wells could write of the Great War as "a war to end all wars," only to prompt Prime Minister Lloyd George's famous retort: "Until the next one." At the 1943 Teheran conference, Winston Churchill saw fit to embellish the commonplace that the first casualty in war is the truth, informing Stalin in an aside, "In wartime, truth is so precious that she should always be attended by a bodyguard of lies." A US Army major in Vietnam told reporters without any hint of irony that "it was necessary to destroy the town to save it." And while negotiating an end to the war in Bosnia, US diplomat Richard Holbrooke implored NATO to "bomb for peace" in Serbia. From Plato to NATO, the complementary relationship of war and peace has been captured by the paradoxical Greek concept of *pharmakon*: both disease and cure for the body politic.[6]

Pushing this etymology further provides evidence of an early and often beneficial relationship of paradox to war. The Greeks first coined the word *paradoxos* to convey the sense of a world contrary to expectations in the present that required one to go beyond or outside (*para*) the usual ways of thinking (*dokein*). Facing a paradox of existential significance, as with the decision to wage war or seek peace, the leaders of the *polis* sent out envoys (*theors*) to the site of an oracle (*theon*), such as Delphi, for a studied contemplation (*horao*) of the paradox.[7] If the gods were beneficent and the humans not hubristic, the envoy would return with sagacious advice for the polis. From this came the notion of a "theory" as the taking of a ritual or journey to presage the futures of war and/or peace.

James Der Derian

I do not wish to make too much of this historical and etymological snapshot, especially one so inflected by mythology. Nor do I claim my journey to the Danish War Museum yielded a theory equivalent to Delphic wisdom. However, the setting proved sufficiently unsettling, giving me cause to join my past classical and constructivist inquiries with a quantum approach in pursuit of a mode of theorizing (*pace* Gilles Deleuze) that I hope will be worthy of multiple futures of war.[8] The strange looping of feudal, national, and imperial European wars inside and outside the museum also influenced my choice of three theoretical guides from the fields of military strategy, continental philosophy, and quantum physics, each of whom treat paradox as a goad rather than an obstacle to new thinking about radically uncertain futures.

The first is Carl von Clausewitz (1780–1831), military strategist, director of the Prussia's War College, and author of the classic *On War*. Clausewitz challenged the orthodox view of the nineteenth century—resurgent in the twenty-first—that positive science could produce eternal principles and predictable outcomes for future wars.[9] Paradoxes are rife in *On War*. They emerge from the gaps that open up between war as an application of military force and a continuation of politics, between a battle plan and the first encounter with the enemy, and between what Clausewitz called "real war" and "absolute war." The effort to close this gap through military and political science yields a new paradox: "Our knowledge of circumstances has increased, but our uncertainty, instead of having diminished, has only increased."[10] Historically contingent, dialectically experienced, futures of war are sure to produce further paradoxes: "Every age," cautioned Clausewitz, "has its own kind of war, its own limiting conditions, and its own peculiar preconceptions."[11]

The second is Friedrich Nietzsche (1844–1900), classical philologist, musical composer, and poet, thought by some to be a great genius of German philosophy and by others to be the heartless monster whose ideas gave Nazism its intellectual nourishment. Nietzsche wrote that "life is a consequence of war, society itself a means to war." But this drive could not be reduced, as the traditional realist would have it, to survival alone: "Life itself is will to power; self-preservation is only one of the indirect and most frequent results." Nietzsche viewed life as a contest of wills and a desire for recognition: directed toward the future, the will to power was self-affirming and creative; projected upon the past, a resentment of others and insecurity produced collective pathologies, most notably war. The motivating paradox for Nietzsche, *über alles*, was how "madness is rare among individuals; in entire nations it is common."[12]

The third is Niels Bohr (1885–1962), modeler of the atom, philosopher of science, and Nobel Prize winner for his seminal formulations of quantum mechanics. Through quantum theory, Bohr sought to explain how entities could exist in multiple probabilistic states (superposition), correlate across vast distances (entanglement), and take on an ontic reality only when measured or observed (uncertainty). While Bohr found paradox to be felicitous for scientific progress, Bohr's relationship to paradox in politics and

war was more complicated. As we shall see, in 1939, on the cusp of Hitler's invasion of Poland, Bohr published with physicist John Wheeler the article on the production of energy by nuclear fission that would prove instrumental in the development of the atom bomb. In 1943, he was smuggled out of Nazi-occupied Copenhagen to help the Manhattan Project build the bomb. And in 1952, alarmed by the dangerous rivalry and secrecy of a nuclear arms race, Bohr wrote an open letter addressed to the United Nations on the urgent need for international cooperation on new technologies that might help solve rather than add to the world's problems.

I choose Clausewitz, Nietzsche, and Bohr not only for their transformative work in strategy, philosophy, and physics but also for their facility with paradoxical and complementary thinking, which spurs them to think outside and beyond conventional wisdom. Their intellectual ease with paradox and complementarity could well come from their openness to contrary views from fields of study considered alien or even taboo by their peers. Both Clausewitz and Nietzsche borrowed ideas and concepts from science: Clausewitz picked up his strategic concept of the "center of gravity" at a physics conference; at one point, Nietzsche considered giving up philology for the study of chemistry; and both were, in their respective fields of expertise, critical of contemporary efforts to make a positive science of strategy *or* philosophy.[13] Bohr acknowledged metaphysical influences in the development of key principles of quantum mechanics, from Kierkegaard's aesthetics/ethics distinction to the Tao's yin/yang, so much so that his contemporary Werner Heisenberg remarked, not disparagingly, that Bohr "was primarily a philosopher, not a physicist."[14]

Clausewitz, Nietzsche, and Bohr might appear to be an unholy trinity, but I think they provide the best combination of strategic, philosophical, and scientific methods for investigating three potential and coterminous futures of war: a semiology of classical war, a genealogy of cyberwar, and a phenomenology of quantum war.

I say "potential and coterminous" because classical war will remain a viable policy option in an anarchical society; cyberwar has not yet reached its asymptote, which might well be quantum technology; and quantum technologies in computing, communication, control, sensors and artificial intelligence, while surely significant factors in futures of war, are still primarily confined to the laboratory. But every powerful new technology is eventually weaponized, and quantum technology is highly likely to create material asymmetries, disrupt societies, and probably reconfigure the global balance of power. I have explored the techno-scientific factors extensively as part of Project Q at the University of Sydney.[15] In this setting, among fellow theorists of war, the primary focus of my essay is based on the need *now* to develop better theoretical tools for understanding quantum *phenomena* of uncertainty, superposition, and entanglement that are already profoundly shaping the futures of war.

Nor does quantizing war necessarily entail the repudiation of all classical approaches. I leave that judgment for the "stress test" of international politics. However, there are

already plenty of signs that the dominant school of realism in international relations might be ready for the recycling if not the dustbin of history. Stuck in Cartesian-Newtonian-Hobbesian worldviews, in which the future is interpreted as a recurring causal effect of the past, realism has proven increasingly ineffective in anticipating uncertainties that are nonlinear, low probability, and of high consequences—which could be said of practically every transformative moment in recent history, such as the end of the Cold War, 9/11, the 2008 financial crash, and the global impact of the coronavirus pandemic.[16] However, classical realism's often-neglected principles of nonintervention, self-defense, and proportionality—most visibly on display if not very effective in the march to war in Iraq—are well worth salvaging.

These openly speculative and, even worse, transdisciplinary methods might well draw opposition from physical scientists, who will insist that quantum phenomena cannot scale up from the subatomic to the macrophysical level; from social scientists, who will belittle quantum concepts as mere metaphors; and from philosophers, who will view the effort to import quantum theory as one more instance of "science envy." A short rebuttal to these criticisms is provided below; more extensive ones can be found in a growing body of literature on the quantum advantage for social and political inquiry.[17] But there is another reason, with added urgency, to undertake a transdisciplinary approach to the futures of war. When observational practices and visual imagery transmitted in near simultaneity through densely networked systems of multiple media produce powerful superpositional *effects* as well as entangled *affects*, it is time to assess the advantages of quantum over classical approaches to war and world politics. Providing what we might call a new human science for world politics, this transdisciplinary approach provides more effective epistemics (ways of knowing), ontics (ways of being), and praxis (ways of doing) for a new global heteropolarity, in which networks, super-empowered individuals, and nongovernmental actors using critical technologies challenge classical practices of war and diplomacy.

A Semiology of Classical War

War has its own grammar, but not its own logic.
—Carl von Clausewitz[18]

First, why a *semiology* of classical war? Although semiology as a science of reading patterns of meaning dates back to the twentieth century and the seminal works of Ferdinand de Saussure, C. S. Peirce, Louis Hjelmslev, Julia Kristeva, and Roland Barthes, among others, the concept coevally emerges in the seventeenth century with new developments in the military and medical sciences.[19] With improvements in gunpowder and the rifling of firearms changing the nature of battle, the vulnerability of general officers to more accurate weapons and the need to maneuver at greater distances, a new visual system of signaling was instituted. At roughly the same time, the incipient

practice of modern medicine was applying novel instruments and methods (as well as painterly representations) for the scientific study of symptoms of disease. In their respective theaters of operations, the medical and the military fields coined a new term to describe the study of pathological symptoms and signs of long-distance warfare: semiology, or as it has come to be known, semiotics. In this originating moment, the professional arts of healing and killing shared a common pharmacotic imperative: survival of the body and the body politic meant getting the signs right. Facing the increased acceleration and complexity of not only traditional warfare but also infowars, netwars, and cyberwars, semiology has become an even more valuable tool for conducting as well as understanding war.

A semiology of classical war reveals ambiguities from its earliest semantic roots. In many language trees, the word "war" traces back to a god with particularly destructive tendencies. The Greek *polemos* sometimes represents a god ("father of all things," Heraclitus), other times a general estrangement ("a setting apart," Heidegger), but it evolves into a sense of a forceful dispute (hence "polemic"). The Latin *bellum* similarly emerges from a Roman god and then comes to represent conflict among belligerents in a general state of nature or condition of anarchy (*bellum omnium contra omnes*, Hobbes). The phonetic origin of Anglo-Saxon usage comes from the German-Frankish *werra*, conveying an even more abstract sense of a general state of discord or confusion. In some languages, divine origins persist in colloquial expressions, such as the Irish "begorra" (from the Celtic war god, *gorra*).

Modern definitions of warfare stick close to the Latin concept of *bellum*, referring to open, armed, and almost always political conflict between nations, states, or other organized actors. The value of these traditional definitions, however, has diminished with the increased effects of globalization, the rise in subnational conflicts, and the privatization of war. Now, even the broadest definitions of war, as "a legal condition of hostile activity" by Quincy Wright, as "organized violence between political units" by Hedley Bull, or even as "organized confusion" by Arthur William Tedder, must be considerably stretched to accommodate a range of conflicts that involve pirates, mercenaries, militia, warlords, drug lords, hackers, and other non-state actors traversing national borders and challenging the state's monopoly on judicial violence.[20] In the process, state-on-state war as the ultimate reality principle of sovereignty has come under sustained challenge, with all kinds of sub- and supra-state conditions of discord carrying the epithet of "war," like the various wars over the years on drugs, poverty, crime, terror, and so on.

Although held up as the canonical father of military strategy, Carl von Clausewitz sought to create a human science of war that was dialectical, intersubjective, and accommodating of the ambiguous character of war. He variously describes war as "an act of force to compel our enemy to do our will," as "nothing but a duel on a larger scale," and as "simply the continuation of political intercourse with an admixture of other means." A war discontinuous with the reason of states or disproportionate in the application of

means to ends is a recipe for national disaster. War is never an objective thing in itself: it cannot be isolated from political decisions, normative imperatives, troop morale, and, most significantly, force of circumstance.[21] Clausewitz's aim might be to make war a rational instrument of state power, but he fully and ultimately comprehends war as a paradox, simultaneously physical *and* metaphysical, simple *and* complex, literal *and* metaphorical. To paraphrase Immanuel Kant, one of Clausewitz's favorite Enlightenment philosophers, war is crooked, as are all things human.

To interpret war, as Clausewitz emphatically did in book 8, chapter 6 of *On War*, as having "its own grammar, but not its own logic" is to recognize that war, like language, is as much an open art shaped by communicative actions and uncertainty as it is a hard science governed by authoritative rules and predictability. He seeks to bridge the gap between the art and science of war through metaphors such as friction and, most memorably, fog: "planned in a mere twilight, which in addition not infrequently—like the effect of a fog or moonlight—[war] gives to things exaggerated dimensions and unnatural appearance." And like language, war makes us as we make war. Indeed, French philosopher Michel Foucault, political sociologist Charles Tilly, and other critical thinkers go so far as to invert (some might say pervert) Clausewitz's famous dictum to argue that politics, the state, and even modern subjectivity is a continuation of war by other means.[22] To seek a solely objective nature to war under such reflexive conditions will only give rise to greater irrationalities and worse dangers for the state.

A Genealogy of Cyberwar

I fear we are not getting rid of God because we still believe in grammar.
—Friedrich Nietzsche[23]

Trained as a philologist, Nietzsche understood the value of semiology for uncovering the true nature of life. In *The Twilight of the Idols*, Nietzsche endorses the power of "semeiotics" for a fuller understanding of morality:

> To this extent moral judgment is never to be taken literally: as such it never contains anything but nonsense. But as semeiotics it remains of incalculable value: it reveals, to the informed man at least, the most precious realities of cultures and inner worlds which did not know enough to "understand" themselves. Morality is merely "sign" language, merely symptomatology; one must already know what it is about to derive profit from it.[24]

Indeed, Nietzsche advocates the semiotic "cure" of Thucydides's and Machiavelli's realism against Plato's decadent idealism:

> My recreation, my preference, my cure from all Platonism has always been Thucydides. Thucydides, and perhaps the *Principe* of Machiavelli, are related to me

closely by their unconditional will not to deceive themselves and to see reason in reality—not in "reason," still less in "morality" . . . Courage in face of reality ultimately distinguishes such natures as Thucydides and Plato: Plato is a coward in face of reality—consequently he flees into the ideal; Thucydides has himself under control—consequently he retains control over things.[25]

However, to truly know what signs are "about" requires a genealogy of the *power* behind the signs, be it God or other pretender to sovereign control over the individual. Created by Nietzsche to disabuse "histories of the present," a genealogy rescues forgotten voices of dissent and lost possibilities for change. As I have written earlier, a genealogy calls into question the origin stories, essential identities, and deep structures of dominant schools of thought, revealing their metaphorical, even mythical beginnings.[26] For Nietzsche, genealogy is not simply a critique of the past but rather a mode for creating counter-histories that enable new futures. Picked up by scholars in multiple disciplines, genealogy has become a powerful tool for uncovering the highly contingent, nonlinear, and discontinuous nature of history.[27]

A useful start for investigating the futures of war would be a genealogy of the so-called new wars, Mary Kaldor's umbrella concept, along with a host of other terms seeking to give sense to the admixture of domestic, foreign, and global conflicts that followed the end of the Cold War.[28] Some terms, such as "hybrid," "irregular," and "fourth generation" signified a combination or a break while acknowledging continuities with past forms of warfare. In similar fashion, the "post" prefix proliferated to describe phenomena that built upon but went beyond past practices, such as "postindustrial," "postmodern," and "posthuman" wars. Other terms emphasized the spatial ("three-block," "3D," and "360-degree" war), the spectral ("TV," "visual," or "meme" war), the temporal ("long," "forever," and "permanent" war), or the technical ("infowar," "netwar," and "cyberwar").[29]

One in particular, cyberwar, warrants its own genealogy not only to uncover its transformative significance but also to understand why it is likely to outlive its conceptual contenders as a player in all futures of war. The first and fairly inauspicious appearance of "cyberwar" was in 1987, when an anonymous editor from *Omni* (Bob Guccione's other magazine) attached the neologism as a title for an article by Owen Davies.[30] Although he never used the word or developed the idea of "cyberwar," Davies accurately called the coming of robotic warfare. And something was clearly in the zeitgeist: also in 1987 (but avant la lettre), cyberwar in the narrow sense of an attack by malicious code on a computer system, communications network, or critical infrastructure made its debut as the Jerusalem virus aka the PLO virus, a logic bomb that would pop up on any given Friday the thirteenth.

As it happens, and by way of a disclaimer, I have a dog in this citation fight. The next recorded use of "cyberwar" was in 1991 when, after reading too much William

Gibson and Bruce Sterling and watching too much of the 24/7 coverage of the Gulf War, I decided to title my paper and explore the idea for the Second Annual Cyberspace Conference in Santa Cruz California, "Cyberwar, Videogames and the Gulf War." Shortly afterward, I was asked by the short-lived PBS television show *Late City* to distil the 100-hour "TV War" into a two-minute video buzz clip (set to "Sweet Bird of Truth" by The The). At the Santa Cruz presentation, I purposely gave the concept a definition that could expand as the phenomenon evolved: "a new virtual and consensual reality, the first cyberwar, in the sense of a technologically generated, televisually linked and strategically gamed form of violence." For the *Late City* video, I ended on a prophetic note: the Gulf War "was our first but not our last cyberwar." Aside from a brief mention in *Visual Anthropology Review* by two PhD students who attended the conference, the introduction of "cyberwar" into the vernacular received little notice. I took solace in one of Nietzsche's more famous quotes: "only that which has no history can be defined."[31]

But then history responded with a vengeance: just about every major war since the Gulf War has had a cyber element to it. To be sure, acts of primal if not always organized violence by and against tribes, nations, and superpowers continue, all too often in the name of origin myths that would not be out of place in the Stone or Bronze Age. And the contemporary landscape of world politics is littered with *casus belli* that would not be unfamiliar to Clausewitz or, for that matter, to his eminent precursors such as Machiavelli and Hobbes, who identified wars of gain (produced by imperial, economic, and military struggles for dominance), wars of fear (prompted by perceptions of a rising power or threatening evil), and wars of doctrine (caused by the clash of monolithic faiths and universalist ideologies).[32]

But Al Qaeda, ISIS, and other non- and wannabe-state actors stress tested the Westphalian system with new cyber-weapons. Intent on challenging the state's monopoly on violence, today's insurgents, jihadists or private militia, are not far removed from their earlier counterparts, like the pirate, mercenary, and holy crusader. Even the *guerre du jour* of "hybrid war," the corrosive mix of private criminality, public bellicosity, and authoritarian politics that scars the residual borders of the Cold War, has more than a hint of the medieval in the interplay of overlapping sovereignties, polymorphous combatants, and clashing cosmologies. And so long as global violence remains viable, sometimes the only option in the face of intractable political differences, social injustices, and cultural struggles for recognition, war in one cyber form or another will find a way in the future. Contemporary non-, para-, and anti-state actors have proven to be willing as well as able to use networked technology to wage asymmetric cyberwars—which, in turn, prompts overreactions by states and further cycles of mimetic violence.

Depending on whether one goes back to the Greek (*kubernētēs* or "steersman"), Norbert Wiener ("cybernetics," 1948), or William Gibson ("cyberspace," 1984), "cyber" has been used to describe everything from a control system with a feedback capacity to a technologically induced consensual hallucination to a four-hundred-pound hacker

(*pace* Trump) subverting the US elections. Carbon-dating the tools of cyberwar is no easier. Some day in the future, archeologists will sift through the ruins of Bell Labs, find wire etchings in germanium and silicon, and declare 1947, give or take a year, as point zero from which microprocessors, packet switches, and fiber optics as well as digital code, information theory, and networked systems soon followed. However, science will not capture the ghost in the machine. For that, we best go back to the originating myths. "Cyber" is literally as old as the bible and other holy texts in which gods "steer" or "govern" the universe. In the Judeo-Christian version, those "who have no direction (*kubernēsis*) fall like leaves" (Prov. 11:14); those who prosper understand that "with strategic planning (*meta kubernēseōs*) war is conducted" (Prov. 24:6). Leaping a millennium or two forward, our techno-deities might not be as omniscient or omnipotent as past gods, but weaponized and sanctioned by national security, they deter, disrupt, and, if necessary, destroy our enemies with relative impunity to us. Obama got religion, ordering ten times the number of drone attacks executed by Bush. Barely two months in office, President Trump increased them by another 400 percent over Obama, and they continue to enjoy first-use status in the Biden administration.

Perhaps the most peculiar characteristic of cyberwar is how well it resists the traditional *restrictions* of warfare. As everything and everyone becomes connected, it's very hard to confine cyberwar to a discrete place or bounded time. With a few clicks and several thousand shares, an incident escalates from a local to regional to international crisis. This is the force-multiplier effect of cyberwar, with 9/11 as the most seminal and inspirational example. Access to the Internet and flight simulators made it possible for Osama bin Laden and nineteen kamikaze fanatics to topple the World Trade Center, hit the Pentagon, kill nearly three thousand people, and cause billions of dollars in damages (trillions if we include second-order effects such as the Iraq War and the rise of ISIS).

If there is a prejudice in the Clausewitzian sense to cyberwar, it can be found in the conceit that virtualization makes war more virtuous. Rather than resorting to the convention of bombs, the United States and Israel inserted the Stuxnet virus to degrade the Iranian nuclear weapon program; no matter that the virus proved to be a less than precise munition and rapidly spread to nontargeted industrial platforms. Wikileaks hacked thousands of embassy cables to make US diplomacy more transparent and democratic; no matter the collateral damage done to alliances and coalition efforts to restrain antidemocratic regimes. Drones pursue a cleaner kill; no matter the virtual terror induced upon whole populations.

It is safe to say that we have not seen the end—or the worst—of cyberwar. With so many networked actors operating simultaneously across multiple levels of power, the prediction, preemption, or restriction of cyberwar is exceptionally difficult. Distinguishing intentional from accidental acts is hard. When cyber as control in warfare bleeds into cyber as influence in active measures, distinctions will be even harder to maintain, with all kinds of second- and third-order effects. The cyber advantage might now go to

the most technologically advanced powers, but the law of uneven development gives latecomers the edge. This is why we should be asking now, before rather than after the owl of Minerva takes flight at dusk, what kind of new paradoxes cyberwar will engender when it goes quantum.

A Phenomenology of Quantum War

It is no longer possible to make predictions without reference to the observer and the means of observation.
—Niels Bohr[33]

We cannot yet say what the Russia–Ukraine conflict *means* for the futures of war. This did not, of course, stop amateur semiologists from speculating the moment Russian tanks rolled over the Ukrainian border. One signifier stood out from others: "Open source analysts and military experts first spotted the mysterious Z-shaped letter hand-painted on Russian tanks and military trucks massed on the Ukrainian border on 19 February, leading to widespread speculation among western experts as to what the letter meant."[34]

"Z" quickly become the call sign of the war. It was clearly a phenomenon ("a thing that appears" from the Greek), one that cries out for a phenomenology ("the study of things as they appear in our experience")—but as a sign of the first or the last of future wars?[35]

That takes a deeper dive into philosophy and physics. Drawing on the works of phenomenologists such as Edmund Husserl, Martin Heidegger, Simone de Beauvoir, Jean-Paul Sartre, Maurice Merleau-Ponty, and others, I interpret "Z" as what Husserl called an *epoché*, a "cessation" in which a phenomenon stops being what it *is* and is experienced anew for what it *means*.[36] It then becomes apparent that the "Z" had taken on an excess of meaning, requiring an excessive interpretation.[37] A phenomenology can help us understand not only what the "Z" means but also what I believe is emergent in the conflict: a quantum war.

This mode of inquiry reflects a fundamental tenet of phenomenological practice, captured by Husserl's frequent instruction in lectures to go "back to the things themselves," to see "what stands before our eyes, to distinguish, to describe."[38] He enjoined students to forsake the kind of metaphysical or academic inquiry that shows what we already know *about* for what can do anew *with* philosophy and science. This means experiencing "Z" not as an object in itself but rather as a phenomenon inscribed by intersubjective intentionality. Again, according to Husserl, "All consciousness is consciousness of something"—including the consciousness of others.[39]

In the process, I believe the coeval development of phenomenology and quantum mechanics in the interwar provides a hybrid method well suited to radically uncertain times. Shared by leading thinkers in both fields—or at least in the dominant Copenhagen

interpretation of quantum mechanics—is a philosophical disposition, viewing consciousness always as a consciousness of something outside of ourselves, not just of "others" but as an externalized relation in which classical distinctions of subject and object no longer hold. Phenomenology projects a worldview that is holistic, relational, and observer dependent. This disposition, as presented earlier, is expressed at a microcosmic level by the core principles of quantum mechanics, in which entities can exist in multiple probabilistic states (superposition), correlate across vast distances (entanglement), and take on an ontic reality only when measured (uncertainty). Early quantum physicists were open and willing about the need to parse the macro-philosophical implications. Aside from Einstein and a few others, most broke from classical conceptions of scientific empiricism by positing individuals not as subjects perceiving an objective world out there but rather as participants in the construction of reality. Now better known as "participatory realism," these ideas were first put forward by the likes of quantum physicists Niels Bohr, Max Born, Wolfgang Pauli, and John Wheeler, among others, and then further developed by phenomenologists and then by quantum philosophers at Oxford, New York, Sydney, and other universities.[40]

This might seem a bridge too far for what has widened from a disciplinary divide into a paradigmatic chasm between the sciences and humanities. But if we are to understand where warfare is heading, we need to go back to the future, to a time when academic fields of inquiry had yet to acquire the hard epistemic boundaries of today. Philosophers and physicists of the interwar were part of a shared academic community, operating under the rubric of "natural philosophy."[41] Their dialogues spilled over from departmental hallways into broader engagements: Werner Heisenberg attended lectures by Martin Heidegger; Niels Bohr was heavily influenced by William James, Søren Kierkegaard, and Taoism; Alfred North Whitehead and David Bohm were in regular correspondence, as were Carl Jung and Wolfgang Pauli, with numerous other examples.[42]

What was commonplace then has today taken on an academic taboo, and I have recounted above and in other work how such speculative transdisciplinary methods are likely to draw heavy criticism on multiple fronts.[43] For reasons of space, I offer a limited defense here.

First, microphysical quantum phenomena have already been shown to scale up to biological, cognitive, and behavioral levels, including photosynthesis, bird migration, and decision making.[44] Second, metaphors—especially those whose metaphorical nature have been forgotten (*pace* Nietzsche)—matter: we have witnessed the power of classical metaphors like sovereign states bouncing off one other like billiard balls or a balance of power functioning like a positive law of Newtonian physics.[45] But how they matter is also phenomenological, in the sense of how global events are increasingly *experienced* as quantum phenomena. When former US secretary of state George Shultz spoke of a new "quantum diplomacy" or the president of Armenia Armen Sarkissian (who happens

to be a theoretical physicist) of a globalizing "quantum politics," they sought to highlight the superiority of quantum over classical heuristics for understanding quantum-like phenomena.[46] Third, what *should* matter is what works, in the sense of providing more plausible explanations than traditional accounts. I believe the paired fields of phenomenology and quantum mechanics can generate a powerful mode of inquiry, in particular for the first *truly* worldwide war, the Russian–Ukrainian war, but also in general for future observer-dependent, over-mediated, participatory wars.[47] Finally, this might all be an untimely worry: with the emergence and potential convergence of quantum computers going online, quantum science scaling up, and quantum consciousness proving measurable at the macrophysical level, quantum could well prove to be the most *realist* of geopolitical theories.

An historical analogy, from another moment of history on edge, might help to convey the urgency of getting this right, now. In 1939, several of the world's most eminent physicists gathered at the Princeton Institute of Advanced Studies to debate widening differences in the new field of quantum mechanics. Albert Einstein in particular could not abide the counterintuitive weirdness of the Copenhagen interpretation of an indeterminate and observer-dependent reality, famously deriding radical quantum principles such as uncertainty ("God does not play dice with the universe"), entanglement ("spooky action at a distance"), and superposition ("Does the moon only exist when I observe it?"). However, great uncertainties and spooky actions emanating from Europe intruded upon their academic idyll. The physicists would put aside their theoretical differences to posit practical applications of quantum mechanics that would transform world politics.

In August, Einstein and the Hungarian physicist Leo Szilard sent a letter to Franklin Roosevelt, warning the president of a new source of incredible energy from the splitting of an atom that could well lead to the "construction of extremely powerful new bombs."[48] The American physicist John Wheeler and Danish physicist Niels Bohr wrote a seminal article on "The Mechanism of Nuclear Fission"; it would be published on September 1, the same day Germany invaded Poland and World War II began. A political chain reaction followed: the Manhattan Project, Los Alamos, and the dropping of two atomic bombs on Japan. Several years later, after the bomb helped end World War II and start a Cold War with the Soviet Union, Einstein voiced his regret for the inability of humankind to manage the powerful technology that he and other physicists had brought to life: "The unleashed power of the atom has changed everything save our modes of thinking, and we thus drift toward unparalleled catastrophe."[49]

Einstein might have been wrong about much of the theory, but he was proven at least half-right about the geopolitical significance of quantum mechanics. The same year Einstein warned Roosevelt of the possibility of an atomic bomb, GCHQ—then known as GC&CS (the Government Code and Cypher School)—brought physicists, mathematicians, and engineers to Bletchley Park, set with the urgent task of breaking the German

Enigma code. Operating under a shroud of secrecy that rivaled the Manhattan Project, Alan Turing and his brilliant team constructed an electromechanical Bombe (after the Polish prototype, *bomba kryptologiczna*) that began breaking the Enigma ciphers of the German military within a year.

Secrecy was paramount in both the development of the bomb and the Bombe, forever coloring what happened next. Shortly after Hiroshima and Nagasaki, there was common agreement, from President Truman on down, that Japan surrendered because of the dropping of the two atomic bombs. This view would only be challenged years later, after historians sifted through the archives (including messages that had been broken by the *other* Bombe) and began to question whether the shock of atomic devastation made it possible for Japan to save face and sue for a surrender that already had been deemed inevitable if not imminent once the Soviets entered the Pacific War (and faced even worse terms). Because Bletchley's operations were kept secret until the 1980s, historians were slow to recognize the significance of code breaking first in England and then in the United States by electromechanical Bombes. However, by the 1990s, most agreed that the Bombes had shortened World War II by at least a year, saving millions of lives.[50]

Physicists in 1939 had been fairly quick to recognize that the principles of quantum mechanics would lead to a revolution in energy, and facing the possibility that Nazi Germany might get there first, most of them enlisted in the effort to produce weapons of mass destruction (which, as we now know, from Heisenberg and others involved, never came close). Physicists and other scientists showed considerably less celerity understanding how quantum principles applied to the invention of semiconductors and fiber optics would lead to a second revolution in information, producing even more disruptive effects on society after the war.[51] Potentially the most critical question for the future is how we respond to the paradoxes of a third quantum revolution: When quantum computing, communications, control, and artificial intelligence (QC3AI) converge, will the collapse of the wave function still require an observing human in the loop? Good reason to end on a cautionary note, supplied by the poet Paul Valéry, who looking back at the two world wars understood better than most just how high the stakes were for the future behind and ahead of them:

> The future, like everything else, is no longer quite what it used to be... No calculation of probabilities is possible. Why? Because the modern world is assuming the shape of man's mind. Man has sought in nature all the means and powers that are necessary to make the things around him as unstable, volatile, and mobile as himself, as admirable, as absurd, as disconcerting and prodigious as his own mind. If we imprint the form of our mind on the human world, the world becomes all the more unforeseeable and assumes the mind's own disorder.[52]

James Der Derian

Theorizing Futures of War: A Coda for Now

I write about potentially unpleasant futures in the hope they will not become real.
—Margaret Atwood[53]

It is still too early to make any conclusive statements about the long-term ramifications of the Russo-Ukrainian War, but I believe that the first year of the conflict provides a snapshot of the evolution from classical to quantum warfare. Classical, Newtonian forms, dominating the early stages of the war, also revealed their heuristic shortcomings, beginning with Putin's misguided strategy and rationale for the invasion (and predictions of "experts" of a quick Russian victory) that featured kinetic force by tanks and artillery to level cities and the weaponization of fossil fuels and food supplies. However, a combination of classical and quantum phenomena so protean as to be paradoxical swiftly began to challenge the assumptions that led up to the war and the early days of its execution. Putin's chauvinistic bravado and disinformation campaigns barely masked a fear of ontic uncertainty. His paranoia, openly evident in his personal distancing and rare public appearances, peaked at the annual Valdai Discussion Club in late 2022, organized under the theme of "A Post-Hegemonic World: Justice and Security for All." After declaring the world to be in "the most dangerous, unpredictable and at the same time important decade since the end of World War II," Putin went on to criticize the political interventionism and cultural decadence of the West, which was undermining the prospects for a "pragmatic dialogue" and "a multipolar order." Repudiating the image of Russia as a revisionist power, Putin presented himself as the savior of a classical states system based on sovereignty and balance of power: "Unlike the West, we mind our own business."[54]

In contrast, Zelensky responded to the radical uncertainty of the war with a clear-eyed assessment of actual risk against potential opportunities, and then leveraged his decisions through strategic live feeds to major Western parliaments and the US Congress as well as to civic organizations, international institutions, and corporate benefactors (most vividly when he appeared as a hologram at the largest Big Tech conference in Europe).[55] Adeptly using open intelligence and social media, he and his tech-savvy staff were able to take measure of breaking events in near real-time simultaneity, producing superpositional political *e*ffects as well as entangled, empathetic *a*ffects, or, if you will (and *pace* Einstein), they practiced spooky action at a distance to turn uncertain, probabilistic situations into positive, predictable outcomes. To paraphrase the memorable quote by Nobel laureate William Lawrence Bragg that opened this essay, Zelensky will be remembered as the first wave of a quantum future, Putin as the residual particle of a classical past.

Notes

1. The contrapuntal effect of the Danish War Museum was mirrored by its Wiki entry: "More than 8000 swords, pistols, armours, machine guns and other weapons and military attributes are displayed in the museum's Great Gallery and the Canon [*sic*] Galley boasts more than 300 canons [*sic*] dating from the 16th century to present days." Wiki also notes that Louis XIV of France had the *ultima ratio regum* (last argument of kings) cast on the cannons of his armies; https://en .wikipedia.org/wiki/Danish_War_Museum.

2. See John Lewis Gaddis, *The Long Peace: Inquiries into the History of the Cold War* (New York: Oxford University Press, 1987); John Mueller, "The Obsolescence of Major War," *Bulletin of Peace Proposals* 21, no. 3 (September 1990): 321–328; Francis Fukuyama, "The End of History?," *The National Interest* 16 (Summer 1989): 3–18; Michael Hardt and Antonio Negri, *Empire* (Cambridge, MA: Harvard University Press, 2006); Steven Pinker, *The Better Angels of Our Nature: Why Violence Has Declined* (New York: Viking, 2011).

3. See "Democracy Index 2021," https://www.eiu.com/n/democracy-index-2021-less-than-half-the -world-lives-in-a-democracy/; and "Bulletin of the Atomic Scientists," January 20, 2022, https:// thebulletin.org/doomsday-clock/#nav_menu.

4. William Lawrence Bragg, *The Development of X-Ray Analysis* (London: Macmillan, 1975); Niels Bohr, as quoted by Ruth Moore in *Niels Bohr: The Man, His Science, and the World They Changed* (New York: Knopf, 1966). Paired, the two quotations invoke a more famous one from Bohr's favorite philosopher and fellow Dane, Søren Kierkegaard: "Life can only be understood backwards, but it must be lived forwards."

5. The pairing of a mindful pessimism with a willful optimism draws on the political strategy of Italian Marxist Antonio Gramsci ("pessimism of the mind, optimism of the will") and on the so-called Stockton paradox ("one must be optimistic about the future while also being realistic about the present," espoused by John Stockton, who survived seven and a half years as a prisoner of war in the Hanoi Hilton).

6. From Jacques Derrida, "Plato's Pharmacy," in *Dissemination*, trans. Barbara Johnson (Chicago: University of Chicago Press, 1981). See also Larry George, "The Pharmacotic War on Terrorism: Cure or Poison for the US Body Politic?," *Theory, Culture and Society* 19, no. 4 (August 2002): 161–186.

7. This etymology is drawn in James Der Derian, *On Diplomacy: A Genealogy of Western Estrangement* (Oxford: Blackwell, 1987); Martin Heidegger, *The Question Concerning Technology and other Essays*, trans. William Lovitt (New York: Harper, 1977); and Costas M. Constantinou, *On the Way to Diplomacy* (Minneapolis, MN: University of Minnesota Press, 1996).

8. Pairing Bohr's concept of a quantum complementarity—in which the properties of wave and particle are complementary yet exclusionary until observed or measured—with a constructivist philosophical perspective is not novel, as Bohr himself acknowledged when he first introduced the idea in his 1927 lecture at the International Physics Congress in Como, Italy: "I hope, however, that the idea of complementarity is suited to characterize the situation, which bears a deep-going analogy to the general difficulty in the formation of human ideas, inherent in the distinction between subject and object." Indeed, some historians and philosophers of science believe Bohr's concept was inspired by his readings of William James on the "complementary" nature of consciousness in *The Principles of Psychology*. See Zheng Want and Jerome Busemeyer, "Reintroducing the Concept of Complementarity into Psychology," *Frontiers in Psychology* 6 (2015): 1822.

Others see a Taoist influence at work, retrospectively noting his adoption of the yin/yang symbol in his family crest. See Ruth Moore, *Niels Bohr: The Man, His Science, and the World They Changed* (Cambridge, MA: MIT Press, 1985).

9. "All these attempts to base the conduct of war upon arithmetic and geometrical principles are to be discarded, as the application of the rule exclude the genius and limit the activity of intelligence." See Carl von Clausewitz, *On War*, trans. and ed. Michael Howard and Peter Paret (Princeton, NJ: Princeton University Press, 1976), II, 2.

10. Clausewitz, *On War*, I, 3.

11. The now standard Howard/Paret translation of this quote, which makes a virtue of clarity, loses some of the nuance, context, and, admittedly, the messiness of the original 1873 translation by Colonel J. J. Graham:

> We here bring our historical survey to a close, for it was not our design to give at a gallop some of the principles on which war has been carried on in each age, but only to show how each period has had its own peculiar forms of war, its own restrictive conditions, and its own prejudices. Each period would, therefore, also keep its own theory of war, even if everywhere, in early times, as well as in later, the task had been undertaken of working out a theory on philosophical principles.

See Clausewitz, *On War*, trans. J. J. Graham (New York: Barnes and Noble, [1873] 2004), VIII, 3.

12. Walter Kaufmann, ed., *The Portable Nietzsche* (New York: Viking Press, 1954).

13. The significance of this extra-disciplinary influence was brought to my attention by Antoine Bousquet and Anzar Gat at the annual Project Q Symposia. While searching for textual evidence, I discovered a Canadian scholar, Youri Cormier, who has also done foundational work in the area. See Antoine Bousquet, *The Scientific Way of War* (New York: Columbia University Press, 2009); Anzar Gat, *A History of Military Thought* (Oxford: Oxford University Press, 2001); and Youri Cormier, *War as Paradox: Clausewitz and Hegel on Fighting Doctrines and Ethics* (Montreal: McGill-Queen's University Press, 2016).

14. John Honner, "The Transcendental Philosophy of Niels Bohr," *Studies in History and Philosophy of Science* 13, no. 1 (March 1982): 1–29.

15. See https://projectqsydney.com.

16. See Peter Katzenstein, who has led an extensive investigation into the analytical failure of traditional IR to understand uncertainty, which he attributes to the persistence of outmoded Newtonian worldviews, in his introduction to an edited collection of essays, *Uncertainty and Its Discontents: Worldviews in World Politics* (Cambridge: Cambridge University Press, 2022).

17. For a more detailed account, see James Der Derian and Alexander Wendt, eds., *Quantum International Relations: A Human Science for World Politics* (New York: Oxford University Press, 2022).

18. Carl von Clausewitz, *On War*, ed. Michael Howard and Peter Paret (Princeton, N.J: Princeton University Press, 1984), VIII, chap. 6.

19. The term also appears in the seventeenth-century work of English philosopher John Locke, although not as an interdisciplinary concept. See "Semiotics," *Britannica*, https://www.britannica.com/science/semiotics.

20. See Quincy Wright, *A Study of War* (Chicago: Chicago University Press, 1964); Hedley Bull, *The Anarchical Society: A Study of Order in World Politics* (New York: Columbia University Press, 1977); and Arthur William Tedder, *Air Power in War* (London: Hodder and Stoughton, 1948).

21. Clausewitz, *On War*, VIII, chap. 3.

22. See Michel Foucault, *Society Must Be Defended: Lectures at the College de France, 1975–1976* (New York: Picador, 2003), 15; and Charles Tilly, "Reflections on the History of European State-Making," in *The Formation of National States in Western Europe*, ed. Charles Tilly (Princeton, NJ: Princeton University Press, 1975).

23. Friedrich Nietzsche, *The Twilight of the Idols* (Middlesex, England: Penguin, 1968), 190.

24. Nietzsche, *The Twilight of the Idols,* 55.

25. Nietzsche, *The Twilight of the Idols*, 117–118.

26. See James Der Derian, "A Reinterpretation of Realism: Genealogy, Semiology, Dromology," in *International Theory: Critical Investigation*, ed. James Der Derian (London: Palgrave Macmillan, 1995), 367.

27. For an excellent genealogy of the transdisciplinary emergence of quantum worldviews, see Jayson Waters, "Estranged/Entangled: The History, Theory and Technology of International Relations in Quantum Mechanics," PhD Dissertation, University of Sydney, 2022.

28. Mary Kaldor, *New and Old Wars: Organised Violence in a Global Era* (Oxford: Blackwell Press, 1998).

29. I too have indulged in this naming game under the justification that new phenomena, largely driven by technological transformations, warranted new concepts. See *Virtuous War: Mapping the Military-Industrial-Media-Entertainment Network*, 2nd ed. (New York: Westview Press, 2001).

30. https://en.wikipedia.org/wiki/Bob_Guccione.

31. See Chris Hables Gray and Mark Driscoll, "What's Real about Virtual Reality? Anthropology of, and in Cyberspace," *Visual Anthropology Review* 8, no. 2 (September 1992): 39–49; and *Late City*, https://youtu.be/jl9bDIs1oek. See also Jessica Andrus Lindstrom, "A Short History of "Cyberwar," *TAG Cybersecurity Annual Report*, April 2022, in which the Santa Cruz event and subsequent essay are acknowledged.

32. Niccolò Machiavelli, *The Prince and the Discourses* (New York: Random House, 1950); Thomas Hobbes, *Leviathan* (Oxford: Blackwell Press, 1946).

33. Remark by Niels Bohr at the 1927 Solvay Conference, in Werner Heisenberg, *Physics and Beyond: Encounters and Conversations* (New York: Harper and Row, 1971), 174.

34. Pjotr Sauer, "Why Has the Letter Z Become the Symbol of War for Russia?," *The Guardian*, March 8, 2022.

35. An early and formative encounter with phenomenology informs this account, my first philosophy course at McGill University, taught by Charles Taylor, in which the first assignment was to write a review of Jean-Paul Sartre's *Being and Nothingness*. Other phenomenological works from which I draw include Edmund Husserl, *The Crisis of the European Sciences*; Martin Heidegger, "The Age of the World Picture"; Simone de Beauvoir, *The Ethics of Ambiguity*; and Maurice Merleau-Ponty, *Phenomenology of Perception*.

36. See Christian Beyer, "Edmund Husserl," *Standford Encyclopedia of Philosophy* ay https:// plato.stanford.edu/entries/husserl/.

37. The use of "deconstruction" here intentionally invokes Derrida, who began his philosophical journey with a dissertation on the limits of phenomenology, a theme to which he returned twenty years later, acknowledging intellectual debts to the phenomenologists. See Jacques Derrida, *The Problem of Genesis in Husserl's Philosophy* (Chicago: University of Chicago Press, 2003), and Jacques Derrida, "Et Cetera. . . ." *Deconstructions,* ed. N. Royle (London: Palgrave, 2000). Paradigm shift is used here in the Kuhnian sense as a fundamental change in the essential concepts and practices of a scientific discipline. See Thomas Kuhn, *The Structure of Scientific Revolutions* (Chicago: University of Chicago Press, 1962).

38. Edmund Husserl, *Logical Investigations*, trans. J. N. Findlay (London: Routledge, 1973), 39, 168.

39. Husserl, *Logical Investigations.*

40. Christopher Fuchs is leading the effort to synthesize the physics and philosophy in Qbism. For a short introduction, see Project Q panels and interviews with Fuchs at https://projectqsydney .com/q-multimedia/.

41. The Universities of Oxford, Cambridge, Edinburgh, Glasgow, and St. Andrews still have professorships and chairs in natural philosophy, as they were created before the demarcation of disciplinary boundaries.

42. For a fuller account of the transnational and transdisciplinary dialogue between physicists and philosophers in this period, see James Der Derian and Alexander Wendt, *Quantum International Relations* (Oxford: Oxford University Press, 2022), particularly the chapters by Grove ("A Quantum Temperament"), Waters ("Mind, Matter, and Motion"), and Harrington ("First Encounters").

43. A lengthier counter-critique can be found in the introduction to Der Derian and Wendt, *Quantum International Relations.*

44. See J. Al-Khalili and J. McFadden, *Life on the Edge: The Coming of Age of Quantum Biology* (London: Bantam Press, 2014); P. Buckley and D. Peat, eds., *Conversations in Physics and Biology* (Toronto: Toronto University Press, 2014); J. Busemeyer and P. Bruza, *Quantum Models of Cognition and Decision* (Cambridge UK: Cambridge University Press, 2012).

45. Friedrich Nietzsche, "On Truth and Lie in an Extra-Moral Sense," *The Portable Nietzsche* (New York: Viking Penguin, 1968), 46–47.

46. On quantum war and quantum diplomacy, see James Der Derian, "From War 2.0 to Quantum War: The Superpositionality of Global Violence," *Australian Journal of International Affairs* 67, no. 5 (October 2013): 570–585; and "Quantum Diplomacy, German-American Relations, and the Psychogeography of Berlin," *Hague Journal of Diplomacy* 6, nos. 3–4 (2011): 373–392. On quantum politics, see John Thornhill, *Financial Times Weekend*, "Quantum Politics" and "Lunch with the FT" (with former theoretical physicist and president of Armenia, Armen Sarkissian).

47. See Olga Boichak, "Battlefront Assemblages: Civic Participation in the Age of Mediatized Warfare," PhD thesis, Syracuse University, New York, 2019, https://surface.syr.edu/etd/1010/.

48. Einstein, "Einstein to President Franklin Delano Roosevelt." For a detailed account of the letter, see Ralph Lapp, "The Einstein Letter That Started It All," *New York Times* (August 2, 1964, 13). Lapp, "The Einstein Letter."

49. This now famous line was coined by Einstein in a telegram appeal to several hundred prominent Americans, asking for contributions: "to let the people know that a new type of thinking is essential" in the Atomic Age. See Robert R. Holt, "Meeting Einstein's challenge," *Bulletin of the Atomic Scientists* (April 3, 2015). (NB. This essay was being revised as the more disturbing parallels emerged between September 1939 and February 2022.)

50. F. H. Hinsley, who worked as liaison between Bletchley and Whitehall during this period, later concluded that "it [ULTRA] shortened the war by not less than two years and probably by four years–that is the war in the Atlantic, the Mediterranean and Europe." See Harry Hinsley, "The Influence of ULTRA in the Second World War," Lecture (October 19, 1993), https://www.cdpa.co .uk/UoP/HoC/Lectures/HoC_08e.PDF); and Jack Copeland, "Alan Turing: The Codebreaker," BBC (19 June 2012), https://www.bbc.com/news/technology-18419691.

51. Leaving aside (for now) the question of whether weapons of mass destruction or tools of mass (dis)information have proven more disruptive since that fateful year.

52. The verdict is out as to whether Berra "borrowed" his famous aphorism from Valery. Berra later claimed that "He just meant that times are different. Not necessarily better or worse. Just different."

53. Margaret Atwood, *Burning Questions* (New York: Doubleday, 2022).

54. See John Keane, "Metaverse Wars," *Eurozine*, June 15, 2022; Masha Gessen, "Why Vladimir Putin Would Use Nuclear Weapons in Ukraine," *New Yorker*, November 1, 2022; and the full text of Putin speech and answers at Valdai Discussion Club, https://www.miragenews.com/full-text -of-putin-speech-and-answers-at-valdai-884161/.

55. See "Zelensky Hologram Appeals for Tech Firm Help," *FRANCE 24*, https://www.youtube.com /watch?v=wQDTTvcOhv8.

III

THE FUTURES OF WAR

10

The Future of Death: Algorithmic Design, Predictive Analysis, and Drone Warfare

Anthony Downey

If we wait for threats to fully materialize, we will have waited too long.
—George W. Bush, June 1, 2002[1]

We kill people based on metadata.
—General Michael Hayden (former director of the National Security Agency and the Central Intelligence Agency), 2014[2]

On August 29, 2021, Zemari Ahmadi, an employee of a nonprofit aid organization, arrived at his home in the Kwaja Burga neighborhood of Kabul in Afghanistan. Driving a Toyota Corolla, the most popular car model in the country, Ahmadi had been under surveillance for at least forty-eight hours by the time he parked in the family compound. At 4:53 pm local time, moments after greeting his children and extended family, a Hellfire missile strike was launched from an overhead MQ-9 Reaper drone. In the confined space of the compound, the ensuing detonation killed three adults and seven children. Related through marriage, those killed were recipients of a Special Immigrant Visa and, on the day in question, were awaiting escort to the Hamid Karzai International Airport in Kabul. From there, they were due to be airlifted out of Afghanistan as part of the US withdrawal from the country—previously announced in February 2020—following a protracted twenty-year war. In the immediate aftermath of the bombing, the US military claimed that it had conducted a successful missile strike on its intended target, the Islamic State in Khorasan Province (ISKP, or ISIS-K). Three days later, and despite mounting evidence to the contrary, the chairman of the US Joint Chiefs of Staff, General Mark Milley, continued to insist that it had been a "righteous strike" prosecuted against a legitimate enemy. On September 17, 2021, nineteen days after the killings in Kabul, the commander of US Central Command, General Kenneth F. McKenzie Jr., held a press briefing to announce that it was "unlikely that the vehicle and those who died were associated with ISIS-K or were a direct threat to US forces."[3] The MQ-9 Reaper drone strike, McKenzie duly confirmed, had been a "tragic mistake."

In the immediate aftermath of August 29, 2021, it was disclosed that the Hellfire missile strike that had killed Ahmadi and nine of his family members had been sanctioned by an over-the-horizon (OTH) strike cell group based in Qatar. Invoking the so-called

ticking-bomb scenario, the firing of a Hellfire missile had been approved in the wake of a series of reports indicating an imminent threat posed by the ISKP to both US forces and Afghan citizens. Following a suicide bombing in Kabul airport three days earlier (at 5:50 pm local time on August 26, 2021), those pressures of time had introduced, McKenzie and others intimated, further miscalculations into the overall operation. These included a failure to conduct a full and extended pattern-of-life analysis on the intended target.[4] Defined as "the intelligence from intercepted digital data communications" a pattern-of-life analysis is compiled from numerous sources, including surveillance data gleaned from unmanned aerial vehicles (UAVs) and on-the-ground intelligence.[5] Despite the mitigating claim that no prolonged pattern-of-life analysis was undertaken prior to the sanctioning of a Hellfire missile strike on August 29, 2021, there exists no agreed definitive length of time within which a pattern-of-life protocol is said to be complete or, perhaps more crucially, incomplete. What we do know, at the time of writing, is that Ahmadi's death was the result of a so-called signature strike which, unlike a decapitation strike (where the target is known), specifies operations that are routinely predicated on pattern-of-life analyses rather than verifiable evidence of nefarious activities, insurgent or otherwise.[6] As we will see, the official absence of such information is, in this instance, misleading insofar as pattern-of-life analyses can and do routinely result in demonstrable error. Putting concerns over due process and operational capacities to one side, the third associated factor in the killing of Ahmadi and his extended family was determined to be confirmation bias.[7] Referring to a tendency, conscious or otherwise, to interpret or make individual judgment calls based upon preexisting views (or entrenched prejudice), the presence of confirmation bias indicates the selection of data that reinforces rather than questions preconceived notions. It can, as in the case of Ahmadi, produce preemptive conclusions based on the presumption of guilt rather than any actual evidence of risk or imminent threat.

To date, the rationale put forward to explain the events of August 29, 2021, embrace a prevailing assumption that the US military's standard operating procedure (SOP) for an OTH missile strike had tragically failed due to the pressure of time (the ticking-bomb scenario), errors in due process (the apparent lack of an extended pattern-of-life analysis), and the absence of impartiality (i.e., the overriding presence of confirmation bias). Under such circumstances, human error is the designated and accepted point of failure in an OTH operation, with the attendant belief being that future "mistakes" can be avoided if such errors are adequately addressed. This was very much the conclusion drawn in the ensuing report on the drone strike, released on November 3, 2021. Reasoning that no violations of military protocol or law had occurred in the lead-up to the events in Kabul, the enquiry duly put forward several recommendations. These included the implementation of procedures to "mitigate risks of confirmation bias," the enhanced sharing of "overall mission situational awareness during execution," and an affiliated review of "pre-strike procedures used to assess [the] presence of civilians."[8]

Anthony Downey

At no point in this report, the full extent of which remains classified, or in the previous press briefing (held on September 17), or indeed in any of the explanations thus far offered by any of the agencies involved in the killings in Kabul on August 29, 2021, has a potentially more troubling consideration been raised: What if these deaths were not *just* the result of human error but, rather, the outcome of deficiencies encoded into the technological apparatuses that maintain UAVs? What if the "mistakes" in question are structurally programmed into the very systems—that is, the algorithmic models powering calculations of threat—that sustain the US military in their prosecution of unmanned aerial warfare in Afghanistan and elsewhere? What if, in sum, the events of August 29, 2021, have less to do with failures in human intelligence and more to do with the categorical (systematic) biases involved in the uploading of data—in the form of a full-motion video feed rendered in numeric form—and the (algorithmic) systemic flaws that underwrite the design of artificial neural networks?

<p style="text-align:center">***</p>

With respect to those who died on August 29, 2021, and the unimaginable loss endured by their families, throughout what follows, I want to concentrate these interlocking questions into one overarching enquiry: Can the deaths of Zemari Ahmadi and his extended family be understood, in some measure at least, as the outcome of an in-built, operational failure in the models of predictive analyses propagated by algorithms? The projection of threat, as we saw in Kabul in August 2021, is closely aligned with the logic of the preemptive strike in military operations: to wait for a threat to materialize, it would seem, is to wait too long. The key anxiety here is whether the authorization of deadly preemptive action—in the form of a Hellfire missile strike—is based on a calculus of presumed threat that reveals not so much the actual presence of a risk but rather the enduring existence of an algorithmic predisposition to render "real" the specter of apparent menace. From the outset, I will therefore focus on the susceptibility of algorithms to misread (mistake) existing patterns of activity and produce erroneous predictions due to both the in-built categorical bias (found in data labeling) and the computational (systemic) bias that underwrites the operations of neural networks.[9]

To understand the ramifications of this more fully, I will explore the role of digital images—specifically, the use of full-motion video footage extracted from zones of conflict—in these apparatuses. The information extruded from digital images, when rendered into vectors of numbers, generates the datasets upon which algorithms are trained. Deployed in numeric form to instruct models of computer and "machine vision," digital images can and do, as we will see, predefine orders of life and, indeed, death. To the extent that we can understand the functioning of digital images as a means to determine distinctions between life and death, the latter sections of this essay will focus on how neural networks—the basis of contemporary forms of artificial intelligence (AI)—regularly "hallucinate" and summon forth imaginary if not phantasmagorical events and

objects. From this perspective, I will stress how algorithms rely on models of computational statistics for their functioning and subsequent application.[10] Founded on numeric code, and following Matteo Pasquinelli's formulation, we need to understand an algorithm as an instrument of "knowledge or logical magnification that perceives patterns that are *beyond the reach* of the human mind."[11] More generally, the functioning of algorithms incorporate the "calculation of the relation between the initial images (input) and their labels (output) with the purpose to predict the labels (output) of similar *future images* (input)."[12] In their aptitude to summon forth realities that are nonexistent, these "future images" are both the product of an algorithmic process of data extraction and the simultaneous projection of so-called raw data into the future. It is from within this precipitous, phantasmagorical, and precarious realm that we can trace, I will argue, the extent to which the historical ideal of colonial "imaginative command" has mutated into a neocolonial algorithmic command that generates, in turn, a techno-political order that is invariably concentrated on occupying (or virtually colonizing) future realities.[13] It is from within this order that we can critically engage with the ramifications of deferring life-and-death decisions to a mechanical calculus of probability that is ultimately beholden to martial devices of pre-emption, political expediencies, and the neocolonial logic of expendability.

Data Extraction and Patterns of Life: Preemptively Producing Threat through AI Prediction Analysis Models

Following the invasion of Afghanistan in 2001, the threat posed by so-called improvised explosive devices—the extent, that is, to which they were both undetectable and regularly fatal—all but guaranteed significant military investment in airborne surveillance apparatuses. These included the development of wide-area motion imagery systems and, more generally, wide-area aerial surveillance apparatuses.[14] In the wake of the subsequent invasion of Iraq in 2003, and with the ongoing war in Afghanistan in mind, the US Defense Advanced Research Projects Agency (DARPA) bankrolled the Autonomous Real-Time Ground Ubiquitous Surveillance Imaging System (ARGUS), one of the first airborne configurations to allow for wide-area persistent surveillance. ARGUS was to become the cornerstone of the so-called Gorgon Stare—an all-seeing, perpetual surveillance apparatus that has since revolutionized the prosecution of drone warfare. By early 2007, it was reported that the high-resolution sensor systems located on a UAV could not only reliably distinguish people and objects on the ground but also process the extracted raw data through onboard, rather than on-the-ground, computer imaging-processing methods. By 2013, ten years after the invasion of Iraq, the company contracted by DARPA to develop ARGUS announced that their 1.8 gigapixel colour camera and its full field-of-view (FOV) vehicle motion detection had the capacity to generate "[r]eal-time forensic reachback capability" alongside "thumbnails and metadata for ~40,000 targets." Crucially, this "unprecedented situational awareness" was achieved using "onboard,

embedded image processing algorithms."[15] Equipped with such technologies and high-resolution digital imaging equipment, the MQ-9 Reaper drone used in the surveillance of Zemari Ahmadi would have been instrumental in gathering data (rendered in the form of digitized images of the "target") and marshaling metadata (specifically, the GPS location of where pictures were taken, alongside the date, time, and user information) in order to algorithmically predict the potential presence of threat. Insofar as they are designed to detect signs of impending threat based on previously perceived and statistically analyzed patterns of activity, these forms of data extraction have a singular purpose in mind: prognostication. The operationalization of this prognostic model of algorithmic projection, as we will see, often results in the sanctioning of drone missile strikes such as the one that killed Ahmadi and his extended family on August 29, 2021.

On January 19, 2022, through a Freedom of Information Act lawsuit brought against the US Central Command (the agency that oversaw the Kabul missile strike), the *New York Times* obtained declassified drone footage that affords further insight into how data was extracted from the Kwaja Burga neighborhood in Kabul and thereafter used to target Zemari Ahmadi.[16] Although the time stamp (metadata) and other information was obscured in the footage by military censors, the enhanced, high-resolution video feed reveals a number of significant details, including the arrival of Ahmadi's car, the presence of bystanders in the lead-up to the missile strike, and the broader activity of people in the surrounding streets. While three videos were released by the US military, it is notable that in the longest one—which lasts fifteen minutes—the camera has the capacity to zoom in instantaneously on a given location and shift from relatively crepuscular black-and-white images to a high-definition color video feed (figures 10.1 and 10.2).[17] At seven minutes and seven seconds into the video from drone 1 (as labeled by the *New York Times*), the abbreviations "LRD LASE DES" appear on the screen (figure 10.3). This text refers to the fact that a laser designator has identified and ranged the target, namely, Ahmadi's white Toyota Corolla. There is a slight shudder, or jolt, in the video footage at seven minutes and forty seconds (which is presumably due to the firing of a missile; see figure 10.4), which is followed twenty-one seconds later, at approximately eight minutes, by an explosion that was recorded on the ground at 4:53 pm local time in Kabul (figures 10.5 and 10.6). The explosion obliterates the footage for some time, but later, and now in color and higher definition, the video feed shows smoke billowing from the compound as neighbors desperately try to quell the fire with buckets of water (figure 10.7).

Collated from the immediate vicinity of Zemari's neighborhood by two MQ-9 Reaper drones, although more drones were apparently involved on the day, the extracted data from this video feed would have been instantaneously relayed to on-the-ground operators in the lead-up to the missile strike. However, and crucially for the discussion that follows, this process is not *just* a matter of relay. Given the sensitivities surrounding the autonomous identification of subjects (threats), it is unsurprising that the US Air Force is unwilling to share the exact details of the algorithmic training undertaken

Figure 10.1

Screen grab from the video labeled "Raw
Footage of Lethal Aug. 29 Kabul Drone Strike,"
published in *The New York Times*, January 19,
2022. https://www.nytimes.com/video/us /politics
/100000008166257/kabul-drone-strike-video.html
?playlistId=video/investigations

Figure 10.2

Screen grab from the video labeled "Raw Footage of Lethal Aug. 29 Kabul Drone Strike," published in *The New York Times*, January 19, 2022. https://www.nytimes.com/video/us /politics /100000008166257/kabul-drone-strike-video.html ?playlistId=video/investigations

Figure 10.3

Screen grab from the video labeled "Raw
Footage of Lethal Aug. 29 Kabul Drone Strike,"
published in *The New York Times,* January 19,
2022. https://www.nytimes.com/video/us /politics
/100000008166257/kabul-drone-strike-video.html
?playlistId=video/investigations

Anthony Downey

Figure 10.4

Screen grab from the video labeled "Raw
Footage of Lethal Aug. 29 Kabul Drone Strike,"
published in *The New York Times*, January 19,
2022. https://www.nytimes.com/video/us /politics
/100000008166257/kabul-drone-strike-video.html
?playlistId=video/investigations

Figure 10.5

Screen grab from the video labeled "Raw Footage of Lethal Aug. 29 Kabul Drone Strike," published in *The New York Times,* January 19, 2022. https://www.nytimes.com/video/us /politics /100000008166257/kabul-drone-strike-video.html ?playlistId=video/investigations

Anthony Downey

Figure 10.6

Screen grab from the video labeled "Raw Footage of Lethal Aug. 29 Kabul Drone Strike," published in *The New York Times,* January 19, 2022. https://www.nytimes.com/video/us /politics /100000008166257/kabul-drone-strike-video.html ?playlistId=video/investigations

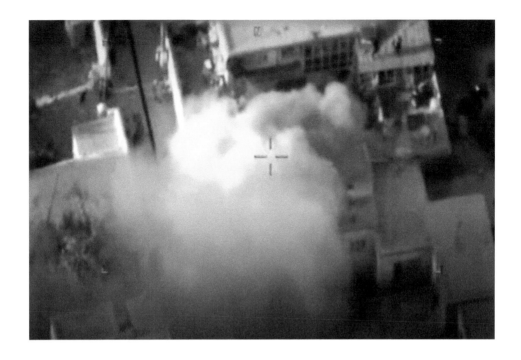

Figure 10.7

All images are screen grabs from the video labeled "Raw Footage of Lethal Aug. 29 Kabul Drone Strike," published in the *New York Times*, January 19, 2022, https://www.nytimes.com /video/us/politics/100000008166257/kabul-drone -strike-video.html?playlistId=video/investigations, accessed January 22, 2022.

Anthony Downey

to produce advanced paradigms of independent, machine-based targeting. However, we do know a number of elements in the process of training such systems. First, we know that these algorithms would have been originally trained on datasets of digital images—procured from countries such as Afghanistan—that would have been labeled by human operators. We can thereafter determine key stages in this labeling process that can lead to a fuller understanding of how predictive calculations of threat are made, in part at least, on the basis of the categorical bias involved in labeling the raw data that trains algorithms. To begin with, there is, of course, no such thing as raw data insofar as any decision, algorithmic or otherwise, to harvest or extract information—from, say, Afghanistan—presupposes a definitive interest in the epistemological, historical, economic, political, military, and strategic value of such material. If we consider how the colonial "fixing" of countries such as Afghanistan historically involved representing it—visually, politically, socially, and existentially—as a violent, atavistic, and threatening locus of unrest, there appears to be an inevitability to the neocolonial encoding of the country through precisely such data labeling. Second, and despite the levels of secrecy surrounding the application and predictive functioning of algorithms in OTH operations, we know that from at least 2013 onward, as noted above, the ARGUS project had already introduced the practice of using onboard, embedded image-processing algorithms to retrieve and observe patterns in relevant data. In a subsequent memorandum from the US Deputy Secretary of Defense, dated April 26, 2017, it was likewise stated that the Department of Defense (DoD) "must integrate artificial intelligence and machine learning more effectively across operations to maintain advantages over increasingly capable adversaries and competitors."[18] Encoded into such apparatuses, instrumental forms of categorical bias provided the template for the ensuing DARPA-funded Algorithmic Warfare Cross-Function Team, which was established in 2017, and the controversial joint military-industrial-commercial venture that goes by the title Project Maven.[19]

Developed with one goal in mind, in 2018, Project Maven demonstrated the capacity to track, tag, and target people autonomously.[20] According to a 2019 report, succeeding advances in the project, which was by then fully supported by engineers based at Google, involved the deployment of software that had been "trained on thousands of hours of smaller low flying drone cam footage depicting 38 strategically relevant objects from various angles and in various lighting conditions."[21] Although we do not know the exact constitution of these thirty-eight objects, the author of the 2019 report details how—in reference to their application in zones of conflict—the objects ("raw" data) depicted in such footage were "labeled as [to] what we know the objects to be, such as a traveling car, a weapon, or a person."[22] As noted, the full report into the procedural lead-up to the firing of the Hellfire missile that killed Zemari Ahmadi and other members of his family remains classified, but we do know from the publicized protocol associated with Project Maven in 2017 that the Pentagon's operating procedure was designed to upload full-motion video data onto systems that then fed the footage into

a neural network for the purpose of identifying and predicting threat.[23] This process takes place *after* the footage has been taken and uploaded to the neural network, but there is also, crucially, a prior rationalization of information that takes place: given the vast cache of material involved in aerial surveillance, the data and metadata gleaned by drone reconnaissance in the lead-up to drone strikes inevitably undergoes onboard algorithmic rationalization *in advance* of its transmission to on-the-ground operators. The computer vision technologies and onboard image processing systems receiving and transmitting images, such as those employed on August 29, 2021, would have been calibrated by algorithms designed to autonomously seek out "erroneous" activities or patterns of behavior deemed non-normative *before* relaying the "evidence" of such activity—that, in short, is the function of training neural networks to recognize, if not predict, imminent or unfolding forms of threat.

The furor surrounding Google's involvement in Project Maven, and their subsequent withdrawal from it, has arguably overshadowed the sobering fact that the venture, steeped as it is in predictive analytics, did not end there. In 2019, it was reported that the privately owned company Palantir had taken it over and changed its name to TRON, the latter title being an allusion to the eponymous 1982 sci-fi film.[24] While there are entries on the Palantir website outlining the company's work with the US Army, there is no direct current reference, at the time of writing, to Project Maven; however, its legacy can be found in the stated aims that accompany the martial implications of autonomous technology: "Palantir offers solutions to harness the power of [. . .] hardware solutions, reduce system complexity, and provide improved human-machine interfaces [. . .] Palantir's solutions can *reduce cognitive burden*, protect, and connect the warfighter."[25] Elsewhere, we learn that "[n]ew aviation modernisation efforts extend the reach of Army intelligence, manpower, and equipment to dynamically deter the threat at *extended range*. At Palantir, we deploy AI/ML-enabled solutions onto airborne platforms so that users can *see farther*, generate insights faster and react at the speed of relevance."[26] As to what reacting "at the speed of relevance" means, we can only surmise it has to do with the preemptive martial logic of autonomously anticipating and eradicating threat *before* it becomes manifest.

Employing advanced algorithmic models of pattern analyses and tracking algorithms (which are used to enhance the ability of both the UAV and drone operator to visualize the future position of multiple moving objects), the AI-supported onboard imaging systems powering a MQ-9 Reaper drone have the inherent potential to flag the presence of threat autonomously. And herein lies a significant concern: although the MQ-9 Reaper drone cannot make an actual decision to launch a missile without a human in the loop to make a final call, its systems can target subjects (such as Zemari) through an autonomous process that is based on the preemptive algorithmic computation of the statistical probability of an existing or imminent threat.[27] Promoted as a tool to aid human forms of identification, Project Maven is implicitly concerned with developing a

computational infrastructure that would automatically process drone footage through algorithmic means and generate, in turn, a decision-making process that can and does result in death. The detection of threat and the avowed ability to "see further" nonetheless remains dependent on the predictive functioning of algorithms, neural networks, and the opaque convolutions of deep learning.

We will return to this latter point below, but for now, I want to emphasize that, through collating intelligence based on preconceived notions of threat, data labeling (categorical bias) has given rise to, as Jutta Weber observes, a "data-driven killing apparatus." This is a systematic arrangement that entangles and renders opaque levels of human and nonhuman decision-making methods in the pursuit of a "possibilistic, preemptive culture of technosecurity."[28] The amassing of metadata—that is, data about data—likewise concentrates the activity of lived life into sequences of anonymous information, so much so that the "convergence of metadata systems and digitized identification systems exemplifies the rendering of life into an orderable system of information through the application of algorithmic formulae."[29] Considering how existing (neo) colonial representations of the Middle East, both real and imagined, often encode the entire region as the incarnation of an enduring threat to so-called Western interests, we need to understand this preemptive, fatalistic logic in the context of the labeling and subsequent computation of (meta)data. The algorithmically calculated phantasm of insurgency, that is to observe, provides a consistent rationale for present-day and future occupation, virtual and otherwise.[30] The "orderable system" of information (in the form of data) is a disciplinary mechanism designed to effect occupation. To avoid summary retribution (for a perceived display of insurgency) or preemptive targeting (in the event that they might consider such insurgency), the algorithmic gaze, or "aperture," also induces normative behavior on behalf of those placed under surveillance.[31] We return here to my earlier point: namely, algorithmic command is a technology of power that is concentrated on occupying (virtually colonizing) future realities rather than just present-day realities.

<p style="text-align:center">***</p>

In accordance with military priorities and political exigencies (including the decision made in February 2020 to effectively withdraw US troops from Afghanistan by August 2021), raw data is extracted from zones of conflict and labeled by human operators with the singular goal of predicting and managing threat. This is effectively stage 1 in the extraction, compilation, and categorization methods involved in producing datasets for the purpose of training algorithmically defined image-processing systems for the deployment on UAVs such as the MQ-9 Reaper drone. In broad terms, this is where we can locate the systematic presence of "categorical bias" in data labeling. In stage 2 of the image recognition process, data—namely, a digitized image or full-motion video feed—needs to be rendered intelligible in the form of sequenced numeric codes

(vectors) that have been extruded from the digital images under consideration. It is at this juncture that we can locate the systemic forms of computational bias that emerge in the neural networks employed by deep learning and algorithmic models of pattern analysis and prediction. This is also where we can situate the profound impact of digital images in the decision-making processes that determine the distinction between life and death in zones of conflict.

How Do (Digital) Images Participate in the Destruction of Human Beings?

Given the sheer enormity of data involved—a "single 10-hour Gorgon Stare mission generates 65 trillion pixels of information"—the demand for advanced models of algorithmically defined imaging sensors is fully vindicated, in a military context, when it comes to the autonomous management of risk and threat prediction.[32] For image recognition and processing to operate effectively, the digital images compiled and labeled for the purpose of computer vision are commonly, but not exclusively, rendered in the form of a legible vector or raster-based model of representation, the latter being a rectangular matrix or grid of square pixels. When magnified, in the case of a raster-based image, a pixel appears (conventionally at least) as a square of sorts—or, more precisely, a "blob."[33] Image-processing algorithms assign weights and biases to these colored blobs, based on intensities of colors, which are represented by three or four color components such as red, green, and blue, or cyan, magenta, yellow, and black. These intensities of color (or blobs/pixels) are then allotted a numeric value so they can be assigned "weights" that are factored through the convolutional systems of the neural networks that define computer vision today. This is, admittedly in simple terms, the basis of machine vision: images, rendered as pixels, are assigned a numerical "intensity" value that can be given an algorithmically defined weighting that can be, thereafter, calculated alongside other weights to give an output estimation as to what the image represents. Once an algorithm has been calibrated to recognize and identify known images (labeled input) through sequenced codes, unlabeled footage from a zone of conflict can be uploaded (again as numeric code) to train (test) its capacity for prediction further.

For the purpose of my argument here, I have outlined a relatively traditional algorithmic model developed for the purpose of image recognition and processing. However, I should note that such systems have become incrementally more complex over time, not least when we consider the availability of big data to train neural networks and how, in deep learning in particular, AI models have been developed with the purpose of mimicking the brain's visual structure and our neurological capacity to see the "real" world. Employed to identify the "invariant features" of an object that could then be used to define a given object independent of the many variable forms that it could assume, these neural networks have evolved into deep neural networks (DNN) or convolutional neural networks (ConvNets).[34] Trained on big data—large datasets that, once analyzed,

can reveal patterns in human behavior and other complex associations—to consume massive amounts of images, or labeled data, DNNs and ConvNets are central to contemporary computer vision research and the ongoing deployment of UAV image-processing systems. The algorithms behind Project Maven, for example, are equipped "to determine the contents of . . . footage and identify any anomalies or strategically relevant objects it has been trained to flag."[35] Thereafter, these systems, which can alert a "human operator in *some unknown fashion* and [highlight] flagged objects within the video display," predict threat on the basis of the statistical probabilities and patterns that are algorithmically established through the computation of sequenced numeric codes.[36] Through the computational disposition of the neural networks used in systems of algorithmic image-processing and computer vision models, we can readily see how the process of predicatively flagging threat through autonomous systems ensures that human involvement in the process—who could possibly understand sixty-five trillion pixels of information—is inevitably devolved to a rationalizing process based on statistical probability.

The shift toward algorithmically defined forms of autonomous computer vision, or machine vision, in military terms is not, of course, without historical precedent.[37] Since at least World War II, the overproduction (industrialization) of images—as the filmmaker Harun Farocki comprehensively explored throughout his work and writings—and our inability to consume (or exhaust) them as aesthetic artifacts, sources of information, or harbingers of doom have inevitably given way to automated processes of machine vision.[38] Farocki used the term "operational images" to define these ongoing advances in image-processing technologies: void of an aesthetic context, digitized operational or operative images—that is, images rendered as numeric code—are an inextricable part of machine-based calculations that, based on sequences and patterns of numbers, do not "portray a process . . . but are themselves part of a process."[39] The term "operational," moreover, indicates that the image "no longer stands 'for itself' in any way but is merely an element of an *electro-technical operation* in which aesthetic standards are detached from functional criteria."[40] Defined by the operation in question (the targeting of an insurgent, for example), rather than through any symbolic connotations, operational images are therefore not propagandistic (they do not try to convince), nor are they instructive (they are not interested in directing our attention). They are not, strictly speaking, content based, inasmuch as they exist as abstract numeric, sometimes binary, code rather than pictograms. Reduced to numeric code, operational images, in the form of the sequenced code extracted from pixels, function to detect and predict future threat in the algorithmically defined realm of drone warfare. Based on the prevalence of sequential code, this predictive procedure is statistical and fundamentally calculative (computational) in its fatal logic. This is perhaps why Georges Didi-Huberman, writing in reference to the work of Harun Farocki, posed the following far from simple question: "Why, how, and in which way do the production of images participate in the destruction of human beings?"[41]

We turn here to a singular impediment in the algorithmic functioning of operational images in the service of computer vision: if (systemic) computational biases, in conjunction with (systematic) categorical biases, are present, then they will be inevitably replicated in future outputs. Working from the statistical prevalence of past features, patterns and occurrences, machine learning strives to autonomously generalize from input—data in the form of, say, full-motion video images from zones of conflict—in order to predict the future and, thereafter, eradicate pending threats. In a theater of war, prediction not only therefore begets preemption, it also stimulates computational exemplars of paranoiac projection. As Melanie Mitchell notes, if "there are statistical associations in the training data, even if irrelevant to the task at hand, the machine will happily learn those instead of what you want it to learn."[42] Machines powered by neural networks tend to learn what *they* identify in the data rather than what *you* (the human) might observe. This process is called "over-fitting," an event that indicates a systemic and recurrent form of computational bias that is located in the presence of so-called noise that disrupts the signal required to make correct predictions. As we will shortly see, over-fitting occurs with worrying frequency in the algorithmically defined functioning of neural networks, so much so that their use in military forms of machine and computer vision remains, at best, fraught. To date, numerous examples abound of neural networks misclassifying or misidentifying objects. A particularly germane case in point would be a study involving an InceptionV3 image classifier that consistently classified an image of a turtle as a "rifle."[43] The authors of the paper outlining these findings noted that as "an example of an adversarial object constructed using our approach," a 3D-printed turtle was "consistently classified as rifle (a target class that was selected at random) by an ImageNet classifier."[44] This occasionally dry technical analysis reveals a profound reality that remains intrinsic to the neural networks and deep learning systems involved in training machines to "see": not only are they systematically prone to producing specious and biased outputs based on the datasets used in training, they can be also fooled into seeing things that do not exist.

<p style="text-align:center">***</p>

In the moment of deferring our responsiveness to images *of* the world, be they operational or otherwise, we disavow responsibility *for* the real-world effects of algorithms and—through the numeric codes extracted from pixelated images—their statistical sequencing of threat based on categorical bias. In dislocating responsibility for perception, and responsiveness to what is perceived, a legal, if not ethical, alibi of sorts is formulated through a technologically induced model of physical, if not moral distanciation—a point all the more succinctly captured in Grégoire Chamayou's observation that "the drone is the weapon of an amnesiac postcolonial violence."[45] The question we need to pose as we proceed is whether this alibi is always already in place if not systemically encoded into the presumptive rationalizations made by algorithms. Should

Anthony Downey

a drone strike turn out to be less than either accurate or indeed "righteous," can the blame be understood as an outcome of the computational pathologies that remain inherent to contemporary models of machine learning, rather than the—albeit increasingly extraneous—role of a human operator?

The (Phantasmagorical) Subject of Deep Neural Networks

The devolution of human input into life-and-death decisions becomes all the more notable when we consider the distinction between the use of supervised learning in the training of algorithms and unsupervised learning. In the first example, supervised learning generally defines the use of known, fully labeled datasets that are processed by algorithmic convolutions with the goal of correctly predicting various outputs (or correctly identifying images). These predictions are evaluated against a "test set" to calibrate the internal weightings of the algorithmic operations further. "Unsupervised learning" is a term broadly used to define the training of algorithms without the use of labeled or tagged data. The ambition in unsupervised learning is that algorithms, through mimicking the neurological systems associated with how our brains see objects and events, will be able to generate future content (images) that corresponds to the perceivable world. And herein, as we will see, lies the pathological potential for algorithms to hallucinate.

The phantasmagorical and hallucinatory realm of deep learning reveals a far from rational side to neural networks. To begin with, in deep learning, a signal represents the true underlying pattern that computer engineers hope to extract productively from input data. The signal can be used to model and predict future events, while the neural network, if working efficiently and with more and more accuracy, will eradicate noise and make increasingly correct predictions. A signal, the true input of a dataset, is nonetheless susceptible to random or irrelevant noise (false input). Disrupting the ability for a neural network to predict a given outcome with total certainty, the presence of noise is a systemic concern in algorithmic functioning when it comes to over-fitting or producing erroneous predictions of objects.[46] More specifically, over-fitting defines how noise, or random fluctuations in the training datasets (initial input), compromise the ability of the model to universalize or, in the case of drone technologies, make consistent distinctions between, say, types of weapons—as seen in our example of the turtle/rifle—and household objects or, for that matter, everyday patterns of behavior and threatening activities. The frequency of noise also undermines the ability of algorithms to state with statistical certainty the likelihood of an event taking place. In the example of all-too-ubiquitous instances of drone error, and putting human error to one side, mistakes are usually attributable to the fact that a neural network cannot effectively generalize—extract a true signal—from training data (input) and apply it, minus noise, to unseen data or unique, one-off events (the daily rounds of an individual distributing humanitarian aid, for example).

The implementation of neural networks in deep learning models of computer vision and image processing, in an era of UAVs and lethal autonomous weapons (LAWs), remains far from abstract. In *Army of None: Autonomous Weapons and the Future of War*, Paul Scharre, a former US Army ranger who served in Iraq and Afghanistan, observed multiple concerns with neural networks, including how—given their highly convolutional structural design—they can lead to "systems that are effectively a 'black box'—even to their designers."[47] In military terms, where operational control is paramount, these "black-box" systems engender mistrust based on this unfathomable operational opacity. In a 2017 report on the implications of AI for the US Defense Department, quoted by Scharre, we are left with little doubt as to the potential problems of fully autonomous weapons systems powered by neural networks, inasmuch as "the sheer magnitude, millions or billions of parameters (i.e., weights, biases, etc.), which are learned as part of the training of the net...makes it impossible to really understand exactly how [a neural network] does what it does."[48] This apparent impenetrability, however, is a perennial concern that has been overtaken by a further major structural failing in neural networks—a failure largely associated with "a counterintuitive and unexpected form of brittleness...replicated across most deep neural networks currently used for object recognition."[49] In one example of this "brittleness," a state-of-the-art image-recognition neural network identified one particular class of images with a 99.6 percent certainty as being familiar objects such as an armadillo and a cheetah.[50] These images are all but unintelligible to humans, consisting as they do of random pixels. All of this raises the possibility that such systems are systemically vulnerable to adversarial images, or so-called fooling images, that, once fed into a military AI system, could exploit vulnerabilities in deep learning neural networks to predict the presence of an object or event that does not exist.[51]

Raising further misgivings about the use of algorithmically defined neural networks in UAVs and LAWs, Scharre speculates how a military opponent could deploy "fooling images" to "trick the most advance deep neural networks used for object recognition into confidently identifying false images."[52] This hidden exploit in contemporary imaging processing could be used not only to fool an AI system but also to do so in such a way that would remain invisible to human operators of that system. The implication here is that the presence of a hidden exploit could also fool a UAV image-sensing system into acting upon a perceived threat embodied by the presence of an object such as a weapon: "someone could embed an image into the mottled gray of an athletic shirt, tricking an AI security camera into believing the person wearing the shirt was authorized entry, and human security guards wouldn't even be able to tell a fooling image being used."[53] Scharre's analysis, put forward in the context of whether LAWs can ever be reliably installed without reservation, foregrounds the propensity within such systems for both recursive forms of over-fitting—which is worrying enough when considered in the context of the issues raised above in relation to categorical and computational bias—and

Anthony Downey

the concomitant liability for AI to "hallucinate," with a significantly high degree of computational if not pathological certainty, an object or event into (virtual) being.

Over-fitting, alongside the propensity for hallucinating patterns, is an indicative, structural failing in deep learning neural networks, despite the latter being promoted as the future of AI and, increasingly, artificial general intelligence—that is, machine intelligence that rivals human understanding and our capacity to think and imagine future realities. Over-fitting can and does result in extrapolation, or the "projection and prediction of output y beyond the limits of x, often with high risks of inaccuracy."[54] Referring to this process as "algorithmic apophenia," or the "illusory consolidation of correlations or causal relation that do not exist in the material world, but only in the mind of AI," Pasquinelli perceives "the problem of the prediction of the new [to be] logically related to the problem of the *generation* of the new."[55] If prediction effects generation, or the production of the new, then the question we return to is one of causality: To what extent do algorithms performatively produce the event they have—based on statistical analysis of input data—been initially programmed to predict? To the degree that apophenia, in Pasquinelli's use of the term, describes the propensity to calculate or seek out, unreasoningly if not perversely, patterns, specters, and phantasms in otherwise random information (input data), for the most part, it defines a generative activity that needs to be closely monitored rather than summarily classified. Given that it has the demonstrable capability to summon forth the apparition of a weapon, event, threat, or an armed opponent, prediction—that is, the capacity to produce threat—also disregards the actual need to be proven right inasmuch as "proof" is encoded ex post facto—that is, retrospectively—in the very logic of algorithmically determined notions of risk. To this end, the generative disposition of technologically enhanced computer vision involves a proleptic collapse of temporal and geospatial reality wherein which "perception telescopes into the interval of events that are 'not-yet-taking-place.'"[56] In this scenario, the random movements of a car can be, through forms of over-fitting, statistically associated with the probability of an emergent or imminent threat, while the day-to-day collection or dropping off of foodstuffs and provisions, to take the case of Zemari Ahmadi, could be likewise considered to be prima facie evidence of future combative intent, as we will see below.

Despite the fact that apophenia is used to describe, in more exact terms, the early stages of delusional behavior and the overinterpretation of sensory perceptions (and is for that reason often referenced in contradistinction to the event of an actual hallucination), its phantasmagorical aspect divulges an alarming predisposition in neural networks to generate objects and subjects arbitrarily. A class of algorithmic failure, over-fitting, the root of apophenia, can cause an algorithm to "hallucinate" nonexistent behavior patterns (or indeed objects or threats). In Dan McQuillan's astute essay on "algorithmic paranoia," he relates how recursive processes in AI suggest a "machinic process" that feeds on itself, before further highlighting how such a "situation has the

potential for a machinic form of *paranoiac self-justification*, an algorithmic attribution bias that generates systematic errors in evaluating the reasons for observed behaviors. Under these conditions, *algorithmic seeing tends towards paranoia.*"[57] Recalling Joseph Masco's discussion of the nightmares that underwrite the internal circuitry involved in threat-based projection, we can observe here how the interlocking of military paranoia and computational hallucination are not only mutually reinforcing but also indefinitely fatal for anyone unfortunate enough to enter their phantasmagorical ambit.[58]

Although McQuillan does not reference Harun Farocki in his essay, I would suggest that there are clear echoes here of how operational images—which enable human perception to be disavowed in decision-making processes relating to matters of life and death—are not only preoccupied with their own utilitarian procedures but also capable of summoning forth a phantasmagorical reality based on paranoiac forms of algorithmic self-justification.[59] Arguably, operational images, in this context, are to all intents and purposes demonstrably nonoperational: they produce, that is to note, spectral events (threats) that are *yet to occur* rather than, as we might assume, correctly identifying already occurring and actual threat. If we consider, on the other hand, how models of threat-based projection operationalize the logic of preemption in US military counterterrorism strategies, then it might conceivably be more appropriate to suggest that this is precisely the (dis)functional purpose of operational images: actuating a subject (target) who both exists (virtually) and is yet *always about to exist* (in perpetuity), these images performatively foreshadow and target a nebulous figure who, in inhabiting a hinterland (or an OTH no-man's-land), justifies the projected paranoia of the military-industrial imaginary. To these already pressing concerns about the systemic failings that exist in neural networks, we must likewise enquire into the future evolution of so-called generative AI.[60] The forthcoming era of technological developments in generative AI, exemplified in the ambition for machines to generate something entirely new rather than merely produce or reflect upon something that already exists, will involve the realization of highly realistic images and environments that exist independent of human input.

Conjoining the logic of threat-based projection, the predictive functioning of algorithms, and the propensity for neural networks to "hallucinate," it is not surprising that the historically embedded rationale of preemptive military strikes continues to define the US military's standard operational procedures in environments such as the Middle East. Since at least the invasion of Afghanistan in 2001, the notion of preemption has been politically and militarily codified.[61] No longer referring to that which can be evidenced or verified—a corroborated threat, for example—the function of such preemption, as Brian Massumi has suggested, is concerned with eradicating threats that are "not-yet-taking-place."[62] Although we enter here into a speculative domain, in which events are not yet taking place, the virtual manifestation of perceived threat—through the algorithmic prediction of threat—can justify the summary sanctioning of a preemptive

drone strike. To the extent that future patterns of risk and hazard may indeed, to recall Pasquinelli's point, remain beyond the reach of human minds (inasmuch as they are not yet taking place), it does not necessarily follow that future threats are beyond either conceptualization (algorithmic calculation) or, crucially, the range of UAVs. As employed in drone and satellite reconnaissance, we therefore need to ask whether military AI systems do indeed statistically summon forth—or mobilize through convolutional forms of recursive computation—the very threat that they were programmed to identify.

A "Righteous Strike"?

Underwriting the standard operating procedure involved in OTH drones strikes, as highlighted above, algorithmic image-processing systems consistently extrapolate a generalized liability of threat, based on statistical inference (induction), from the observation of discrete, perhaps unrelated if not entirely random, instances of actual violence (input data).[63] The routes that Zemari Ahmadi's car traveled on August 29, 2021, the stops it made along the way, the passengers it picked up and dropped off, and the loading of materials into the boot of the car were all taken to be a priori evidence of covert, possibly combatant, activity. Blameless behavior patterns, in this life-threatening vector of prediction and preemption, can become proof of guilt by algorithmic association—a fear-inducing state of affairs made all the more palpable in the following report detailing the lead-up to the deaths in Kabul on August 29, 2021:

> When someone in his [Ahmadi's] car retrieved a black bag from that building, *the operators interpreted* the bag as an explosive since the airport bomber had used a black backpack; in fact, it was his boss's laptop. When several people later placed canisters in the trunk of his car, the operators *saw more bombs*; in fact, the objects were most likely water containers. And when there appeared to be a secondary explosion after the missile blew up the car, *they saw evidence* of a bomb; in fact, the military later said, it was most likely a propane tank.[64]

Following revelations made by Edward Snowden regarding the capabilities of the National Security Agency, and programs such as SKYNET in particular, the use of algorithms to target suspicious behavior (erroneously) has long been known and subject to debate.[65] Based on metadata (the location of online activity, the duration of activity, and digitized travel patterns) and data (mobile phone conversations and social media postings, for example), suspects have been routinely targeted through the all-too-skewed aperture of algorithmic rationalization. As observed, these processes are far from glitch free. Highlighting a salient example of error, which seems particularly prescient, given the events in Kabul in August 2021, Holland Michel recounts how he noticed, in a test lasting twenty minutes, the way in which a "behavior-detection algorithm flagged as suspicious an intersection where a car pulled away from a stop sign and a second car

replaced it from behind seconds later ('replacement'—when one car replaces another car—was one of the signatures that the software was designed to search for). In another, it flagged as an example of replacement a clip of a single car making a three-point turn."[66] Given that similar technologies, powered by algorithms, would have tracked Zemari Ahmadi's car and flagged it as suspicious, this example alone should prompt a relatively obvious but, to date, unasked question: To what extent does confirmation bias—the supposed province of operators making erroneous judgment calls—need to be understood in terms of the complicities that exist between categorical bias (labeling) and the systemic computational bias that remains foundational to the complex, if not neurotic, levels of recursion involved in the training of neural networks?[67]

In the case of Ahmadi, as previously noted, an extended pattern of analysis was not undertaken. However, he was under surveillance for forty-eight hours, which would appear to be ample for someone to be deemed a threat through algorithmic assessment. Focused on threat estimation, the use of tracking algorithms likewise involves compiling the history of preceding activity, or position data, that has been intensively harvested over hours, days, or weeks. It is here that we find the often fateful (fatal) predicative logic of categorical bias (labeling) being further compounded by recursive forms of computational bias. Based on prior data introduced into training datasets, the attendant concern is whether such categories, in the moment of seeding data, not only sequentially reproduce the very threats they were designed to identify but also introduce a statistical bias that renders the prevalence of threat a self-fulfilling prophecy. The machine, as Holland Michel highlights, will learn statistical and categorical bias regardless of what we, the programmers, want it to learn. This is to remark further upon how, as McQuillan has stressed, the "eye" of machine vision, seeking to augur the future based on past activity (data input), is ultimately algorithmic: machine vision involves an "algorithmic gaze [that] is part of a cybernetic system that acts on its own predictions. *Seeing the future, it pre-empts it.*"[68]

The encoding of military-industrial AI systems is predicated on the anticipation of, and projections based upon, the premonition of threat. That is the standard operating procedure of the counterterrorism operations: a perceived threat *is* an actual threat. In observing as much, I am here referencing Masco's discussion of "threat-based projection," a process whereby US counterterror measures—specifically, the actions taken to counter an act of terror *before* it occurs—are inevitably fastened to a "potentially eternal project for the security state."[69] When can the future be secure, Masco asks, if we consider how the "perverse effect of the counterterror system is that failure and disaster, like surprise and shock, can be absorbed as part of its *internal circuit*, authorizing an expansion of the number of objects to be surveilled and secured, empowering expert speculation about the various forms of danger that might emerge from an ever-shifting landscape of information and potential threat."[70] These models of anticipatory preemption, for the purpose of my discussion, begin with (algorithmic)

projection, but they cannot be exhausted through action in the world or, unsurprisingly, factual accumulation: "there is always another level to the imaginary, more potential dangers to preempt, other nightmares to locate and eliminate."[71] Augmented perception, including technologically enhanced models of algorithmically defined computer and machine vision, can be understood here in terms of the "modulation of readiness potential, the productive power to *effect* what may come next."[72] Or, as one start-up company involved in modeling forms of algorithmic predictive analysis puts it, "data in, future out."[73]

<center>***</center>

Not only do the affordances of an algorithmically defined analysis of risk and threat give way to the presumption of menace, but also statistical divination elides and disallows independent variables in pattern of life analyses that, in the example of Zemari Ahmadi, inevitably determined the act of distributing humanitarian aid to be a form of incipient insurgency. The algorithmic procedures involved in abducing and extracting raw data, in order to augment machine-learning models of predictive analysis, produce ostensibly intransigent simulations of future threat—based on both systematic (categorical) and systemic (computational) bias—that give way to all-too-real and fatal conclusions. Although neither Masco nor Massumi address the recursive role of algorithms in their discussions of threat-based projection and preemption, the internal circuits of US counterterror operations and the computational, if not pathological, summoning forth of events that are not yet taking place further disclose how the logic of US military policy in the Middle East and elsewhere is encoded into and simultaneously reified through algorithmic exertions. If political debates and military objectives are defined by a paranoiac vision of eternal threat, engendered in the so-called war on terror, and the specter of unending hostility, then the algorithms employed therein become inevitable agents of that paranoia: to wait until a threat materializes is to wait, in this martial logic, too long. This is not so much a case of threat prediction based on pattern recognition as it is about pattern *precognition* or, as suggested, the potential hallucinating *into being* of alternative, yet-to-be-realized, threat-infused realities.

Always about to Happen

They worked for private companies. They served in the military. They were part of the government, what would make anyone think they're terrorists.
—Aimal Ahmadi, Kabul, 2021[74]

Whereas the drone strike on August 29, 2021, heralded the withdrawal of US military forces from Afghanistan, it also recalled the first recorded drone strike in the country, as the Afghan journalist Emran Feroz remarked at the time.[75] Delivered by a Predator drone, the precursor to the MQ-9 Reaper, that missile strike took place on October 7,

2001—that is, twenty years before the one that killed Ahmadi and his extended family.[76] In the wake of the 2001 foray, it was initially claimed that the US military had killed the then leader of the Taliban, Mullah Mohammad Omar, who nevertheless later reemerged, apparently unscathed, and continued to evade both capture and death by drone until his eventual death in Zabul on April 23, 2013, reportedly as a result of tuberculosis.[77] To the specter of imminent threat and the phantasms of future threat, it seems we must also add the figure of the revenant—the one who returns, undead, to haunt the present with an often unwanted but all-too-pertinent presence. "But the question no one seems to want to ask," according to Feroz, "is who was killed instead of [Mullah Mohammad Omar]?" To this day, Feroz laments, "we don't know who was actually killed, and we may never know."[78]

In the twenty or so years between the first and last recorded drone strikes in Afghanistan, erroneous drone strikes continue to prevail, killing those like Zemari Ahmadi (who entered the statistical calculus of an all-too-fallible algorithm), while not killing those who could be considered, from a military standpoint, actual targets.[79] Through examining the self-serving and self-fulfilling prophecy associated with predicting future threat, I have proposed, in this context, that the algorithmic apparatuses that power such tactics reveal a political and technological predisposition to concede, through the technologies of image processing and computer vision, any political responsibility for the vindictive representation of countries such as Afghanistan. The projection of enduring, never-ending, future-oriented threat and belligerent insurgency—which is latent in categorical bias and thereafter made technologically manifest in computational bias—through algorithmic machinations further compounds, I have suggested, the erroneous statistical analyses of threat prevalence. Projection triggers prolepsis: the collapse of chronological time so that death can be administered from the sky in reaction to that which is always about to happen.

The calibrated, instrumentalized, calculated desire to kill, supported by algorithms and drone technologies, is revealed here for what it is: an anachronistic enterprise whereby someone (a combatant) or something (a threat) is posited as always already existing in a future historical order—of precarious life and impending death—that must be virtually occupied. The colonial will toward imaginative command, as noted from the outset, morphs all too conveniently into the neocolonial ambition to command quantum and future realities algorithmically. It is in this realm that we find, suspended in the no-man's-land of lethal hunter-killer MQ-9 Reaper drones, civilian populations enduringly subjected to disciplinary forms of applied algorithms that can result in injury and death based on the computational analysis of past behavior patterns, blameless or otherwise. When Aimal Ahmadi, the brother of Zemari Ahmad, plaintively asked why *anyone* would think his family were terrorists, perhaps the question should have been what would make *something*—algorithmically defined forms of targeting through computer vision, for example—think his family were involved in terrorism.

The future of global conflict is being predetermined and calibrated by algorithms, which gives rise to a parting question: What is the future of death in an algorithmic age and who—or, more precisely, what—will get to decide its biopolitical and legal definitions? In an era of multi-domain kinetic and non-kinetic warfare, are we adjusting to—or acclimatizing from—established ontological and legal frames of reference for defining life and death and on toward the realm of politically expedient, ethically devolved, and autonomous algorithmic calculations of what constitutes being—and, perhaps more significantly, what defines *not* being—in the world? In this dominion of phantasmagorical, inexhaustible threat, established ontological frames of reference—those that define, albeit ineffectually, human rights legislation and international laws regarding a subject's right to life—are usurped by algorithmic computations of autonomously calculated fact. What if, finally, this is not about the singular tragedy of death by drone as such, but rather about the calamity of a death in waiting—the threat of not being that defines the biopolitics of ever-lasting, trauma-inducing, deadly, and apparently indiscriminate forms of hyper-surveillance?

Notes

1. See https://georgewbush-whitehouse.archives.gov/news/releases/2002/06/20020601-3.html, accessed December 12, 2021.

2. General Michael Hayden, quoted in David Cole, "We Kill People Based on Metadata," *New York Review*, May 10, 2014, https://www.nybooks.com/daily/2014/05/10/we-kill-people-based-metadata/, accessed September 12, 2021.

3. For the transcript, see https://www.centcom.mil/MEDIA/Transcripts/Article/2781320/general-kenneth-f-mckenzie-jr-commander-of-us-central-command-and-pentagon-pres/, accessed September 18, 2021. See also Christoph Koettl, Evan Hill, Matthieu Aikins, Eric Schmitt, Ainara Tiefenthäler, and Drew Jordan, "How a US Drone Strike Killed the Wrong Person," *New York Times*, September 10, 2021, https://www.nytimes.com/video/world/asia/100000007963596/us-drone-attack-kabul-investigation.html, accessed September 10, 2021.

4. McKenzie, reported in Eric Schmitt and Helene Cooper, "Pentagon Acknowledges Aug. 29 Drone Strike in Afghanistan Was a Tragic Mistake That Killed 10 Civilians," *New York Times*, September 17, 2021, https://www.nytimes.com/2021/09/17/us/politics/pentagon-drone-strike-afghanistan.html, accessed October 25, 2021.

5. https://nsarchive2.gwu.edu/NSAEBB/NSAEBB24/index.htm, accessed November 15, 2021.

6. There is likewise ample evidence that a pattern-of-life analysis can contribute to civilians being targeted in drone attacks. See Azmat Khan, "The Human Toll of America's Air Wars," *New York Times*, December 19, 2021, https://www.nytimes.com/2021/12/19/magazine/victims-airstrikes-middle-east-civilians.html, accessed December 19, 2021.

7. See David Vergun, "Air Force Official Briefs Media on Deadly Drone Strike in Kabul," US Department of Defense, November 3, 2021, https://www.defense.gov/News/News-Stories/Article/Article/2831896/air-force-official-briefs-media-on-deadly-drone-strike-in-kabul/, accessed November 4, 2021. See also https://context-cdn.washingtonpost.com/notes/prod/default

/documents/b72be59f-f01e-4e3a-bdba-8582472b9c83/note/25812926-b3ca-4280-9e69-2e337a8d6a23
.#page=1, accessed November 4, 2021.

8. Vergun, "Air Force Official Briefs Media on Deadly Drone Strike in Kabul."

9. In the most basic sense, a neural network consists of a series of algorithms designed to detect underlying patterns in data. The McCulloch–Pitts neuron, or perceptron, was invented in 1943 and provided the algorithmic basis for the neural network that underpinned Frank Rosenblatt's Perceptron. Invented in 1958 and funded by the Office of Naval Research in the United States, the Perceptron heralded the early evolution of algorithms in the realm of artificial intelligence, satellite imagery, and feature-recognition software. For further details of its military applications in the field of image recognition, see Jack O'Connor, "Undercover Algorithm: A Secret Chapter in the Early History of Artificial Intelligence and Satellite Imagery," *International Journal of Intelligence and CounterIntelligence* (2022), https://doi.org/10.1080 /08850607.2022.2073542.

10. Matteo Pasquinelli, "How a Machine Learns and Fails—A Grammar of Error for Artificial Intelligence," *Spheres: Journal for Digital Cultures* 5 (2019): 4.

11. Pasquinelli, "How a Machine Learns and Fails," 4 (emphasis added).

12. Pasquinelli, "How a Machine Learns and Fails," 7 (emphasis added).

13. I draw the phrase "imaginative command" from Elleke Boehmer's discussion of Edward Said and others in *Colonial and Postcolonial Literature* (Oxford: Oxford University Press, 2005).

14. Arthur Holland Michel, *Eyes in the Sky: The Secret Rise of the Gorgon Stare and How It Will Watch Over Us All* (Boston: Houghton Mifflin Harcourt, 2019), *passim*.

15. See "Autonomous Real-Time Ground Ubiquitous Surveillance Imaging System—Argus-IS," BAE Systems, 2012, https://www.baesystems.com/en/product/autonomous-realtime-ground -ubiquitous-surveillance-imaging-system-argusis, accessed March 3, 2022.

16. The footage released and shown in its unedited form by the *New York Times* is composed of three videos in total. The first of these, the longest, is fifteen minutes long. It shows Zemari winding through narrow streets before parking in the compound and the actual missile strike. It also includes footage of the aftermath of the strike, with desperate efforts by neighbors to quell the fire that engulfed Zemari's car and extended family. The second video is five minutes long and is made up of color and black-and-white footage of the Toyota Corolla. The final video is also five minutes long and includes wide-angle surveillance footage of location in Kabul. See "Raw Footage of Lethal Aug. 29 Kabul Drone Strike," *New York Times*, January 19, 2022, accessed January 20, 2022. All images used in this essay are screen grabs from this investigation and were taken from https://www.nytimes.com/video/us/politics/100000008166257/kabul-drone-strike -video.html?playlistId=video/investigations, accessed February 21, 2022.

17. See Charlie Savage, Eric Schmitt, Azmat Khan, Evan Hill, and Christoph Koettl, "Newly Declassified Video Shows US Killing of 10 Civilians in Drone Strike," *New York Times*, January 19, 2022. https://www.nytimes.com/2022/01/19/us/politics/afghanistan-drone-strike-video.html, accessed January 22, 2022.

18. "Establishment of an Algorithmic Warfare Cross-Functional Team (Project Maven)," US Deputy Secretary of Defense Memorandum, April 26, 2017, https://dodcio.defense.gov/Portals/0 /Documents/Project%20Maven%20DSD%20Memo%2020170425.pdf, accessed May 22, 2021.

19. Project Maven has provoked much debate that, to begin with, focused on Google's involvement in developing the AI needed to power it. See Daisuke Wakabayashi and Scott Shane, "Google Will Not Renew Pentagon Contract That Upset Employees," *New York Times*, June 1, 2018, https://www.nytimes.com/2018/06/01/technology/google-pentagon-project-maven.html, accessed February 2, 2022.

20. According to the US Department of Defense, Project Maven's "first task involves developing and integrating computer vision algorithms needed to help military and civilian analysts encumbered by the sheer volume of full-motion video data that DoD collects every day in support of counterinsurgency and counterterrorism operations." See Cheryl Pellerin, "Project Maven Industry Day Pursues Artificial Intelligence for DoD Challenges," Department of Defense News, October 27, 2017, https://www.defense.gov/News/News-Stories/Article/Article/1356172/project-maven-industry-day-pursues-artificial-intelligence-for-dod-challenges/, accessed July 17, 2020.

21. See Marcus Roth, "Military Applications of Machine Vision—Current Innovations," *Emerj*, January 9, 2019, https://emerj.com/ai-sector-overviews/military-applications-of-machine-vision-current-innovations/, accessed February 12, 2020.

22. Roth, "Military Applications of Machine Vision."

23. For a fuller discussion of how Google managed the data from the Pentagon, see Cade Metz, *Genius Makers: The Mavericks Who Brought AI to Google, Facebook and the World* (London: Penguin Books, 2021), 246–250.

24. Becky Peterson, "Palantir Grabbed Project Maven Defense Contract after Google Left the Program: Sources," *Business Insider*, December 10, 2019, https://www.businessinsider.com/palantir-took-over-from-google-on-project-maven-2019-12?r=US&IR=T, accessed September 4, 2020. *TRON* is a 1982 American science fiction action adventure film that was written and directed by Steven Lisberger.

25. See Palantir website, https://www.palantir.com/offerings/defense/army/, accessed April 4, 2022 (emphasis added).

26. *Ibid.,* accessed April 4, 2022 (emphasis added).

27. A relatively recent UN Security Council report, published on March 8, 2021, made known that a Turkish-made Kargu-2 drone may have acted autonomously in selecting, targeting, and possibly killing militia fighters in Libya's civil war. If this is proven to be the case, it would be the first acknowledged use of a weapons system with AI capability operating autonomously to find, attack, and kill humans. Letter dated March 8, 2021, from the Panel of Experts on Libya Established pursuant to Resolution 1973 (2011) addressed to the President of the Security Council, S/2021/229, https://digitallibrary.un.org/record/3905159?ln=en>, accessed April 14, 2021. This deployment of a fully autonomous drone is not to be confused with the recent semi-autonomous use of drones in the war in Ukraine, where it has been reported that the Ukrainian Aerorozvidka unit used human-in-the-loop drones to locate, target, and shell about two hundred Russian paratroopers, thus defeating a Russian airborne attack on an airfield northwest of Kyiv. See https://www.theguardian.com/world/2022/mar/28/the-drone-operators-who-halted-the-russian-armoured-vehicles-heading-for-kyiv, accessed April 4, 2022. For a discussion of the Russian Army's use of so-called suicide drones, or the KUB-BLA (a "loitering munition" drone sold by ZALA Aero, a subsidiary of the Russian arms company Kalashnikov, that is likewise semi-autonomous), see Will Knight, "Russia's Killer Drone in Ukraine Raises Fears About AI in Warfare," *Wired*, March 17, 2022, https://www.wired.com/story/ai-drones-russia-ukraine/, accessed March 22, 2022.

28. Jutta Weber, "Keep Adding. Kill Lists, Drone Warfare and the Politics of Databases," *Environment and Planning D. Society and Space* 34, no. 1 (February 2016): 108.

29. Joseph Pugliese, "Death by Metadata: The Bioinformationalisation of Life and the Transliteration of Algorithms to Flesh," in *Security, Race, Biopower: Essays on Technology and Corporeality*, eds. Holly Randell-Moon and Ryan Tippet (London: Palgrave Macmillan, 2016), 6.

30. We should likewise observe here how the neural networks used in computer vision can not only produce realities but also decontextualize—in political, cultural, and historical terms—otherwise provocative images. In one particularly egregious example, as observed by Yarden Katz, an image of an Israeli soldier holding down a Palestinian boy while his family attempts to extricate him was labeled through Show and Tell—Google's deep learning–based image-captioning system—as "people sitting on top of a bench together." See Yarden Katz, *Artificial Whiteness: Politics and Ideology in Artificial Intelligence* (New York: Columbia University Press, 2020), 112–114. The original photograph used by Katz was taken during a protest in the village of Nabi Saleh in the West Bank in 2015.

31. The allusion to an algorithmic "aperture" is drawn here from Louise Amoore's insightful work on the ethics of cloud computing. In her analysis of how algorithms operate in relation to the "crowded data environment of drone images," Amoore proposes that the "defining ethical problem of the algorithm concerns not primarily the power to see, to collect, or to survey a vast data landscape, but the power to perceive and distil something for action." See Louise Amoore, *Cloud Ethics: Algorithms and the Attributes of Ourselves and Others* (Durham NC: Duke University Press, 2020), 16. See also Louise Amoore, "Algorithmic War: Everyday Geographies of the War on Terror," *Antipode: A Radical Journal of Geography* 41, no. 1 (2009): 49–69.

32. Holland Michel, *Eyes in the Sky*, 123. The next generation of this technology, Holland Michel adds, will involve computers embedded in pixels inasmuch as the Wide Area Infrared System for Persistent, or WISP-360, involves "an infrared system built around the computer-in-every-pixel technology that can generate massive images with relatively small fast-spinning cameras and track speeding bullets" (144).

33. For a fuller discussion of what a pixel "looks" like, see Alvy Ray Smith, *A Biography of the Pixel* (Cambridge, MA: MIT Press), *passim*. Ray Smith observes that pixels are not square as such but rather more "blob-like" and have no shape until they are "spread" by a so-called pixel spreader—the latter being a formal filtering mode of reconstructing waves of light for the purpose of display.

34. See Melanie Mitchell, *Artificial Intelligence: A Guide for Thinking Humans* (New York: Picador, 2019), 70.

35. Roth, "Military Applications of Machine Vision."

36. Roth, "Military Applications of Machine Vision" (emphasis added).

37. I have previously discussed the historical evolution of the panoptic colonial gaze into the neocolonial realm of algorithmic "perception" in Anthony Downey, "There's Always Someone Looking at You: Performative Research and the Techno-Aesthetics of Drone Surveillance," *Heba Y Amin: The General's Stork*, ed. Anthony Downey (Berlin: Sternberg Press, 2020), 8–30. I have also formulated, in part, my research on the colonial context of algorithmic violence as presented here in Anthony Downey, "The Algorithmic Apparatus of Neocolonialism: Counter-Operational Images and the Future of Aerial Surveillance," in *Shona Illingworth: Topologies of Air*, ed. Anthony Downey (Berlin: Sternberg Press, 2022), 275–283.

38. See, for example, Harun Farocki's *Images of the World and the Inscription of War*, released in 1988. See also Antoine Bousquet, *The Eye of War: Military Perception from the Telescope to the Drone* (Minneapolis: University of Minnesota Press, 2018), passim.

39. Farocki uses the phrase "operational images" to describe images made by machines for machines, the full implications of which he explored throughout his three-part film *Eye/Machine I, II, III*, released 2000–2003.

40. Volker Pantenburg, *Farocki/Godard: Film as Theory* (Amsterdam: Amsterdam University Press, 2015), 210 (emphasis added).

41. Georges Didi-Huberman, "How to Open Your Eyes," in *Harun Farocki: Against What? Against Whom?*, ed. Antje Ehmann and Kodwo Eshun (London: Koenig Books, 2009), 46. Didi-Huberman goes on to ask a question that remains central to this discussion: "Could it be, then, that the image is in league with violence simply because it is an inseparably technical, historical, and legal object?" Didi-Huberman, "How to Open Your Eyes," 50.

42. See Mitchell, *Artificial Intelligence*, 105.

43. Anish Athalye, Logan Engstrom, Andrew Ilyas, and Kevin Kwok, "Synthesizing Robust Adversarial Examples," *arXiv*, https://arxiv.org/pdf/1707.07397.pdf, accessed November 17, 2021. The video accompanying this paper can be viewed at https://www.youtube.com/watch?v=YXy6oX1iNoA.

44. Athalye et al. "Synthesizing Robust Adversarial Examples," 19.

45. Grégoire Chamayou, *Drone Theory* (London: Penguin Random House, 2015), 95.

46. Nate Silver, *The Signal and the Noise: Why Most Predictions Fail but Some Don't* (London: Penguin, 2012).

47. Paul Scharre, *Army of None: Autonomous Weapons and the Future of War* (New York: W. W. Norton, 2018), 7.

48. Scharre, *Army of None*, 186.

49. Scharre, *Army of None*, 182.

50. As noted by Scharre in *Army of None*, 180–188. For Scharre, this "bizarre [vulnerability] that humans lack" raises considerable doubts about the "wisdom of using the current class of visual object recognition AIs for military applications" (182).

51. See Athalye et al., "Synthesizing Robust Adversarial Examples," *passim*.

52. Scharre, *Army of None*, 180.

53. Scharre, *Army of None*, 183.

54. Pasquinelli, "How A Machine Learns and Fails," 11.

55. Pasquinelli, "How A Machine Learns and Fails," 14–15 (emphasis added).

56. Brian Massumi, *Ontopower: War, Powers, and the State of Perception* (Durham, NC: Duke University Press, 2015), 235.

57. Dan McQuillan, "Algorithmic Paranoia and the Convivial Alternative," *Big Data and Society* 3, no. 1 (July–December 2016): 6 (emphasis added).

58. Joseph Masco, *The Theater of Operations: National Security Affect from the Cold War to the War on Terror* (Durham, NC: Duke University Press, 2014). See also, Brent J. Steele, "Hallucination and Intervention," *Global Discourse* 7, nos. 2–3 (2017): 1–18.

59. McQuillan, "Algorithmic Paranoia," 6.

60. Generative AI refers to so-called convoluted neural networks that enable machines to use fragments of audio, image, and text to anticipate and produce content. DALL-E would be an example of an AI image generator that is capable of creating high-resolution realistic images without any cognitive inputs from a human operator.

61. Massumi, *Ontopower, passim*.

62. Massumi, *Ontopower*, 235 (emphasis added).

63. I am drawing here on a popular conceptualization of induction algorithms that, needless to say, are highly complex and contingent on multiple operational features. For an accessible account of algorithmic induction, see Pedro Domingos, *The Master Algorithm: How the Quest for the Ultimate Learning Machine Will Remake Our World* (London: Penguin Books, 2015), 57–91.

64. Savage et al., "Newly Declassified Video" (emphasis added).

65. See Cora Currier, Glenn Greenwald, and Andrew Fishman, "US Government Designated Prominent Al Jazeera Journalist as 'Member Of Al Qaeda,'" *The Intercept*, May 8, 2015, https://theintercept.com/2015/05/08/u-s-government-designated-prominent-al-jazeera-journalist-al-qaeda-member-put-watch-list/, accessed November 2, 2021. See also, "SKYNET: Courier Detection via Machine Learning," *The Intercept*, May 8, 2015, https://theintercept.com/document/2015/05/08/skynet-courier/, accessed November 2, 2021.

66. Holland Michel, *Eyes in the Sky*, 136.

67. I am mindful here of any inclination to anthropomorphize Artificial Intelligence (AI), an ongoing critical tendency with multiple philosophical and technical ramifications. However, if we consider that the foundations of AI were founded in efforts to produce a mathematical calculus of brain functioning, as per the McCulloch-Pitts neuron, noted above, then we can better understand the allegorical connection between the computational rendering of "rational" cognitive functioning and it potential to err into mechanical dysfunction (that is, erroneous projections or outright hallucinations).

68. McQuillan, "Algorithmic Paranoia," 4 (emphasis added).

69. Masco, *The Theater of Operations*, 14.

70. Masco, *The Theater of Operations*, 14 (emphasis added).

71. Masco, *The Theater of Operations*, 96, 36.

72. Massumi, *Ontopower*, 97 (emphasis added).

73. See https://www.akkio.com, accessed March 22, 2022.

74. Aimal Ahmadi, brother of Zemari Ahmadi, quoted in Ali M. Latifi, "Kabul Families Say Children Killed in US Drone Attack," *Al Jazeera*, August 30, 2021, https://www.aljazeera.com/news/2021/8/30/an-afghan-family-killed-by-a-us-airstrike-in-kabul, accessed August 31, 2021.

75. Emran Feroz, quoted in Ali M. Latifi, "Kabul Families Say." See also Emran Feroz, "Living in the Shadow of the 'Angels of Death,'" *Qantara*, November 14, 2014, https://en.qantara.de/content/drone-war-in-afghanistanand-pakistan-living-in-the-shadow-of-the-angels-of-death, accessed August 31, 2021.

76. Predator tailfin number 3034 now hangs suspended in the Smithsonian Air and Space Museum in Washington, DC, its place in history assured.

77. Mullah Mohammad Omar's son is Mohammad Yaqoob, an Afghan Islamic scholar, cleric, and Islamist militant, who is currently one of two deputies to Hibatullah Akhundzada, the de facto ruler of Afghanistan since the US military withdrawal in August 2021.

78. Emran Feroz, quoted in Ali M. Latifi, "Kabul Families Say."

79. In a 2015 report, to put this into more sobering terms, should they be indeed needed, it was conservatively estimated that nine out of ten people killed by drones in Afghanistan were not the intended target. See https://theintercept.com/drone-papers/manhunting-in-the-hindu-kush/, accessed September 4, 2021. See also https://theintercept.com/drone-papers/, accessed September 7, 2021.

11

When Timing Is Decisive: Distributed Sovereignty's Halting Problem

Mark B. N. Hansen

The Fictive Ideal of Just Revenge

When war journalist Jeremy Scahill chose to end his narrative *Dirty Wars* with the killing of Anwar al-Awlaki's sixteen-year-old son, his aim was at least twofold: to underscore the tragedy of a US military policy that routinely targets its worst enemies for annihilation, and to express in its full perversity the logic of futurity that both drives and (always retroactively) justifies its operation.[1] The victim in question is (or was) the son of a known, or at least highly suspected, enemy of the state, an enemy of the state who also happens (or happened) to be the first American citizen targeted for a drone attack. In itself an issue of note, the American citizenship of the sixteen-year-old son is, at this culminating point in Scahill's story, secondary in importance to his official status as "collateral damage"—although of what exactly (a specific drone strike? the war against terror as such?) is not specified. For Scahill, the boy's killing exemplifies the perverse albeit exacting, rigorous, and certainly cold logic of the US drone war as a whole: "they killed the son," Scahill informs us, "for what he might one day become." And indeed, the "twisted logic" that Scahill discovers in this event—a "logic without end"—is perhaps the purest expression imaginable of the predictive machine that drives the Obama-era war on terror: for like many another suspects whose names appeared on the kill list or Disposition Matrix actively maintained by the National Security Agency, al-Awlaki's son was (or could have been) determined to be guilty based on the *likelihood* of his committing crimes against the United States *in the future*. The son is, however, unlike those suspects who are named on the kill list for two reasons: first, his name was never on the kill list, and second, the determination of his future guilt is based not on a complex calculation of data encompassing past indications of behavior and actual monitoring of his present-day activities but rather on something at once more nebulous and more certain: the hatred of the United States engendered by the killing of his father. For Scahill, this difference expresses the tragic dimension of a policy that embraces collateral damage as part of normal operating procedure and should serve as grounds for condemning the United States and the Obama administration's war on terror.

Without denying the force of this argument, let me distance myself somewhat from its perspective of judgment in order to focus on evaluating the predictive logic the event exemplifies. From this perspective, al-Awlaki's son is—despite being collateral (or even

Figure 11.1

Anwar al-Awlaki and Abdulrahman al-Awlaki.
Source: https://www.independent.co.uk/news
/world/middle-east/family-hits-out-at-us-in-fury-at
-fate-of-anwar-alawlaki-s-slain-son-2372514.html.

Mark B. N. Hansen

"incidental") to the strike that killed him—the perfect victim, for the "certainty" that he will one day do lethal harm to the United States is a certainty of a different order than any merely probabilistic one: not simply the result of an immense data machine capable of analyzing massive amounts of external behavioral traces, the determination of guilt of the son is a matter of *inner* certainty that follows an affective, human, and, we should note, primordial logic—the logic of just revenge. This makes the son's killing a targeted killing that is at once exemplary and singular: exemplary for its expression of the pure certainty of future activity, and singular for its fabular status, that is, the fact that the inner certainty it expresses can only be the production of a fabulation, a storytelling that both draws on the mythological foundations of violence in Western civilization and actively produces the guilt of the target as a fictive ideal. It is this fictive ideal, I want to suggest, that drives the predictive logic of drones and that both justifies and complicates its practice.

The Distribution of Sovereignty

In his account of the developments in military policy from Reagan to Obama, Paul Youngquist underscores the incredible, and incredibly complex, distribution of sovereignty that has taken place. Youngquist's account is marked by a constitutive tension that not only can be anchored in concrete historical detail but also, as we shall see, profoundly and problematically marks the theory and practice of sovereignty as such. In the historical register, this tension occurs through successive developments in security and takes form as the difference between two models of security as a para-sovereign domain of operationality. The first of these spans the period from the founding of the National Security Council (NSC) in 1947 in the face of the looming threat of Soviet nuclear aggression to the Iran–Contra affair of the Reagan administration. Its locus is the creation of the NSC itself and, more pointedly still, the National Security Advisor, whose power is explicitly extralegal, even if its function is strictly advisory. The report commissioned in the aftermath of the Iran–Contra hearings, the 1987 "Report of the President's Special Review Board," more popularly known as the "Tower Commission Report," makes explicit the solely advisory function of the NSC and its subordination to the chief executive, who alone retains the authority to make policy decisions: "the President is responsible for the national security policy of the United States. In development and execution of that policy, the President is the decision-maker."[2] What happened in the Iran–Contra affair remains fully within a paradigm of executive sovereignty. What explains this conclusion—all appearances of para-sovereign activity aside—is the particular agency of the particular chief executive in question.

As Ronald Reagan's note to Chairman Tower makes clear, it is only ignorance on his part—sovereign ignorance—that allows the security apparatus to operate: "In trying to recall events that happened eighteen months ago, I'm afraid that I let myself

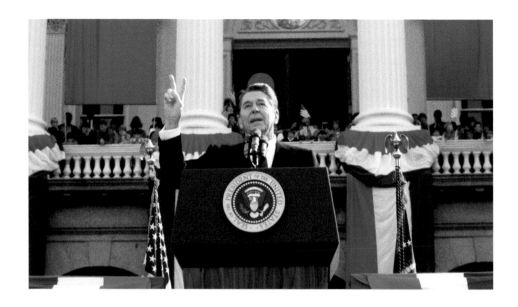

Figure 11.2

Ronald Reagan. Source: https://www.christian
itytoday.com/ct/2020/september-web-only
/abram-van-engen-city-hill-winthrop-american
-exceptionalism.html.

Mark B. N. Hansen

be influenced by others' recollections, not my own."[3] Reagan's inability to determine whether his memories are his own attests to his unique mode of fulfilling the sovereign mandate to decide. Simply put, ignorance is Reagan's way of exercising this mandate, and as such, the Iran–Contra affair marks a continuation of, rather than a break from, the advisory scope of the extended security apparatus created in 1947. In the conclusion of the "Tower Commission Report," Reagan's ignorance betokens nothing more than a failure to lead the security system properly: "Had the President chosen to drive the NSC system, the outcome could well have been different."[4] In other words, the Iran–Contra affair witnesses the chief executive's failure to use his sovereign power and *has no bearing whatsoever on the locus of that power in his authority*. Or, in the words of Youngquist, "On this account, the sovereign retains his sovereignty. He just fails to use it."[5]

Things are quite otherwise—or at least would appear to be so—in the historically second, and contemporary, model of security that took root in the Bush administration but that reached full operationality only with Obama. Instigated by the legal boost granted to the security apparatus—and specifically the NSC—by the September 14, 2001, joint resolution of Congress, known as the "Authorization for the Use of Military Force," this model specifically legitimates violence—the use of "all necessary and appropriate force"—against those who committed, aided, or abetted the 9/11 attacks, "in order to prevent any future attacks of international terrorism against the United States."[6] This expanded mandate for security led to a massive proliferation as well as consolidation of the security apparatus that reached it apogee with Obama's presidential policy statement of February 13, 2009. The changes ensuing from this policy statement heralded a new era in the distribution of sovereignty and perhaps a new paradigm for the exercise of the sovereign mandate. What most starkly distinguishes this new era and paradigm, this second model of distributed sovereignty, is the *distribution of the sovereign decision itself—the decision to kill or better, to target for killing*. Expressly prohibited as state policy by Executive Order 12333—an order signed by none other than an at least somewhat aware Ronald Reagan—assassination or targeted killing takes center stage and paradoxically becomes the paralegal mandate of the "Authorization for the Use of Military Force." In what can only be rationalized as a profound irony of history, a form of violence willfully excluded by Reagan qua sovereign comes to fill the void—indeed to proliferate in the void—between power and function opened by Reagan's own executive ignorance.

In Youngquist's eyes, this moment marks a state of "exceptional legality," if not of exception proper, where not just the *function* but also the *power* of the sovereign mandate is distributed beyond the figure of the sovereign chief executive. Nothing less is at stake in the 2011 Department of Justice white paper that seeks to delimit the use of targeted killing such that it complies with the letter, if not the spirit, of Reagan's Executive Order 12333. The white paper stipulates three criteria necessary to target an enemy combatant: first, that an "informed high-level official" must determine that the combatant "poses an imminent threat of violent attack" against the United States;

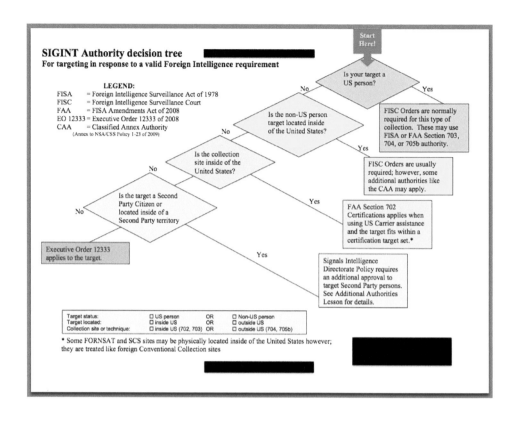

Figure 11.3

SIGINT authority decision tree. Source: https://
unredacted.com/2014/07/24/secret-reagan-era
-eo-12333-comes-under-scrutiny-authors-of-911
-commission-report-call-for-more-ic-transparency
-and-much-more-frinformsum-7242014/.

second, that capture is not possible; and third, that targeting occurs in conformity with "applicable law of war principles."[7] With this unequivocal distribution of sovereign power *and* function to the complex and distributed security apparatus charged with advising the president, we get a clear picture of the stark difference between Obama and Reagan as sovereign chief executives. Where the one distributes sovereignty through his own self-extraction, the other does so through executive order, and indeed through an executive order that explicitly puts into place a structure of surrogacy—or supplementarity: an outsourcing of sovereign decision making to a host of figures capable of standing in for the president in actual, and (importantly) *time-critical* situations.

The Kill Chain

"Only the constitution of an army of robots that would completely eliminate the human factor and would permit a human to destroy anyone whatsoever with the simple press of a button could permit the modification of this fundamental preeminence of power over violence."[8] With this decidedly non-neutral observation, Hannah Arendt interpellates the protagonist of my paper—the drone—directly and centrally into the scene sketched so far, for it is the drone, the unmanned aerial vehicle, that not only executes the paralegal mandate of distributed sovereignty but also governs by modulating the delicate balance between exceptionality and legality. Let us explore this function of the drone, with a specific eye for the essential technicity that structures the operation of drone-implemented targeted killing.

Geographer Derek Gregory describes the informational network that lies at the basis of drone targeting as a marriage between ISR (standing for intelligence, surveillance, and reconnaissance) and high-tech weapon systems. On this score, drones themselves perfectly exemplify the pharmacological logic that informs the development of technology in the West, military technology certainly not excluded, although they do so more in the mode of "perversion" than "recompense," following the distinction I have developed in *Feed-Forward*.[9] This Janus-faced informational network supports the operationalization of what is called the "Disposition Matrix," a complex database of information, informally known as a "kill list," for "tracking, capturing, rendering or killing suspected enemies of the US government."[10] In operation since 2010, the Disposition Matrix is intended, at least in the view of its proponents, to revolutionize how counterterrorist activity is carried out.

In his account of how the Disposition Matrix is operationalized by the drone, Gregory embeds the operation of the Disposition Matrix or kill list within what he, adopting a term introduced by the Air Force, calls the "kill chain." In contrast to the kill list, which specifically designates the data-mining operations involved in determining individuals to target, the kill chain encompasses *all* of the disparate agencies and processes involved in the contemporary operation of targeted assassination. With a consequential nod to

Figure 11.4

Disposition Matrix: Al-Qaeda kill list. Source:
https://dronecenter.bard.edu/the-disposition
-matrix/.

Mark B. N. Hansen

Al-Qaeda Central Senior Leadership
Casualties from Drone Strikes

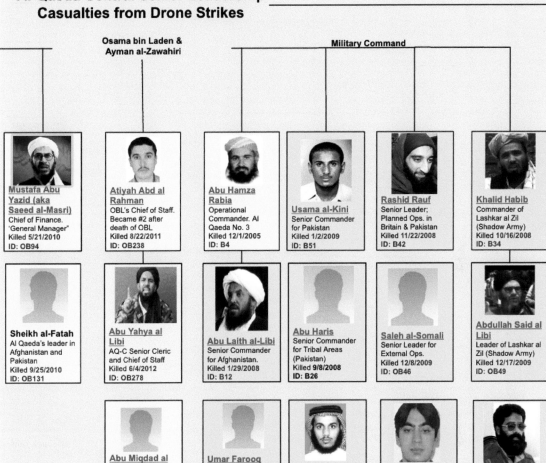

Osama bin Laden &
Ayman al-Zawahiri

Military Command

Mustafa Abu Yazid (aka Saeed al-Masri)
Chief of Finance. 'General Manager"
Killed 5/21/2010
ID: OB94

Atiyah Abd al Rahman
OBL's Chief of Staff. Became #2 after death of OBL
Killed 8/22/2011
ID: OB238

Abu Hamza Rabia
Operational Commander. Al Qaeda No. 3
Killed 12/1/2005
ID: B4

Usama al-Kini
Senior Commander for Pakistan
Killed 1/2/2009
ID: B51

Rashid Rauf
Senior Leader; Planned Ops. in Britain & Pakistan
Killed 11/22/2008
ID: B42

Khalid Habib
Commander of Lashkar al Zil (Shadow Army)
Killed 10/16/2008
ID: B34

Sheikh al-Fatah
Al Qaeda's leader in Afghanistan and Pakistan
Killed 9/25/2010
ID: OB131

Abu Yahya al Libi
AQ-C Senior Cleric and Chief of Staff
Killed 6/4/2012
ID: OB278

Abu Laith al-Libi
Senior Commander for Afghanistan.
Killed 1/29/2008
ID: B12

Abu Haris
Senior Commander for Tribal Areas (Pakistan)
Killed 9/8/2008
ID: B26

Saleh al-Somali
Senior Leader for External Ops.
Killed 12/8/2009
ID: OB46

Abdullah Said al Libi
Leader of Lashkar al Zil (Shadow Army)
Killed 12/17/2009
ID: OB49

Abu Miqdad al Masri
A member of al Qaeda's Shura Majlis
Killed 10/14/2011
ID: OB245

Umar Farooq
Commander in Pakistan AOR. Fmr. Spokesperson & aide to OBL.
Killed 12/7/2014
ID: OB354

Abu Hafs al-Shahri
Commander for Pakistan AOR
Killed 9/11/2011
ID: OB239

Aslam Awan
Deputy Leader of External Operations
Killed 1/10/2012
ID: OB256

Ilyas Kashmiri
Leader of Lashkar al Zil (Shadow Army)
Killed 6/3/2011
ID: OB231

Figure 11.4 (continued)

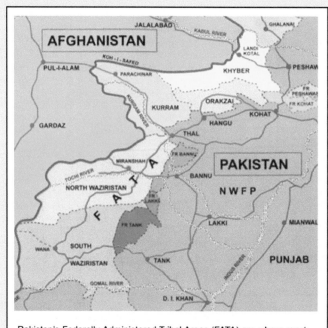

Pakistan's Federally Administered Tribal Areas (FATA) are where most drone strikes are believed to take place. Credit: Wikipedia

Sources: the Bureau of Investigative Journalism, the New America Foundation, and the Long War Journal.

Dan Gettinger / Center for the Study of the Drone at Bard College

Figure 11.4 (continued)

science studies, Gregory defines the kill chain as a "dispersed and distributed *apparatus*, a congeries of actors, objects, practices, discourses and affects, that entrains the people who are made part of it and constitutes them as particular kinds of subjects."[11] Noting that the contemporary kill chain is "increasingly directed at mobile and emergent targets," Gregory underscores its ever-increasing dependence on the informational network, and specifically the capability for processing the large volumes of ISR that is now necessary to respond to such fleeting and fast-morphing targets. According to the US Air Force, drone-based counterterrorism requires three to four times as much ISR as conventional combat operations, with an average combat air patrol mission requiring 180–200 personnel. Indeed, according to General Philip Breedlove, the demands placed on personnel fuel a media pharmacological cycle driven by the pressure to automate: "The No. 1. manning problem in our Air Force is manning our unmanned platforms . . . The intel take that we bring off of these things, to then break that out into . . . useable intelligence . . . , that is a manpower intensive piece. What we need to do is train machines to know rule sets."[12] The paradox at issue here—the problem of manpower in an unmanned platform—is only an apparent one once we comprehend that the operational point of drone warfare is not so much the removal of the human from the cockpit as it is the time-space compression of the kill chain, that is, the diminution of the time necessary to perform "risk mitigation" and issue—and execute—the order to kill. The pressure to automate results from a complex mix of factors—a mix that certainly, and indeed centrally, includes innovation, but only in its multilayered correlation with factors such as the status of information, the (limited) opportunities for human perceptual intervention, and the horizontality of the terrorist threat itself.

The Impossible Ideal of Self-Synchronization

According to Brian Massumi, the key factor at work in today's horizontal, network-centric warfare is the constitutive incompleteness of information, which institutes a pressure toward its immediate operationalization. In a gesture that dynamically reactivates Niklas Luhmann's claims concerning the value of information as transitory novelty or change in informational state—as *news* and not merely as information[13]—Massumi suggests that the value of incomplete information is proportional to how quickly it can be operationalized: "the entire enterprise" of military theory, he argues, "is predicated on the conviction that in a complex threat-environment information is by nature incomplete. The 'fog of war' cannot be overcome. It is an epistemo-ontological given. The challenge, then, is to operationalize lack of information. This is done by ensuring that what little information there is is instantaneously transformed into action-perception."[14] Massumi's understanding of contemporary network warfare aims to extend his earlier analysis of the Bush-era war on terror to full-scale drone warfare. In a series of well-known articles, Massumi has characterized the logic underlying the war on terror

as an expression of preemptive power. What makes preemptive power preemptive, according to Massumi, is a certain inversion, even confounding, of the normal relation between cause and effect: "Deterrence revolved around an objective cause," he informs us, whereas "preemption revolves around a proliferative effect. Both are operative logics. The operative logic of deterrence, however, remained causal even as it displaced its cause's effect. Preemption is an *effective operative* logic rather than a *causal operative* logic. Since its ground is potential, there is no actual cause for it to organize itself around. It compensates for the absence of an actual cause by producing an actual effect in its place. This it makes the motor of its movement: it converts an absent or virtual cause really, directly, into a taking-actual-effect."[15] As I see it, Massumi's analysis is closely tied to Donald Rumsfeld's infamous analysis of threat on a continuum from known knowns to unknown unknowns. Indeed, what lends the virtual cause its force is the operation of the unknown unknown understood as a kind of ultimate final cause for the threat at issue here. This absolute unknowability renders the threat an ontological problem—the problem of how to construct a relationship to what, from the standpoint of the present, remains "objectively uncertain":

> Like deterrence, preemption operates in the present on a future threat. It also does this in such a way as to make that present futurity the motor of its process. The process, however, is qualitatively different. For one thing, the epistemology is unabashedly one of uncertainty, and not due to a simple lack of knowledge. There is uncertainty because the threat has not only not yet fully formed but, according to Bush's opening definition of preemption, *it has not yet even emerged*. In other words, the threat is still indeterminately in potential. This is an ontological premise: the nature of threat cannot be specified.[16]

In *Ontopower*, Massumi makes clear that this logic of preemption, by which an effect is manufactured to stand in for—and make operational—the absolute unknowability of cause, continues to characterize the war on terror. Once generalized beyond the semiotic square of knowns and unknowns, preemption informs a view of power as ontopower, which Massumi glosses as "a power of becoming whose force is maximally abstract: whose power resides in a 'conceptual persuasion,'... a power for the serial production of variations belonging to the same power curve, or tendency."[17] Following this generalization, preemption can be understood as "an *operative logic of power* defining a political epoch in as infinitely space-filling and insidiously infiltrating a way as the logic of 'deterrence' defined the Cold War era... An operative logic... [is] one that combines an *ontology* with an *epistemology* in such a way as to trace itself out as a self-propelling *tendency* that is not in the sway of any particular existing formation but sweeps them all... up in its dynamic."[18] The key to this generalized sway of preemptive ontopower is, as already mentioned, the ability to *operationalize lack of information* in the shortest possible time frame. In the face of an imminent but unknowable threat,

"information becomes 'pointy.' It becomes a weapon, directly and mediatedly, despite its incompleteness. It becomes the cutting edge of preemptive power, striking at the bare-active heart of the becoming of war. The unrectifiable incompleteness of information is compensated for by its pointedness: the speed of the transduction of information into action-perception."[19]

Defined by Massumi as "the virtual attractor of preemptive war," this becoming pointy of information demarcates an ideal limit toward which contemporary network-centric warfare tends. The name of this ideal limit, Massumi tells us, is "self-synchronization." "Self-synchronization is when information is so rapidly and effectively distributed throughout 'battlespace,' or the unbounded processual field of asymmetric war, that even the lowest level 'battlespace entities' are empowered to decide autonomously, in the interval. This distribution of decision at the most immediate level of action-perception makes the apparatus of war maximally self-organizing. The impossible ideal of self-synchronization is reached when the machinery of war becomes so instantaneously self-organizing that the military hierarchy becomes the functional equivalent of a purely horizontal organization."[20]

This impossible ideal of self-synchronization, I want to emphasize, is at the same time an impossible ideal of fully distributed sovereignty; it imagines a situation in which the distinctions on which sovereignty operates—above all the distinction between those included in and those excluded from power—are effectively leveled: "In other words," Massumi summarizes, in network-centric war, "information is so quickly transduced through the military apparatus into action-perception that the differential between the hierarchy and ground-level battlespace entities (which are sometimes soldiers, but increasingly often nonhuman) diffuses into the network."[21] With this observation, Massumi paints a picture of distributed sovereignty that goes quite far toward capturing the mode of operationality, as well as the fundamental contradiction at the heart of contemporary power. His account astutely grasps (a) the automation of the war machine; (b) the enfranchisement of nonhuman, technical processes as "entities" in the battlespace; and (c) the fundamental role of temporality, or what I would prefer to call (following Wolfgang Ernst) "time-criticality."

The Halting Problem of Distributed Sovereignty

As astute as his analysis is, however, Massumi's emphasis on immediate action-perception as the deliverable of the informational situation of war remains fundamentally one-sided, and for at least two reasons. First, by importing the affective logic of preemption into the contemporary scene, Massumi misrecognizes the shift from an epistemology of suspicion to an epistemology of data and prediction that, I want to suggest, underscores the break of the Obama- and Trump-era drone machine with the Bush-era war on terror. And second, Massumi neglects, or perhaps refuses, to

Figure 11.5

Trevor Paglen, *Untitled (Reaper Drone)*, 2010.
Source: https://www.nytimes.com/slideshow/2017
/08/29/t-magazine/trevor-paglens-art.html.

Mark B. N. Hansen

consider the specifically technical dimension of this shift: the fact that it is increasingly machines—what Ernst calls "measuring media"—that make information operational, that gather, process, and analyze ever-more information in ever-shorter periods of time. What this means, in essence—and this is my argument here—is that the contemporary drone machine, far from operating by producing effects that stand in for causes and that work through affective coercion, marks both a fundamental reinvestment in the force of causal efficacy and a localization of the force of causal efficacy at granular, microtemporal levels that evade the grasp of action-perception.

Building on my earlier analysis in a 2015 article entitled "Our Predictive Condition," my thesis regarding drone warfare seeks to expose the gap that opens between the micro-logical causal propensities and macro-logical events. If Massumi's logic of preemption operates through the production of macro-logical events as operative effects without cause, the logic of the drone machine operates through the automation of decision on the basis of a machinic and predictive calculus of causal efficacy. As I put it in "Our Predictive Condition," "decisions concerning the targeting of individuals for drone killing will be made not in virtue of an ultimate, and ultimately unknowable, source but rather on the basis of as thorough an analysis as the given time frame permits of all available data concerning the situation at issue."[22] Just as contemporary social media companies focus on behavioral traces that bypass consciousness entirely, contemporary drone warfare targets patterns of data understood as propensities of reality, entirely without consideration for representational and affective registers. One need only think of the invisibility of drone warfare—as exposed, for example, in the photographs of artist Trevor Paglen—to grasp this point of difference.

In this shift, the operational problem changes fundamentally. Whereas, for the Bush-era logic of preemption, the problem is one of justification—of finding or rather manufacturing a blanket justification for any operation—the problem faced by the drone machine is to close the gap between the diffuse micro-logical operation of causal efficacy or propensity and the macro-logical decision that the time pressure of a situation compels. Put another way, these distinct problems involve two different operations of suture: in Massumi's account of preemptive power, it is the gap between effect and missing cause that must be sutured; in drone logic, by contrast, it is the gap between necessarily incomplete information and the time-critical pressure to decide that must be sutured. Following this shift, Massumi's analysis of the immediate operationalization of incomplete information takes on a new guise: increasingly, what drives this operationalization is less military theory or strategy than the technically distributed logic of the drone machine itself. While this logic is often justified by the aim of keeping boots off the ground, of minimizing the deaths of US soldiers, to my mind the true logic at work here is a machinic one: to solve—or rather dissolve—the problem of decision in the face of uncertain information and time-criticality by displacing it onto the machine. That the gap at the heart of this displacement can never be eliminated is one of the fundamental

claims I want to make here. It is what my title names the "halting problem" of technically distributed sovereignty: the fact that any decision is and can only be an arbitrary stoppage or break in an interminable *différend* between causal analysis of information and its operationalization.

Data Potentiality: A New World Picture?

Drone warfare is informed through and through by the pressure to automate. Noting that the "informational liquidity facilitated by the extended network has . . . dramatically compressed . . . the kill chain," Derek Gregory reports that "the time from finding to engaging emergent targets is now 30–45 minutes" and that the Air Force "aims to reduce this to less than two minutes." What makes (or will make) this possible, if indeed it is (or will be) possible, is a "juridico-technical" confluence that converges in an "activity-based intelligence" paradigm for data gathering and analysis focused on establishing "pattern of life." With the longer dwell times that unmanned aerial vehicles can sustain, permitting continuous surveillance for periods in excess of twenty-four hours, the ability to discern subtle traces of behavior and patterns of activity is vastly enhanced. This enlarged temporal frame, and the massive amount of intel it affords, has yielded a vast expansion of the scope of targeting itself. At the limit, this means that targeting is no longer restricted to individuals, let alone individuals on the kill list, and indeed that the positive confirmation of identity no longer plays—no longer *can* play—a criterial role in the decision to kill. In so-called signature strikes, as *Washington Post* journalist Greg Miller notes, the Central Intelligence Agency and the Joint Special Operations Command are able "to hit targets based on patterns of activity—packing a vehicle with explosives, for example—even when the identities of those who would be killed is unclear."[23] In such situations, linking a pattern of life to an identity either is impossible or would simply take too long. I term this a "*juridico*-technical" confluence to mark the fact that it instantiates a shift in the scope of targeting—the exercise of the sovereign right to kill—that is driven, if not in fact determined, by the enhanced technical capacities to gather and process massive amounts of information.

This juridico-technical shift in the scope of targeting lays bare the predictive basis on which the "gigantic data-mining apparatus" of drone warfare operates.[24] "The whole problem," observes Grégoire Chamayou in his *Theory of the Drone*, "lies in this claimed ability to be able to correctly convert an assembly of probable indices into a legitimate target."[25] So, how is this done? The answer, in a word, is by exploiting what, in *Feed-Forward*, I have called the "potentiality of data"[26]: with machines sufficiently complex to perform pattern recognition analyses on massive datasets, captured images can be compared with millions of other images in order to find potential connections that would otherwise remain latent. "Optical surveillance is not limited to the present time," states Chamayou. "It also assumes the important function of recording and archiving . . .

Once such a movie of every life and everything [in a city-size area] is completed, it could be rerun thousands of times, each time focusing on a different person [or unit of activity], zooming in . . . so as to reexamine that person's [or event's] own particular history."[27] The resulting picture—a world picture if ever there was one—captures the wealth of potentiality with which the locality in question is quite literally teeming. The question is to know—or to be able to guess with some assurance (some threshold level of probability)—which potential scenario resulting from such granular, multiply-permutational, and (within the time available) exhaustive data analysis is most likely to occur. Within this analytic operation, the images or frames are not simply inert and atomic representations but in fact Whiteheadian "superjects": actualities that possess in themselves real potentiality to act in the future.[28] And the relations between such actualities are not simply empty, formal permutations of a mathematical dataset but are themselves more complex configurations of real potentiality. Finally, the different sets of relations or relationalities that inform contrasting "future scenarios"—while incompossible with one another—are all themselves scenarios that, from the vantage point of the present moment, are differentially likely to occur, where, by "occur," I mean not that they take place as a foreknown integral event, but rather something more like that they have the real potentiality for all their constituting elements and relationalities to be actualized. Figuring out how to decide among the myriad possibilities at issue in any situation, as daunting as it is, remains the sole means to "predict" the future, where prediction does not simply mean an extrapolation from data about the past but rather means something more like the confluence of micro-decisions made about each and every data point/element, converging upward into larger relationalities. As instantiated by the powerful video analysis programs of today's ISR systems—which generate more than a hundred thousand image frames per hour—what is involved is a complex process of comparison and selection that operates at the level of the frame and that can only remain inscrutable to the myriad individual humans involved in supporting the operation of the kill chain.

How to Decide on a Threat

Paul Youngquist characterizes the futurity of the kill chain on the measure of the day and in terms of the "plot": "The dangerous terrorist plots today but acts tomorrow," he notes; "targeting him or her requires factoring tomorrow into a calculation of culpability."[29] With this characterization, Youngquist fundamentally mistakes the scale at which prediction operates. For what the gigantic data-mining operation that is drone surveillance affords is, as we have just seen, a capacity to capture and analyze incremental data about an evolving situation *from instant to instant*, and to treat each incremental progression not simply in relation to the real potentiality of each instant but rather to constrain or modulate the development of potentiality moving forward through a selectivity that operates *from*

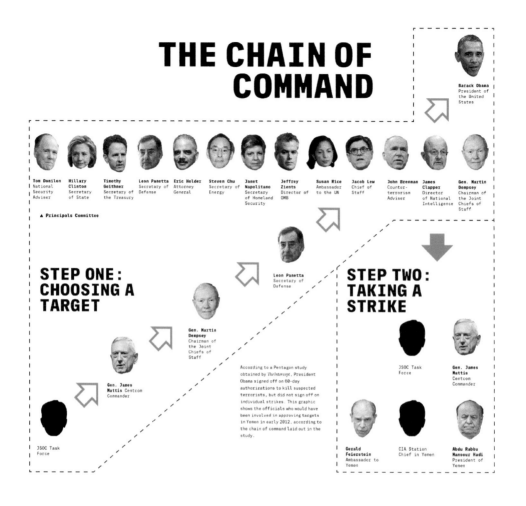

Figure 11.6

Chain of command. Source: https://theintercept
.com/drone-papers/the-kill-chain/.

Mark B. N. Hansen

instant to instant and that continuously opens and closes distinct apertures onto the future in light of this incremental development. On this score, Youngquist's observation about the lack of total information, which recalls Massumi's similar one, is more on point. Such a lack makes it impossible to define "imminent threat," as required by the first criterion for targeting outlined in the 2011 Department of Justice white paper. As a result, the "real issue" is displaced from the definition of "imminent threat" to the "process of identifying it."[30]

We must, I think, take this line of reasoning one step further, for in light of the predictive basis of the drone machine, the "real problem" is not so much identifying the threat—*that* takes place through the operation of the machine—as it is that of *deciding on the threat*. It is the problem of how to decide when a threat identified by the drone machine licenses the sovereign right to kill. What the concrete situation of drone killing concretely adds to the picture of incomplete information is a specifically technical enframing that goes by the name of "time-criticality." Theorized most centrally by German media scholar Wolfgang Ernst, time-criticality refers to "a special class of events where exact timing and the temporal *momentum* is 'decisive' for the processes to take place and succeed."[31] Observing that crisis etymologically refers to "the chances of a decision," and that it invokes an impulsive not durational time, time as *kairos* Ernst correlates crisis with postmodern processes of just-in-time production and antiaircraft prediction in World War II.

Decision and the Time of Crisis

In an essay that links together computational media, crisis, and sovereignty, media scholar Wendy Chun similarly suggests that crisis is "media's critical difference."[32] By this, she means that computational media lend crisis a technical specificity: as "moments that demand real time response," crises "make new media valuable and empowering by tying certain information to a decision, personal or political."[33] In what would seem to be a reiteration (or preiteration) of Massumi's link between the value of information and the temporal pressure to decide, Chun demonstrates how media, or more precisely code, operates *normally* only by including in that operation what is excluded from it— that is, interruptions of its lawlike executability. Her account thus seeks to *normalize* crisis or at least a certain understanding of crisis:

> Crisis promises to take us out of normal time, not by referencing the real but rather by indexing real time, by touching a time that touches a real, different time: a time of real decision, a time of our lives. It touches duration: it compresses time. It points to a time that seems to prove that our machines are interruptible, that programs always run short of the programmability they threaten. Further, crises … punctuate the constant stream of information, so that some information, however briefly, becomes (in)valuable.[34]

In order to make this argument, Chun criticizes the well-known argument that code is law. In Chun's eyes, this position is misguided because in contending that software actually does what it *says*, it "assumes no difference between source code and execution, instruction and result"[35] and, as a consequence, cannot appreciate the delicate dance between ideality and implementation, potentiality and actuality, programming and inter-ruption that defines the actual operation of code. Against such a view, Chun introduces the notion that "code as law is code as police." By this, she means that code necessarily operates through violence and, in so doing, includes within its operation precisely that which is excluded from its "being" or ideality: interruption or crisis.

To appreciate the significance of this account and to establish the basis for con-trasting it with the situation of drone killing, let us follow Chun down the rabbit hole of exceptionality. Her reference to the state of exception is, of course, a reference to the term introduced by Giorgio Agamben in his work on sovereignty and the figure of the *Homo sacer*. Agamben defines the state of exception as "the opening of a space in which application and norm reveal their separation and a pure force-of-law realizes . . . a norm whose application has been suspended. In this way, the impossible task of welding norm and reality together, and thereby constituting the normal sphere, is carried out in the form of the exception, that is to say, by presupposing their nexus. This means that in order to apply a norm it is ultimately necessary to suspend its application, to produce an exception."[36] The state of exception exposes the fact that norm and reality are separate—as Chun puts it, it marks the moment of their greatest separation—and that they can only be brought together by a force without law, by violence beyond power, to recall Arendt's analysis. "In every case," Agamben continues, "the state of exception marks a threshold at which logic and praxis blur with each other and a pure violence without *logos* claims to realize an enunciation without any real reference."[37] Following Chun's application of Agamben's argument to code, crisis plays the role of exception in the sense that it marks the non-automaticity of code, the fact that code is not law, but law as police.

Artifactual Undecidability

The onto-socio-technical crisis instigated by the drone machine—the moment where the decision is or is not made to execute the sovereign right to kill—engages Agam-ben's theory in a different register entirely. Where, for Chun, crisis furnishes the basis for the normal operation of code—it is, again, "media's critical difference"—in the case of the drone machine, crisis is a singular moment, and for two reasons. First, it is the moment that precipitates the execution (or non-execution) of the sovereign mandate to kill. Second, it is, as I just rather awkwardly put it, an onto-socio-technical crisis and, as such, involves the *technical distribution of sovereignty* not simply across the series of surrogates or supplements of the chief executive, from John Brennan to the host of

"informed high-level officials" designated in the Department of Justice white paper, but crucially across all the agencies and processes—human, technical, and otherwise—that are involved in the kill chain. Rather than proving that our machines are interruptible, this onto-socio-technical crisis is precisely the moment when an interruption from the functioning of the machine is demanded: an interruption of the operationality, the executability, of code and the larger machine to which it belongs, in order to make a decision that cannot be programmed or be the result of programming. Here, we broach the domain of the undecidable, which, in Derrida's description from "Force of Law," perfectly describes the aporetic situation of the drone decision: it requires an extraordinary response that, "though foreign and heterogeneous to the order of the calculable and the rule, must . . . nonetheless . . . deliver itself over to the impossible decision *while taking account of law and rules*."[38]

I can think of no better description of the impossible decision that is forced by and from the drone machine. But I would insist on one specification: the "law and rules" that drive the drone machine to its time-critical crisis are themselves *technical* in a sense that neither Chun nor Derrida, neither Massumi nor Agamben, are capable of thinking. They are technical, that is, in precisely the sense that Ernst underscores in his conceptualization of medial time-criticality: namely, they can only be executed, and also perceived—Ernst himself says "measured"—by technical media themselves, which are, he insists, their best and perhaps only archeologists.[39] For this reason, the undecidability that is faced when the drone machine must decide is a thoroughly artifactual one: it is an undecidability that is specified and constrained by the "real potentiality" indexed by the data analytics performed by the drone machine, a real potentiality that might be likened to Derrida's concept of haunting. Moreover, even though it is a human component of the kill chain that has—at least so far—provided the necessary surrogacy to execute the sovereign decision to kill, this human component has done so, and cannot but have done so, and can only continue to do so, largely in ignorance of the actual force of potentiality that specifies and constrains the undecidable situation. For this force of potentiality—insofar as it is an accomplishment of the time-critical drone machine producing time-critical crisis—remains (largely) outside the purview and experience of humans. At the far end of the chain of sovereignty's distribution, perhaps then we are all in the position of President Reagan, the ignorant sovereign, who must decide—or allow a decision to be made—without being able to know what exactly is being decided or allowed.

Resisting the Time-Critical Crisis

To return one final time to the specificity of the drone machine's time-criticality, we can now understand precisely how it differs from the crisis mode that constitutes the normality of code, new media's critical difference. The time-critical crisis that compels

Figure 11.7

Force of law. Source: https://www.law.gwu.edu
/exploring-trump-administration-and-use-force
-under-international-law

Mark B. N. Hansen

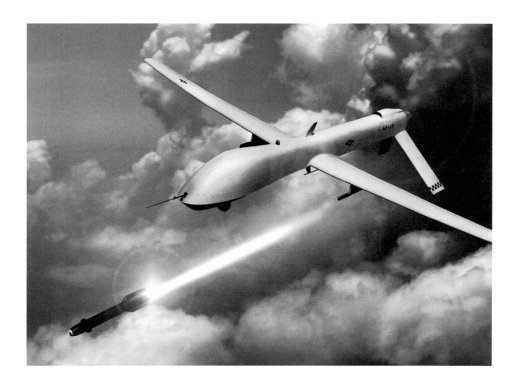

Figure 11.8

Lethal drone strike. Source: https://www
.robedwards.com/2013/07/bt-under-fire-for
-helping-deadly-us-drone-strikes.html.

decision in the face of constrained undecidability calls for and requires a collapse of the separation of norm and reality—the separation that prevents the state of exception from giving license to pure violence. At the moment that it compels a sovereign decision, the drone machine, that is, perfectly instantiates Agamben's vision of the juridico-political system transforming into a killing machine:

> The state of exception is the device that must ultimately articulate and hold together the two aspects of the juridico-political machine by instituting a threshold of undecideability between anomie and *nomos*, between life and law, between *auctoritas* and *potestas*. It is founded on the essential fiction according to which anomie (in the form of *auctoritas*, living law, or the force of law) is still related to the juridical order and the power to suspend the norm has an immediate hold on life. As long as the two elements remain correlated yet conceptually, temporally, and subjectively distinct ... their dialectic—though founded on a fiction—can nevertheless function in some way. But when they tend to coincide in a single person, when the state of exception, in which they are bound and blurred together, becomes the rule, then the juridico-political system transforms itself into a killing machine.[40]

What distinguishes the drone machine as a distinct kind of killing machine is its technicity, which yields two important outcomes: on the one hand, it is not clear whether we can speak here of the norm and reality as coinciding in a *single person*; on the other, the temporal scope of the rule of exception has been radically telescoped into the moment of execution, which is mandated in every instance by a specific, technically concrete, onto-socio-technical constrained real potentiality that cannot be dissociated from the authority or mandate itself. In this sense, drone killing marks a truly radical distribution of sovereignty, one that not only makes its theorization difficult but also effectively removes it from any apparent possible connection to normal life. The question it leaves us with is this: Can and how can we use the machine—what Ernst calls the true archivist of the future—to keep open the space between norm and reality, to make decisions on the basis of their ineliminable gap, and not simply as a purely passive result of their collapse?

It is finally only by resisting the time-critical crisis—the collapse of norm and reality—that we can grasp the fictive ideal as it unconsciously informs and justifies the killing machine. Only once the artifactuality of undecidability is exposed for what it is—a time-critical *forcing* of decision—can the deeper, inner logic of the drone machine, replete with its complex racist dimensions, come to the fore. An immunological drive against just revenge lies at the heart of this inner logic, as my introductory remarks have already suggested. At once motivated and justified by a fictive ideal of total security, this immunological drive fuels the time-critical machine of killing precisely by absolving decision from responsibility: it processes decision technically, in ways that both mechanize and obfuscate its complex operationality.

Mark B. N. Hansen

Notes

1. Jeremy Scahill, *Dirty Wars: The World Is a Battlefield* (New York: Nation Books, 2013).

2. Paul Youngquist, "Stats of Exception: *Watchmen* and Nixon's NSC," *Postmodern Culture* 23, no. 2 (2013): 9.

3. Cited in Youngquist, "Stats of Exception," 8–9.

4. Cited in Youngquist, "Stats of Exception," 9.

5. Youngquist, "Stats of Exception," 9.

6. Cited in Youngquist, "Stats of Exception," 12.

7. Cited in Youngquist, "Stats of Exception," 12.

8. Cited in Grégoire Chamayou, *The Theory of the Drone*, trans. J. Lloyd (New York: New Press, 2015), 285.

9. Mark B. N. Hansen, *Feed-Forward: On the Future of Twenty-First-Century Media* (Chicago: University of Chicago Press, 2015), 69–73.

10. Wikipedia, "Disposition Matrix," https://en.wikipedia.org/wiki/Disposition_Matrix.

11. Derek Gregory, "From a View to a Kill: Drones and Late Modern War," *Theory, Culture and Society* 28, nos. 7–8 (2012): 196.

12. Marc V. Schanz, "The Reaper Harvest," *Air Force Magazine*, April 2011, 37.

13. Niklas Luhmann, *Social Systems*, trans. J. Bednarz Jr. (Stanford, CA: Stanford University Press, 1995), 67–69.

14. Brian Massumi, *Ontopower: War, Power, and the State of Perception* (Durham, NC: Duke University Press, 2015), 237.

15. Brian Massumi, "Potential Politics and the Primacy of Preemption," *Theory and Event* 10, no. 2 (2007): 11–12 (online version).

16. Massumi, "Potential Politics," 6 (emphasis added).

17. Massumi, *Ontopower*, 221.

18. Massumi, *Ontopower*, 5.

19. Massumi, *Ontopower*, 237.

20. Massumi, *Ontopower*, 237.

21. Massumi, *Ontopower*, 237.

22. Mark B. N. Hansen, "Our Predictive Condition, or Prediction in the Wild," in *The Posthuman Turn*, ed. R. Grusin (Minneapolis, MN: University of Minnesota Press, 2015), 107.

23. Greg Miller, "Plan for Hunting Terrorists Signals US Intends to Keep Adding Names to Kill List," *Washington Post*, October 23, 2012, 7.

24. Glenn Greenwald, cited in Wikipedia, "Disposition Matrix."

25. Chamayou, *The Theory of the Drone*, 49.

26. Hansen, *Feed-Forward*, 167–172.

27. Chamayou, *The Theory of the Drone*, 39.

28. Hansen, *Feed-Forward*, 84–88, 103–109.

29. Youngquist, "Stats of Exception," 13.

30. Youngquist, "Stats of Exception," 13.

31. https://jussiparikka.net/2013/03/18/ernst-on-microtemporality-a-mini-interview/.

32. Wendy Chun, "Crisis, Crisis, Crisis, or Sovereignty and Networks," *Theory, Culture and Society* 28, no. 6 (2011): 92.

33. Chun, "Crisis, Crisis, Crisis," 95.

34. Chun, "Crisis, Crisis, Crisis," 96.

35. Chun, "Crisis, Crisis, Crisis," 100.

36. Giorgio Agamben, *State of Exception*, trans. K. Attell (Chicago: University of Chicago Press, 2005), 40.

37. Agamben, *State of Exception*, 40.

38. Jacques Derrida, "Force of Law," 252, cited by Chun, "Crisis, Crisis, Crisis," 99 (emphasis added).

39. Wolfgang Ernst, *Digital Memory and the Archive*, ed. J. Parikka (Minneapolis, MN: University of Minnesota Press, 2013), 55, 62.

40. Agamben, *State of Exception*, 86.

Mark B. N. Hansen

12

The End of Reciprocity?

Caroline Holmqvist

The massacre was horrifying and, to my mind, the ideology behind it reprehensible, but I did not regard 9/11 as "unbelievable," a word repeatedly used to describe the day. How could anyone with a sense of history find it unbelievable?
—Siri Hustvedt, "9/11 and the American Psyche," *Financial Times*, September 10, 2021

I feel we are living in a time of cognitive anarchy. [...] Cognitive anarchy is something from which we can probably recover, but only if we become capable of thinking symmetrically, if we learn to imagine the way the world looks from the perspective of an opponent, and if we practice reattaching words to their true referents.
—Elaine Scarry, interview in *Los Angeles Review of Books*, December 4, 2017

Introduction

With the callous Russian invasion of Ukraine in February 2022, the twenty-year-long war on terrorism almost appeared a historical parenthesis, sandwiched between old and new geopolitics of territorial expansion, nuclear arms races, and defense alliances. But the means and ends of the twenty-first-century war on terror have been normalized, routinized, and bureaucratized; its epitome—drone warfare—continues unbridled. In his speech marking the withdrawal of US troops from Afghanistan in September 2021, President Joe Biden affirmed, "to those engaged in terrorism against us or our allies, know this. The United States will never rest . . . We will hunt you down to the ends of the Earth, and you will pay the ultimate price . . . We have what's called over-the-horizon capabilities, which means we can strike terrorists and targets without American boots on the ground."[1] Promising undiminished drone war, the channeling of technologies of automation and algorithmic warfare through a global war-scape, it is clear that although the war in Afghanistan may have "ended," over-the-horizon (OTH) capabilities colonize the future.

In the new orthodoxy of an endless drone war on terrorism, it is often asserted that war is no longer reciprocal. This assertion comes in many forms: that there is neither reciprocity of risk nor reciprocity of threat in contemporary war, neither reciprocity of bodily injury nor reciprocal sacrifice. The liberal fantasy of a war to which there can be no *real* opposition (and its derivatives, global contingency operations and counterterrorism) has obscured and made impossible any proper understanding of war relations or war encounters. So too, from an altogether different standpoint, has the

critical theoretical claim that "war" in any meaningful sense has disappeared, leaving empty processing, disembodied killing, or torture. Against this backdrop of improbable companions, I set out to recover "reciprocity" in and of war. I argue that developing such a sensibility–a mode of apprehension or perception–is essential to developing ethico-political critique: unless we recover our ability to see and understand reciprocity in and of war, we remain locked into the depoliticizing views that permeate and perpetuate global war.

This chapter is organized into two parts. The first part expands on the various ways in which reciprocity has been *written out of war*–connecting the dots between discursive moves, legalistic arguments, and substantivist accounts of the contemporary drone war-scape. In the second part, I proceed to write reciprocity back in, as it were, proposing a more complex, disassociated, and disembodied understanding of reciprocity in and of war. The central argument is that uncovering and elucidating war encounters and exchange makes possible the symmetrical thinking, akin and pursuant to Scarry's call.

Endless War, Disorientation, and Conceptual Anarchy

In the modern social imaginary, war had temporal demarcations. Wars were thought of as finite events, bracketed by definitive dates, whether by an outbreak of hostilities or the declaration of war, to decisive victory or defeat, compromise, and the signing of peace treaties. Whatever the circumstances, wars were presumed to have contours.[2] The understanding of war as a bounded event was embedded with the consolidation of the state as a political, legal, and moral entity,[3] and the temporal distinction between a condition of war and a condition of peace remains central to understandings of international order, international humanitarian law, and the laws of war.[4] Of course, war was always ill-contained in both spatial and temporal terms, always already seeping out into the consciousness of people, populations, and societies in a myriad of ways–through militarization and mobilization, shock, residual trauma, and societal malaise. Moreover, to insist on the demarcations of war–its limits in time and space–as a standard against which to gauge the incidence of violence in our present time is to play to a Western conceit. In the colonies, war was ever present,[5] and for the study of war to be fully decolonized, war would need to be conceived of as an ordinary dimension of politics and the co-constitutive character of war and society relations adequately accounted for rather than papered over by ideal-type demarcations between "war" and "peace."[6]

Notwithstanding such qualifications, there is conversion around the idea that there is a particular temporal quality to contemporary US drone warfare as perpetual, endless, unending, ubiquitous, or forever war.[7] Temporal boundaries are eviscerated as practices of surveillance and drone war merge wartime and peacetime practices, and the United States' global architecture of military bases and targeted killing campaigns amounts to an "everywhere war," making up a "colonial present," a "predator empire" of looming "full spectrum dominance."[8] Technologies of automation and robotics trouble the

"where" of war as theaters are delocalized and ever present: everywhere and anytime a potential target.[9] The "event-ful" quality of both military and terrorist violence has been pivotal to our current predicament, where vulnerabilities are differentially distributed but widely dispersed.[10] Frédéric Gros calls the moments that punctuate people's everyday lives "moments of pure laceration"—moments that expose the irrelevance of the battlefield as conventionally understood, delimited in time and space.[11] It is against this background that claims of war as no longer being reciprocal are made, and it is from here that critique must be excavated.

I Writing Out Reciprocity

Claims about reciprocity are central to conceptualizations of war. Conventionally, it is the baseline that enables a distinction between violence and war: war is understood as a reciprocal contest, a duel, whereas violence is one-sided. Such accounts span the history of writings on war: from the Peloponnesian war that lasted from 431 to 405 BCE to the great power rivalries that dominated the world wars in the twentieth century. The function of this reciprocal recognition was to be the same under conditions of war and conditions of peace: under the Westphalian system, states recognized one another in peace as they did in war. Clausewitz centered reciprocity both to the mutual recognition between states and to the escalation of war itself: "war is an act of force, and there is no logical limit to the application of force. Each side therefore compels its opponents to follow suit; a reciprocal action which must lead, in theory, to extremes."[12] Reciprocity can mean retaliation, the escalation of war or the threat thereof, in the form of an arms race and its corollary, deterrence. The doctrine of mutually assured destruction made strategic thinking autonomous and, as such, sublimely mad.[13] On the one hand, we have the negative impetus of reciprocity: the downward spiral of reciprocating in kind, tit for tat or an eye for an eye. On the other, we have the honoring of a promise, a contractual kind of reciprocity. It is in this sense that reciprocity has engendered hope of ending war: in the virtues of negotiation, compromise, and agreement. Commensurate with the unwieldy genealogy of reciprocity, challenges thereto have taken many forms. At the present juncture of life in the age of drone warfare (Parks and Kaplan 2017), reciprocity is questioned, undermined, written off, or concealed discursively and materially. Let us consider in turn the arguments that have been made for dispensing with the concept and principle of reciprocity in our understanding of the global battlespace.

Discursive Arguments: Post-Antagonistic War

Against dystopic readings of failed states and global extremism from the Balkans and Somalia to Afghanistan and Iraq, the fantasy of state building and counterinsurgency was advanced by liberal internationalists from Tony Blair to Barack Obama both before and after 9/11. It was an irresistible illusion of warring to build "legitimate, accountable

governance" in Afghanistan and Iraq.[14]At the height of the Iraq War, the British liberal arts magazine *Prospect* dubbed David Petraeus, the general behind the *US Counterinsurgency Field Manual 3–24*, public intellectual of the year, and the field manual the "first actively humane warfighting doctrine." The population-centric wars of the early 2000s, wars taking place "among the people," were underpinned by a set of assumptions about "local populations," how they can be "known" in the context of war, and what it would take to "win their hearts and minds."[15]

These wars were guided by the fictious imagination of a war free from antagonism: directed against criminal or terrorist opponents, to which the response was conceived as one of policing, not war.[16] As Chantal Mouffe has pointed out, liberals refuse to acknowledge the antagonistic dimension of politics—the existence of real opposition—as to do so would endanger the pretenses of consensus available through the use of reason.[17] Post-political visions were projected onto the international realm, accompanied by a post-adversarial understanding of war. Reciprocal relations are made impossible; this is a politics "without frontiers, without a 'they'—a win-win in which solutions could be found favouring everyone in society."[18] In the logic of counterinsurgency war, then, there can be no *real* opposition, only those not yet convinced. "There can only be one winner: democracy and a strong Afghan state," said Gordon Brown.[19] Barack Obama was careful to distance himself from the terminology of the war on terror, shifting to global contingency operations, but the smug assumption of post-antagonistic war remained.

Critics from the Left often ended up replicating the image of nonreciprocal war. Michael Hardt and Antonio Negri argued that "if war is no longer an exceptional state condition . . . then war [is] not a threat to the existing structure of power, not a destabilizing force, but rather, on the contrary, an active mechanism that constantly creates and reinforces the present global order"[20]—a form of warfare that more closely resembles a global and possibly permanent policing operation that is focused on managing risks.[21] Whether understood as a war that cannot be resisted because there is no outside (the liberal account of post-antagonistic war) or a Marxist/critical theoretical account of war as policing social relations, the effect of both debates was to silence the idea and account of a mutually antagonistic and reciprocal war. Variants of these two accounts have dominated discourses from the very outset of the war on terror until today.

Legal and Ethical Arguments: Radical Asymmetry and the Legality of Torture

Legal and ethical arguments have also complicated understandings of reciprocity and, at times, been mobilized to write out reciprocal relations in and of war. In his book *The End of Reciprocity* (no question mark), Mark Osiel deliberates whether the United States should at all "restrain itself" in detaining, interrogating, and targeting terrorists.[22] Three types of reciprocity are brought out as relevant to warfighting: reciprocity as fairness in fighting (drawing on Kantian ethics as well as Rawls's veil of ignorance), reciprocity as enforcement device (self-policing), and diffuse rather than specific reciprocity, by which

Osiel means that the United States might be inclined to respect the laws of war, as it stands to gain from the international legal system as a whole. Osiel suggests America's most controversial counterterrorism practices might in fact be justified as "commensurate responses to indiscriminate terror," indicating that from an international law perspective, writing out the principle of reciprocity is altogether possible.

Lisa Hajjar relatedly demonstrates how US officials have constructed a legal framework fit to the purpose of prosecuting a territorially unbounded war against an evolving cast of enemies, a framework that threatens to supersede the customary law principles enshrined in international humanitarian law.[23] As such, drone warfare is itself a "quasi-juridical process," a form of lawfare where the law is used tactically in the hope of achieving counterinsurgency objectives.[24] It is sustained through legal interpretations that prey on the inherent ambiguities within principles such as imminence, proportionality, combatant status, named targeting, and last resort in the contemporary security environment. The crux of this is not that targeted killings violate the law but rather that they can work *within* legal frameworks.[25] In this quasi-juridical realm, the harnessing of legal arguments to enable and make the case *for* targeted killings, legal arguments function to eviscerate reciprocity. This is so because they both operate to provide an "extra-strategic legitimating rationale" for targeted killing and to depoliticize the practice by presenting its acceptability as a technical question for legal experts.[26]

As one of the oldest principles of warfare, reciprocity depends on the distinction between civilian and combatant.[27] One of the most obvious and notorious traits of the war on terror is the violence it has done to that distinction. Indeed, it can be argued that the principle of distinction has been mobilized to *legitimize* the killing of civilians during war rather than protecting them. Legal arguments have been made to produce new categories of targetable subjects (and subvert existing ones), violating the civilian/combatant distinction with (quasi-legal) notions of "human shields" or post hoc labeling of "enemies killed in action."[28] Indeed, a task force on US drone policy led by the former head of the US Central Command concluded in 2014 that "basic categories such as 'battlefield,' 'combatant' and 'hostilities' no longer have clear or stable meaning."[29] The ability to produce such write-offs is contingent on writing out the principle of reciprocity from war.

Ethical arguments have similarly written out reciprocity. Often, such arguments are based on an understanding of contemporary war(s) as asymmetric, taking place between parties with such discrepancy of capabilities, threat, risk, and sacrifice. US warfare has become "post-heroic,"[30] prioritizing a form of warfighting that devalues the warrior ethos—an ethos that is undergirded by respect for the principle of reciprocal recognition between warring parties.[31] The notion of a warrior ethos as a normative category is contingent on a notion of reciprocal risk as the precondition for mutual respect between warring parties. Indeed, reciprocal risk plays both an explicit and a tacit role in the moral determination of the right to kill in war.[32] In this vein, Michael Walzer's "moral theory" of war is grounded in an understanding of the moral equality

of combatants, a symmetry between enemies that ultimately conditions war's ethical or moral content. The *notion* of asymmetric war consequently challenges the basis for this moral theory of war: if only one side is harmful, then there can be no justification for killing. The rub, for our purposes, is that *describing a conflict in asymmetric terms is in itself an ethical move*, not an objective fact.

Neil Renic conjures up a different notion of reciprocity in the context of what he calls "radically asymmetric war," a category invoked to signify warfare conducted by one party in the near-complete absence of physical risk across the full scope of a conflict zone. The advent of unmanned aerial vehicle–exclusive violence places the stronger party, in this view, at a crossover point wherein the violence is so unidirectional as to undermine the moral basis for its permissiveness.[33] Contra most ethical theorists on asymmetric war, Renic identifies war as a site of reciprocal *structural* risk between belligerents rather than a collective risk in the sense of the Walzer conventionalists. The kind of reciprocity that Renic writes of—the structural relationship between belligerents—cannot, in fact, be written out of war.

Substantialist/Phenomenological Arguments

A third body of literature that eviscerates reciprocity from its account of war is found in critical theoretical work on contemporary drone war. Grégoire Chamayou's hugely influential account of drone warfare as resembling a manhunt is a key source. Inquiry into the history of manhunting shows that the targeting of individuals as prey takes place along specific procedures of exclusion and lines of demarcation, "drawn within the human community in order to define the humans who can be hunted."[34] Through what Donna Haraway has called the "god-trick" of Western scientific epistemologies, intersubjective war in Chamayou's account is replaced by the manhunt, placing drone warfare in a long history of hunting from ancient Sparta to the Middle Ages to the modern practices of chasing undocumented migrants. In this account, the deployment of drones undermines the premise of reciprocal potential to kill or be killed. It challenges the concomitant exposure to killing and exposure to death upon which modern conceptions of war, and its legitimation, rests. Chamayou sees the rapport of reciprocity being suspended and the very concept of "war" undermined. Instead, drone warfare is akin to police action, relayed as surgically precise and clean. Chamayou's writings are not void of accounts of reciprocity (we shall return to these below), but the overwhelming use to which his writings have been put has taken violence out of the realm of reciprocal relations.

Kevin McSorley similarly characterizes contemporary US drone warfare as "predatory war," an articulation of late modern war with current signature motif being the drone strike.[35] Drawing on Scarry's *The Body in Pain*, McSorley argues that predatory war in fact more closely resembles the structure of torture than war. The central claim is that the modes of embodiment are "radically nonreciprocal" and that the wound-scapes of conflict are "profoundly asymmetric."[36] The casualty in this reading of Scarry is the

possibility and potential opening onto the *ending* of conflict—addressing the crisis of substantiation in ways that may strengthen our ability to "think symmetrically."

In a different vein, Nordin and Öberg argue that "warfare has become a reiterative process which strictly speaking lacks antagonistic engagement with 'an enemy.'"[37] Drawing on Baudrillard, they argue that the notion of war as "born of an antagonistic, destructive but dual relation between two adversaries" lacks relevance for understanding contemporary US-dominated warfare. Instead, targeting processes are better understood as the ends and means of military operational procedures and planning, whereby war disappears into the processing of warfare.[38] War thus vanishes into "a repetitive battle rhythm that symbolically dissolves subjects and targets," and acts of insurgency or terror "ways of acting out, rather than a response as such."[39] Similarly, literature that centers the concept of assemblage(s) to the study of war tends to understand war relations as dispersed along flows or lines of becoming, connecting nodes rather than subjects. In so doing, such accounts often end up eviscerating accounts of reciprocal relations in war.[40]

The range of literature discussed over the past pages indicates that the claim that contemporary drone war lacks meaningful exchange and reciprocal relations is widely shared. We saw that it derived in part from liberal fetishizations of a post-political world, wherein which the possibility of real political conflict has been all but obliterated and war thus post-antagonistic. Such accounts ring palpably hypocritical and untrue to those subjected to such war precisely because it occludes reciprocal recognition. Yet, ironically, critiques and critics thereof often end up replicating this occlusion of reciprocal relations in their accounts of quasi-imperial rule and subjugation, predatory war, torture, or manhunting. Reciprocity has similarly been written out in legalistic analysis of war: the relevance of the laws of war questioned with reference to the circumstances where war is waged against criminal or terrorist Others. We have also seen how accounts of war as profoundly asymmetric has led to a destabilizing of ethical categories and ethical critiques of war. Finally, martial empiricist accounts of war as a socio-technological assemblage or empty processing often belie or eclipse appreciation of the reciprocal relations that war always already entails. The idea that insurrection or acts of terror are ways of acting out, rather than a response as such, is at the heart of this elision.

Interlude

So drone bomb me
Blow me from the mountains
And into the sea
Blow me from the side of the mountain
Blow my head off
Explode my crystal guts
Lay my purple on the grass
—"Drone Bomb Me," from the album *Hopelessness* by Anohni, 2016

The Bureau of Investigative Journalists has recorded a minimum of 14,040 US drone strikes since 2004. Estimates of the number of people killed vary between 8,858 and 16,040, out of which between 910 and 2,220 are estimated to be civilian deaths and between 284 and 454 child deaths.[41]

It is sometimes said that to have others see a different perspective, you have to make it personal. The song "Drone Bomb Me" is a narrative told in the voice of a young girl whose family has been killed in a drone strike. "It's a love song from the perspective of a girl in Afghanistan, say a nine-year-old girl whose family's been killed by a drone bomb," Anohni explains. "She is kind of looking up at the sky and she's gotten herself to a place where she just wants to be killed by a drone bomb too."[42]

Drone war beckons us to reorder our understanding of war relations, but from where do we begin?

II Writing Reciprocity Back In

Failure to discern war relations also precludes proper understanding of the cycles of violence that continue to shape the international realm. Recovering an understanding of the encounters and exchange that take place under the aegis of "endless war," on the other hand, paves the way for more symmetrical thinking and, with it, meaningful critique. Reciprocity is immanent to the current condition of war: it is already *there*. Developing a sensibility toward that which is always already there is the task of immanent critique. In close contact with the social and the political, perception orients and reorients; it a "science of the sensible," in Baumgarten's rendition (see also the introductory essay to this volume). The three sections to follow are all concerned with perceiving and deciphering war encounters and reciprocal relations between subjects that are *not*—the crucial hallmark of drone war—co-present in time and space.

Killing at a Distance: Visible/Invisible Reciprocities

"This is close-up war—the breath of the person you are searching is upon you"—these were the words of General Kenneth F. McKenzie Jr., the head of US Central Command, as he described the face-to-face contact between marines and the Afghans they searched for at Kabul airport in August 2021.[43] Almost to the day twenty years after the September 11 attacks, US forces stood ready to depart from Afghanistan. On August 29, 2021, a US unmanned Reaper drone fired a Hellfire missile at a vehicle approaching the airport. Military officials stated that they did not know the identity of the car's driver when the missile was fired but that he had been deemed suspicious. He had, they said, possibly visited an ISIS safe house and, at another point, seemed to load explosives into the car. It was a "righteous strike," they said.[44] The attack was conducted by the OTH strike cell group of the US Central Command. It was later found, after investigation by the *New York Times*, that the driver, Zemari Ahmadi, in fact worked for Pasadena, a California-based

food charity and had no connections to ISIS, and that the ten people killed in the attack were, in fact, all civilians. Seven of them were children. These killings at a distance seemed to be the parting words of the US forces—those same forces that claimed, in General McKenzie Jr.'s words, to be sensing the breath of their adversaries.

The juxtaposition of distance and proximity is found not only in the contrast between the body searching at the entrance of the airport in Kabul and the Reaper drones preying on Zemari Ahmadi but also within drone warfare itself. Locating reciprocal relations in the context of (in)visibility is about finding modes of perception, apprehension, and recognition that withstand distance and invisibility.

Visibility has many senses, of course. On the immediate physical level, belligerents may be invisible to one another either because of distance or as a result of vision being impeded in other ways. Antoine Bousquet tells the story of how military perception technologies throughout history have rendered subjects targetable, of how visibility equals death.[45] Contemporary lethal surveillance indeed renders the martial gaze global in reach and potential, but does this mean that belligerents are *visible* to one another in a meaningful way?[46] One of the conceits of the remote operations of later modern war, writes Derek Gregory, is "that their digital mediations allow not only virtual but also virtuous war; 'war without bodies.'"[47] A disproportional focus on the subjects behind the screens, the drone operators, has shaped debates of drone warfare, its technical apparatus, and its execution, decoupling belligerents and concealing reciprocity.[48] Contemporary war is most clearly not "without bodies" for those targeted, but the reciprocal visibility of belligerent subjects is complicated in ways that seem to exceed the categories of visible/invisible.

One of the ways in which this complication is manifest is captured in the notion of intimacy and its relationship to the collapse of visibility. Hugh Gusterson has written of the "remote intimacy" of drone warfare: the way in which a certain narrativization from afar always accompanies the gaze of the drone operator.[49] Whereas war can be intimate in more ways than one, there seems to be something peculiar about the screen-mediated intimacy that constitutes drone warfare: a perplexing combination of proximity and distance, absence, and presence. On the one hand, we have the inviolability and safety of the drone operator in his control room somewhere in, say, Nevada, and his utter obscurity from the subjects he is targeting. On the other hand, we have the minute detail available on screen as images magnify targets beyond the regularly visible. The immersive quality of screens, the rate of post-traumatic stress disorder among drone operators, and the extrapolated narration that attempts to bridge such distance all testify to the paradoxical nature and effect of such remote intimacy. The ready availability of terrorist modes of violence on screen—such as the series of decapitation videos posted by ISIS in 2014–2015 or the suicide bomber—similarly draws us in.

The intuitive linking of distance with readiness to kill is hard to disrupt. David Grossman's study of the relationship between the physical distance to a target and

resistance to killing insists on a smooth, simple graduation: the further away, the easier it is to kill.[50] Carlo Ginzburg, too, writes of how "airplanes and missiles have proved the truth of Diderot's conjecture, that it would be much easier to kill a human being if he or she would look no larger than a swallow."[51] Yet, as Chamayou, Gusterson, and others point out, in contemporary drone warfare, that which is far away looks impossibly close.

In a further twist, however, those so hyper-visible in death on the screen are rendered invisible again by their deaths failing to be reported and, when they are to be reported, with being named. The Bureau of Investigative Journalism's Drone War project, which ran between 2010 and 2020, tracked US drone strikes in Pakistan, Afghanistan, Yemen, and Somalia, and it reported civilian deaths not only in number but also in name (Naming the Dead), precisely because of this.[52] Of course, this lack of a human face to those reported as killed indicates a deeper lack. As Judith Butler writes, "the conditions for whose death will be noticed and whose not are set far earlier: such is the political saturation of invisibility that lives not registered as 'living' in the first place are also not grievable in death."[53] Norms of recognizability prepare the way for recognition (in Butlerian strong sense); and in the same way, schemas of intelligibility condition and produce norms of recognizability. Thus, there are "subjects" who are not quite recognizable as subjects, and there are "lives" that are not quite—or, indeed, are never recognized as lives.

Butler's move enables us to recognize that the epistemological problem of apprehending a life underwrites the ethical problem of what it is to acknowledge or, indeed, to guard against injury and violence. The recognition that Butler invites is necessarily reciprocal, and writing it back in with the ubiquitous war paves the way for symmetrical thinking. The encounter we render visible is an ethical encounter, one that cannot be erased by killing at a distance.

As we shall further explore in the two next sections, to locate reciprocity is also to acknowledge the ways in which the (in)visible belligerents produce one another. Caren Kaplan calls out a kind of "bromance" between the pursuer and pursued, a mutual co-constitution that resonates with "object relations" in psychoanalytic terms.[54] A "dyadic fusion of difference" draws opponents close.[55] Only by elucidating, rendering decipherable this reciprocal relationship, can we begin to offer meaningful critique.

Posthuman Reciprocities

On November 3, 2002, a vehicle carrying six men through the desert of the Marib province in Yemen was struck by a Hellfire missile fired from a US Predator drone. This was one of the very first drone strikes in Yemen, killing Qaed Salim Sinan Al-Harithi, identified as having orchestrated the attack on the USS *Cole* missile destroyer ship that killed seventeen US sailors and wounded thirty-nine in the Aden harbor in Yemen on October 12, 2000. The five other passengers, although not the original target, also perished, one of whom was an American citizen. The operation was deemed a success,

setting the stage for the expansion of the US targeted killing program. Since then, more than a thousand people have been killed in counterterrorism operations in Yemen.[56]

One of the conceits of drone warfare is that it somehow takes the human out of war—the human, that is, who is the drone operator. But the drone operator is not diverged from the technology that he operates; they are part of the same techno-cultural assemblage, wherein the human cannot be separated from the weapons systems that he operates, however autonomous that system may be. Drone warfare is both embodied and embodying; it is, as Lauren Wilcox writes, a form of embodiment that "reworks and undermines essentialist notions of culture and nature, biology and technology."[57] Thus, while absence/presence can be conceptualized in spatiotemporal terms, there is an absence/presence also to the human/technological convergence in automated war. I have previously analyzed the combination of steely and fleshy bodies in contemporary war by drawing on Maurice Merleau-Ponty's engagement with materiality—in particular, his work on corporeality, beings-in-the-world, and intertwining.[58] The argument herein is that we need to think of the combination of human and material—indeed, of the category of "human" as such—in ways that allow for the full complexity of the varying relationships between bodies of and in contemporary war. Merleau-Ponty's non-dualist and relational ontology underpins human subjects and other living beings in what he calls an "interworld," an interworld populated by subjects involved in reciprocal relations as much as any.[59]

We have already seen how drone warfare reorganizes perception in its play on distance/proximity and visibility/invisibility. The reorganization of perception is equally significant when it comes to the understanding of material/immaterial or animate/inanimate in drone war relations. While Chamayou's work has been widely appropriated to argue that war has become one-sided, where contemporary drone war takes its place in a long history of manhunting, he also argues that there the technology-mediated corporeality can imply both distance and proximity at the same time, and both animate and inanimate. In a lengthy footnote to chapter 10 ("Killing at a Distance") of *Drone Theory*, Chamayou elaborates on the concept of "pragmatic co-presence."[60] The point he makes is that pragmatic co-presence can exist without physical or temporal co-presence. Nor does pragmatic co-presence require *consciousness*. In other words, one does not need to be conscious that one is in the presence of another for co-presence to exist or occur. This goes to the heart of locating reciprocity in the context of the man/machine assemblage: we cannot expect to perceive it in the same way as we would the reciprocal relations of the archetypal duel. Instead, "co-presence" is radically restructured under the somatic-technical architecture, producing new forms of experience (damaged presence, blind presence, and so on). This amounts to nothing less than "*a revolution in the modes of co-presence and, at the same time, in the structure of intersubjectivity.*"[61]

Unpacking reciprocal relations seemingly lost in a technologically mediated assemblage demands attention both to the ways in which bodies constitute one another as

subjects and to how these subjects can be fashioned out of the interworld of matter, meaning making, and reflexivity. Technology and its child, data, are embedded with human relations. As Anthony Downey and Louise Amoore both implore, there is no such thing as "raw" or innocent data. Rather than being an inanimate landscape of techno-fetishization, senses are reformatted; they are no longer contained within the human body but are widely mediated perceptions. It is this that is the "aesthetic regime of somatic war."[62]

Elke Schwarz juxtaposes the drone and the suicide bomber, two ostensibly antithetical figures in the war on terror, in order to draw out the ways in which they are, in fact, part of the same technologically-mediated ecology of violence.[63] By drawing out the shared material-technical logos, she demonstrates not only how the pathologization of one (the suicide bomber) enables the reverence of the other (the "clean" and precise pursuit of evil by the lethal drone). The surge in drone attacks is exactly mirrored by the surge in suicide bombings; in fact, they appear to conspicuously co-evolve over the course of the targeted killing programs. The killing of Qaed Salim Sinan Al-Harithi in Yemen in 2002 is thus simply one of the many instantiations of the terrorism/counterterrorism complex, where suicide attacks have been on the rise for decades, indeed accelerating from 2004, the very same year that the Central Intelligence Agency (CIA) drone program was launched by George W. Bush. The underlying commonality, as Schwarz demonstrates, is a particular relation to the technological embodiment as contemporary means of waging war: the suicide bomber is the weapon, much as the drone operator is his missile. Rather than reflecting antithetical materialities, these figures adhere to similar logics and—crucially—*take each other as referent*.[64] This insight is central to the task of writing reciprocity back in: it attunes to the co-constitutive relationship and its production of never-ending spirals of attack and counterattack. For the ecology of drone war has "iatrogenic effects"[65]; that is, instead of solving the problem of terrorism, drone war escalates and perpetuates cycles of violence.

Clash and Emergence—Disassociated Reciprocity

"Who the fuck did that?" The words greeting the first-ever combat strike by a remotely piloted aircraft were uttered not in praise but in anger. A botched Hellfire-missile attack by a CIA Predator had just cost the United States a likely chance to kill Taliban Supreme Commander Mullah Mohammed Omar. In response, the US Air Force general in charge of airstrikes in Afghanistan was about to threaten to call off the entire opening campaign of the War on Terror, unless he was given control of the CIA's secret weapon.[66]

Locating reciprocity from the very first drone strike of the war on terror to the reinstated commitment to OTH capabilities on the part of Joe Biden on occasion of the departure of US troops from Afghanistan takes us to the phenomenological core of war.

Clausewitz, whose work has been so thoughtlessly colonized and truncated in strategic studies scholarship insisting on the military means as subject to linear rationality and instrumentality, ought to be remembered more often for his insights onto the phenomenology of war. War, Clausewitz writes, is at its essence a clash of force, a mutual confrontation between antagonists where the use of force knows no inherent limit. This clash cannot be eviscerated from war. Here, Clausewitz followed in the steps of Hegel and Henri Bergson, who both grounded notions of war as essentially constituted by encounter, collision, and clash.

The clash that is inherent to war is simultaneously destructive and generative; one cannot be separated from the other. This is the essence also of Emmanuel Levinas's understanding of war as a "casting into motion": it is the clash inherent in war that makes it a generative force and casts subjects into motion, making and unmaking social and political orders.[67] Invoking Clausewitz and Levinas, Tarak Barkawi and Shane Brighton ushered in renewed attention to the phenomenology of war with their seminal piece calling for critical war studies.[68] "While war is destructive, it is a generative force like no other," they wrote, and proceeded to locate the ontological core in the Clausewitzian notion of *fighting*—a kinetic exchange that makes and unmakes the world. It is ironic that while Barkawi and Brighton's writings have spawned a wide literature on the power/knowledge structure of war and of the co-constitutive relations between war and society, it is perhaps *kinetic exchange* that has been the least addressed within this new generation of critical war studies scholars. This is at the heart of the evisceration of reciprocity from accounts of contemporary drone war outlined in part I of this chapter: a collective blindness to the clash that takes place when protagonists are not co-present in time and space, as is the case with both drone war and its constitutive Other, suicide attacks.

For what are we to make of a clash where belligerents are utterly distant from one another, where the clash as such is disassociated in time and space? In his mediation on pragmatic co-presence, Chamayou writes of a "bursting apart" into a "disarticulated co-presence."[69] The emergent quality of the clash is vindicated: the force of the casting into motion, the bursting apart is the essential quality of war.

The attacks of September 11 were of course the ultimate casting into motion: events that were so formative of the political consciousness of the twenty-first century that they came to constitute not only a Ground Zero but also a Time Zero.[70] There was nothing inevitable about the response to 9/11, however: as was repeatedly stated at the outset of the war on terror by critics of George W. Bush's totalizing "you are with us, or with the terrorists," it was not necessary to call this a war. Military response was not a given; there would have been other ways in which 9/11 could have been received. Indeed, that very critique was part of what came to be the liberal internationalist creed described in part I of this chapter: a view of terrorism as a criminal phenomenon that should be met with a policing response, not war. The crux of course was that 9/11 *was* met with warfighting—in Afghanistan, Iraq, Yemen, Syria, Mali, and elsewhere—and

harrowing reciprocal cycles of violence ensued. Barack Obama went to great lengths to distance himself from his predecessor's war on terrorism (he favored the term "global contingency operations"). But, of course, Obama only accelerated the targeted killing program, paving the way for omnipresent war). It did not matter that the war on terror went out of fashion: it was there, and it was a war nonetheless. And, in an exact replica of Bush's reaction to 9/11, President Francois Holland declared after the attacks on the Bataclan theater in Paris in 2015, "*Nous sommes en guerre.*" This was not a discursive move: it was a move to announce France's military strikes on Syria.

"If war has an ontology, it must be coterminous with its consistent mutability," wrote Antoine Bousquet, Jairus Grove, and Nisha Shah.[71] Reciprocity in the war on terror is no conventional reciprocity of relations: it is based neither on mutual recognition in formal political, legal, or ethical terms nor on physical spatiotemporal co-presence. The reciprocity we find is a disassociated reciprocity, sometimes seemingly disembodied, sometimes seemingly distant or taken over by technology, but reciprocity nonetheless. If we are to keep up with the constant evolution of warfighting without losing sight of its political stakes and consequences, we must be prepared to reconsider what it means to be engaged in reciprocal warfighting. In acknowledging the inherently relational nature of war, and war's antagonisms as emergent, we end up recovering reciprocity: a disassociated, disembodied, and dispersed reciprocity—but reciprocal war relations nonetheless.

Conclusions and Openings

Why are we so blind to reciprocity in the contemporary global war-scape? It makes things easier. It is convenient for liberals to imagine a world free from conflict, where antagonists can be policed rather than recognized in political terms. It is tempting, for critics on the Left, to criticize the inherent imperial logic of this enterprise. It is exciting from a theoretical point of view to pursue the techno-cultural processing that is drone targeting, in all its inanimate and ephemeral forms. Legal and ethical theorists join hands in condemning the violence of asymmetric war but fail to see that reciprocity is never the foremost legal or ethical principle but rather endemic to war itself.

Against an overwhelming body of work, wherein reciprocal relations have been written out of war because they are deemed too difficult, too unwieldy, lost in techno-fetishizations, or altogether too distant, I have sought to reinscribe the reciprocal relations that not only still carry the burden of the cycles of violence but also, crucially, carry the promise of a different opening onto the landscape of endless, global war. As Butler insists, we are undone by one another through our mutual vulnerability—this is what it means to be human. Recovering adversaries and antagonism, although this is only partly knowable amid the folds and hidings of the global war-scape, is key to understanding the endless cycles of violence.

This is not to say that recovering of reciprocity—a more complex, disassociated reciprocity—leads us unequivocally toward a more peaceable end. An apprehension of precariousness can also lead to "a heightening of violence, an insight into the physical vulnerability of some set of others that incites the desire to destroy them."[72] Yet, akin to what Scarry figures as the function of bodily injury in the political contest, a recognition of the reciprocal pain inflicted under the current predicament of OTH drone wars against terror may just provide the substantiation of meaning from which we must start. Reciprocal pain is the inevitable affinity that war brings, but it is also the only possible starting point for openings toward something that could be different.

Notes

This chapter stems from a wider research project, "Time and Discourses of Global Politics," funded by the Swedish Research Council. I would like to thank Gregor Noll, Kevin McSorley, and Colleen Bell for stimulating conversations on the topic of reciprocity, and Stefan Borg for providing generous feedback on the text. My sincere thanks to Anders Engberg-Pedersen and the rest of the team on the "Aesthetics of Late Modern War" research program. It has been a joy and privilege to be part of this project.

1. Transcript of Biden's speech of the US' withdrawal from Afghanistan, https://www.nytimes.com/2021/08/31/us/politics/transcript-biden-speech-afghanistan.html.

2. Herfried Münkler, *The New Wars*, ed. Patrick Camiller (Oxford: Polity, 2005).

3. Charles Tilly, "War Making and State Making as Organized Crime," in *Bringing the State Back In*, eds. Peter Evans, Dietrich Rueschemeyer, and Theda Skocpol (Cambridge: Cambridge University Press, 1985), 169–191.

4. Mary L. Dudziak, *War Time: An Idea, Its History, Its Consequences* (Oxford: Oxford University Press, 2012).

5. Frantz Fanon, *The Wretched of the Earth* (Harmondsworth: Penguin Books, 1967).

6. Tarak Barkawi, "Decolonising War," *European Journal of International Security* 1, no. 2 (2016): 199–214.

7. Mark Duffield, *Development, Security and Unending War: Governing the World of Peoples* (Cambridge: Polity, 2007); Dexter Filkins, *The Forever War* (New York: Alfred A. Knopf, 2008); Derek Gregory, "The Everywhere War," *The Geographical Journal* 177, no. 3 (2011): 238–250; David Keen, *Endless War? Hidden Functions of the "War on Terror"* (London: Pluto Press, 2006); John Morrissey, *The Long War: CENTCOM, Grand Strategy, and Global Security* (Athens: Georgia University Press, 2017).

8. Derek Gregory, *The Colonial Present* (Oxford: Blackwell, 2004); Gregory, "The Everywhere War"; Ian G. R. Shaw, *Predator Empire: Drone Warfare and Full Spectrum Dominance* (Minneapolis: University of Minnesota Press, 2016).

9. Medea Benjamin, *Drone Warfare: Killing by Remote Control* (London: OR Books, 2011); Steve Niva, "Disappearing Violence: JSOC and the Pentagon's New Cartography of Networked Warfare," *Security Dialogue* 44, no. 3 (2013): 185–202; Peter W. Singer, *Wired for War* (New York: Penguin, 2010).

10. Derek Gregory, "Seeing Red: Baghdad and the Event-ful City," *Political Geography* 29, no. 5 (2010): 266–279.

11. Frédéric Gros, *States of Violence: An Essay on the End of War* (London: Seagull Books, 2010).

12. Carl von Clausewitz, *On War* (Oxford: Oxford University Press, 2008).

13. Philip Windsor, "The Autonomy of Strategy in the Nuclear Age," in *Strategic Thinking: An Introduction and Farewell*, eds. Mats Berdal and Spyros Economides, (London: Lynne Rienner, 2002), 1–6.

14. Rory Stewart, "The Irresistible Illusion," *London Review of Books* 31, no. 13 (2009).

15. David Kilcullen, "Counter-Insurgency Redux" *Survival* 48, no. 4 (2006): 111–130; John A. Nagl, *Learning to Eat Soup with a Knife: Counterinsurgency Lessons from Malaya and Vietnam* (Chicago: University of Chicago Press, 2005).

16. Caroline Holmqvist, "War, 'Strategic Communication' and the Violence of Non-Recognition," *Cambridge Review of International Affairs* 26, no. 4 (2013): 631–650; Caroline Holmqvist, *Policing Wars: On Military Intervention in the Twenty-First Century* (Basingstoke: Palgrave Macmillan, 2014).

17. Chantal Mouffe, *On the Political* (London: Routledge, 2005), 29.

18. Mouffe, *On the Political*, 31–32.

19. Quoted in Stewart, "The Irresistible Illusion."

20. Michael Hardt and Antonio Negri, *Empire* (Cambridge, MA: Harvard University Press, 2000), 13.

21. Holmqvist, *Policing Wars*; Mark Neocleous, *War Power, Police Power* (Edinburgh: Edinburgh University Press, 2014); Niva, "Disappearing Violence"; Shaw, *Predator Empire.*

22. Mark Osiel, *The End of Reciprocity* (New York: Cambridge University Press, 2009).

23. Lisa Hajjar, "The Counterterrorism War Paradigm versus International Humanitarian Law: The Legal Contradictions and Global Consequences of the US 'War on Terror,'" *Law & Social Inquiry* 44, no. 4 (2019): 922–956.

24. Charles Dunlap, "Lawfare: A Decisive Element of 21st-Century Conflicts?" *Joint Force Quarterly* 54 (2009): 34; Kevin McSorley, "Predatory War, Drones and Torture: Remapping *The Body in Pain*," *Body and Society* 25, no. 3 (2017): 73–99.

25. Kyle Grayson, "Six Theses on Targeted Killing," *Politics* 32, no. 2 (2012): 120–128; Charlie Savage, "Secret US Memo Made Legal Case to Kill US Citizen," *New York Times*, October 8, 2011.

26. Grayson, "Six Theses."

27. Jonathan A. Chu, "A Clash of Norms? How Reciprocity and International Humanitarian Law Affect American Opinion on the Treatment of POWs," *The Journal of Conflict Resolution* 63, no. 5 (2019): 1140–1164.

28. Nicola Perugini and Neve Gordon, "Distinction and the Ethics of Violence: On the Legal Construction of Liminal Subjects and Spaces," *Antipode* 49, no. 5 (2017): 1385–1405.

29. https://www.stimson.org/wp-content/files/file-attachments/recommendations_and_report _of_the_task_force_on_us_drone_policy_second_edition.pdf

30. Edward N. Luttwak, "Toward Post-Heroic Warfare," *Foreign Affairs* 74, no. 3 (1995): 109–122.

31. Christopher Coker, *Humane Warfare* (London: Routledge, 2001); Christopher Coker, *Ethics and War in the 21st Century* (London: Routledge, 2008); Christopher Coker, *The Warrior Ethos: Military Culture and the War on Terror* (London: Routledge, 2008).

32. Neil C. Renic, "UAVs and the End of Heroism? Historicising the Ethical Challenge of Asymmetric Violence," *Journal of Military Ethics* 17, no. 4 (2018): 188–197; Neil C. Renic, *Asymmetric Killing: Risk Avoidance, Just War, and the Warrior Ethos* (New York: Oxford University Press, 2020).

33. Renic, *Asymmetric Killing*.

34. Grégoire Chamayou, *Manhunts: A Philosophical History* (Princeton: Princeton University Press, 2012), 2.

35. McSorley, "Predatory War."

36. See also Sebastian Kaempf, *Saving Soldiers or Civilians? Casualty Aversion versus Civilian Protection in Asymmetric Conflicts* (Cambridge: Cambridge University Press, 2018).

37. Astrid H. M. Nordin and Dan Öberg, "Targeting the Ontology of War: From Clausewitz to Baudrillard," Millennium: *Journal of International Studies* 43, no. 2 (2015): 392–410.

38. Dan Öberg, "War, Transparency and Control: The Military Architecture of Operational Warfare," *Cambridge Review of International Affairs* 29, no. 3 (2016): 1132–1149.

39. Nordin and Öberg, "Targeting the Ontology of War," 409.

40. Jan Bachmann, Colleen Bell, and Caroline Holmqvist, *War, Police and Assemblages of Intervention* (London and New York: Palgrave Macmillan, 2014); Colleen Bell and Caroline Holmqvist, "Assemblages," in *Handbook on International Political Sociology*, eds. Stacie Goddard, George Lawson, and Ole Jacob Sending (Oxford: Oxford University Press, forthcoming).

41. https://www.thebureauinvestigates.com/projects/drone-war.

42. Interview, BBC Radio 1, March 9, 2016.

43. https://www.nytimes.com/2021/08/27/us/politics/marines-kabul-airport-attack.html.

44. https://www.nytimes.com/2021/10/15/us/politics/kabul-drone-strike-victims-payment.html.

45. Antoine Bousquet, *The Eye of War: Military Perception from the Telescope to the Drone* (Minneapolis: University of Minnesota Press, 2018).

46. Bousquet, *The Eye of War*.

47. James Der Derian quoted in Derek Gregory, "Eyes in the Sky—Bodies on the Ground," *Critical Studies on Security* 6, no. 3 (2018): 347–358.

48. Peter M. Asaro, "The Labor of Surveillance and Bureaucratized Killing: New Subjectivities of Military Drone Operators," *Social Semiotics* 23, no. 2 (2013): 196–224.

49. Hugh Gusterson, *Drone: Remote Control Warfare* (Cambridge: MIT Press, 2016).

50. David Grossman, *On Killing: The Psychological Cost of Learning to Kill in War and Society* (London: Little, Brown, 1995).

51. Carlo Ginzburg, "Killing a Chinese Mandarin: The Moral Implications of Distance," *Critical Inquiry* 21, no. 1 (1994): 46–60.

52. https://www.thebureauinvestigates.com/projects/drone-war.

53. Judith Butler, *Frames of War: When Is Life Grievable?* (London: Verso, 2009), 4.

54. Lisa Parks and Caren Kaplan, *Life in the Age of Drone Warfare* (Durham: Duke University Press, 2017), 169.

55. Parks and Kaplan*, Life in the Age of Drone Warfare*, 169.

56. https://www.newamerica.org/international-security/reports/americas-counterterrorism-wars/the-war-in-yemen/.

57. Lauren Wilcox, "Embodying Algorithmic War," *Security Dialogue* 48, no. 1 (2017): 11–28.

58. Caroline Holmqvist, "Undoing War: War Ontologies and the Materiality of Drone Warfare," *Millennium Journal of International Studies* 41, no. 3 (2013): 535–552; Maurice Merleau-Ponty, *The Visible and the Invisible* (Evanston: Northwestern University Press, 1968).

59. Anya Daly, ed., *Perception and the Inhuman Gaze: Perspectives from Philosophy, Phenomenology, and the Sciences* (New York: Routledge, 2020).

60. Grégoire Chamayou, *Drone Theory* (London: Penguin, 2015), 254.

61. Chamayou, *Drone Theory*, 254 (my emphasis).

62. Kevin McSorley, "Helmetcams, Militarized Sensation and 'Somatic War,'" *Journal of War and Culture Studies* 5, no. 1 (2012): 46–62.

63. Elke Schwarz, "Flesh and Steel: Antithetical Figures in the War on Terrorism," *Critical Studies on Terrorism* 11, no. 2 (2018): 394–413.

64. Schwarz, "Flesh and Steel," 395.

65. Schwarz, "Flesh and Steel."

66. https://www.theatlantic.com/international/archive/2015/05/america-first-drone-strike-afghanistan/394463/.

67. Emmanuel Levinas, *Totality and Infinity* (Pittsburgh: Duquesne University Press, 1969).

68. Tarak Barkawi and Shane Brighton, "Powers of War: Fighting, Knowledge, and Critique," *International Political Sociology* 5, no. 2 (2011): 126–143.

69. Chamayou, *Drone Theory*, 254.

70. Antoine Bousquet, "Time Zero: Hiroshima, September 11 and Apocalyptic Revelations in Historical Consciousness," *Millennium* 34, no. 3 (2006): 739–764.

71. Antoine Bousquet, Jairus Grove, and Nisha Shah, "Becoming War: Towards a Martial Empiricism," *Security Dialogue* 51, nos. 2–3 (2020): 99–118.

72. Butler, *Frames of War*, 2.

Bibliography

Dunlap, C. 2009. "Lawfare: A Decisive Element of 21st-Century Conflicts?" *Joint Force Quarterly* 54: 34.

Favret, M. A. 2010. *War at a Distance: Romanticism and the Making of Modern Wartime.* Princeton, NJ: Princeton University Press.

Galli, C. 2010. *Political Spaces and Global War.* Minneapolis: University of Minnesota Press.

Haraway, D. 1988. "Situated Knowledges: The Science Question in Feminism and the Privilege of Partial Perspective." *Feminist studies* 14, no. 3: 575–599.

Jabri, V. 2007. *War and the Transformation of Global Politics.* Basingstoke, UK: Palgrave Macmillan.

Massumi, B. 2009. "National Enterprise Emergency: Steps Toward an Ecology of Powers." *Theory, Culture and Society* 26, no. 6: 153–185.

Massumi, B. 2010. "Perception Attack: Brief on War Time." *Theory and Event* 13, no. 3.

Neocleous, M. 2011. "The Police of Civilization: The War on Terror as Civilizing Offensive." *International Political Sociology* 5, no. 2: 144–159.

13

The War on Futures

Louise Amoore

Two Letters

In January 1947, the mathematician and pioneer of cybernetics Norbert Wiener published an open letter—"A Scientist Rebels"—in *Atlantic Monthly*. Wiener's letter was a public reply to a request he received from Boeing Aircraft Company for access to his scientific work. Addressing his reply to other research scientists whose work was sought for military applications, Wiener wrote, "the interchange of ideas which is one of the great traditions of science must of course receive certain limitations when the scientist becomes an arbiter of life and death."[1] Reflecting on the bombing of Hiroshima and Nagasaki—and the scientists who had worked on the atomic bomb—Wiener expressed his disquiet about the relationship of science to war and, specifically, the responsibility he bore for government and military-industrial deployment of his scientific ideas. Other scientists echoed his concerns in the ensuing public exchange, writing, "I decided not to do any war work myself" and withdrawing from projects that might have led to the "development of weapons, or devices designed for use on machines of war."[2] A boundary is sought between science and war—a boundary that is defined at the line of "war work" where a technology is designed for use in war. Indeed, Wiener expresses some relief in the withdrawal of his science from the work of war, writing that he is "much gratified to find that my publication on 'Extrapolation, Interpolation, and Filtering of Stationery Time Series' is no longer available to those who construct missiles."[3]

Seventy years later, in April 2018, thousands of Google employees signed a letter protesting the involvement of their company in Project Maven, a Pentagon-sponsored program using neural network algorithms for video analysis in the drone program. "We believe that Google should not be in the business of war" and should not build "warfare technology," said the letter addressed to the Google chief executive Sundar Pichai.[4] In a historical echo of Wiener's cautionary letter on the dangers of science as "war work," the Google workers' letter on the "business of war" sought a clear delineation of the mathematics and computer science of object recognition, image analysis, and scene representation from the deployment of such technologies in the theater of war. It is curious perhaps that the world's leading theorist of automation and the feedback loops of human and machine imagined there to be a limit that could be inscribed at the edge of war. In so many ways, Wiener's work precisely pointed to the multiple information

channels that adjust and correct the actions of humans and machines. To sever the relay of algorithmic feedback that feeds the work of war—as the Google employees also advocated—is to imagine a technological limit point at the threshold of war.

At the heart of this essay is the question of why it is that one cannot merely establish and enforce an ethico-political limit on technology at the threshold of war. To seek to do so would be to obscure another sphere of violence that flourishes unchecked beneath the appearance of a prohibition of war work. It is not the case that science and technology emerge in some kind of nonpolitical sphere of laboratories and computer models, only to be intermittently co-opted and corrupted by their political enrollment into the business of war. Such technologies are not governable via the limit point because they are precisely limit devices; that is, they function to inscribe and to expand the limit of war as such, their operations generative of thresholds that are malleable and useable. Algorithmic technologies cannot be limited at the threshold of war because they make the world in ways that extend the possible space for warlike structures and conditions of action. The tools of machine learning, for example, not only become "weaponized" for use in the battlefield of a *future war* (as the Project Maven letter suggested) but are, in fact, already warlike in their foreclosure of political futures, or what I will call a "war on futures." The contemporary algorithmic technologies I will address here are actively making forms of targeting, recognition, and attribution that are integral to the pursuit of the conduct of war in apparently peaceful everyday political life. Put simply, one could prohibit and prevent the deployment of algorithmic technologies in war, but their techniques of refining the target, recognizing ourselves and others, and attributing qualities of danger or threat—these would continue to proliferate unchecked. This is not to say that the international community should not seek to draw a line at the use of artificial intelligence (AI) on the battlefield, but nevertheless algorithmic ways of knowing, seeing, and acting on the world will continually draw and redraw the political line.

And so, it is more important than ever perhaps that we heed Wiener's warning on how scientific knowledge becomes the arbiter of life and death. Yet, a meaningful response to the problem would require that the war on futures be considered critically to overflow the decisions on individual futures that mark the threshold of life and death. The war on futures is, I suggest, foreclosing not only the life of an individual but also a crucial ground for collective politics and the space to image a future politics that is not already targeted, recognized, and attributed. In the sections that follow, I first address the question of how technologies become generative of a war by other means, and what this could mean for politics and the idea of plural possible futures. I then turn my attention to how the war on futures is at work in algorithmic technologies that target, recognize, and attribute in novel forms. The essay concludes with a comment on the war unfolding in Ukraine at this moment in February 2022, and how algorithmic foreclosures limit the capacities for an ethics of hospitality and response to violence.

A War on Futures by Other Means

In a series of oft-cited discussions of political power and war, Michel Foucault famously proposes to invert Clausewitz's dictum that war is a continuation of politics by other means and to "say that politics is the continuation of war by other means."[5] His proposition is suggestive of how warlike structures might be thought to inhabit politics beyond the moment of apparent endings to war or cessations of violence. If our contemporary algorithmic technologies are not circumscribed by a limit on their use in war, then how might they be implicated in the struggles of a war by other means? Foucault's formulation of political power as active and relational affords politics the capacity to inscribe and underwrite indefinitely the violent logics of war, even and especially where this is by means other than overt weaponry and physical violence. Understood in this way, politics always also involves relations of force that are capable of exceeding the spaces of military war and entering economic, social, and political institutions. "While it is true that political power puts an end to war and establishes or attempts to establish the reign of peace in civil society," writes Foucault, the act does not suspend or "neutralize the disequilibrium revealed by the last battle of war."[6] Politics specifically continues the force of war by other means, or to "inscribe it in institutions, economic inequalities, language, and even the bodies of individuals . . . politics, in other words, sanctions and reproduces the disequilibrium of forces manifested in war."[7] Viewed in this way, the strict military deployment of a technology—from battlefield biometrics to drone video analysis—does not cease to exercise force at the moment of its prohibition. Rather, the exposure to the violent actions and instabilities of war actively supplies the technology with the forces it will continue to sanction and reproduce on "peacetime" city streets, at border and in immigration systems, in policing and judicial decisions.[8]

In sum, if algorithmic technologies reinscribe warlike forces long after the apparent ceasing of violence, then another and less visible form of violence is at work in sustaining the effects in the bodies of people. A war by other means is thus also a war on alternative futures in the sense that it locks in and amplifies the inequalities and effects of the last war. The architectures of machine-learning algorithms, for example, resurface in novel forms of border control that violently reinscribe the racialized boundaries of war.[9] Where politics becomes the continuation of war by other means, it matters to be attentive to the silent violences that take place in the "civil peace" or under the cover of the absence of war.[10] In the political struggles within civil peace, Foucault identifies a specific form of the continuation of war, in which politics is "interpreted as so many episodes, fragmentations, and displacements of the war itself," and so "we are always writing the history of the same war, even when we are writing the history of peace and its institutions."[11] It is precisely the episodes, fragments, and displacements of war that lodge within the very algorithms that will continue to identify bodies, faces, signals, threats, and dangers in the gatherings of people that form under the name of a civil peace. For example, the

algorithmic surveillance of Black communities organizing in cities to protest police violence is also a fragmented displacement of colonial war that reinscribes and reconfigures the algorithmic technologies of race.[12] The algorithmic war by other means thus enacts the displaced fragments of war at the very same moment as it produces new racialized technologies of war. For a group of protesters gathering to make the claim that Black Lives Matter, their facial biometric templates, the video footage of their protest, their exchanges on social media—each of these becomes a data input to a government model to interrupt civil unrest. A war on futures by other means makes it more difficult and riskier to make a political claim on the future, or even to assemble and associate with others to make that claim. The actions of the algorithm carry the architecture of war so that they continue the capacity for a violent foreclosure of possible political futures.

How would one begin to locate an ethical limit on algorithmic technologies at the edge of war when the forces of war penetrate so deeply every sphere of social and political life? Put differently, how is it possible to arbitrate the boundaries of war and politics when the political logics of contemporary algorithmic technologies embrace the very essence of forces of war? "What is rumbling away and what is at work beneath political power," writes Foucault, "is essentially and above all a warlike relation."[13] It is to this rumbling and vibrating force of political technologies that I now turn my attention. It is not sufficient to consider machine-learning algorithms as instruments of late modern war—in the sense of instrumental or causal effects—but, more than this, as arrangements of propositions that extend the politics of possibility, where uncertain futures are acted upon as future likelihood, annulling the potential for alternative political futures.[14]

Generating Targets

Let us move a little closer to the concrete practices of the development and procurement of algorithms for war and how the operation of the algorithm overflows any sense of the boundaries of a defined theater of war.[15] During this pause, I will describe the onward life of a neural network algorithm as it travels across "domains," from consumer targeting to military targeting, and as it modifies and updates its parameters with each new iteration of the model.[16] A group of computer scientists meet with government and defense officials to outline and discuss the requirements for a machine-learning model that will recognize and risk score potential threats.[17] One of the government scientists shows a slide of the playbook that is envisaged for the experimental model. Mirroring what I have elsewhere described as a "space of play" in the iterative and experimental building of a machine-learning model, the "targeting threat" playbook outlines the broad outcomes of the project.[18] It includes, for example, the aim of moving beyond individual person-based profiles of threat and toward the inference of intentions that are high risk. In the room are computer scientists from defense companies Thales and BAE Systems, alongside consumer analytics specialists. What they share with their colleagues in the

political administration is an interest in generating and assessing "targets of opportunity" from the features in large volumes of input data, from video feeds to social media trends.[19] Their neural network algorithms are trained using semi-supervised methods so that the machine extracts features from the data and ascribes attributes to different people, groups, objects, and scenes, creating thresholds of likelihood and risk.

The machine-learning algorithms that are being speculatively discussed in the room do not quite share the qualities of the pre-programmed and rules-based arrangements of more conventional models.[20] Indeed, the gathered teams express their desire to capture the emergent phenomena and unpredictable surprises that exceed pre-programmed rules. What is sought instead is an optimal target under conditions of profound uncertainty. Rather than being defined by its rules, the algorithm instead generates functions from the contingencies of input and output data. In effect, the algorithm is "useful" to war and to the political governance of population because it seeks to optimize the priority targets, whether these are combatants in a war scenario or new customers in an online store. This enrollment of the algorithm into target generation is not quite the same thing as automating human decisions. In fact, human decisions are being made continually and at every point in the building of the model. The updating of weights and parameters in the algorithm takes place in a kind of collaborative dance between human and machine, with each run of the model provoking more discussion in the room: What is a useful output? How should the system prioritize? What is taking place here, though, is not merely a technical matter of refinement and testing. The machine's search for the best function all too readily slips and slides into the political claim that this is the best and optimal political outcome. The neural network for threat targeting actually embodies multiple possibilities, and occasionally these come to the surface—Is this group of people in the video an unruly mob? Is that vehicle civilian or military?—but these are contingent on many millions of parameters and weights that are undecidable. So, the war on futures that takes place here is actively reducing the plurality of possible political decisions to a single output of a machine-learning model. At the moment of decision about a target—from drone program to border security—the multiplicity that is political difficulty is reduced to one, condensed to the single output of the neural network, a numeric score between zero and one.

Put simply, the machine-learning algorithms emerging at the intersection of war and politics contain a quite specific form of violence in their spatial arrangements: a violence that forecloses alternative futures. As technologies of classification, enumeration, and recognition, such algorithms are always political in the sense that they arrange assumptions and propositions about the world. The algorithm acts to condense and distill the target as though it appears in the world ready formed and precomputed. The spatial imagination of a neural network—whose millions of potential parameters dwell beneath the search for optimal targets—itself establishes an aesthetic of branching pathways that lead irrevocably toward the best possible approximation of a function (figure 13.1). This is

Figure 13.1

Eight test images drawn from the AlexNet image recognition algorithm.
Source: Alex Krizhevsky, Ilya Sutskever, and Geoffrey Hinton, "ImageNet Classification with Deep Convolutional Neural Networks," *Advances in Neural Information Processing Systems* 2 (2012): 1097–1105.

always a potentially lethal function because it generates a malleable threshold of decision, whether this is within systems of autonomous weaponry, cancer treatment pathways, or immigration controls.[21] The lethality of the targeting decision extends into a war by other means that condenses the potential futures of a life to the single output. We have seen the results of political pathways foreclosed by the algorithms of Cambridge Analytica, Palantir, Faculty AI, and others, but the residue of rejected alternative pathways remains lodged in the algorithmic calculus. Put differently, politics is not annulled by the output of the algorithm. It is, of course, of the utmost importance that every possible limit is placed on autonomous weapons systems and AI in war, but this crucial necessity is also insufficient as a measure on its own.[22] What is needed is a full restoration and recovery of the politics and undecidability that is present but obscured in the layered pathways of the algorithm.

Regimes of Recognition

What could it mean to understand late modern war in terms of the forms of violence that are made possible by algorithmic systems? The contributions to this book are collectively animated by a concern with the culture and aesthetics of war futures. For me, a defining feature of algorithmic war is the culture and aesthetics of how something or someone becomes recognizable to other people and machines. One aspect of this is the technologies of biometric recognition that circulate from battle spaces to borders and city streets, where the aesthetics of war is also a pixelated and machine-learned recognizability of the body. Yet, the question of recognition is concerned not with how technologies identify individuals, or even how machines come to see, survey, or visualize war and politics. Rather, machine-learning algorithms are generating entire regimes of recognition that differently render a politics of enmity beyond the spaces of war itself. What Michael Shapiro has called a "violent cartography" supplies the aesthetic and political "frames within which enmities give rise to war as policy."[23] Shapiro's architecture of enmity is also, I suggest, present in the regimes of recognition of machine-learning algorithms, where notions of the inside and outside, the friend and the enemy, the proximate and the distant combine to embed war as policy. I will say something now about this regime of recognition as it pervades contemporary machine-learning architectures, and once again, I will begin with a reflection from field notes.

A designer of convolutional neural nets (these are the algorithms that are most often used to recognize images) for the UK defense sector shows me how her models learn to recognize the difference between civilian and military targets amid an occluded data environment of video drone images. She illustrates the problem with an image of Kandahar, explaining that a specific vehicle could be a suspect entity or, crucially, a school bus taking children home to rural villages. In the earliest days of training their model, she explains, the team quickly realized that the most commonly used training

dataset included predominantly US derived images of yellow school buses. Human labeling of the training images had led to the classifier deciding on the threshold of civilian/military vehicles on the basis of highly specific representations of, for example, "tractor" and "school bus." The problem of the model over-fitting to its training data is common and very widely researched, but the question of how a regime of recognition spills out into the world is also important. A potential act of violence, such as a school bus targeted by a drone or a marketplace object misrecognized as an improvised explosive device, is contingent on how the algorithm detects the possible edges of an object in relation to the attributes of other things. None of this would be possible without a series of very ordinary but game-changing breakthroughs in computer science.

The regimes of recognition in contemporary geopolitics are significantly shaped by the practices, databases, and breakthrough algorithms of computer science. The recognition and classification of handwritten digits via the famous MNIST dataset is a common example, but the problem could equally be the recognition of faces, threats, targets, weather patterns, suspicious transactions, or the text on placards in a protest march. The 2012 computer science breakthrough of the AlexNet algorithm, for example, fundamentally changed how algorithms learn to recognize and classify images, and this scientific work was swiftly deployed in technologies from drones to the analysis of satellite images.[24] AlexNet is a neural network that was trained on fifteen million labeled images, with the input data of a new image taking the form of pixel-level data. In the eight test images, the algorithm performed well on the recognition of a leopard, and even a mite, which is positioned at the edge of the frame, but less well on the aesthetic ambiguities of a cherry and a grille. My point is that the capacity of the machine-learning algorithm to recognize things in the world is contingent on the exposure to data and to the indefinite series of weightings, probabilities, and thresholds that tell it how important each pixelated element of data is. The exponential growth of biometric recognition biometric systems at borders, on the battlefield, and in city streets is also a condition of appearance in the world, a condition of being able to appear in public space. The AlexNet algorithm now has many progeny systems at work in the world, not only in the recognition of individual people and objects but also in the behavioral analysis of events that are unfolding—protests gathering, trains leaving stations, people pausing as they cross a public square, or a particular walking gait or style of dress. The algorithms continue war by other means precisely because they generate the thresholds of recognizable normal and abnormal behaviors, reasonable and unreasonable movement or travel, the very arbitration of the good and the bad, the friend and the enemy.

Algorithms and Attribution

There is a particular point of alliance between techniques of modern war and the methods of contemporary computer science. Where twenty-first-century war deploys

preemptive and anticipatory tactics to understand the possible attributes of a social group, a population, a battlefield scene—What could happen? What are their characteristics? How to act on this uncertain set of relations?—our contemporary computer science uses attributes and features to describe the dimensions of the dataset. While these two modes of attribution—attributes of population and attributes of a dataset—are ontologically distinctly different, they are forming epistemic alliances that generate novel ways of acting upon an uncertain future. Consider, for example, how computer scientists consider features to be a "set of attributes associated to an example."[25] This means that the sets of attributes are not quite like the variables one would define in advance of a computational operation, but instead they are inductively generated from all of the data examples that the algorithm is exposed to. Put simply, this opens the prospect of the space of war as simultaneously a feature space of examples from which a machine-learning model can learn. This is somewhat different from a notion of automated or programmed war, where the rules and variables are defined in advance, and is closer to a war by other means in which every data point is potentially a feature in the scene. One effect of this *battlespace as feature space* is that the data pertaining to war are vastly expanded—anything could be an example that yields an attribute—from a database of millions of labeled images of faces to the data streams of social media sentiment.

Let us consider here an example of how the creation of a feature space is implicated simultaneously in attributing the dynamics of war and politics. Among the most highly cited scientific papers in machine learning are those developing so-called neural caption generators.[26] These bundles of scientific knowledge published in the pages of the *IEEE* matter because they represent a desire to move a step beyond the recognition and classification of an image or object and to capture the meaning of what is happening in a scene. While classification algorithms certainly enact politics in their actualization of the differences and similarities between entities, the claim to capture meaning extends and deepens the politics of the algorithm as classifier. In claiming to attribute meaning and text descriptors to a video or an image, the computer scientists are proposing to provide an elusive context to a human decision-maker at the end of a chain of algorithmic outputs (e.g., the armed person is moving toward the checkpoint, or the child is being lifted over the border fence). In describing the architecture of their "show, attend, and tell" algorithms, the computer scientists express their desire for "scene understanding." "A description must capture not only the objects contained in an image," they propose, "but it must also express how these objects relate to each other, as well as their attributes and the activities they are involved in."[27] It is precisely in this computation of how objects or people relate, what their attributes are, and the inference of their activities that I am locating a political violence that extends the enmities of war by other means. The first set of algorithms are convolutional neural networks (descendants of AlexNet) that are said to "distill information in an image down to the most salient features."[28] In this process of distillation and spatial reduction to an assumed essence, the model is

learning how to "infer scene elements" and to foreground what is considered to matter among the relations of people and things. Once the first neural networks have extracted the feature vectors of what matters, a second set of algorithms—recurrent neural networks designed for natural language processing—then act upon the output of the first in order to "decode those representations in natural language sentences." Put simply, what begins as an image input is parsed through two sets of different algorithms in order to generate a "human user friendly" output of structured text. The difference on the screen of the drone operator or the police deployment officer is that a color-coded risk flag is replaced with a text-based summary of what a scene means, what is taking place, or what is about to unfold. The algorithms precipitate and structure action.

In the test images for the neural caption generator, we find a curious and compelling aesthetic of showing and telling for our times. A group of people gather in a marketplace, the location profoundly uncertain and the relations among the figures indeterminate. To infer a probable meaning from the image, one would have to assume the attributes of the people and objects in the scene. Yet, the neural networks work together to generate a most likely output set of sentences: a group of people shopping at an outdoor market; there are many vegetables at the fruit stand. The algorithms are thus doing much more than classifying people and objects. They infer a field of meaning, and they decide *what is to be* in the single output, even where this attributes both vegetables and a fruit stand. As the neural caption generator algorithms travel from their laboratory site of test images to new domains, how might the output decide what is to be in the drone target, at the refugee camp or the border checkpoint? My point is that the algorithm's mode of attribution is becoming a political technology for attributing and annulling some potential futures. The complexity and uncertainty of a social scene—a public space, a military theater—is distilled to a most likely or probable single output. The output of "show, attend, and tell" is a war on futures because it condenses the intractable difficulties and duress of living, the undecidability of what could be happening at a particular moment in time.

The politics of attribution that is exhibited in the example of these neural networks is not limited to the recognition of digital images, however. Among the most significant changes wrought by these technologies is the increasing agnosticism as to the sources of their input data. This matters because ascertaining the relevance of a particular input is no longer a question of whether it is materially related to war but rather whether it can be used to infer warlike relations, hence the vast expansion of algorithmic systems to analyze multiple forms of data simultaneously: government databases from across different functional departments, social media hashtags, travel data, cell phone location data, and so on. Taken together, all of these data sources yield potential examples to the feature space. In a quite direct sense, it no longer matters where or whether one defines the limits of war, or the distinction between war and public policy, or the boundary of war and border controls, because there are no such distinctions in the feature space.

What comes to count in this form of algorithmic war is the capacity to find the best representation of data, to generate and assess an output, to render that output actionable, to decide what is meant by a particular arrangement of bodies and objects in the scene. In this flourishing alliance—between a computer science modeling the potential meaning of scenes and a modern politics seeking the attributes of populations—there are urgent and profound ethico-political challenges. Of course, it matters greatly that work continues to delimit and restrict the actions of AI in the spaces of war, and yet this is also insufficient if it does not address how the spaces of warlike relations are intrinsic to the very building of an algorithmic model itself. In the final section, I will turn my attention to the ethico-politics of a war on futures. What are the potential harms of the algorithmic war by other means, and how might these harms be more fully in the foreground of the politics of algorithmic warfare?

Ethico-Politics and War on Futures

It is March 3, 2022, and in Berlin Central Station, many thousands of Berliners are crowding the concourse to welcome the arrival of those people fleeing the war in Ukraine.[29] The Berliners hold aloft improvised cardboard signs with drawings of stick-figure adults and children, conveying in a language-agnostic way their offer of hospitality. In the intensity of this political scene, where war and the politics of human movement are deeply entwined, how could one envisage the algorithmic extraction of features that outputs a single meaning to the scene? Certainly, the geopolitical algorithms of our times have the capacity to extract handwritten text and images and infer meaning, outputting the best fit to the data. And indeed, it is exactly this kind of unanticipated and ungoverned crowd that is the object of so much algorithmic technological governing. But importantly, there can be no algorithmic response to the generosity of these acts. At the very moment that a technology would seek to reduce the difficulty and uncertainty of the decision to an optimal output, this would actively replace hospitality with a calculation. In the preface to Jacques Derrida's *On Cosmopolitanism and Forgiveness*, Simon Critchley and Richard Kearney write that "unconditionality cannot, must not, Derrida insists, be permitted to program political action" so that "decisions would be algorithmically deduced from incontestable ethical precepts."[30] For Derrida, hospitality "is culture itself and not simply one ethic amongst others," and insofar as hospitality involves "the manner in which we relate to ourselves and to others, to others as our own or as foreigners, *ethics is hospitality.*"[31] There can be no algorithmic deduction of hospitality, no inference of ethics. The generosity of the acts of the people of Berlin necessarily inhabits a space without inference. The rudimentary communication of the cardboard signs and the welcoming of those who arrive, these are acts precisely *without inference*. The givers and the receivers of hospitality are not algorithmically matched or optimally paired but quite the opposite—they meet in the dark of incomplete knowledge of what is to come. It is

a kind of ethico-political matching that runs entirely counter to the logics of matching algorithms that extract features, generate clusters, and infer proximities.

What takes place at that railway station in Berlin is the very antithesis of algorithmic war by other means. Six hundred miles away, in Calais, something else takes place that does follow the logic of the algorithm and that disavows the hospitality of action in the face of uncertainty and non-knowledge. Here, the offshored UK Home Office processing center turns away Ukrainian people who have fled the war and traveled day and night to seek safety.[32] The UK Home Office routinely uses algorithms to stream immigration decisions, and their algorithms require input data in a specified format, from an address on a utility bill to the capture of face and fingerprint biometrics. In short, the model cannot function without the algorithm and, therefore, without its logic—even where people have fled without belongings and without papers, and where no place for biometric capture is a safe place to be. In one sense, the war algorithm is at work by other means, even though it fails and falls apart because it is unable to respond to this event that was not already present in the model. Here is a definitive foreclosure of a future for the person who arrives, a war on futures that displaces and refuses the hospitality of the Berlin train station and its handwritten signs. Everything must be extracted, everything must be a feature, no future must proceed without calculation.

For the Ukrainian refugees who are turned away by the UK Home Office at Calais, the experiences of war and trauma do not cease when they leave the direct violence. The violence precisely extends into the continued inequalities, injustices, and disavowals of the immigration system with its attendant algorithms that extract and cluster data features. This continuation of war by other means installs algorithmic logics into the heart of the political decision. One should surely prohibit the analysis of data inputs for the algorithms of the drone program—stop science's "work of war," as Wiener proposes—and yet meanwhile the machine-learning border line continues to proliferate and foreclose the political claims of those who arrive.

The harms of algorithmic war are, of course, multiple and manifest. Often, we tend to think first of the ceding of human control to machines and the reflex protection that seems to reside in restoring authority and control to the human in the system. What I have proposed here, however, is that algorithmic war is not limited to autonomous systems deployed over and against humans in the battlefield, but rather extends into entire worlds of targeting, recognition, and attribution that overflow the delineation of war and the civil peace. In short, it does not so much displace the human as fundamentally reconfigure what it means to be human in the context of geopolitics. A principal animating violence of these technologies, then, is a more diffuse threat to our capacities to respond without inference and in the absence of a guiding calculus, for we live together and must decide together, uncertainly and in the face of impossible and intractable political questions. To condense those questions to the most likely output of a model is to foreclose the terrain of ethico-politics that can extend hospitality without

attribution of characteristics or qualities. Perhaps it could be possible not only to heed Wiener's warnings on the dangers of the governmental and commercial deployment of computer science on the battlefield, but also to acknowledge that the scope of warlike technological systems far exceeds war as such. To draw the line at the edge of war will never be enough to limit the capacities of algorithmic systems to enact the regimes of targeting, recognition, and attribution that are integral to a war by other means. It is present on our city streets, at our borders, and in our welfare and immigration systems, and its less visible violence lurks under the appearance of civil peace.

Notes

1. Norbert Wiener, "A Scientist Rebels" [1947], folder 573, box 28C, Norbert Wiener Papers, Institute Archives and Special Collections, MIT Libraries, Cambridge, MA.

2. Norbert Wiener and Leo Pach, "From the Archives," *Science, Technology, and Human* 8, no. 3 (Summer 1983): 36–38.

3. Wiener and Pach, "From the Archives," 36.

4. Scott Shane and Daisuke Wakabayashi, "The Business of War: Google Employees Protest Work for the Pentagon," *New York Times*, April 4, 2018.

5. Michel Foucault, *Society Must Be Defended: Lectures at the Collège de France 1975–76* (London: Penguin, 2004), 15.

6. Foucault, *Society Must Be Defended*, 15.

7. Foucault, *Society Must Be Defended*, 16.

8. I have in mind here the kind of forces discussed by the research collective on algorithmic violence, where they foreground the "force of computation" and the "force that computation leverages" in their analysis of "invisibilized forms of algorithmic violence." Rocco Bellanova, Kristina Irion, Katja Lindskov Jacobsen, Francesco Ragazzi, Rune Saugmann, and Lucy Suchman, "Toward a Critique of Algorithmic Violence," *International Political Sociology* 15, no. 1 (2021): 121–150.

9. Claudia Aradau and Martina Tazzioli, "Biopolitics Multiple: Migration, Extraction, Subtraction," *Millennium* 48, no. 2 (2020): 198–220; Louise Amoore, "The Deep Border," *Political Geography*, https://www.sciencedirect.com/science/article/pii/S096262982100207.

10. Foucault, *Society Must Be Defended*, 16.

11. Foucault, *Society Must Be Defended*, 16.

12. Simone Browne, *Dark Matters: On the Surveillance of Blackness* (Durham, NC: Duke University Press, 2015); Achille Mbembe, *Necropolitics* (Durham, NC: Duke University Press, 2019).

13. Foucault, *Society Must Be Defended*, 17.

14. I have elsewhere described the politics of possibility as "a change in emphasis from the statistical calculation of probability to the algorithmic arraying of possibilities" in which the future is acted upon in its unfolding potential. Louise Amoore, *The Politics of Possibility: Risk and Security Beyond Probability* (Durham, NC: Duke University Press, 2013), 23. A significant element

of the algorithmic arraying of possibilities is the neural network's orientation to modeling uncertain representations of data. The machine-learning algorithm is thus implicated not only in war when it is actively deployed in weaponry but also, in fact, at every point that it represents and acts to foreclose futures.

15. For an extended discussion of how algorithmic war elides military and civilian imaginaries, see Lucy Suchman, "Algorithmic Warfare and the Reinvention of Accuracy," *Critical Studies on Security* 2, no. 8 (2020): 175–187; Louise Amoore, "Algorithmic War," *Antipode: A Radical Journal of Geography* 41, no. 1 (2009): 49–69.

16. In many current uses of machine learning in geopolitical systems, there is a premium placed on models that are flexible and multifunctional, able to cross domains freely and move between civilian and military applications. It is often the case that a model trained in one domain has an onward life in the "transfer learning" that sees it deployed to a new domain. For an illuminating discussion of the logic of domains in computing and science, see David Ribes, Andrew Hoffman, Steven Slota, and Geoffrey Bowker, "The Logic of Domains," *Social Studies of Science* 49, no. 3 (2019): 281–309.

17. Field notes from observations of deep learning model team, London (conducted online), July 12, 2021.

18. The "space of play" describes an open-ended and contingent process of experimentation in the building of a machine-learning model. The act of play often involves iterative updating of a model based on the proximity or distance from a target output. When data scientists discuss a model with government clients, this target output is often a key focus of experimentation. Louise Amoore, *Cloud Ethics: Algorithms and the Attributes of Ourselves and Others* (Durham, NC: Duke University Press, 2020), 68.

19. Samuel Weber's notion of "targets of opportunity" traces the genealogy of the target so that the military target is thoroughly enmeshed with political and commercial seizing of opportunity or profiting from a singular strike. Samuel Weber, *Targets of Opportunity: On the Militarization of Thinking* (New York: Fordham University Press, 2005).

20. A rules-based algorithm establishes correlations among a set of "if, then else" variables, for example "if x and y, then high risk, else low risk." Such rules-based systems were integral to war and to military planning because they set out the parameters for the detection of threats and the ranking of risks. However, machine-learning models do not have to rely on established rules alone because they use the patterns in data to detect and generate a function. See Taina Bucher, *If . . . Then: Algorithmic Power and Politics* (Oxford: Oxford University Press, 2018).

21. As Lisa Parks and Caren Kaplan propose in their studies of drone warfare, the technical architecture of the drone is part of broader "cultural imaginaries" that "draw upon and generate particular ways of perceiving and understanding the world." Thus, the lethal decision of the drone strike extends and proliferates in the "assumptions and ideologies," the "ideas" and the fantasies" of the machine. Lisa Parks and Caren Kaplan, "Introduction," in *Life in the Age of Drone Warfare*, eds. Lisa Parks and Caren Kaplan (Durham, NC: Duke University Press, 2017), 9.

22. Nehal Bhuta, Susanne Beck, Robin Geiß, Hin-Yan Liu, and Claus Kreß, eds., *Autonomous Weapons Systems: Law, Ethics, Policy* (Cambridge, MA: Cambridge University Press, 2016).

23. Michael J. Shapiro, "The New Violent Cartography," *Security Dialogue* 38, no. 3 (2007): 293.

24. Krizhevsky et al., "ImageNet Classification with Deep Convolutional Neural Networks," 1097–1105.

25. Mehryar Mohri, Afshin Rostamizadeh, and Ameet Talwalkar, *Foundations of Machine Learning* (Cambridge, MA: MIT Press, 2018), 4.

26. Oriol Vinyals, Alexander Toshev, Samy Bengio, and Dumitru Erhan, "Show and Tell: A Neural Image Caption Generator," *IEEE Transactions on Pattern Analysis and Machine Intelligence* 39, no. 4 (2017): 2048–2057.

27. Vinyals et al., "Show and Tell," 2048.

28. Vinyals et al., "Show and Tell," 2049.

29. Damian Grammaticas, "Germans Welcome Ukrainian Refugees by Train: It Could Have Been Us," BBC News, March 3, 2022, https://www.bbc.co.uk/news/world-europe-60611188, accessed March 14, 2022.

30. Simon Critchley and Richard Kearney, "Preface," in *On Cosmopolitanism and Forgiveness*, ed. Jacques Derrida (London: Routledge, 2001), xii.

31. Derrida, *On Cosmopolitanism*, 16–17.

32. Mark Townsend and Shaun Walker, "Stranded and Desperate, Ukrainian Refugees Wait for the Home Office Reply, But It Never Comes," *The Guardian*, March 13, 2022, https://www.theguardian.com/world/2022/mar/13/stranded-and-desperate-ukranian-refugees-wait-for-the-home-office-reply-but-it-never-comes, accessed March 13, 2022.

Contributors

Louise Amoore is professor of political geography at Durham University. Her research and teaching focuses on aspects of geopolitics, technology, and security. She is the author of the monographs *The Politics of Possibility: Risk and Security Beyond Probability* (Duke University Press, 2013) and *Cloud Ethics: Algorithms and the Attributes of Ourselves and Others* (Duke University Press, 2020), and she has co-edited the volumes *Algorithmic Life: Calculative Devices in the Age of Big Data* (Routledge, 2015) and *Risk and the War on Terror* (Routledge, 2008).

Ryan Bishop is professor of global art and politics at the Winchester School of Art. He is the co-author of *Modernist Avant-Garde Aesthetics and Contemporary Military Technology: Technicities of Perception* (Edinburgh University Press, 2010) and *Technocrats of the Imagination: Art, Technology, and the Military-Industrial Avant-Garde* (Duke University Press, 2020). He co-edits the book series *Technicities* for Edinburgh University Press and *A Cultural Politics Book* for Duke University Press. He is currently working on a book project on histories, genealogies, and archaeologies of military technologies that alter time and space as used by artists, composers, and writers.

Jens Bjering holds a PhD from the University of Copenhagen. He is the author and co-author of several articles on war and violence, such as "Old Stars in New Settings: The Critical Potential of Post-9/11 Action Comedy," "From Hermeneutics to Archives: Parasites and Predators in Homeland," "A Bipolar Machine: Sovereignty and Action in 24," and "Ecology, Capitalism, and Waste: From Hyperobject to Hyperabject."

James Der Derian is Michael Hintze Chair of International Security Studies and director of the Centre for International Security Studies at the University of Sydney. His research and teaching interests are in international security, information technology, international theory, and documentary film. He is the author of *Virtuous War: Mapping the Military-Industrial-Media-Entertainment Network* (Routledge, 2009) and *Critical Practices in International Theory* (Routledge, 2009) and the co-editor of *Quantum International Relations: A Human Science for World Politics* (Oxford University Press, 2022).

Anthony Downey is professor of visual culture in the Middle East and North Africa at Birmingham City University. Recent and upcoming publications include *Trevor Paglen:*

Adversarial Hallucinations (Sternberg Press/MIT Press, 2024), *Shona Illingworth: Topologies of Air* (Sternberg Press & The Power Plant 2022), and *Heba Y. Amin: The General's Stork* (Sternberg Press/MIT Press, 2020). He sits on the editorial boards of *Third Text*, *Journal of Digital War*, and *Memory, Mind & Media*, and is the series editor for *Research/Practice* for Sternberg Press.

Anders Engberg-Pedersen is professor of comparative literature at the University of Southern Denmark, chair of humanities at the Danish Institute for Advanced Study, and director of the Nordic Humanities Center. He is the author of *Empire of Chance: The Napoleonic Wars and the Disorder of Things* (Harvard University Press, 2015) and *Martial Aesthetics: How War Became an Art Form* (Stanford University Press, 2023). Several co-edited volumes on war include, most recently, *War and Literary Studies* (Cambridge University Press, 2023). He edits the book series *Prisms: Humanities and War* with MIT Press.

Solveig Gade is associate professor in theatre and performance studies at the University of Copenhagen. She also works as a dramaturge at the Royal Danish Theatre, Betty Nansen Teatret, Sort/Hvid, and the Norwegian National Theatre. She is the author of *Intervention & kunst* (Politisk Revy, 2010) and co-editor of *(W)Archives: Archival Imaginaries, War, and Contemporary Art* (Sternberg Press/MIT Press, 2021). She is currently writing a book on documentary artistic responses to contemporary image wars.

Mark B. N. Hansen is the James B. Duke Distinguished Professor of Literature at Duke University. Among several books, he is the author of *Bodies in Code: Interfaces with New Media* (Routledge, 2006) and *Feed-Forward: On the Future of 21st Century Media* (University of Chicago Press, 2014), as well as the co-editor of *Critical Terms for New Media* (University of Chicago Press, 2014).

Caroline Holmqvist is senior lecturer in war studies at the Swedish Defence University. She is the author of *Policing Wars: On Military Intervention in the Twenty-First Century* (Palgrave Macmillan, 2016) and the co-editor of *War, Police and Assemblages of Intervention* (Routledge, 2016) and *The Character of War in the 21st Century* (Routledge, 2009).

Vivienne Jabri is professor of international politics in the Department of War Studies at King's College London. Her research focuses on international political theory, critical social and political theory, postcolonialism, and feminist perspectives, with a specific interest in the politics of conflict, violence, and security practices. She is the author of *Discourses on Violence: Conflict Analysis Reconsidered* (Manchester University Press, 1996), *War and the Transformation of Global Politics* (Palgrave Macmillan, 2007), and *The Postcolonial Subject: Claiming Politics/Governing Others in Late Modernity* (Routledge, 2012).

Caren Kaplan is professor of American studies and affiliated faculty in cultural studies and science and technology studies. She is the author of *Questions of Travel:*

Postmodern Discourses of Displacement (Duke University Press, 1996) and *Aerial After-maths: Wartime from Above* (Duke University Press, 2017). Among other volumes, she has co-edited *Life in the Age of Drone Warfare* (Duke University Press, 2017), as well as two digital multi-media scholarly works, *Dead Reckoning* and *Precision Targets*.

Phil Klay is a writer and a veteran of the US Marine Corps. His short-story collection, *Redeployment*, won the 2014 National Book Award for Fiction and the National Book Critics' Circle John Leonard Prize for best debut work in any genre. His first novel, *Missionaries*, appeared with Penguin Press in 2020. Most recently, he has published the nonfiction book *Uncertain Ground: Citizenship in an Age of Endless, Invisible War* (Penguin Press, 2022).

Kate McLoughlin is professor of English literature at the University of Oxford and fellow of Harris Manchester College. She is the author of *Martha Gellhorn: The War Writer in the Field and in the Text* (Manchester University Press, 2007), *Authoring War: The Literary Representation of War from the Iliad to Iraq* (Cambridge University Press, 2011), and *Veteran Poetics: British Literature in the Age of Mass Warfare* (Cambridge University Press, 2018), as well as the editor and co-editor of *The Cambridge Companion to War Writing* (Cambridge University Press, 2009), *Writing War, Writing Lives* (Routledge, 2017), and *The First World War: Literature, Culture, Modernity* (Oxford University Press, 2018).

Elaine Scarry is the Walter M. Cabot professor of aesthetics and general theory of value at Harvard University. Among several monographs, she is the author of *Thermonuclear Monarchy: Choosing between Democracy and Doom* (W. W. Norton, 2014), *Thinking in an Emergency* (W. W. Norton, 2011), *On Beauty and Being Just* (Princeton University Press, 1999), and *The Body in Pain: The Making and Unmaking of the World* (Oxford University Press, 1985).

Christine Strandmose Toft is a postdoc in the Department for the Study of Culture at the University of Southern Denmark. She has published articles on literature and warfare and co-edited the special issue "Krigkunst" of the journal *Passage*. In 2021, she defended her dissertation titled "'This Isn't a Real War': The Wars in Iraq and Afghanistan in Fiction," which she is currently working into a monograph.

Joseph Vogl is professor of modern German literature, cultural and media studies at Humboldt-Universität zu Berlin, as well as regular visiting professor at Princeton University. His research and teaching covers literature from the eighteenth century to the twentieth century, media and aesthetics, cultural and political theory. He is the author of *Ort der Gewalt. Kafkas literarische Ethik* (Wilhalm Fink Verlag, 1990), *The Specter of Capital* (Stanford University Press, 2014), *The Ascendency of Finance* (Polity, 2017), and, most recently, *Capital and Ressentiment. A Short Theory of the Present* (Polity, 2023).

Arkadi Zaides is an independent choreographer. Born in 1979 in Belorussia, former USSR, he immigrated to Israel in 1990 and currently lives in France. His work examines the ways in which political and social contexts affect the physical body and constitute choreography. His works, such as *Talos, The Cloud*, and, most recently, *Necropolis*, have been presented across the globe. He is the recipient of the Emile Zola Prize for Performing Arts for demonstrating engagement in human rights issues in his work *Archive*. Currently, he is working on a project titled "Towards Documentary Choreography."

Index

Page numbers followed by *f* indicate figures.

suffering soldiers immeasurably more valuable than civilians back home, 28
"truth" and "pity," 20
universal pervasion of Ugliness, 31–32

Paglen, Trevor, 155–159, 256f, 257
Paine, Thomas, 174, 175
Painfully present tense, 47
Palantir, 222, 295
Paradox and war, 188–190
Paradox of war representation, 4
Para-ode, 166
Parikka, Jussi, 160
Paris (Mirrlee), 47
Parker, Rozsika, 79, 98n24
Parks, Lisa, 302n21
Participatory realism, 198
Pasquinelli, Matteo, 212, 229, 231
Pattern-of-life analysis, 210, 233, 235n6
Pattern precognition, 233
Pauli, Wolfgang, 198
Peace Museum (Hiroshima), 166
Peirce, C. S., 191
Peloponnesian war, 271
Penrose, Roland, 90, 92f
People of Peace at War, 86
Pepperell Manufacturing Company, 86
Perceptron, 236n9
Perennial suffering, 30
Perpetual Peace (Kant), 54, 179
Perry, William, 172
Petraeus, David, 272
Phantom Noise (Turner), 40
Phenomenology, 198, 204n35
Phenomenology of Perception (Merleau-Ponty), 204n35
Phenomenon of consent, 174
Philosophical aesthetics, 1
Philosophy, 173
Photomontage, 65, 71n35
Physical distance and readiness to kill, 277–278
Picasso, Pablo, 88
Pichai, Sundar, 289
Pinker, Steven, 179
Pitkin, Hanna, 174
Pixels/blobs, 224, 238n33
Pixel spreader, 238n33
Plato, 193
Plural ways of seeing, 40
Poetry as witness, 20, 21, 24, 29, 30, 32. *See also* War, beauty, and the trouble with witness

Pointillism, 88
Polani, Naomi, 129f, 130f, 139
Policing social relations, 272
Political Sublime, The (Shapiro), 69n15
Political within the aesthetic, 58, 64–67, 68
Politics of aesthetics, 55
Politics of possibility, 292, 301n14
Polyphonic music, 65
Post-antagonistic war, 272
"Post-Hegemonic World: Justice and Security for All, A," 201
Posthuman reciprocities, 278–280
Potentiality of data, 258–259
Potez Aircraft factory, 100n65
Pragmatic co-presence, 279, 280
Pratt Institute, 90
Predator drone strike (Oct 7/2001), 233
Predator drone strike killing Al-Harithi, 278–279
Predator tailfin number 3034, 241n76
Predatory war, 274, 275
Preemption, 254, 257
Preprogrammed missiles, 186n44
Princeton Institute of Advanced Studies, 199
Principles of Psychology, The (James), 202n8
Project Apollo, 136, 138, 139, 143
Project Maven, 221, 222, 225, 237n19, 237n20, 289
Project Q, 205n40
Project Q Symposia, 203n11
Prolonged existence, 44
Prophetic denunciation, 25
Prospect (magazine), 272
Protentions, 167n3
Psychotecnics, 167n3
Putin, Vladimir, 201

Qbism, 205n40
QC3AI, 200
Quantizing war, 190, 191
Quantum acoustics, 163
Quantum complementarity, 202n8
Quantum diplomacy, 198
Quantum physics, 163
Quantum politics, 199
Quantum war, 197–200
Quantum worldviews, 204n27
Quasi-imperial rule and subjugation, 275
Quasi-juridical process, 273
Quételet, Adolphe, 111

Racialized technologies of war, 292
Radically asymmetric war, 274

Rafael, 139
Ramage, Magnus, 139
Rammstein, 116
Rancière, Jacques, 2, 69n15, 145
Random happenings, 41
Rapatronic shutter (rapatronic's technics), 158, 159
Rawls, John, 186n38
Rawls's veil of ignorance, 272
Read, Herbert, 23–24
Reagan, Ronald, 11, 245, 246*f*, 247, 263
Reaganomics, 118
Realism, 191
Real potentiality, 259, 263, 266
Real-time tele-technologies, 10, 152
Real war, 189
Reciprocity. *See* End of reciprocity
Reconnaissance Survey of the American West, 158
Rectilinear temporal narrative, 40
Rehding, Alexander, 168n31
Reich, Steve, 168n34
Reification of the war model, 55
Reit, Seymour, 90
Remote intimacy, 277
Remote sensing, 162
Renic, Neil, 274
Renoir, Jean, 3
"Report of the President's Special Review Board"
 (1987), 245, 247
Representational authority, 4
Rights of Man, The (Paine), 174
Rilke, Rainer Maria, 46
Rio Declaration on Environment and Poverty, 171
Roads, Curtis, 163
Rocklea munitions plant, 100n65
Roebuck, John A., Jr., 136, 137*f*
Romanticism, 23
Roosevelt, Franklin, 164, 199
Rosenblatt, Frank, 236n9
Ross, Betsy, 78
Rössler, Tille, 128
Rousseau, Jean-Jacques, 179
"Route" (Oppen), 30
Royal Engineers, 90
Rules-based algorithm, 302n20
Rumsfeld, Donald, 47, 254
Running amok, 106. *See also* Area panic–"-
 running amok"
Russell, Bertrand, 176
Russett, Bruce, 179, 182, 183
Russian constitution, 175
Russo-Ukrainian War, 201

Said, Edward, 236n13
Saint-Amour, Paul, 37, 47
Saint-Gaudens, Homer, 86
Sandfly, mosquito, and camouflage nets, 86
Sarkissian, Armen, 198
Sartre, Jean-Paul, 197, 204n35
Sassoon, Siegfried, 32
Al-Sayegh, Adnan, 41, 44–47
Scahill, Jeremy, 243
Scarry, Elaine, 1, 269, 270, 274, 283
Scene understanding, 297
Scharre, Paul, 228
Schiller, Friedrich, 1, 166
Schmidt, Brian C., 180, 181
Schmitt, Carl, 55, 56, 60, 180
Schmittian aesthetic of horror, 55, 56
Schwarz, Elke, 280
"Scientist Rebels, A" (Wiener), 289
Screen-mediated intimacy, 277
Seidel, Shmuel, 140, 141*f*
Selfless courage, 27
Self-synchronization, 255
Semiotics, 192
Sense of infinity, 46
Sensibility, 28, 33
Sensorial military triptych, 151–169
 acoustic signatures for earthquakes and
 explosions to distinguish between the two,
 161
 aisthesis, 152, 153
 ballistic aesthetics, 155, 157, 158
 "clockwork orange," 166
 conversion of aisthesis to aesthetics, 153
 conversion of speech to code, 164
 converting geographical space into "real time,"
 154
 Cooley-Tukey algorithm, 161
 "deadly harmony" between eye and weapon,
 155
 ears, 160–163
 eyes, 155–160
 Fast Fourier Transform (FFT), 161, 163
 frozen speech, 154
 granular synthesis, 162–165, 168n34
 hominization, 166
 institution of human-centric metaphysical
 inquiry and wizardry, 166
 mechanized voice as mechanized, 166
 media-induced disruptions of human perception
 of time, 153
 metaphysics, 151, 152

War (cont.)
 mainstream canon of war writing being skewed
 and limited, 4
 martial techno-aesthetic apparatus, 3
 normalizing practices, 76
 no singular rendition/no uniform aesthetic, 56
 ongoing wars, 33
 paradox of war representation, 4
 perceptual spectrum, 13
 preemptive logic of military security apparatus, 3
 quotidian, even invisible affair, 5
 tactical thinking, 123
 "technology" in the government of population,
 60
 tension between visible and invisible, 5
 violence, compared, 271
 "war is film, and film is war," 3
 waste and failure of war in which truth lies,
 27
 "witnessing" of the devastations of war, 51
War, beauty, and the trouble with witness, 4–5,
 19–35
 barbarism, 31
 beauty, 30–33
 born warriors, 22
 creating spaces where writers meet reader with
 greater equality, 32
 death at level of pure perception, 23
 desiring that which we know is hateful, 33
 epistemological and moral claims, 5
 everyday soldiers, 22
 expanding our conception of the world, 33
 faith, 33
 immanences, 29
 moralistic fiction, 25
 moral warning, 31
 noble lie, 25
 ongoing wars, 33
 Owen (see Owen, Wilfred)
 perennial suffering, 30
 playful image of poem as disembodied aesthetic
 object, 21
 poet as machine, 26
 poetry as witness, 20, 21, 24, 29, 30, 32
 political categorization, 26
 prophetic denunciation, 25
 representation of reality, 30
 romanticism, 23
 selfless courage, 27
 sensibility, 28, 33
 totalizing political visions, 30

 "true record" distinct from Owen's true
 warning, 24
 true stories, 28
 universal pervasion of Ugliness, 31–32
 voice of the oppressed, 24
War, the aesthetic, and the political, 6, 51–71
 Adorno, Theodor, 65, 67
 aerial photography, 61–64, 68
 aestheticization of violence, 52
 aesthetic negativity, 67, 68
 aesthetics of horror, 55, 56
 aesthetics of the exception, 53–56
 aesthetics of violence, 65
 aesthetics of war and opposition, 56–60
 anti-colonial resistance, 66, 68
 bearing witness and the raising of emotions, 52
 Chapman brother's defacing of Goya's
 Disasters of War, 58–60
 colonial violence, 61, 66, 68
 constitutive capacity, 53, 69n10
 constitutive tension within the triptych, 67
 de-aestheticization of war in contemporary art,
 60–64
 dialectical mediation, 66
 Disasters of War (Goya), 56, 57f, 58
 epistemological and structural violence of
 untrammeled power, 68
 Ethiopian colonial war, 55
 Fanon, Frantz, 60, 66–68
 Fascism, 55, 65
 Foucault, Michel, 60
 Futurists, 55
 juxtaposition of domination and resistance, 58
 Kantian sublime, 54
 landscapes devoid of human presence (lands
 without a people), 61, 62f
 liberal governmentality, 60, 70n27
 photomontage, 65, 71n35
 political within the aesthetic, 58, 64–67, 68
 reification of the war model, 55
 Schmittian aesthetic of horror, 55, 56
 shock and awe, 52, 53, 65, 69n9
 sovereign power, 53, 56
 spectacle and spectatorship, 67
 "sublime," 53–54, 69n15
 sublime horror of war, 58
 transgressive capacity, 53
 visual archaeology, 64, 70n32
War and Aesthetics (Bjering et al.)
 aesthetic configurations of perception,
 technology, and time, 4

Watkins, Carleton, 157
Watson, Janet, 21
Weapon dance, 123
Weapons of mass destruction, 38
Weart, Spencer, 179
Weber, Jutta, 223
Weber, Samuel, 302n19
Weinberger, Eliot, 29
Weizman, Eyal, 2, 142
Westphalian system, 195, 271
Wheeler, John, 190, 198, 199
Whitehead, Alfred North, 198
Whiteheadian "superjects," 259
Whitman, Charles, 112
Whitman syndrome, 112
Wide Area Infrared System for Persistent
 (WISP-360), 238n32
Wiener, Norbert, 157, 195, 289, 290, 300, 301
Wiertz, Wendy, 97n4
Wikileaks, 196
Wilcox, Lauren, 279
William Perry Project, 172
Wilson, Eva, 139
Windowing technique, 163
WISP-360. *See* Wide Area Infrared System for
 Persistent (WISP-360)
Wolfenstein 3D, 116
Wolin, Richard, 55
Women in the Voluntary Services (WVS), 89*f*
*Work of Art in the Age of Mechanical
 Reproduction, The* (Benjamin), 64
Wright, Quincy, 192
Writing Mesopotamia, 44
WVS. *See* Women in the Voluntary Services
 (WVS)
Wyatt, Francis, 86

Yanai, Zvi, 124, 135
Yaqoob, Mohammad, 241n76
Yeats, W. B., 21
Yom Kippur War, 125, 140, 141, 148n43
Yosemite, 157, 158
Youngquist, Paul, 245, 247, 259

"Z," 197
ZALA Aero, 237n27
Zelensky, Vladimir, 201
Zionist movement, 132, 143